VINCENZO SCA
CHOROGRAPHY OF EARLY

The first English-language overview of the contributions to Renaissance architectural culture of northern Italian architect Vincenzo Scamozzi (1548–1616), this book introduces Anglophone architects and historians to a little-known figure from a period that is recognized as one of the most productive and influential in the Western architectural tradition.

Ann Marie Borys presents Vincenzo Scamozzi as a traveler and an observer, the first Western architect to respond to the changing shape of the world in the Age of Discovery. Pointing out his familiarity with the expansion of knowledge in both natural history and geography, she highlights that his truly unique contribution was to make geography and cartography central to the knowledge of the architect. In so doing, she argues that he articulated the first fully realized theory of place. Showing how geographic thinking influences his output, Borys demonstrates that although Scamozzi's work was conceived within an established tradition, it was also influenced by major cultural changes occurring in the late 16th century.

Ann Marie Borys is Associate Professor in the Department of Architecture at the University of Washington, USA.

VISUAL CULTURE IN EARLY MODERNITY

Series Editor: Allison Levy

A forum for the critical inquiry of the visual arts in the early modern world, *Visual Culture in Early Modernity* promotes new models of inquiry and new narratives of early modern art and its history. We welcome proposals for both monographs and essay collections which consider the cultural production and reception of images and objects. The range of topics covered in this series includes, but is not limited to, painting, sculpture and architecture as well as material objects, such as domestic furnishings, religious and/or ritual accessories, costume, scientific/medical apparata, erotica, ephemera and printed matter. We seek innovative investigations of western and non-western visual culture produced between 1400 and 1800.

Vincenzo Scamozzi and the Chorography of Early Modern Architecture

Ann Marie Borys

LONDON AND NEW YORK

First published 2014 by Ashgate Publishing

Published 2016 by Routledge
2 Park Square, Milton Park, Abingdon, Oxon OX14 4RN
605 Third Avenue, New York, NY 10017

First issued in paperback 2021

Routledge is an imprint of the Taylor & Francis Group, an informa business

Copyright © Ann Marie Borys 2014

Ann Marie Borys has asserted her right under the Copyright, Designs and Patents Act, 1988, to be identified as the author of this work.

All rights reserved. No part of this book may be reprinted or reproduced or utilised in any form or by any electronic, mechanical, or other means, now known or hereafter invented, including photocopying and recording, or in any information storage or retrieval system, without permission in writing from the publishers.

Notice:
Product or corporate names may be trademarks or registered trademarks, and are used only for identification and explanation without intent to infringe.

Publisher's Note
The publisher has gone to great lengths to ensure the quality of this reprint but points out that some imperfections in the original copies may be apparent.

British Library Cataloguing in Publication Data
A catalogue record for this book is available from the British Library

The Library of Congress has cataloged the printed edition as follows:
Borys, Ann Marie.
　Vincenzo Scamozzi and the chorography of early modern architecture / by Ann Marie Borys.
　　pages cm. -- (Visual culture in early modernity)
　Includes bibliographical references and index.
　ISBN 978-1-4094-5580-6 (hardcover) 1. Scamozzi, Vincenzo, 1548-1616--Criticism and interpretation. 2. Scamozzi, Vincenzo, 1548-1616--Philosophy. 3. Observation (Scientific method) I. Title.
　NA1123.S34B58 2014
　720.92--dc23

2013031553

ISBN 13: 978-0-367-43327-7 (pbk)
ISBN 13: 978-1-4094-5580-6 (hbk)

This book is dedicated to Daniel, Michael, and Leigh

Contents

List of Figures ix
Preface: Chorography, Place, and Time xv

1 "Citizen of the World" 1

2 Geography and Chorography: Scamozzi's Theory of Place 25

3 Mapping the Natural World: *Casa* and Villa 55

4 Mapping the City: Palaces and Civic Buildings 97

5 Chorography and Cosmography: Place and Transcendence 137

6 "A Scientific Habit" 173

Appendix 195

Bibliography 197
Index 209

List of Figures

1 "Citizen of the World"

1.1 Paolo Veronese (Paolo Caliari), Portrait of the Architect Vincenzo Scamozzi c. 1585 (Denver Art Museum Collection: Charles Bayly, Jr. Collection, 1951.85, photograph courtesy of the Denver Art Museum)

1.2 Vincenzo Scamozzi, Palazzo Trissino al Corso and Palazzo Trissino al Duomo, Vicenza (Photos: author and J. Derwig)

1.3 Andrea Palladio, plan and section/elevation of Villa Rotonda, Vicenza from *The Four Books of Architecture*, Book Two, Pl. XIII and a view showing the dome profile (Photo: author)

1.4 Andrea Palladio and Vincenzo Scamozzi, section of Teatro Olimpico, Vicenza (© The Courtauld Institute of Art, London)

1.5 Vincenzo Scamozzi, plan and elevation of Villa Pisani, Lonigo from *L'Idea della Architettura Universale*, Book Three, p. 273 (RIBA Library Photographs Collection) and a view of the approach (Photo: J. Derwig)

1.6 Vincenzo Scamozzi, Villa Molino, Mandria (© The Courtauld Institute of Art, London)

1.7 Vincenzo Scamozzi, San Gaetano, Padua (Photos: J. Derwig)

1.8 Vincenzo Scamozzi, Procuratie Nuove on Piazza San Marco, Venice (Photos: author)

1.9 Vincenzo Scamozzi, Palazzo Communale, Bergamo (Photo: Giorces)

1.10 Vincenzo Scamozzi, section and elevation of a design for Salzburg Cathedral (Collection Centre Canadien d'Architecture/Canadian Center for Architecture, Montréal)

1.11 Scamozzi, frontispiece of *L'Idea della Architettura Universale* (RIBA Library Photographs Collection)

2 Geography and Chorography: Scamozzi's Theory of Place

2.1 Vincenzo Scamozzi, plan of a fortified city from *L'Idea della Architettura Universale*, Book Two, pp. 166–7 (RIBA Library Photographs Collection)

2.2 Vincenzo Scamozzi, a wind rose from his architectural plans and cosmographies from *L'Idea della Architettura Universale*, Book Two, p. 96 (RIBA Library Photographs Collection)

2.3 Vincenzo Scamozzi, plan and section of Villa Bardellini project from *L'Idea della Architettura Universale*, Book Two, p. 138 (RIBA Library Photographs Collection)

2.4 *Cosmographia Petri Apiani* (A 1545.A75. Special Collections, University of Virginia, Charlottesville, VA)

2.5 Anthony Jenkinson, *Russiae Moschoviae at Tartariae Descriptio* from *Theatrum orbis terrarium* (A 1570.O77.

Special Collections, University of Virginia, Charlottesville, VA) and Egnazio Dante, *Genoa*, Galleria delle Carte Geographiche, Vatican Museums, Vatican State (Scala/Art Resource, NY)

2.6 Franz Hogenberg, *Venetia* from *Civitates orbis terrarium* (Alfredo Dagli Orti/Art Resource, NY)

2.7 Battista Pittoni, *View of the forum*, Rome from *Discorsi sopra L'Anitchità di Roma* (RIBA Library Books & Periodicals Collection)

2.8 Vincenzo Scamozzi, sketch of cathedral of Meaux from *Taccuino di Viaggio di Parigi a Venezia*, p. 40 (Museo Civico di Vicenza)

2.9 Vincenzo Scamozzi, *Chorographia Omnium Partium Thermarum Diocletiani, Quae Romae Ad Hvc Visvntvr In Alta Semita Sexta Regione* (The Getty Research Institute, Los Angeles, 870672)

2.10 Vincenzo Scamozzi, plans and elevations for two palace projects from *L'Idea della Architettura Universale*, Book Two, pp. 126–7 (RIBA Library Photographs Collection)

2.11 Andrea Palladio, plan and elevation of Villa Badoer, Polesine from *The Four Books of Architecture*, Book Two, Pl. XXXI and Vincenzo Scamozzi, plan and elevation of Villa Badoer, Peraga from *L'Idea della Architettura Universale*, Book Three, p. 291 (RIBA Library Photographs Collection)

2.12 Vincenzo Scamozzi, plan and elevation of Palazzo Trissino al Duomo, Vicenza from *L'Idea della Architettura Universale*, Book Three, p. 258 (RIBA Library Photographs Collection)

2.13 Vincenzo Scamozzi, plan and elevation of Villa Trevisan, San Donà di Piave from *L'Idea della Architettura Universale*, Book Three, p. 293 (RIBA Library Photographs Collection)

2.14 Details from Scamozzi's villa plans from *L'Idea della Architettura Universale*, Book Three (RIBA Library Photographs Collection)

3 Mapping the Natural World: *Casa* **and Villa**

3.1 Vincenzo Scamozzi, reconstructions of Pliny the Youger's villa at Laurentina and the Vitruvian farmhouse from *L'Idea della Architettura Universale*, Book Three, pp. 269 and 284 (RIBA Library Photographs Collection)

3.2 Giovanni Maria Falconetto, Cornaro loggia and odeon, Padua (Scala/Art Resource, NY)

3.3 Diagram of Serlian villa plan, Palladio's design for Villa Pisani, Bagnolo, and Scamozzi's design for Villa Pisani, Lonigo (Illustration: E. Anderson)

3.4 Diagram of Scamozzi's project for a villa on the Brenta and a Serlian villa site plan (Illustration: E. Anderson)

3.5 Andrea Palladio, plan and elevation of Villa Emo, Fanzolo from *The Four Books of Architecture*, Book Two, Pl. XXXVIII and Vincenzo Scamozzi, plan and elevation of Villa Contarini, Loreggia from *L'Idea della Architettura Universale*, Book Three, p. 289 (RIBA Library Photographs Collection)

3.6 Vincenzo Scamozzi, Villa Molino, Mandria from *L'Idea della Architettura Universale*, Book Three, p. 275 (RIBA Library Photographs Collection)

3.7 Vincenzo Scamozzi, Villa Cornaro, Paradiso from *L'Idea della Architettura Universale*, Book Three, p. 281 (RIBA Library Photographs Collection)

3.8 Vincenzo Scamozzi, Villa Cornaro, Puisuolo from *L'Idea della Architettura Universale*, Book Three, pp. 296–7 (RIBA Library Photographs Collection)

3.9 Spatial diagram of Scamozzi's Villa Cornaro, Paradiso (Illustration: E. Anderson)

3.10 Vincenzo Scamozzi, drawings for Villa Verlata, Villaverla and Villa Ferramosca, Barbano (© Devonshire Collection, Chatsworth. Reproduced by permission of Chatsworth Settlement Trustees)

3.11 Vincenzo Scamozzi, aerial view of Villa Pisani, Lonigo (Photo: S. Maruzzo)

3.12 Ludovico Pozzoserrato, *September* (© Fitzwilliam Museum, Cambridge/Art Resource, NY)

3.13 Illustration from the description of the travels of the Venetian Charles Magius from an Italian manuscript, 18th century (Erich Lessing/Art Resource, NY)

3.14 Vincenzo Scamozzi, plan and elevation of Villa Pisani and view from the northeast (Photo: S. Maruzzo)

3.15 Vincenzo Scamozzi, a well-lighted stair in the Villa Pisani (Photo: L. Merrill)

3.16 Vincenzo Scamozzi, central rotunda and dome, Villa Pisani (Photos: Scala/Art Resource, NY)

3.17 Vincenzo Scamozzi, Serliana and floor of the rotunda, Villa Pisani (Photos: © The Courtauld Institute of Art, London)

3.18 Daylighting studies of the central rotunda of Villa Pisani: top row—June 21; bottom row—September 21 (Illustration: University of Washington Integrated Design Lab)

3.19 Diagram based on Leonardo da Vinci's study of the penumbral zone (Illustration: E. Anderson)

4 Mapping the City: Palaces and Civic Buildings

4.1 Leonardo da Vinci, plan of the city of Imola from the Windsor Codex (Scala/Art Resource, NY)

4.2 Jacopo de'Barbari, perspective plan of Venice (Cameraphoto Arte, Venice/Art Resource, NY)

4.3 Jacopo Sansovino, Libreria Marciana, Venice and Andrea Palladio, the Basilica, Vicenza (Photos: author)

4.4 Diagram of Piazza San Marco, Venice: A—early 16th century construction; B—Sansovino's Loggetta; C—Sansovino's Library; D—Sansovino's Zecca; E—line of medieval structures in 1580; F—Scamozzi's completion of Library; G—Scamozzi's Procuratie Nuove (Illustration: E. Anderson)

4.5 Jacopo Sansovino, the Zecca and the Loggetta, Venice (Photos: Abxbay and Joanbanjo)

4.6 Andrea Palladio, San Giorgio Maggiore and Il Redentore, Venice (Photos: D. Descouens and A. Fernandez)

4.7 Vincenzo Scamozzi, façade and plan of Palazzo Ravaschieri, Genoa from *L'Idea della Architettura Universale*, Book Three, p. 265 (RIBA Library Photographs Collection)

4.8 Vincenzo Scamozzi, plan and façade of Palazzo Fino, Bergamo from *L'Idea della Architettura Universale*, Book Three, p. 263 (RIBA Library Photographs Collection)

4.9 Plan of central Bergamo: A—Duomo; B—Palazzo della Ragione; C—Palazzo Nuovo; D—Piazza Duomo; E—Piazza Vecchia (Illustration: E. Anderson)112

4.10 Andrea Palladio, Palazzo Chiericati, Vicenza and Vincenzo Scamozzi, Palazzo Trissino al Corso, Vicenza (Photos: author)

4.11 Bird's-eye view of Vicenza c. 1580 (Biblioteca Angelica, Rome) and Palazzo Trissino al Corso site plan

4.12 Andrea Palladio, elevation of Palazzo Chiericati, Vicenza from *The Four Books of Architecture*, Book Two, Pl. II and Vincenzo Scamozzi, elevation of Palazzo Trissino al Corso, Vicenza from *L'Idea della Architettura Universale*, Book Three, p. 260 (RIBA Library Photographs Collection)

4.13 Vincenzo Scamozzi, corner detail and axial entry sequence of Palazzo Trissino al Corso, Vicenza (Photos: author and J. Derwig)

4.14 Vincenzo Scamozzi, plan of Palazzo Trissino al Corso, Vicenza from *L'Idea della Architettura Universale*, Book

Three, p. 260 (RIBA Library Photographs Collection) and view of cortile (Photo: author)

4.15 Diagram of Scamozzi's Palazzo Trissino al Corso and Palladio's Palazzo Valmarana (Illustration: E. Anderson)

4.16 Vincenzo Scamozzi, drawing for Palazzo Trissino al Duomo, Vicenza with drawing for San Gaetano, Padua (© Devonshire Collection, Chatsworth. Reproduced by permission of Chatsworth Settlement Trustees)

4.17 Diagram of separate levels of Palazzo Trissino al Corso, Vicenza (Illustration: E. Renouard and E. Anderson)

4.18 Diagram of the correspondence between Palazzo Trissino al Corso and Vicenza: A—the Corso; B—Piazza del Signori; C—Pal. Trissino portico; D—Pal. Trissino cortile (Illustration: E. Renouard and E. Anderson)

4.19 Vincenzo Scamozzi, Palazzo Contarini dagli Scrigni and Palazzo Contarini Corfù, Venice (RIBA Library Photographs Collection)

4.20 Gentile Bellini, detail from *Procession of the Cross in Piazza San Marco* (Cameraphoto Arte, Venice/Art Resource, NY)

4.21 Jacopo Sansovino and Vincenzo Scamozzi, joint between the Zecca and the Libreria Marciana, Venice (Photo: Abxbay)

4.22 Vincenzo Scamozzi, two designs for the joint between the Libreria Marciana and the Procuratie Nuove (Uffizi Gabinetto Disegni e Stampe A194 and © RMN-Grand Palais/Art Resource, NY)

4.23 Jacopo Sansovino and Vincenzo Scamozzi, continuous elevation of Libreria Marciana and the Procuratie Nuove, Venice (Illustration: E. Renouard, photo: author)

4.24 Façades along the Grand Canal, Venice (Photo: author)

4.25 Vincenzo Scamozzi, partial plan and section of Procuratie Nuove, Venice (Illustration: E. Renouard)

5 Chorography and Cosmography: Place and Transcendence

5.1 Vincenzo Scamozzi, sketch of the cathedral of Basel from *Taccuino di Viaggio di Parigi a Venezia*, p. 40 (Museo Civico di Vicenza)

5.2 Vincenzo Scamozzi, proportional diagram of the human body from *L'Idea della Architettura Universale*, Book One, p. 40 detail (RIBA Library Photographs Collection)

5.3 Vincenzo Scamozzi, the orders in proportional sequence from *L'Idea della Architettura Universale*, Book Six, pp. 6 and 34–5 (RIBA Library Photographs Collection)

5.4 Vincenzo Scamozzi, Doric arcade from *L'Idea della Architettura Universale*, Book Six, p. 75 (RIBA Library Photographs Collection)

5.5 Vincenzo Scamozzi, Ionic capital and entablature from *L'Idea della Architettura Universale*, Book Six, p. 101 (RIBA Library Photographs Collection)

5.6 Vincenzo Scamozzi, fortification details from *L'Idea della Architettura Universale*, Book Two, n.p. (RIBA Library Photographs Collection)

5.7 Vincenzo Scamozzi, Villa Duodo and San Giorgio, Monselice (Photo: author)

5.8 Vincenzo Scamozzi, Via Romana at the Villa Duodo, Monselice (Photo: author)

5.9 Vincenzo Scamozzi, two chapels of the Via Romana (Photos: author)

5.10 Andrea Palladio and Vincenzo Scamozzi, plan and view of stage scenery, Teatro Olimpico, Vicenza (Photo: P. Geymayer)

5.11 Vincenzo Scamozzi, drawing for stage scenery at Teatro Olimpico, Vicenza (Uffizi Gabinetto Disegni e Stampe A197r)

5.12 Vincenzo Scamozzi, view of theater, Sabbioneta and location diagram (Photo: J. Derwig; illustration: E. Renouard)

5.13 Palazzo Ducale, Sabbioneta (Photo: D. Papalini)

5.14 Vincenzo Scamozzi, elevation details of the ducal theater, Sabbioneta (Photos: author)

5.15 Vincenzo Scamozzi, speculative elevations of the ducal theater, Sabbioneta (Illustration: E. Renouard)

5.16 Vincenzo Scamozzi, plan and speculative section of the ducal theater, Sabbioneta (Illustration: E. Renouard)

5.17 Vincenzo Scamozzi, interior views of the ducal theater, Sabbioneta (Photos: J. Derwig)

5.18 Diagram of the correspondence between the ducal theater and Piazza Ducale: A—Duke's balcony; B—Piazza Ducale; C—Theater; D—Duke's viewpoint; E—Stage (Illustration: E. Anderson)

6 "A Scientific Habit"

6.1 Lord Burlington, Chiswick House, Greenwich and William Kent, Mereworth Castle (RIBA Library Drawings & Archives Collections)

6.2 Vincenzo Scamozzi, geometric figures from *L'Idea della Architettura Universale*, Book One, p. 32 (RIBA Library Photographs Collection)

6.3 Vincenzo Scamozzi, natural, architectural, and geometric forms from *L'Idea della Architettura Universale*, Book One, p. 40 (RIBA Library Photographs Collection)

6.4 Vincenzo Scamozzi, areas of irregular sites and polygonal fortresses from *L'Idea della Architettura Universale*, Book Two, pp. 123 and 185 (RIBA Library Photographs Collection)

6.5 Vincenzo Scamozzi, sketch of the city of Nancy from *Taccuino di Viaggio di Parigi a Venezia from Taccuino di Viaggio di Parigi a Venezia*, p. 26 (Museo Civico di Vicenza)

Preface
Chorography, Place, and Time

From Bruno, therefore, we learn that space makes room for place. In saying this, Bruno is building not only on Cusa, but also on Epicurus (via Lucretius), and still further back, on Plato, who proposed the first Western model of room in the form of *chōra*.
Edward Casey, *The Fate of Place*

This book is written for architects and historians interested in architecture; its primary aim is to present the built work of a relatively little-known Italian architect of the 16th century, Vincenzo Scamozzi. Like many practicing architects of his time, Scamozzi also wrote about architecture. His treatise is not the central subject of this book, but it must be brought to bear on any analysis and interpretation of his work. His 1615 treatise has received an increased level of attention among architectural scholars lately, and is finally being translated into English one book at a time. This study of Scamozzi's architectural works is intended to complement recent scholarly interpretations of the treatise.

There is one particular theme in the treatise that I am highlighting above the others as most relevant today to an understanding of Scamozzi's creative contribution: the importance of geographic knowledge in the production of architecture. Geographic knowledge at the end of the 16th century was still influenced by the authority of the ancients, especially Ptolemy, whose *Geography* (c. 150 A.D.) had been preserved from antiquity by Arab scholars. It was first brought to Italy around 1400 from Constantinople, and the first printed edition was made in Italy in 1477. There were many further editions released in the 16th century with updated information that was accumulating from the oceanic voyages of discovery.

The *Geography* was an atlas whose principles continued to guide Renaissance cartography. In it, Ptolemy emphasized a difference between "geography—the representation of the *intera ecumene* (entire world) complete with regions and their general features—and chorography, the representation of small parts of this world."[1] In fact, there were three scales of mapping in Ptolemy's system:

cosmography described the celestial sphere, the movements of heavenly bodies; geography described the surface of the earth, the shape and location of land masses, water bodies, cities and regions; and chorography described a particular place in greater detail. 'Chorography' is the combination of two Greek words: *chōra*, place; and *grapho*, to describe. Ptolemy defined chorography as a representation of "localities such as harbors, farms, villages, river courses and such,"[2] but did not include any in his atlas. His lack of precision gave rise to wide interpretation in the Renaissance. For Italian cartographers, geography and chorography were therefore relative terms, and a chorography could be any map that represented at a larger scale something that was represented at a smaller scale elsewhere. However, Ptolemy had further clarified that the function of chorography was to supersede the location of features and their relationships to each other, it was "to paint a true likeness and not merely to give exact positions and size." The most cogent definition that pins down this relativistic term is that a chorography is a visual representation that can be understood as a portrait of place.[3]

'Place' itself is not easily defined, a concept whose "definition is damaged when put into words."[4] It can be presumed that a certain shared notion exists without needing to define such a simple, everyday word. However, it has a certain currency just now, so it may be worth addressing the relationship between what we may mean by place today and what Scamozzi may have meant. Today the term is shared by geographers, architects, landscape architects, and urban designers. The geographer Yi-Fu Tuan tells us that a place "has identity ... it is a center of felt values ... a center of meaning."[5] Castello and Rand offer a good survey of the nuances in and among various disciplinary interpretations; among them all, their own statement that "place is a concept understood as denoting a qualification of space through perception of its objective and subjective potential for the realization of existential experiences" seems most apt.

Scamozzi uses the Italian words '*luogo*' and '*sito*' to distinguish between place and site.[6] Site for us today more often than not refers to physical characteristics, or at least emphasizes physical and visual features. Place, relative to site, implies a broader context that surpasses technical descriptions to consider social, historical, cultural, and even transcendental dimensions. I find justification in suggesting that Scamozzi's '*luogo*' is closer to current ideas of 'place' than 'site' in his descriptions throughout Books Two and Three of his treatise, and also from his travel journal, discussed at some length in Chapter 2.

Scamozzi Studies

In 2003 a major comprehensive exhibit on Vincenzo Scamozzi was mounted by the Centro Internazionale di Studi di Architettura Andrea Palladio (CISA) in Vicenza; it was the culmination of 50 years of modern scholarship on the architect and his work. Up to the mid-20th century, Scamozzi was largely overlooked or dismissed by architectural historians due to the long-lasting

misconception that he was the pupil, or at least the inheritor, and a poor imitator of Palladio in Venice and Veneto. While Scamozzi's 1615 treatise, especially his book on the orders, was embraced in northern Europe early on, little was written about its role. In 18th century Italy, historians Francesco Milizia and Tommaso Temanza made negative assessments within their surveys, and this perspective was adopted by subsequent 19th- and early 20th-century historians.

Franco Barbieri was the first historian to challenge the basis of these negative assessments in the first monograph published on Scamozzi in 1952. He forged a new appreciation of Scamozzi's work through an overview of the treatise and its significance and a chronology of his works. Most importantly, he re-characterized Scamozzi as an independent intellectual whose work was not imitative, but in fact a critique of Palladio. He also suggested that Scamozzi was an originator of neoclassicism. Although Barbieri's early interpretation is too rigid in its insistence on stylistic labels and categories, especially in defining early, mature, and late (repetitive) works, this remains an important foundational work for Scamozzian study.

There has been only one other monograph published since, a German-language work by Rainald Franz that appeared in 1999. The first half of the book is a well-illustrated chronology of works, and follows Barbieri in uniting biography with an interpretation of the work. The second half provides a history and interpretation of the treatise that concludes on the importance of Scamozzi's system of the orders. The author characterizes his book as an introduction to German readers that poses questions and provides a starting point for further research.

In the decades following Barbieri's book, several important Italian scholars studied aspects of Scamozzi's work, including Jannaco, Zorzi, Puppi, Tafuri, and Olivato. Barbieri himself followed up with several focused studies as well. English-language publications lagged however. An early notice that cast Scamozzi in a lineage of Renaissance architects exploring numerology and proportional systems in palazzo design, *Pythagorean Palaces*, was published by George Hersey in the 1970s. Subsequently, another important appreciation appeared in Françoise Choay's *The Rule and the Model*, where Choay found in Scamozzi the only 16th-century architect that appreciated and built upon Alberti's urbanism. Kurt Forster and Marco Frascari also published critical interpretations of two important works, the theater at Sabbioneta and the Villa Pisani, as essays. Design controversies over the Procuratie Nuove were the focus of a chapter in Tafuri's widely read *Venice and the Renaissance*, which cast Scamozzi and his supporter Marc'Antonio Barbaro as insensitive to the Venentian context; this same topic was more recently researched by Deborah Howard in *Venice Disputed*, from which a more nuanced interpretation emerged.

The greatest boost to English-language scholarship has come as a result of an upsurge of interest in architectural treatises. A description of *L'Idea della Architettura Universale* is placed chronologically in two large compendia (by Kruft in 1988 and Biermann in 2003). Of far greater significance are two

works that focus on the Renaissance treatise. In Hart and Hicks' collection of essays, *Paper Palaces*, Marco Frascari explored the unusual epistemology of the treatise, which was inspired by the memory theater of Giulio Camillo Delminio. Alina Payne, in *The Architectural Treatise in the Italian Renaissance*, focused on the impressive synthesis of Renaissance architectural thinking that Scamozzi succeeded in providing, but also credited him with bringing new attitudes in certain areas, making the work more than a summary.

Work on Scamozzi in English has increased steadily since the 1990s. But the most significant recent publications are a new Italian language edition of the treatise, the Italian language catalogue from the 2003 CISA exhibition, and the English language translations of Book Three and Book Six of the treatise. The catalogue, edited by Barbieri and Beltramini, includes 14 essays by leading scholars and 88 detailed entries on his works. While the essays span a wide array of topics on his theoretical influences and positions as well as important themes of his works, they do not coalesce into a clear composite or arrive at a comprehensive critical assessment. However, it is a key resource for any study of Scamozzi, anchored by the essays of Barbieri, Puppi, and Oechslin on Scamozzi's intellectual heritage. Azzi Visentini on gardens and Mazzoni on theater design are the best interpretations of his works. Hopkins, Burns, and Ottenheym provide excellent analysis of his impact.

Translations of the treatise are being undertaken by a team of Dutch scholars led by Koen Ottenheym. They are a valuable new resource for English-language scholars; each is published with a lengthy interpretive introduction and is extensively illustrated. The introduction to Book Three provides summary background information and a nicely condensed synopsis of the book's contents. Ottenheym ended with the evidence of Scamozzi's influence on Dutch public architecture in terms of plan and elevation. Ottenheym focused almost exclusively on the role of antiquity, and especially Vitruvius, in Scamozzi's domestic designs. While his acuity on this theme is appreciated, it is an imbalanced view of the generating issues in Scamozzi's work. The introduction to Book Six provides an extremely valuable analysis of the proportional sequence of the orders in the major 16th century treatises and illuminates the mathematical rigor of Scamozzi. However, the comparatively short analysis of his application of the orders in his own work is too simplistic, suggesting that the rigor of the 'idea' was upheld in its real-world application; however, Scamozzi applied the orders with less orthodoxy, designing in accordance with project-specific and place-specific influences.

The present work aims at a balance between scholarship, interpretation, and appreciation; its intentions are not exhaustive in the manner of its subject. My desire is to raise awareness of Scamozzi's contribution in a broader English-speaking audience through his designs and those works that are most intact, allowing a direct visual judgment by the reader. For that reason some important works that are still standing are not among those presented in detail (where alterations, additions, and frescos obscure the effect of Scamozzi's design intentions). The works are presented according to themes

rather than chronologically. Also, since discussions of the treatise as a whole are available in English, and the translation is being published serially as well, I chose to focus on one part of the treatise as an interpretive tool rather than to undertake an original comprehensive treatment.

I would like to acknowledge my teachers, principally the luminous Marco Frascari who introduced me to Scamozzi and who gently tried to temper my rational tendencies with his own poetic vision of architecture. David Leatherbarrow and Joseph Rykwert both inspired curiosity and courage, and were patient with my limitations. Thanks to Erin Anderson and Elisa Renouard for assistance in graphic production; and to photographers Stefano Maruzzo in Vicenza and Jan Derwig in Amsterdam who were exceedingly generous. James Claus contributed special assistance in a difficult translation. For heroic support on digital images, thanks are due to Joshua Polanski and the College of Built Environments Visual Resource Center staff. For collaboration on lighting studies, I am grateful to Christopher Meeks, Philip Syvertsen, and others in the Department of Architecture's Integrated Design Lab. Thanks are due to David Strauss for his editorial contributions, and to Ann Huppert and Thaisa Way for collaborative endeavors in Rome. For general support through the last three years, I am grateful to colleagues David Miller and Jeffrey Ochsner. Finally, Erika Gaffney at Ashgate has been consistently patient, helpful, and encouraging.

Ann Marie Borys

Notes

1 Naomi Miller, "Mapping the City: Ptolemy's Geography in the Renaissance," in *Envisioning the City: Six Studies in Urban Cartography*, edited by David Buisseret (Chicago, IL: University of Chicago Press, 1998): 35.

2 Miller's quotations, translated from a facsimile edition, *Géographie de Ptolemée* (Paris, 1926) at the Biblioteque Nationale, Paris.

3 The idea of portrait is connected to chorography by Lucia Nuti, "Mapping Places: Chorography and Vision in the Renaissance," in *Mappings*, edited by Denis E. Cosgrove (London: Reaktion Books, 1999): 98–102.

4 Lineu Castello and Nick Rands, *Rethinking the Meaning of Place: Conceiving Place in Architecture-Urbanism* (Farnham: Ashgate, 2010): xiv.

5 Yi-Fu Tuan, *Space and Place: The Perspective of Experience* (Minneapolis, MN: University of Minnesota Press, 1977): 4 and 173.

6 Vincenzo Scamozzi, *L'Idea della Archituttura Universale* (Venice, 1615): Book Two Ch. 7.

1
"Citizen of the World"

Architecture is a science and an art so difficult to learn and
to accomplish in the brief and turbulent life of a man.
Vincenzo Scamozzi, *L'Idea della Architettura Universale*

As it is often told, the story of Renaissance architecture begins with an architect's journey from Florence to Rome shortly after 1400; and two journeys undertaken about 200 years later are central to the story of the last Renaissance architect, Vincenzo Scamozzi (1548–1616). The distance that Brunelleschi (1377–1446) traveled in 1403 to study the Pantheon and other construction from antiquity was not that great, but the intellectual leap was of course monumentally significant. (Brunelleschi's use of antique construction to solve contemporaneous problems was shortly thereafter further enabled by the discovery of Vitruvius' ancient treatise by Poggio Bracciolini in 1414 on his own transalpine trip.[1]) Subsequent Italian architects recognized the importance of direct contact with the ruins of Rome for understanding classical construction and ornament and followed in Brunelleschi's footsteps as they were able. Eventually, the spread of Italian architectural culture induced architects from northern Europe to embark on the same Brunelleschian journey to Rome from ever greater distances. They all wanted to see the ruins with their own eyes, to study and draw, and to also see contemporary building design *all'antiqua*.

Vincenzo Scamozzi worked within a well-developed tradition now commonly called Renaissance design—composition of legible building forms articulated by a sculptural interpretation of classical ornament, the whole harmonized through proportion—but in a changing context; he brought certain fresh intentions and new knowledge to the question of architecture. Scamozzi's own architectural journeys illustrate the profound shift in cultural context that was under way. He too made the architectural pilgrimage to Rome, in his case in 1578 at around 30 years of age, to study Roman antiquity directly

as an essential conclusion to his education as an architect. Roman architecture was studied in order to directly inform his own design understanding, to seek the essential principles of good form and a proportionally correct language of ornament as did others before and after him. But 20 years later, he undertook a more unusual and significant journey to Paris. This journey was not in pursuit of commissions from royal patrons, the reason that a few other Renaissance architects had ventured northward from Italy; Scamozzi traveled in order to study the non-classical architecture there. Parisian architecture was studied to gain knowledge of how cultures build differently and why. He was curious about the building practices, materials, and technologies north of the Alps, and he wanted to see the northern ways of dwelling. As an architect, he was not only a student of Rome and a student of antiquity though these forms were clearly acknowledged as superior. He sought knowledge of the world, of humanity, and of all the ways that human needs and desires are met with buildings and cities. He called himself a "citizen of the world,"[2] rejecting the narrowness of identity and knowledge based on his birthplace and patrimony, and embracing instead the global imagination of curious travelers from Herodotus to Columbus.[3]

Scamozzi's Parisian journey made no immediate impact on design practices in the way of Brunelleschi's journey, and this is one reason it has not received much notice by architectural historians. But it is a potent marker of a theoretical milestone, and of cultural change, even though the changes signaled were long and slow in their realization. Additionally, it has been overshadowed in the telling of Renaissance history by the Italian journeys of English architect Inigo Jones (1572–1652) around the same time.[4] Jones was, famously, the first English designer to make the Brunelleschian trip, first in 1598 and again in 1613, with far-reaching impact on subsequent English architecture. The later trip, an architectural pilgrimage less focused on Rome than on the Veneto, also had an impact on the story of Vincenzo Scamozzi. Jones concentrated his interest on the works of Andrea Palladio (1508–1580), making a thorough study of his built work, purchasing his books and drawings, and seeking a meeting with Vincenzo Scamozzi because he had completed several Palladian works after his death 30 years earlier. Scamozzi was the last living link to Palladio, so Jones no doubt had high expectations of what he might learn from such a meeting. When he returned to England, Jones praised and emulated Palladio; and though he obtained some of his knowledge of Palladio's architecture through Scamozzi, he insulted and condemned him.[5] The disapproval of Jones profoundly marked the historical record, especially among the English, with regard to Scamozzi's architectural contributions.[6]

The Scamozzi that Jones encountered was nearing the end of his life, as his culture was nearing the end of the Renaissance. Jones described a difficult man who spoke in bitter terms of Palladio, and to the disciple Jones, there could be no greater offense. What is remarkable is that subsequent historians continued to cast Scamozzi as an ungrateful apprentice of the master, a pupil who copied Palladio's designs and then insulted him in order to relieve his conscience.[7]

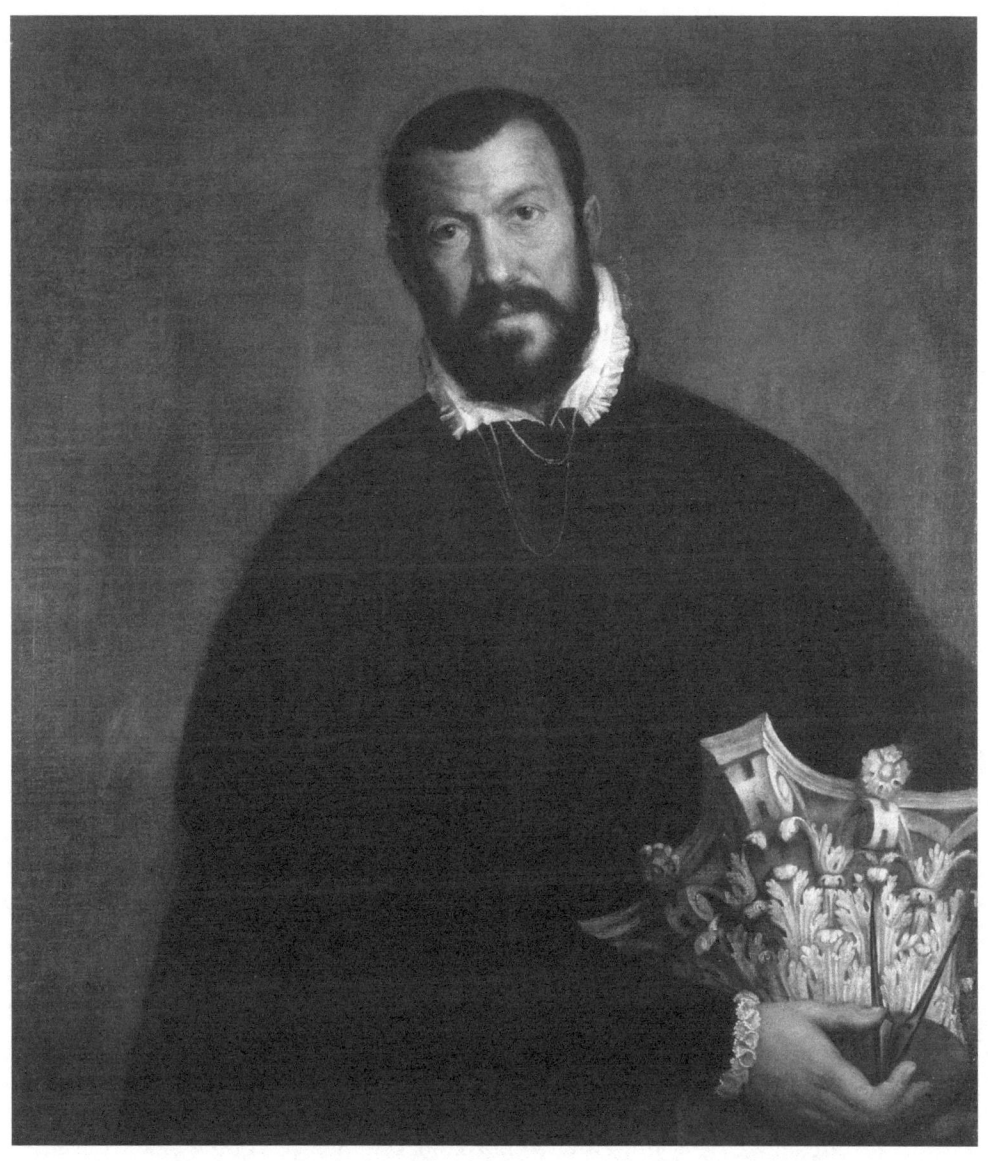

1.1 Paolo Veronese (Paolo Caliari), Portrait of the Architect Vincenzo Scamozzi c. 1585 (Denver Art Museum Collection: Charles Bayly, Jr. Collection, 1951.85, photograph courtesy of the Denver Art Museum)

Scamozzi no doubt attempted to explain to Jones how his own ideas were distinct from those of Palladio, and certainly promoted his own strongly held beliefs. And even if, in old age, Scamozzi expressed bitterness to an enthusiastic student of Palladio, he did not disparage either Palladio or his works in his treatise.[8] In fact, there is no other significant record of the ill-will Jones reported. Jones, himself a quarrelsome personality,[9] had only been studying architecture for a comparatively short time; with his limited judgment he declared Scamozzi a poor imitator based on appearances rather than a full understanding.

There is not much alternative evidence by which to judge Scamozzi's personality—only the facts of his life and the 'voice' of his books. This much is certain: he was extremely intelligent, was devoted to learning, and clearly dedicated to a noble role for architecture in society. He was fully versed in classical texts on every subject, but not dogmatic about their authority. Even though he held fast to an Earth-centered universe, he was generally open to the new knowledge of his own time. By the time he met Inigo Jones, he had thought deeply on architecture for 50 years, and had absorbed and synthesized 16th-century architectural culture. Scamozzi was neither apprentice nor imitator of Palladio; he was a formidable intellect and an accomplished architect who arrived at his architectural wisdom along a clearly independent and unique path. He certainly shared key sources and certain intentions with Palladio, but his idea of architecture was quite different, and his architecture achieved its effectiveness along different lines.

Scamozzi's Early Life and Education

Vincenzo Scamozzi was born at the mid-point of the 16th century, a century of such dense architectural interest, creativity, and investment in Italy that the results continue to have impact five centuries later. He grew up in Vicenza, and lived in Venice as an adult, both cities with important cultural and political differences from the important central Italian cities in which Renaissance architecture had first developed. His father Giovanni Domenico Scamozzi (1526–1582) decided very early in his son's life that he would be an architect.[10] This in itself was unusual; most architects at the time were either artists or craftsmen as a first vocation, and became engaged in architectural projects as a matter of circumstance later in life. Even more unusual was the elder Scamozzi's plan for realizing this ambition. There was no tradition, per se, but a more expected means of preparing Vincenzo for the chosen profession would have been to apprentice him to an established architect working on a monumental project. For instance, Antonio da Sangallo the Younger had been sent at an early age to work with Bramante at St. Peters in Rome. But rather than going on-site to assist a master in the many varied tasks of design and construction, Vincenzo was enrolled at a seminary school for a classical education in the liberal arts. Scamozzi's immersion in classical studies as a prerequisite for architectural practice rather than as a supplement

to an apprenticeship in artistic practice placed him in a rare category of Renaissance architects. As a result, he gained the capacity to engage in the developing ideas of broader intellectual discourse of his time, clearly evident in his treatise.

Though Scamozzi spent his early years developing an apparently precocious intellectual aptitude, an impressive fund of knowledge, and a considerable library, his early life was not without some practical education as well. The Scamozzi family lived in Vicenza from about 1555 on, a time of relative peace and prosperity. Though not of nobility, it is clear from the property that Giovanni Domenico owned and from his ability to finance his son's education that he was reasonably well-off. It appears that he made his living principally by land surveying and construction estimating, and possibly also designing and building. Vincenzo helped his father and learned the value of these practical applications of mathematics and geometry. In his treatise, Scamozzi would credit his father with a particularly good knowledge of mathematics. He would also repeatedly champion the importance of realistic cost estimates to ensure that projects would not be undertaken without the financial means to complete them.

After beginning an independent professional career, Scamozzi completed his formal education in Rome at the end of the 1570s. He studied the ruins and must have made sketches,[11] but unfortunately none survive by which to track the development of his thinking—he requested in his will that all incomplete studies be burned because their imperfections rendered them of little value.[12] The extent of his archeological investigation of Rome is obvious however in his descriptions of the ancient buildings in the *Discorsi*, a book of views of Rome; and the thoroughness of his research can be seen in a meticulous reconstruction of the Baths of Diocletian, an etching executed by Mario Cartaro under his direction (see Figures 2.7 and 2.9). There is no clear evidence of a particular building or approach to design that is specifically traceable to this encounter with Roman architecture, but Scamozzi recounts seeing those buildings that he had studied in books in his treatise.[13] It clearly sharpened his judgment, allowing him to distinguish between the works that reached perfection, and those that did not. He claimed that he learned more in his two years in the south than he did in the preceding 10, which indicates just how important this verification process was.

Besides his archeological investigations, he studied higher mathematics with the Jesuit Christopher Clavius at the Collegio Romano.[14] Clavius' name is not as familiar today, but he worked at the same high level of mathematical discourse as Copernicus just before him and Galileo, who followed. Clavius wrote textbooks on mathematics and astronomy, and was known among his own contemporaries as the Euclid of his time. Among architects, proportion and geometry were readily acknowledged as the evidence of the connections between heaven and earth, between the human and the divine. But Scamozzi was unique in his pursuit of greater understanding of mathematics itself. Moreover, mathematics was no longer merely an abstract mental construct;

it was increasingly seen as a tool for understanding the natural world.[15] For instance, while Scamozzi was in Rome Clavius was appointed by the pope to work on calendar reform.[16] The subsequent adoption of the newly calculated calendar in 1582 resulted in a loss of 10 days,[17] a dramatic demonstration of applied mathematics. Scamozzi studied contemporary mathematics with a top scholar of his time rather than relying on the mathematics of his seminary studies, indicating an important aspect of his intellectual appetite. In mathematics as well as in architecture, he mastered classical knowledge and used it as a constant reference, but he was also dedicated to extending it and updating it, rather than simply accepting it as sufficient. Though the time in Rome marked the end of Scamozzi's formal education, he never stopped reading, studying, and traveling in order to increase his knowledge. He even remained unmarried to avoid distractions and commitments of family life that might interfere with his pursuit of knowledge.

Scamozzi's Influences and the Problem of Palladio

Scamozzi's early thinking was strongly influenced by his father's work and interests.[18] Giovanni Domenico Scamozzi participated in a Vicentine culture that embraced architecture as a demonstration of civic *virtù* and a means to more firmly establish the nobility of the ruling class, an oligarchic system similar to that of Venice, but not as old and established.[19] He was a member of the Accademia Olimpica, where he would have enjoyed lectures and dialogues on classical literature, theater, and philosophy, as well as architecture. The academy spread its humanist ideals widely among the literate classes of Vicentine society. The pervasiveness of its humanist intellectual framework must be seen as the starting point for both father and son.

Giovanni Domenico Scamozzi developed a significant interest in the ideas of Sebastiano Serlio (1475–1554) that he shared with his son. On the one hand, Serlio's books provided the most up to date account of architecture and antiquity available, easily accessible in its vernacular text. But the appeal might have also been due to Serlio's particular blend of the practical and theoretical aspects of architectural knowledge. Practical knowledge was in the foreground; Vitruvius provided a point of departure rather than a strict model.[20] Precise attributions differ, but Giovanni Domenico and Vincenzo clearly collaborated on a project of posthumously publishing the first collected volume of Serlio's books, which had been individually and non-sequentially produced. Gathering the previously published books (One through Five) and two manuscripts (the *Libro Estraordinario*, initially mistaken for Book Six, and Book Seven) together and ordering them sequentially in a single edition allowed their sum to exceed the value of the parts: in numeric order the sequence of knowledge made a better mental map and was therefore more meaningful. It was also easier to use as a reference book that way, an intention made clear by the addition of a complete index. Finally, they also provided

a preface, entitled "Discourse on Architecture"[21] and attributed solely to Giovanni Domenico; it is an interpretation of the importance of Serlio's overall design and intent. The planned edition was finally published in 1584, two years after the death of Giovanni Domenico. Vincenzo subsequently augmented the index for further publications that appeared in 1600 and 1619. The continued work on Serlio's treatise even after having begun work on his own sometime around 1590 exhibits a remarkable commitment, and is a clear expression of the importance Scamozzi found in the work.

From Serlio, Vincenzo Scamozzi inherited a relatively coherent theory of the orders, with an appreciation of the parts and a careful understanding of the profile.[22] In his own book on the orders, Scamozzi would stress the idea of "precedence and succession,"[23] the proper sequencing of the parts that he had come to know first from Serlio's illustrations. Though he rejected the fantastic forms of Serlio's portals in the *Libro Estraordinario*, he clearly absorbed the lessons of the unpublished book on domestic architecture—both its embrace of non-Italian forms, and a de-emphasis of the orders. He did not learn geometry from Serlio, but he no doubt appreciated Serlio's position on its importance to architecture. He certainly also studied Serlio's book on perspective, including the fundamentals of 16th century theater design. Serlio's temporary theater installation in Vicenza, executed in 1539, loomed large in the city's cultural memory. Scamozzi published his own book on perspective in 1575 and designed stage sets and a theater in the 1580s. Though his book is now lost, we can infer that he had mastered the construction and manipulation of perspective at the earliest stage of his professional life. Finally, Serlio's sequence of architectural knowledge in accordance with the epistemological model of Giulio Camillo Delminio's memory theater provided a starting point for his own theory of architectural memory and imagination. Delminio (1480–1544) was a contemporary of Serlio, well known in Venice and beyond for his theories on the art of memory; he used the form of a theater to organize knowledge and make it readily accessible. Serlio's books correspond to the hierarchy of levels of the memory theater; Scamozzi stated his own reference to the theater unambiguously in his preface.[24]

Another major influence acknowledged by Scamozzi in his treatise was Daniele Barbaro (1514–1570) whose edition of Vitruvius (with extensive commentary) he read three times early on.[25] Scamozzi was well suited to appreciate the lessons of Barbaro, who advocated a scientific and mathematical basis for architecture. Scamozzi fully absorbed Barbaro's view that all architectural intentions, even those arising from intuition or an artistic response, must be subjected to reason. Barbaro brought his extensive reading of classical texts to his explications of Vitruvius; through it, architecture and architectural knowledge were advanced as highly erudite topics with political significance,[26] with implications for the social position of the architect. Scamozzi's training in surveying made him particularly receptive to Barbaro's attention to machines and issues of infrastructure. Between Vitruvian recommendations for the siting of the city, and Barbaro's explicit commentary

on the heroics of Venetian infrastructure (itself inspired by Alberti),[27] Scamozzi formed an idea of the city as a primary concern of the architect. Palladio had provided the illustrations for Barbaro's commentary, and had also helped his with certain technical knowledge, but these contributions did not render Barbaro's Vitruvius in any way Palladian. Ackerman analyzed the commentary for evidence of mutual influence as a result of the collaboration and concluded that Barbaro's views had limited impact on Palladio,[28] further evidence of the differences between Palladio and Scamozzi.

It is important to both acknowledge and to draw the limits of Palladian influence in order to confront the "master–pupil" and the "poor imitator" myths regarding the relationship of Palladio and Scamozzi.[29] Most of Scamozzi's life was spent in Vicenza, Venice, and the Veneto, where Palladio's works had widespread impact, and must certainly have influenced Scamozzi. He adopted certain formal characteristics that Palladio had disseminated: the bilaterally symmetrical domestic plan and an idea of proportional relations among volumes. He also followed the Palladian idea of the hierarchically ordered primary façade centered on a pedimented portico for domestic architectures, especially in the case of villas that can be seen for some distance. However, these similarities of form do not conceal a fundamentally distinct approach.[30] The fact that he was chosen to complete Villa Rotonda and Teatro Olimpico after Palladio's death caused him to be cast as Palladio's "inheritor," but it must be remembered that Scamozzi brought to this work a mature intelligence formed along independent lines. Furthermore, though Scamozzi's own father was contemporary with Palladio, there was never any professional relationship established between the two. Giovanni Dominico was himself Scamozzi's "master" to the extent that he had one, and he outlived Palladio by two years. So, though there was certainly much that the two shared—immersion in the humanist culture of the small city of Vicenza, adherence to the classical language and the architecture of antiquity as a model, certain clients, and the influential support in Venice of Daniele Barbaro and his brother Marc'Antonio—there is no basis to imagine that Scamozzi found in Palladio or his work a special inspiration or model. And though Palladio's 1570 treatise contained illustrations of a large number of his designs, much of his built work was incomplete, not yet able to be judged or appreciated as Scamozzi came of age. Like Sansovino in Venice, Palladio was a reputable architect of the previous generation who brought classical forms and ornament into accepted use in northern Italy and who set the context for Scamozzi's own work.

Palladio and Scamozzi each had an architecturally productive span of about 40 years. Palladio's buildings were created from about 1540 to 1580, a time when the social and economic circumstances of Venice and Vicenza afforded Palladio a quantity of projects that, over time, established a new image for the city of Vicenza and new landscape for the surrounding region.[31] In Venice, the maritime economy was in decline, provoking the wealthy class to increase and develop landholdings in the surrounding region.

In Vicenza, an essentially industrial economy, largely in silk, remained unchanged, but the political landscape finally stabilized; after decades of changing hands, Vicenza became part of the Venetian state. Palladio enjoyed a larger array of clients in these oligarchic societies than earlier Renaissance architects, breaking away from dependence on one or two powerful patrons. However (and this may be a point on which Scamozzi cast aspersions in conversations with Jones), Palladio was plagued by unfinished works. Scamozzi, working roughly from 1570 to 1610, continued in the same social and economic context, as well as the physical context strongly conditioned by Palladian work. But Scamozzi had the capacity to comprehend the region from a global perspective; he was influenced by new attitudes of scientific observation; he had a more meaningful grasp on environmental forces; and, most significantly, he recognized a world of continual change and motion rather than a world of stability. Consequently, he interpreted the task of the architect as one of establishing relations and interactions. He fit each building carefully to its place, balancing the needs and conditions, and creating an architecture that revealed its place to the inhabitants. Palladio, trained first as an artist and only later acquiring a humanist education focused on Vitruvius, created buildings that ultimately succeed through the visual effect of his clear and rigorous compositional approach combined with a sculptural ornamental program, an architecture of beauty that stirs the emotions. Scamozzi created an architecture of clarity intended to make sense—that is, to be rational and comprehensible in and of itself, but also to make sense of its position in the world and under the heavens, and to make sense of history, of human needs, and of daily lives.

Scamozzi's Architectural Clients and Works

Scamozzi's career was enabled by a string of patricians and religious orders as clients, rather than the princes, cardinals, and popes of Roman Renaissance architects. Padua and Venice were as important as his hometown of Vicenza as sites of his urban projects, while suburban and rural projects were spread out across the Veneto region. Only a few projects were commissioned beyond the borders of the Veneto, but these range from Florence to the south to Salzburg and Poland (in an area that is now the Ukraine) to the north.

In cinquecento Vicenza, private residential clients provided the primary opportunity for practice. These clients were uniformly steeped in the culture of the learned academies, and had a shared view of the palazzo *all'antiqua* as a symbol of their social standing. Palladio preceded Scamozzi in serving the noble class of Vicenza, and he established the two-story palazzo as a norm. When Scamozzi was barely out of school, the Godi brothers commissioned a double palazzo on a generous site in 1569; the plan and elevation are illustrated in his treatise, but the project was never constructed. Thus, when Francesco Trissino called on Scamozzi in 1577 for a modest palazzo on an irregular site near the duomo, his first building in Vicenza was realized (see Figure 1.2).

1.2 Vincenzo Scamozzi, Palazzo Trissino al Corso and Palazzo Trissino al Duomo, Vicenza (Photos: author and J. Derwig)

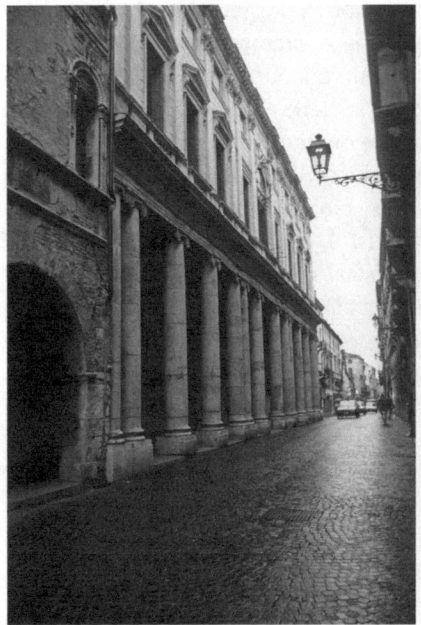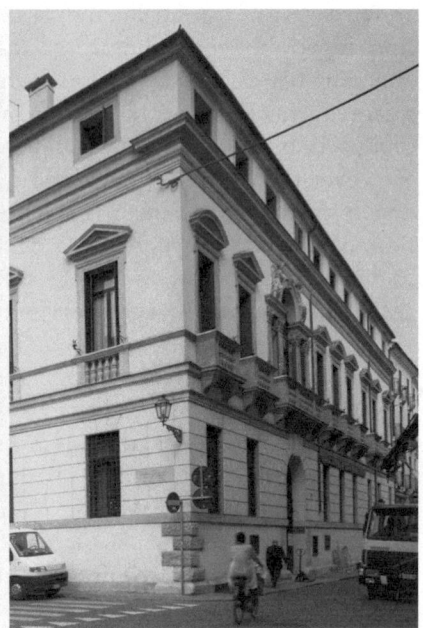

More importantly, over a decade later Galeazzo Trissino commissioned Scamozzi for a palazzo on a prominent site right in the center of the city. In addition to these private residential projects, there were two civic projects, one temporary and one never constructed, and a church, also never executed. For the second Trissino palazzo, Scamozzi realized a masterful and innovative interpretation of the Renaissance palazzo. It is the happy accident of history that this impressive opportunity arose at the height of Scamozzi's career.

Vicenza is also the location of the two Palladian projects that have positioned Scamozzi in the historical record perhaps above all others.[32] Upon returning from Rome in 1580, he was quickly identified as most qualified to complete Palladio's villa for Paolo Almerico, La Rotonda. This now-famous building, begun in 1566, had a long and unhappy construction history.[33] It was in use by 1569, but still incomplete. Evidently little more was accomplished in the 1570s. Scamozzi was brought in to re-start work in 1580; his work continued sporadically for the rest of his life. Not much was accomplished in the 1580s, but new owners made better progress in the 1590s. Scamozzi's most significant modifications to Palladio's design that are still visible today affected the profile of the dome (see Figure 1.3) and part of the site. The dome was lowered from its more sculptural hemispherical form in order to allow the creation of an oculus to admit light to the central rotunda. This was never completed under Scamozzi, and subsequent work retained the altered shape of the dome without its reason, the oculus.

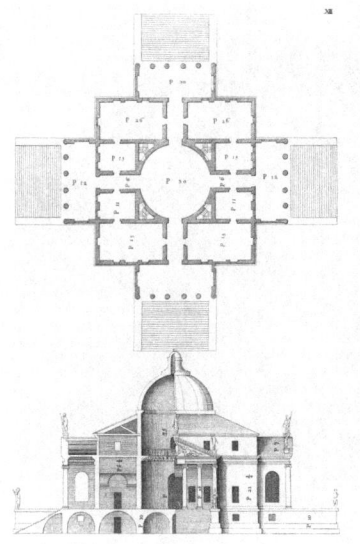
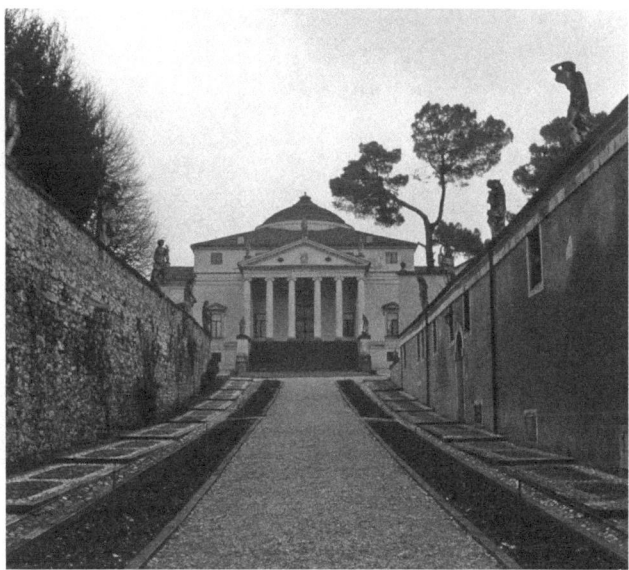

Site alterations were made to answer to the needs of the new owners; farm buildings forming an entry allée were added to support agricultural activities. Without new owners completing the building for their own purposes, it is likely that Villa Rotonda would have never been completed at all, and would no doubt have fallen into complete ruin. While some have mourned the loss of the original Palladian purity in the dome profile and the equivalence of the two crossing axes, Palladio's idea has survived nonetheless with remarkable strength.

The second Palladian project that Scamozzi completed is another architectural wonder, the Teatro Olimpico, a space that has fascinated audiences and architects alike for over 400 years.

Here Scamozzi played a much clearer role, one in which his interventions substantially altered certain core intentions of Palladio. Teatro Olimpico was barely begun when Palladio died in 1580, but construction of the stage screen and audience risers continued under the direction of his son. Palladio's composition was meant to follow the Vitruvian description of a Roman stage, closing off the space of the theater interior and serving as a backdrop to the action. When Scamozzi was chosen in 1584 to prepare the theater for its opening, he altered Palladio's stage building, enlarging three existing openings and creating two more to allow adequate views of sets he placed behind the wall. These were designed to represent the mythic seven streets of Thebes for the premier production of *Oedipus Rex*. Scamozzi's masterful construction of the forced perspective behind the stage screen (see Figure 1.4) fundamentally altered the spatial construct of the theater from a finite container for audience and players to the suggestion of a limitless urban space. Its visual effect, together with the lighting he installed, created a true spectacle for theatergoers, and it still gives a thrill to modern visitors.

1.3 Andrea Palladio, plan and section/elevation of Villa Rotonda, Vicenza from *The Four Books of Architecture*, Book Two, Pl. XIII and a view showing the dome profile (Photo: author)

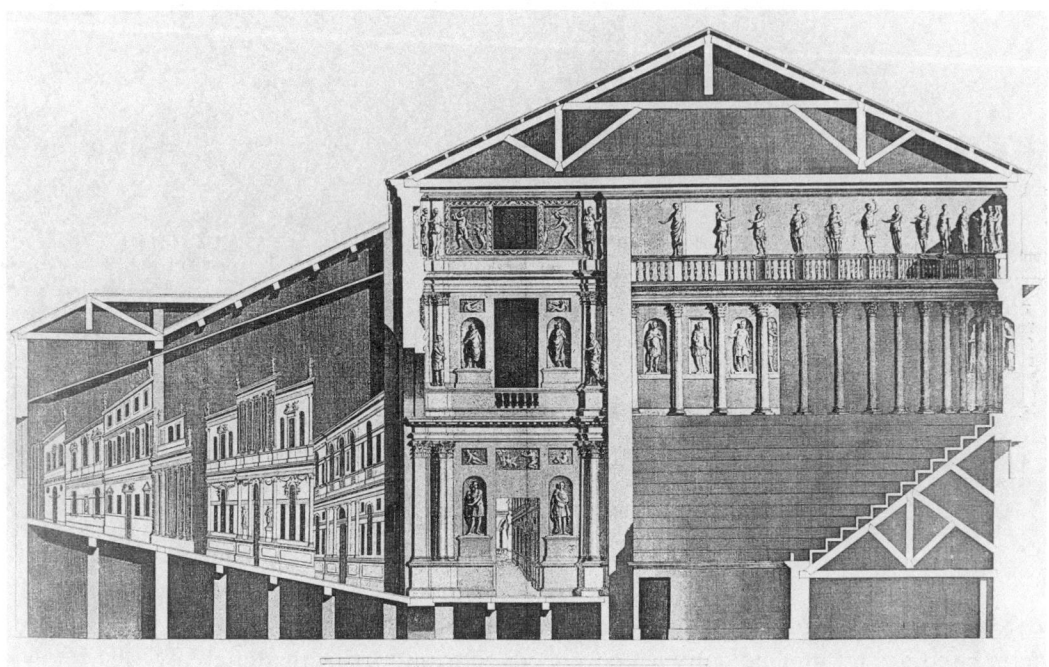

1.4 Andrea Palladio and Vincenzo Scamozzi, section of Teatro Olimpico, Vicenza (© The Courtauld Institute of Art, London)

He also provided the design for a small odeon performance space in the same old prison building. It is doubtful that the Teatro Olimpico would have achieved its fame and stature as a world-renowned architectural treasure without Scamozzi's contributions.

Moving outward to the Veneto, the socio-economic circumstances favoring villa construction continued in the last decades of the 16th century. Scamozzi's first client for a villa project was Leonardo Verlato, for whom he initiated some work in 1574 (possibly in collaboration with his father), although the final project would not be built until 1590. Then in 1576, at 28 years of age, he was hired by Vettor Pisani to design a villa now known as La Rocca Pisani. The Pisani family already owned a villa by Palladio in nearby Bagnolo, but this gentleman wanted (or may have needed for health reasons) a hilltop location. La Rocca followed the typology of a suburban villa, with a cubic massing and a central interior hall for cooler temperatures in the summer. Scamozzi employed the same plan type in his design for Valerio Bardellini in 1594 and for Villa Molino in 1597, though the former design was never completed due to the death of the client. A resemblance between La Rocca and Villa Rotonda has been a primary source of the opinion that Scamozzi imitated Palladio.

However, the circumstances and the execution show the comparison to be superficial. More importantly, Palladio's design is a pavilion marking a landform, more form than space; the porches on all sides address four different landscapes he describes in his treatise. It is a beautiful and noble

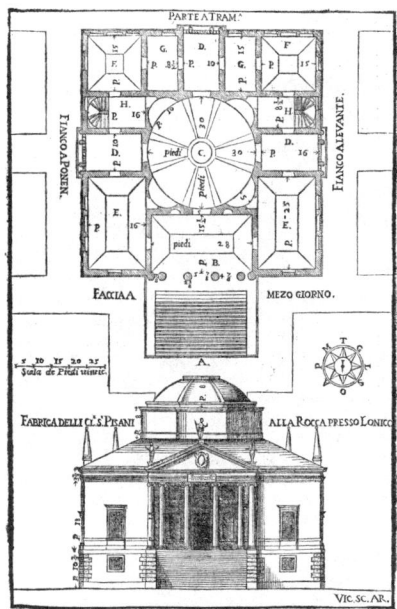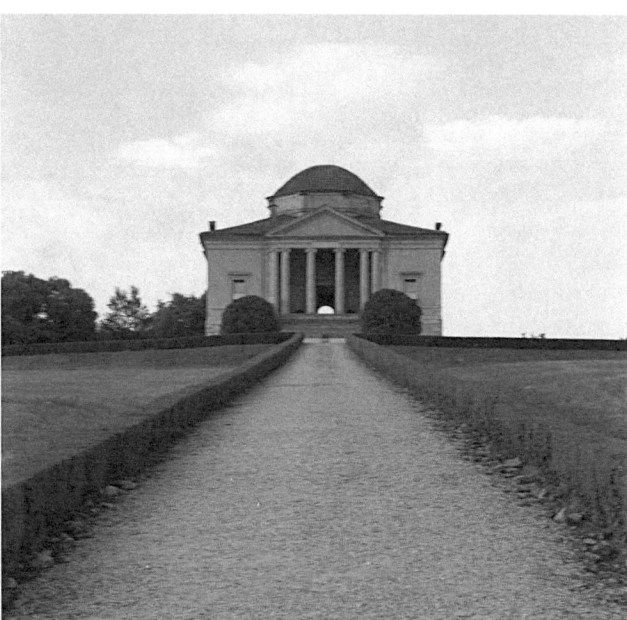

thing to be seen, and a restless space for looking out, and moving out, in four directions. Scamozzi's design is a vessel for receiving the surrounding landscapes, more space than form, and while there is motion of light and air, there is also space to rest.

His other villas are more rural in nature, established with agricultural programs. Clients, all members of the ruling nobility of Venice and Vicenza, included members of the Godi, Cornaro, and Trevisan families; their villas show Scamozzi's approach to gardens and the intimate relationship of building and landscape. Villa projects in the vicinity of Padua were for members of the Duodo, the Pruili, and the Molino families (see Figure 1.6) and were all mature works of the 1590s.

In the city of Padua, Scamozzi's projects were for Counter-Reformation religious orders. The most extensive was S. Gaetano; the Theatine church was begun in 1582 (see Figure 1.7) and a convent added later.

He also added a convent to the existing church of the Ognisanti, and also designed numerous altars and tombs. In nearby Este, he built the church and convent of S. Michele in 1591.

In Venice, Scamozzi designed or renovated a number of palaces. The clients were of the same noble families that commissioned some of his villas: the Duodo, Cornaro, and Contarini. The most significant Venetian religious project was the church and convent for S. Nicola dei Tolentini. This was the largest of his church designs that was built, but unfortunately it was subsequently altered. In addition to these private and religious commissions, Scamozzi was engaged in significant public works at the heart of Venice.

1.5 Vincenzo Scamozzi, plan and elevation of Villa Pisani, Lonigo from *L'Idea della Architettura Universale*, Book Three, p. 273 (RIBA Library Photographs Collection) and a view of the approach (Photo: J. Derwig)

1.6 Vincenzo Scamozzi, Villa Molino, Mandria (© The Courtauld Institute of Art, London)

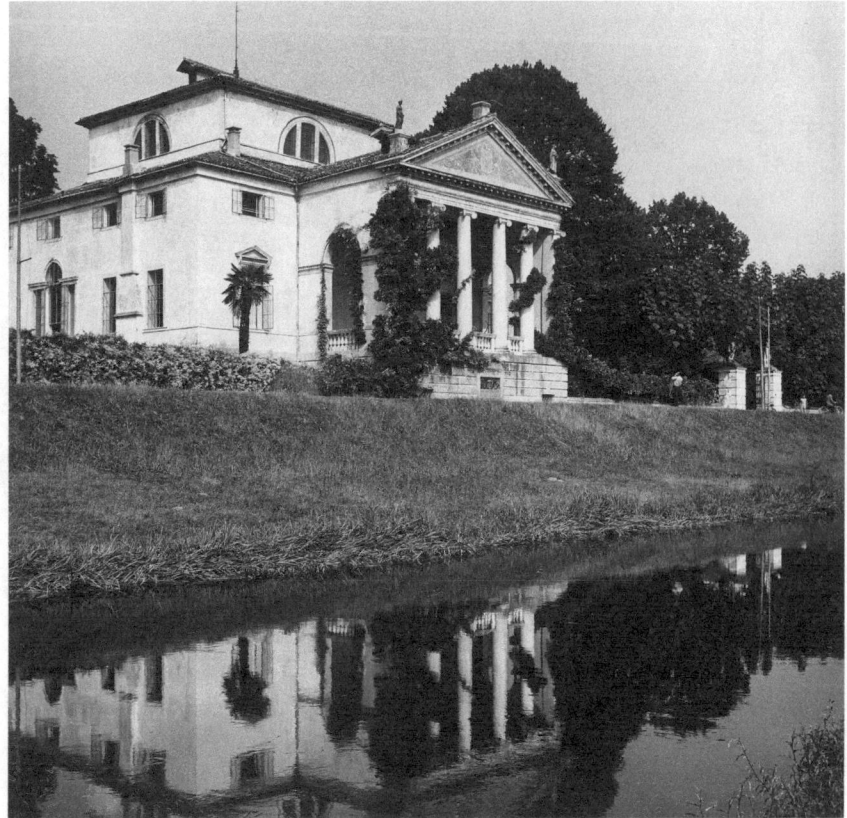

His first Venetian project was the completion of Jacopo Sansovino's Library (Libreria Marciana), begun several decades earlier, and intentionally completed in stages. The final bays were added in accordance with the original plan; Scamozzi faithfully continued the ornamental system so that the two-part construction sequence cannot be detected in the final result. He also designed some of its interior spaces. More importantly, Scamozzi won the commission for the Procuratie Nuove (see Figure 1.8), a large civic building to replace a series of medieval structures and regularize the southern edge of Piazza San Marco.

Unfortunately, the procurators of Venice were a divided body, and the work that they commissioned was subject to powerful political forces in addition to normal design challenges. Despite long delays and an eventual dismissal from the project, the completed building remains in its essence the design of Scamozzi and must be counted among his most important works.

Outside the Veneto, the most significant Scamozzi project was a theater designed for Vespasiano Gonzaga's new town of Sabbioneta near Mantua. For Bergamo, Scamozzi provided designs for Palazzo Nuovo (now Palazzo Communale), a civic building on the main public square, and consulted on renovations to the cathedral.

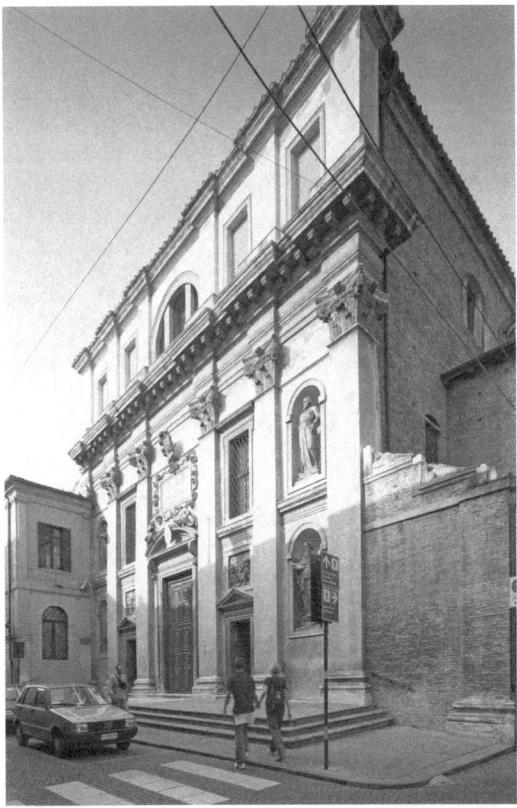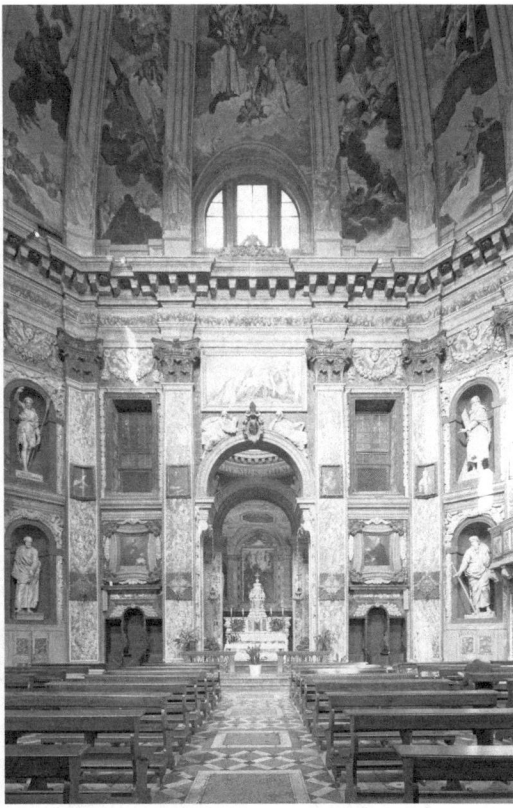

These public projects arose from his work with the Contarini family in Venice. He also designed several private residences there, as well as one in Genoa. Further still, he was brought to Florence by Roberto Strozzi for work on a large palace on a prominent site in the center of the city. Beyond Italy, his most significant work was the design for the Cathedral of Salzburg (see Figure 1.10), commissioned in 1604 by the Archbishop Theodore Wolfgang Raitenau.

1.7 Vincenzo Scamozzi, San Gaetano, Padua (Photos: J. Derwig)

He also designed a bishop's palace there, and provided the designs for several palaces further north, in Germany and Poland. Unfortunately, construction of the cathedral was delayed by at least a decade, and then followed a substantially altered design.

Scamozzi was the only architect of significance working in the Veneto at the turn of the 17th century; the scope of this body of work demonstrates that he was an acknowledged master in his maturity. It also indicates that he had the skill to succeed in a wide variety of social and political contexts. He completed important monumental works of his predecessors in Venice and Vicenza, he was commissioned for civic and ecclesiastical projects ranging in scale from tombs and altars to a major city hall and an urban cathedral, and he designed numerous residential projects, villas and palaces in a variety of contexts. There is greater variety in scale, type, and geographic reach in his body of work than any previous Italian Renaissance architect.

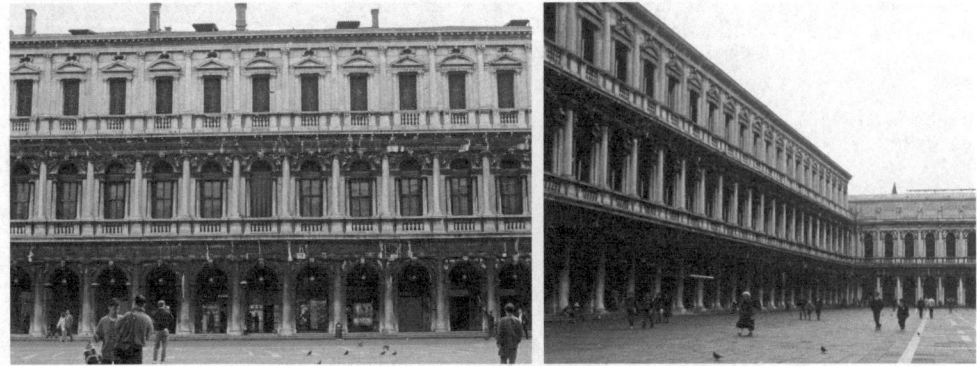

1.8 Vincenzo Scamozzi, Procuratie Nuove on Piazza San Marco, Venice (Photos: author)

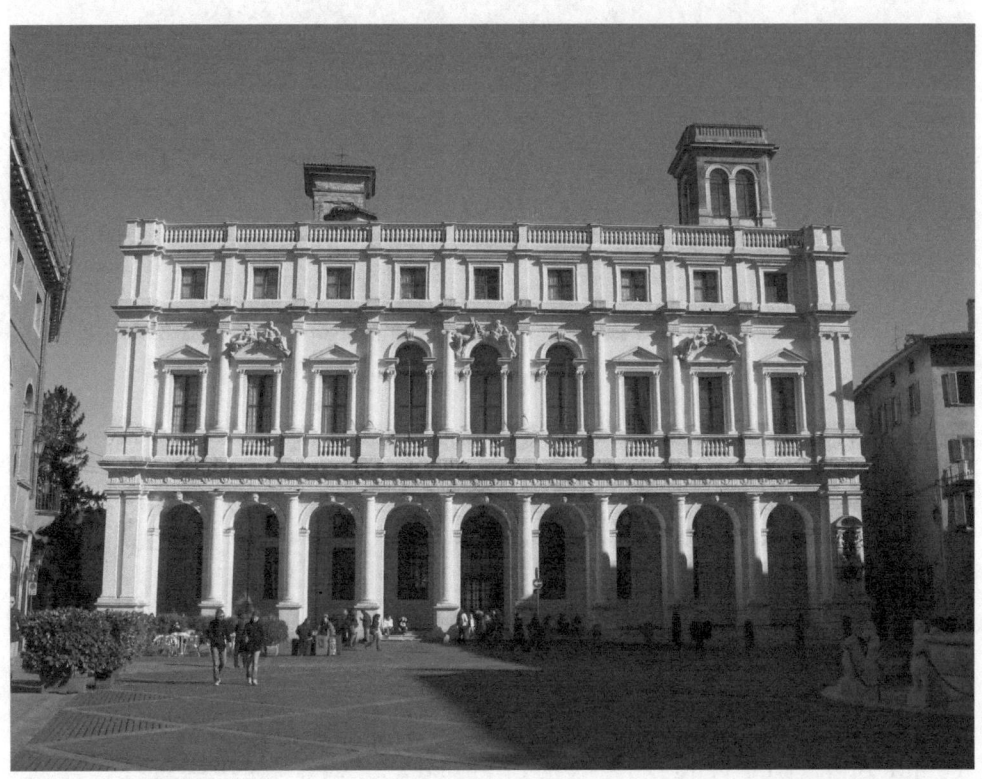

1.9 Vincenzo Scamozzi, Palazzo Communale, Bergamo (Photo: Giorces)

1.10 Vincenzo Scamozzi, section and elevation of a design for Salzburg Cathedral (Collection Centre Canadien d'Architecture/Canadian Center for Architecture, Montréal)

Scamozzi's Treatise

Scamozzi published his incomplete architectural treatise, *L'Idea della Architettura Universale*, in Venice one year before his death in 1616. It was the last in a line of treatises initiated by Alberti 150 years before, and it shared many of the same intentions and features of the major works preceding it; it has in that respect been described as a synthesis.[34] And though he acknowledged the many treatises he had read, his own is in fact more than the sum of the architectural knowledge that came before. Along with the authority of Vitruvius, Scamozzi cited a full complement of classical authors. In doing so, he argued that architectural knowledge is not a narrow discipline but an important part of a broader cultural landscape. The references to ancient philosophers and historians demand of the reader an extensive knowledge of the liberal arts and validate Scamozzi's fundamental belief that competence in architecture requires no less. Just as important, Scamozzi also interpreted certain Renaissance themes in truly innovative ways, rather than merely re-presenting the ideas that he inherited.

Scamozzi began in the early 1590s with the intention of writing 12 books; as the project stretched out in time, he reduced the projected outline to 10 books.[35] In the end, he only completed six of the 10 before his death. His structure was intended to move the reader from the general to the particular: One—the parts of architecture and the role of the architect; Two—site considerations and urban planning; Three to Five—the planning and execution of residential, civic, and sacred buildings; Six—the orders and other ornaments of buildings; and ending (Seven to Nine) with a book on materials, one on construction, and one on finishing. The last (Ten) was to discuss the restoration of failed or ruined buildings. Missing are the planned books on civic and sacred architecture (Four and Five), and the books on finishing and restoration (Nine and Ten). He laid out the treatise in the order of the process of the architect: determining the site, inventing the proper form, and shaping its expression through ornament; these are the primary roles of the architect. Once the form and order are determined, the most appropriate materials can be selected, and finally the building can be constructed.

Scamozzi's 'idea' of architecture becomes clear in multiple ways, starting with a frontispiece (see Figure 1.11) rich with allegorical messages that have been decoded by Frascari and Gordon.[36]

Foremost, theory precedes practice, both in the education of an architect and in the execution of a project. This image-based message is underscored by the explicit inscription over the portal: no one shall enter into an understanding of architecture without first having studied the liberal arts, and no one should attempt to comprehend the treatise to follow without the same. In addition to a two-part basis in theory and practice, architecture is portrayed with a four-part life cycle: precognition,[37] construction, finishing, and restoration. He included a self-portrait, which has been recognized as unique for its honesty,[38] as the visible aspect of his head, while the theory within the book represented the contents of that head.

1.11 Scamozzi, frontispiece of *L'Idea della Architettura Universale* (RIBA Library Photographs Collection)

This highlights the difference between what is accessible directly to the senses, the appearance of things, and the complexity of ideas and knowledge behind them.

The treatise reveals Scamozzi's inclination to use multiple ordering systems simultaneously. The text is preceded by a lengthy table of contents and followed by an index—two different schemes of ordering the contents within and finding one's way. Through these two emerging conventions in publishing, not included in architectural treatises before Scamozzi's, the text is set into motion. It is rendered as a series of points, and the reader is presented with more than one way to move from one point to another. Though the text is lengthy, marginal notations of line numbers and of references are further aids to locate and retrieve information.

The structure of the contents of the treatise shows several epistemologies at work. In addition to the theater analogy connected to Serlio and Delminio,[39] it is also conceived under the influence of the ancient geographer Ptolemy's hierarchal order for cartography that moved from the cosmographic to the geographic, and illustrated their connectedness with the grid lines of latitude and longitude. The persistence of Ptolemy's geographical ordering system indicates that it was more than an effective positioning device; it provided a way to organize and access knowledge of the world.[40] It is further evidence of Scamozzi's unique position in history—he was equally influenced by the inheritance of Renaissance humanism and by the increasingly mathematical and scientific description of the world and its order.

The relationship between text and illustrations is a primary characteristic of each Renaissance treatise. *L'Idea* contains both, but is heavily weighted toward text; indeed, Scamozzi expressed reservations about a drawing's power of communication. Not surprisingly, the heaviest concentration of illustrations is in Book Six, the book on the orders. In Book Two he included geometric diagrams, comparative measuring standards, technical plans and sections of fortifications, and some building plans that show how characteristics of the site were managed with the design. Similarly to Serlio and Palladio, Scamozzi illustrated his book on domestic architecture with his own designs in order to show suitable compositions for contemporary domestic design that apply classical design principles—mathematical proportions, the orders, harmony of parts and whole. But he made it clear that his projects were specific to site and client, therefore they could not be taken as a model; they were intended in sum to illustrate an approach.[41]

The first book consists of customary opening topics—an explanation of architecture through an enumeration of its parts, and the knowledge and skills needed by the architect. His definition of the architect and the requirements for professional success go further than previous authors in separating the role of the architect from the master-builder. He set a standard for the professional that would never be met by any designer having only studio or workshop experience. Like Barbaro in his commentary on Vitruvius, Scamozzi insisted on placing the architect clearly above the master-builder in

the chain of project authority, and believed that comprehensive knowledge was necessary to invent or generate the best form for any design problem.[42] They both saw the architect as the one capable of the mental work that must precede the physical construction.

The body, geometry, material, and form are familiar treatise themes, but in each case, Scamozzi either follows the idea further and with greater rigor, or has a unique interpretation of an accepted framework. More importantly, in this book he established his fidelity to Barbaro's idea of architecture as a science, that is, that architecture is valid only when it is based on knowledge—knowledge of the physical world, knowledge of the cosmos, knowledge of the human realm. Artistic intuition or caprice is antithetical to architecture as science; for Scamozzi, everything must have a reason. Human rationality is a foremost value; it bestows on man intelligence, memory, and will:[43] "An architectural work is a scientific habit located in the architect's mind, concerning the universal or particular thing he would like to build."[44] For Scamozzi, architecture begins in thought, in geometric constructions that must be planned and proportioned in order to be realized properly. It begins with knowing what is needed for particular conditions and for particular needs. The architect alone has the skill to bring these different kinds of knowing, the universal ideas and the particular place, together in order to "invent" or devise the most appropriate forms for the project, to relate them properly, and to give them order.

L'Idea shares with other Renaissance treatises a consistent reference to Vitruvius and an interest in the architecture of antiquity as a model of excellence. Scamozzi's theory of the orders is clearly aligned with the systematic approach that evolves throughout the 16th century—his five orders are arranged as a rank, an image introduced by Serlio, and illustrations of the details of each are arranged in parallel graphic formats similar to those of Vignola and Palladio, though expanding the number of details and assemblies illustrated. In a clear departure from Serlio and Palladio, however, he did not include a book on antiquities or any illustrations or reconstructions of actual Roman monuments. His only models of antique buildings are four imagined reconstructions of buildings known only through literature: the typical Greek and Roman houses, a Roman rural agricultural estate, and the first-ever reconstruction of the ancient writer Pliny's villa. Pliny the Younger, Roman lawyer and writer, owned a vacation house that he described at length in a letter that has enjoyed a long life in architectural theory. Though no archeological remains were ever discovered, his rich description of the villa's architectural features and the pleasures they afford prompted Scamozzi to use it to illustrate of the idea of the villa. The divorce in Scamozzi of the classical canon from its basis in actual Roman ruins signals a greater interest in the logic of the formal system than its historical particularities of application. He was promoting mastery of the idea of the orders so that application to contemporary buildings would be logical rather than patterned on a different formal context—an approach

that is consistent with his placement of architecture alongside mathematics as a universal truth, discovered by the ancients but not tied to their own particular uses.

The close of the 16th century and the beginning of the 17th is a historical moment when the turn of a century coincides with a fundamental cultural change. The division of Christian Europe into Protestant and Catholic was a fact, not a fear. The impacts of the printing press and global exploration were being fully realized, and were now accelerating the conditions for the Scientific Revolution. Scamozzi's work, in buildings and texts, shows the influence of multiple ways of understanding the world: classical wisdom, humanist philosophies, and analytical interest in the physical facts of the world. Whether or not he was the disagreeable personality that Inigo Jones described, he fulfilled the Renaissance notion of a virtuous life, a life clearly dedicated with passion and rigor to the highest intellectual pursuits and to an inventive architectural practice. But to describe him as a Renaissance architect, even the last Italian Renaissance architect, can never be sufficient.

Notes

1. Bracciolini was a humanist scholar whose travels to monasteries outside Italy afforded him the opportunity to search their libraries; he found numerous classical texts and brought copies back to Italy. See Stephen Greenblatt, *The Swerve: How the World Became Modern* (New York: Norton, 2011): 14–22.

2. Vincenzo Scamozzi, *L'Idea della Architettura Universale* (Venice, 1615): Book Eight, Dedica ai Deputati di Vicenza.

3. Ryszard Kapuściński, *Travels with Herodotus*, translated by Klara Glowczewska (New York: Knopf, 2007): 45. Kapuściński describes Herodotus as a "receptive wanderer."

4. Robert Tavernor, *Palladio and Palladianism* (New York: Thames & Hudson, 1991): 119–26.

5. Howard Burns, "Inigo Jones and Vincenzo Scamozzi," *Annali di Architettura: Rivista del Centro Internazionale di Studi di Architettura Andrea Palladio* 18–19 (2006): 215–24.

6. For instance, the entry in the recently compiled *Oxford Companion to Architecture* is still dismissive, calling his treatise "pedantic" and his buildings "not very good copies of Palladio's ..." See *The Oxford Companion to Architecture* (2009), s.v. "Scamozzi, Vincenzo."

7. Marco Frascari, "The Mirror Theater of Vincenzo Scamozzi," in *Paper Palaces: The Rise of the Renaissance Architectural Treatise*, edited by Vaughan Hart and Peter Hicks (New Haven, CT: Yale University Press, 1998): 247–60.

8. Vincenzo Scamozzi, *The Idea of a Universal Architecture VI, The Architectural Orders and Their Application*, translated and edited by Patti Garvin, Koen Ottenheym, and Wolbert Vroom (Amsterdam: Architectura & Natura, 2008): Introduction, 15. Ottenheym says in fact that Scamozzi "praises Palladio's work lavishly."

9. D.J. Gordon, *The Renaissance Imagination* (Berkeley, CA: University of California Press, 1975): 77–101.

10. For the most complete modern accounts of Scamozzi's biography, see Franco Barbieri, *Vincenzo Scamozzi* (Verona: Cassa di Risparmio di Verona e Vicenza, 1952) and David Breiner, "Vincenzo Scamozzi, 1548–1616: A Catalogue Raisonné" (Ph.D. diss., Cornell University, 1994).

11. Scamozzi, *L'Idea*, Book One Ch. 22: Scamozzi says that making sketches of the plans and elevations of ancient and modern buildings is necessary for the education of the architect.

12 Guido Beltramini, "'Lionem ex unguibus aestimare': Un Primo Sgardo d'Insieme ai Disegni di Vincenzo Scamozzi," in *Vincenzo Scamozzi, 1548–1616*, edited by Franco Barbieri and Guido Beltramini (Venice: Marsilio, 2003): 54; Carpo describes the general distrust of drawing as against text, especially in Vitruvius and Alberti. Scamozzi may have retained some of this prejudice although reproducible printed image was unobjectionable. See Mario Carpo, "How Do You Imitate a Building That You Have Never Seen? Printed Images, Ancient Models, and Handmade Drawings in Renaissance Architectural Theory," *Zeitschrift fur Kunstgeschichte* 64 (2001): 223–33.

13 Scamozzi, *L'Idea*, Book One Ch. 21.

14 Katia Basili, "Vincenzo Scamozzi e le Meccaniche," in *Vincenzo Scamozzi, 1548–1616*, edited by Franco Barbieri and Guido Beltramini (Venice: Marsilio, 2003): 65–9.

15 Francesca Fiorani, *The Marvel of Maps: Art, Cartography and Politics in Renaissance Italy* (New Haven, CT: Yale University Press, 2005): 44.

16 Pope Gregory XIII ordered this fix as the inaccuracy of the Julian year had steadily caused the date of the equinox to change. The reform not only re-set the equinox to its proper date, but also changed the reckoning of leap years to prevent further drift.

17 Judith Field, *The Invention of Infinity: Mathematics and Art in the Renaissance* (Oxford: Oxford University Press, 1997): 145.

18 Barbieri, *Vincenzo Scamozzi*, 23–54.

19 Denis E. Cosgrove, *The Palladian Landscape: Geographical Change and Its Cultural Representations in Sixteenth-Century Italy* (University Park, PA: Penn State University Press, 1993): 66–71.

20 Sabine Frommel, *Sebastiano Serlio: Architect*, translated by Peter Spring (Milan: Electa, 2003): 366–7.

21 Sebastiano Serlio, *Tutte l'Opere d'Architettura et Prospetiva*, foreword by Giovanni Domenico Scamozzi (Venice: De'Francheschi, 1619): n.p.

22 Alina Payne, *The Architectural Treatise in the Italian Renaissance* (Cambridge: Cambridge University Press, 1999): 230–31.

23 Scamozzi, *L'Idea*, Book Six Ch. 1.

24 Frascari, "The Mirror Theater of Vincenzo Scamozzi," 253–8.

25 Branko Mitrovic and Victoria Senes, "Vincenzo Scamozzi's Annotations to Daniele Barbaro's Commentary on Vitruvius' De Architectura," *Annali di architettura, Revista del Centro Internazionale di Studi di Architettura Andrea Palladio* 14 (2002): 195–213.

26 Manuela Morresi, "Treatises and the Architecture of Venice in the Fifteenth and Sixteenth Centuries," in *Paper Palaces: The Rise of the Renaissance Architectural Treatise*, edited by Vaughan Hart and Peter Hicks (New Haven, CT: Yale University Press, 1998): 275.

27 Margaret Muther D'Evelyn, *Venice and Vitruvius: Reading Venice with Daniele Barbaro and Andrea Palladio* (New Haven, CT: Yale University Press, 2012): 329–32.

28 James Ackerman, *Origins, Imitation, Conventions: Representation in the Visual Arts* (Cambridge, MA: MIT Press, 2002): 228.

29 Frascari, "The Mirror Theater of Vincenzo Scamozzi," 247–9; and Tavernor, *Palladio and Palladianism*, 106–13.

30 Barbieri, *Vincenzo Scamozzi*, 15–19.

31 While the importance of Palladio's work in the region has long been appreciated, its impact and influence has been most particularly the subject of relatively recent studies. See Cosgrove, *The Palladian Landscape* and Gerrit Smienk, Johannes Niemeijer, Hans Venema, and Frits van Dongen, *Palladio, the Villa and the Landscape* (Basel: Birkhauser, 2011).

32 Scamozzi was also involved with work on two palace projects of Palladio, but the work was fragmentary, and it occurred much later, not in the manner of an inheritance: Palazzo Thiene-Bonin and Palazzo Porto Breganze.

33 Breiner, "Vincenzo Scamozzi 1548–1616," 435.

34 Payne, *The Architectural Treatise in the Italian Renaissance*, 214.

35 Scamozzi, *L'Idea*, Book One Ch. 1.
36 Frascari, "The Mirror Theater of Vincenzo Scamozzi," 258–60; and Gordon, *The Renaissance Imagination*, 92–4.
37 Scamozzi, *L'Idea*, Book One Ch. 2: Scamozzi defines precognition as all the erudition and disciplines necessary to the architect, which means the liberal arts as well as disciplinary knowledge and skills; the overall sense that emerges from the treatise is that it is the architect's power of perception that arises from everything known about the natural and the man-made world.
38 Lionello Puppi, "'Questa Eccellente Professione delle Mathematiche e dell'Architettura'—Idea di Cultura e Ruoli Sociali nel Pensiero di Vincenzo Scamozzi," in *Vincenzo Scamozzi, 1548–1616*, edited by Franco Barbieri and Guido Beltramini (Venice: Marsilio, 2003): 11.
39 Frascari, "The Mirror Theater of Vincenzo Scamozzi," 253.
40 Fiorani, *The Marvel of Maps*, 89.
41 Françoise Choay, *The Rule and the Model: On the Theory of Architecture and Urbanism*, translated by Denise Bratton (Cambridge, MA: MIT Press, 1997): 199.
42 Payne, *The Architectural Treatise in the Italian Renaissance*, 215.
43 Scamozzi, *L'Idea*, Book One Ch. 2.
44 Scamozzi, *L'Idea*, Book One Ch. 16.

2
Geography and Chorography: Scamozzi's Theory of Place

> In order to build, first consider the suggestions of
> the place, which I have spoken of ...
> Vincenzo Scamozzi, *L'Idea della Architettura Universale*

Book Two of *L'Idea* has been convincingly interpreted as a book on urban planning,[1] however this description is too narrow. Though the city is a dominant theme, Scamozzi's text spans scales from nations to regions, cities, and individual buildings, intent on showing how they respond to their natural conditions. By his own account, the second book addresses regions and countries, the qualities of sites and how to design them, the qualities of water bodies, the nature and variety of air and wind and their effects, and the form of cities and fortresses.[2] Some of these topics appear in the last four chapters of the first book in Vitruvius' *De Architectura*,[3] and are consequently also of interest to Alberti, but they are mostly absent from 16th-century architectural treatises.[4] Scamozzi embraced a considerably wider scope than his architectural predecessors: climates were first situated in a global context, and then the fortunes of various nations, cities, and their cultures were attributed to the qualities of their climates. DaCosta Kaufmann has shown how environmental theories such as this were initiated by the Greeks and initially aimed at an understanding of physical and mental health based on a theory of physiology that was connected to the influence of air and water in a place.[5] This presumed connection was eventually extended to explain physical and cultural characteristics of regions. Allied with ancient understanding of environmental influences was the idea that particular forms are associated with particular places—most famously evident in architecture in the historical accounts of the classical orders. These views were given new life in the Renaissance. Alberti considered a fundamental knowledge of environmental factors integral to architectural design,

and Vasari characterized art according to geography as well as to personality of the artist—certain places were associated with particular styles. The interrelations between health, geography, and anthropology assumed even greater importance as the known world expanded.[6] Accordingly, Scamozzi not only renewed the dynamics of the natural and built environments as a topic appropriate to the architectural discipline, he expanded on the tradition and provided more technical information.

In Book Two, Scamozzi consistently connected the prosperity of cities and their inhabitants to latitude, elevation, orientation, air quality, and water supply and control; and ultimately to a capacity to support human production and exchange. The implications for design are manifest, if not precise or prescriptive. Scamozzi proposed that buildings, particularly villas in the open country but also buildings in cities, could only be praiseworthy if the architect understood how to take best advantage of the topography and orientation in proposing a form, position, and openings to provide ordered spaces with beneficial light and air for the inhabitants. Though natural conditions are of primary concern, the influence of man-made factors and social issues on the qualities of sites are not overlooked. For architects today, the attention to working with natural systems and the capacity for bringing knowledge of global climate patterns to bear on the determination of the form of a whole city or an individual building is particularly prescient. Scamozzi explained it this way:

Geography is a science that should be understood alongside geometry and astrology. The geographer needs to have full knowledge and understanding of form, climates, regions, natural philosophy, and the science of air and water. By understanding these things, the geographer has a complete idea of all the elements of the earth: all these components are important. The architect, too, needs to clearly understand climate, regional differences, particularities of place, water, air quality, and wind forces.[7]

More than a theory of urban form, Scamozzi's second book presents a finely tuned and sensitive theory of place that considers climatic, topographic, geographic, economic, and cultural factors.

Scamozzi's innovation in Book Two was to suggest that urban and architectural forms must be designed in accordance with the "particularities of place." Natural forces, when considered at all, had been treated by predecessors as generally applicable to all sites. This new formulation of the architect's responsibility to 'place' may have been overlooked or misunderstood thus far because Scamozzi includes topics and images in Book Two that appear to restate Renaissance conceptions of an ideal city. In fact the chapters addressing design and layout of an entire city are a relatively small portion of book, though they happen to be illustrated by a city plan that resembles those of Filarete and Francesco di Giorgio, as well as the Cesariano and Palladio plans that were produced to illustrate the Vitruvian description of a Roman city.

166 Dell' Architett. di Vinc. Scamozzi, Parte Prima Lib. Secondo, Cap. XX. 167

2.1 Vincenzo Scamozzi, plan of a fortified city from L'Idea della Architettura Universale, Book Two, pp. 166–7 (RIBA Library Photographs Collection)

They all share a regular polygonal shape and geometrically ordered elements within. However, Scamozzi's text makes it clear that he does not expect this well-known form to be realized in any actual city plan. He intended the plan to be understood as "idea city" rather than an "ideal city." That is, he proposed a universal idea of urban order as a starting place for the architect's design rather than its result. It is not 'ideal' because he was not referencing a sacred[8] or an historical model. More importantly, 'place' becomes a middle term between geometric description and urban form, between abstract ideas and material constructions. In departing from universal principles of order, an actual city plan must respond to many natural conditions of its site as well as the political structure of the founding populace. Scamozzi wanted the architect to keep the geometric idea in mind as a general intention, but to transform it as he 'invents' the best forms to suit a particular place. Gordon equates Scamozzi's notion of 'idea' with intellectual conceptualization, and shows that the form, or invention, follows as an interpretation.[9] The source of the idea is knowledge itself—reason initiates architectural design. The rest of Book Two is clearly about the knowledge necessary to move from idea to design, the architect's invention.

Scamozzi signaled the far greater breadth of his intentions at the beginning of Book Two by asserting that architects must have a comprehensive understanding of geography and the skills of a cartographer,[10] that is, the means for engaging with the notion of place. He demonstrated his own mastery of geometry and geography, measuring and describing the earth, in a number of ways throughout. By including observations and information at a range of scales from celestial to global to local, Scamozzi constructed his geography lesson in accordance with the accepted paradigm for cartography. Though many architects may find his text runs far outside the traditional boundaries of their discipline, Scamozzi's conviction emerges that knowledge of all three scales is interconnected. In Book Two, Scamozzi, geographer and cartographer, verbally mapped the known world in order to more fully realize the architectural project. He grasped the universality of the cosmic harmony that 16th-century cartographers made visible as well as the implications inherent to mapping of exploration and the creation of new, more perfect worlds.[11] Scamozzi's architect must not only survey the site, using geometry to make its harmony visible; he must observe and describe, mapping the features and forces that characterize the place, and, connecting description to design, he must finally realize a new construction as a portrait of its place.

Book Two of *L'Idea*: A Natural History of Cities and a Theory of Place

Book Two of Scamozzi's *L'Idea* ranges far and wide; it is a rugged and difficult terrain even for the intrepid intellectual traveler. Scamozzi's text compels the reader to be the geographer that he desires the architect to be. His description of the world appears to jump from one topic to another, from one location to another, from one era to another. The geographer and explorer encounters the world in all its multiplicity, recording phenomena as they appear, while the cartographer organizes the randomness of exploration into more stable forms of knowledge such as maps, charts, and descriptions. Book Two as a whole lacks the clarity of a map, the organization of a chart; even though the chapter titles suggest a certain logical sequence of scale, the text is not always confined to the topic. Any true geographer will likely forgive enthusiasm for the superiority of one place being rapidly replaced by the superiority of the next. But redundancies may discourage even a determined reader. More difficult still, uneasy contradictions arise because each desirable site characteristic, such as a river for navigation, water source, and food source, is at another moment undesirable; in the case of the river there are problems with subsidence and the threat of flooding. However, the patient reader of Book Two will eventually discern Scamozzi's priorities, accumulated through 30 chapters of observations and details. More importantly, his point will finally be clear as well: there are no easy, broadly applicable rules to learn regarding natural conditions

and the construction of cities and buildings for human habitation. Even though he was writing in a long tradition of environmental theory that began with Hippocrates, Scamozzi exemplified a new mentality that valued independent judgment.[12] Scamozzi's architect must understand for himself the nature of environmental forces, must be an acute observer, and must be able to make sound decisions accounting for the widest array of factors. Design emerges as an interpretive operation.

Reading Book Two, like the whole of the treatise, can be difficult not only because of length and reach, but also because of the copious classical references, Latin citations, and Scamozzi's habit of piling up example after example in order to make a point: his encyclopedic scholarship is overwhelming.[13] Compared to the brevity of Serlio, Palladio, and especially Vignola, Scamozzi's verbosity may be perceived by architects seeking guidance in design issues as unnecessary. Though his style did not conform to the tendencies of 16th-century architectural writers, it fit well with the approach in the emerging natural sciences of his time.[14] Late Renaissance development of natural science from natural philosophy depended on the accumulation of examples, the value of description, and reconciliation with ancient sources—in short, it was intentionally encyclopedic, with virtue in length. As with the naturalists of his era, description for Scamozzi was a means of definition, and through definition one achieved knowledge and order.[15] He described in order to define; the density of examples and details demonstrated his own lifetime of learning, and was perhaps intended as a challenge to architects to avoid simplification or generalization and to instead fully comprehend the nature of each particular place before proposing a design. Another inherent message of Book Two is that the architect must be a natural philosopher as well as a geographer.

Scamozzi combined the approaches of Ptolemy and Strabo, the two main sources of classical geography. Ptolemy's *Geography* was an atlas, providing extensive knowledge of what is now called physical geography; in Strabo's *Geography*, the descriptive and historic text outweighed graphic representations of the world. Scamozzi was equally interested in the physical and the cultural phenomena: "The happy and prosperous country is favored by nature and blessed by art, and has all that is needed for people to inhabit and live well."[16] Scamozzi's treatise was the first to include knowledge from the first hundred years of global exploration by European navigators in addition to historical examples of Old World buildings and cities. His knowledge of the New World and other cities beyond the classical boundaries of the Roman Empire was a product of his active engagement in geographic discourse. By moving beyond the limits of classical authorities and embracing this wider array of information, he aimed at a universal understanding of climate's causes and effects—he surveyed the climatic conditions in locations from New Spain in the Americas to Africa, to Scandinavia, Russia, and Iceland.[17] In his socio-economic analysis, poor geographic conditions account for migrations and invasions, city decline, and city destruction.

It may be noted that after his global survey, Scamozzi still declared Italy to be superior, concluding that it had the most perfect climate. But there was a new tension in Scamozzi's Italo-centrism. Though he was originally educated in the traditional view of Italy as central to world history, originating in antiquity and adopted by Renaissance humanists,[18] as an adult he encountered the emerging geographic perspective that privileged no one place above others. Therefore, Scamozzi did not simply re-state the old prejudice; instead he made a serious effort to account for Italy's historic superiority in geographic terms, showing why other locations on the globe were not as favored, connecting growing conditions and air quality to health, and other climatic factors to the general disposition and physical characteristics of populations. Though Ptolemy and Strabo are mentioned by Scamozzi far more frequently, Hippocrates is clearly present in his underlying assumption of a causal connection between a place, including its climate, water supply, and agriculture, and its inhabitants.[19] This basic notion is repeatedly supported by Scamozzi's examples and observations. But there is an additional factor in his view of places: the buildings that the people make. Certain natural conditions could be improved by artifice, and the quality of the constructed environment can in turn affect the social condition.

Although both Vitruvius and Alberti[20] included some advice with respect to environmental forces and urban conditions, Scamozzi amplified the fundamental importance of these topics.[21] Scamozzi brought these issues together and elevated them from fragmentary observations to important determinants of urban and building form. He provided more extensive and accurate information than his predecessors on the topics of climate and geography,[22] merging classical authority with the new knowledge developing in his own time. The first chapters present various regions of the world in terms of climate and other natural conditions, assessing their advantages and disadvantages for the cities built there.[23] Topics that we would now describe as demographics and ethnography enter into his survey of historical and contemporary examples. Scamozzi moved on to discuss local features such as harbors and rivers, and their effect on the planning of a good city. He also devoted several chapters to light, air, wind, and weather. Recommendations on city form and the layout of its elements, the traditional topics of urban design, do not actually arise until chapter 20, on the origin of cities, followed by those on choosing a site, overall form, and placement of public spaces and buildings. These are followed by a similar number on the siting and planning of fortresses, and the book ends with a number of more technical chapters on fortifications.

Though Scamozzi repeated many commonplace recommendations, there are certain observations that indicate his own thinking on these matters even in the chapters that are most typical of urban design literature. Scamozzi comprehended matters of scale, fitting the city into a regional territory with a hierarchy of city sizes. A clear appreciation for dynamic forces in the life of a city comes to the fore: location with respect to other cities for trade, and with respect to natural resources for agriculture and manufacture;

city form that is flexible for growth; strategic planning for invasion and war, but also for times of peace; an awareness of earthquakes and flooding as well as invasions as events that will effect the life cycle of the city. Though Scamozzi's ideas on city planning continued some important Renaissance themes such as the body analogy, geometric ordering, and a correspondence between social and spatial orders, he distinguished himself from his predecessors by insisting that the architect be the one in charge of urban design,[24] by showing that the ideal must always be adapted and transformed to respond intelligently to particular natural conditions of any site, and by anticipating processes of change.

In general, the text proceeds from global to local considerations. At each scale, equal attention is given to enumerating positive and negative qualities. Though given no easy way to prioritize the many considerations or to mediate between positive and negative effects of each factor, at least the reader comprehends that the qualities of a site are often relative and always changeable. Only the architect can determine the form that will utilize the necessary and positive qualities and will avoid the potential deleterious effects. Although the proper siting and design of cities is the underlying topic of the whole work, three natural elements and their complex properties are the true protagonists of Book Two: water, wind, and light.

Water is of course necessary for the inhabitants of the city, but it needs to be understood and controlled. While Scamozzi considered the ill effects of tides, of floods, and other forces, he also recognized the benefits of waterways for commerce, for fishing, and for agriculture.[25] As a long-time resident of Venice, he was well aware of the continuous management that watery conditions demanded. The topic is one of several in the four chapters dealing with the choice of a good site (4–7) and it is addressed directly in chapters 9–11 on tides, rivers, lakes, ponds, and marshes. He categorized water based on its movements: flowing, tidal, wind-driven, or stationary. His observations on rivers are especially extensive and comprehensive, including the changes in size and shape from the source to the coast, the character of the riverbed, the color and odor of different river waters, and seasonal changes in rivers. He concluded that water was the strongest element, having the capacity to move great amounts of material and to break down even rock.[26] While every city must have access to a source of water, in villas some accommodations can be made if there is no natural water source on the site. "Installing a fountain," by digging a well or by piping from off-site, not only served the practical concerns such as drinking, cooking, washing, and gardening, but was recommended because "being surrounded by the beauty of water is excellent for the soul."[27] His point of departure was decidedly practical, and physical wellbeing was foremost, but he did not overlook the aesthetic and psychological benefits of natural elements.

Major portions of the text are devoted to the various winds and their actions, to air quality, and the implications for health. Scamozzi joined Vitruvius and Alberti in acknowledging the varying effects of the winds, but Alberti had

explicitly placed detailed knowledge of the winds outside the scope of architectural knowledge.[28] Scamozzi insisted otherwise; his architect must understand the winds because of the magnitude of their effects on cities, buildings, and the people that live in them. He obtained his detailed knowledge of the winds from sailors, who must be alert to every nuance on the open sea. For Scamozzi, the Vitruvian tradition of eight winds was insufficient; he chose instead the navigational scheme of 16, which he listed in a table not only in Greek, Latin, and Italian, but also, as a testament to his sources, Dutch.[29] Wind, besides directly contributing to air quality, is essentially weather—it is connected to both sun and seasons. Buildings were the primary means available to create comfortable environments for daily life in a world of constantly changing weather conditions. But Scamozzi's thinking passed far beyond mere shelter, or escape from sun, wind, and temperature; he saw the building as an instrument for filtering these natural forces. He attributed particular illnesses to certain winds, and recommended exposures of various room types to mitigate these effects. He also noted how narrow passages in streets and small apertures in buildings intensify the wind. Some specific practical advice on manipulating the wind for the proper conditioning of interior spaces appears later, in Book Three, while his insistence in Book Two on full knowledge of their action points to a vital role in design.[30] Scamozzi included the wind rose on all of his architectural plans, indicating that the space of the building is not, as we may sometimes think, bounded and cut off from the natural world outside; the weather will impact our experience of the spaces we make, and the spaces we make have the capacity to alter the influence of its forces; the architect must design for both. Ultimately, the importance of pure air assumes a moral dimension, not only a matter of bodily health but also contributing to a virtuous soul.[31] The wind rose is a sign of practical knowledge and design consideration; it is also a symbolic reminder of the cosmic dimension of his thinking.

2.2 Vincenzo Scamozzi, a wind rose from his architectural plans and cosmographies from *L'Idea della Architettura Universale*, Book Two, p. 96 (RIBA Library Photographs Collection)

The same innovative approach is more explicit in his comparatively brief discussion of light. Tucked within the second of five chapters on air and winds is a completely unique examination of "the diversity of lights in buildings."[32] Certainly Vitruvius, Alberti, and Palladio recommended particular orientations for domestic spaces based on diurnal and seasonal exposures appropriate to certain uses: morning light for some, evening light for others, and avoidance of the hottest summer sun for others.

2.3 Vincenzo Scamozzi, plan and section of Villa Bardellini project from *L'Idea della Architettura Universale*, Book Two, p. 138 (RIBA Library Photographs Collection)

Scamozzi was the first to notice qualities of light beyond solar cycles and magnitude of illumination and heat gain; he expanded his observations of light conditions effecting interior spaces to include the ambient light of the sky and moonlight. He also described the different kinds of light within a building, enumerating six distinct conditions: intense light from direct sun, "lively and perpendicular" light as in courtyards or domes, "horizontal free" light entering through windows and porticos, limited light restricted by narrow dimensions of the space, "light of light, or secondary light" from an adjacent, directly lit space, and "minimal" light which is reflected from an illuminated surface.[33] He illustrated these conditions using the plan and section of his design for the Villa Bardellini.

Scamozzi recognized that architectural light is not merely a question of the orientation of the space or the solar angle at a given time of day or year; he realized that numerous lights will enter the building through different apertures and will encounter different spatial and material conditions. Openings must be positioned not merely to allow light to enter, but to illuminate corners and other naturally dark areas. The inhabitants will experience the combined and constantly changing effects of these various lights, and the architect is responsible for choreographing this daily dance. As with water and wind, Scamozzi went beyond the practical considerations and appreciated the psychological benefits of light as well, later noting that "bright rooms raise one's spirits."[34]

Scamozzi's whole treatise is predicated on the expectation that the architects who would read it would have achieved the same education in the liberal arts as he had, and so he expected his readers to understand and appreciate his thorough encyclopedic treatment. In Book Two, he explicitly made the mastery of geography and chorography a requirement for urban and building design. Scamozzi not only raised the level of education required for practice, he also admitted far more complexity into the design task than was previously the case. In this way, Book Two more than any other separated the professional architect from a building designer that emerged from building trades or from the artist's studio. Scamozzi stood firmly against the use of geometric diagrams or rules of thumb that could easily be employed by any master-builder, and insisted that the reasoning behind the design and construction must be understood. The determination of urban and architectural form is a matter of such importance and is in fact so inherently complex that it should only be entrusted to professionals with the highest levels of comprehensive knowledge.

Book Two of *L'Idea* breaks the usual boundaries of the architectural treatise. The variety of topics seems to defy a single encompassing title or description. The effects of climate, topography, orientation, and other geographic features on cities are described at length. Historical and political forces are a constant factor. Scamozzi purposely did not derive any easy answers about siting or designing cities or buildings from this complex array of conditions. He clearly intended true architects to assess the complexities of the site conditions,

to understand the ways in which an architectural form could possibly respond to each, and to then distill a single form, an invention, that answered to the greatest number of issues. Success in doing so makes the chosen form a kind of "portrait" of its place.

16th-Century Geography and Cartography

Scamozzi's extensive geographic knowledge was consistent with a culture in which geography and cartography were highly valued, discussed, and celebrated. He had exposure at an early age to the practical necessity for clearly marking boundaries and for representing sites graphically from working with his father.[35] He studied Ptolemy and Strabo among the other classical authors as part of his formal education. Thus he was well prepared to appreciate the newest developments and increasingly wide general interest in maps and geography in the second half of the 16th century, a time marked by a virtual explosion in the production of maps.[36] As the post-Columbian world was assimilated into existing pictures of the world, map-making skills were improving and printing made maps more widely available. Though eclipsed by Northern Europeans in the exploration of the world's oceans, Venice's tradition as a sea power and as a center of printing made it a center for map production. Increasing proficiency in mapping served several different spheres of activity: the practical spheres of navigation and, for Venice, agriculture and hydrological management in the expansion of estates in the Veneto. It also served further exploration, as well as occupation, of new areas of the world, and communication back to European powers about the lands encountered or conquered.

Maps were not only technical drawings but also a primary medium in the artistic and symbolic representation of the expanding knowledge and power of the ruling elite. The publication of new editions of Ptolemy and Strabo by Venice's Accademia della Fama,[37] and the membership of geographers such as Ramusio and Gastaldi are among many indications that the interest in geography pervaded the highest cultural discourse of Venice.[38] Gian Battista Ramusio (1485–1557) compiled three full volumes of geographic descriptions from travellers and explorers across Europe in order to have as complete an account as possible of the whole world in the 1550s. The maps that illustrated the Ramusio publications have subsequently been attributed to Giamcomo Gastaldi (1500–1556) who also painted some of the map murals of the Palazzo Ducale. Scamozzi was certainly familiar with these works, and their comprehensive approach no doubt influenced his own geographic reach in Book Two.

More broadly, the 16th and 17th centuries were a "golden age" for map-making and for landscape paintings as two modes of representing knowledge of the world.[39] New territories were assimilated into the accepted framework inherited from antiquity, the *Geography* of Ptolemy.

Ptolemy devised the first atlas using principles that are still in use today: an initial view that encompasses the whole world as known, followed by a series of subdivisions that present a greater level of detail. The *Geography* exemplified a progressive approach from global to the local and encouraged attention to the relationship between the whole and its parts.[40] Renaissance cartographers such as Gastaldi used the information that came back from the explorers to both correct the maps that Ptolemy had created and to expand on them by adding more subdivisions. This system of world maps was expanded and reprinted several times in Scamozzi's lifetime, and it remained the paradigm for Italian global thinking.

Ptolemy established in his *Geography* a number of basic cartographic concepts that were widely adopted by Renaissance cartographers and can be seen to have influenced Scamozzi in his architectural thinking as well. An important and pervasive one was the use of a grid of longitude and latitude to assist in the positioning of the elements to be mapped. This grid was essential to navigation across the open oceans, a means of stitching together the Old and New Worlds. It was also widely adopted by natural philosophers as a graphic tool to help stabilize the irregular contours of any natural object being visually recorded; in this it resembled the gridded screen used by artists to draw figures in perspective. The grid was also widely used in urban planning during an era of European colonization. Oeschlin shows that the grid was more than an easily deployed formal scheme, that it was in fact evidence of a well-functioning society.[41] Its frequent use in utopic city plans as well as its deployment to New World colonies gave its mathematically rational regularity a moral power.[42] Ptolemy's cartographic grid connected the terrestrial with the celestial, putting the surface of the earth in contact with the cosmos.

Ptolemy's other broadly influential concept was the interrelation of cosmography, geography, and chorography in a hierarchy of description. Cosmography is the description of the heavens, requiring geometry and mathematics. Geography, the description of the surface of the earth, focuses on the outlines of landmasses, water bodies, boundaries, and barriers. It shows the location of places in relation to each other and to these outlines. The maps of the *Geography* illustrate these concepts. Chorography, defined by Ptolemy but not illustrated, is the detailed description of a particular place. And while the concept of this three-part scalar hierarchy was an essential paradigm, there was no rigid division between its categories.

As Ptolemy never illustrated his own conception of chorography, the term was interpreted in a wide variety of ways in the Renaissance. Ptolemy had explained it by means of an analogy that was illustrated by Peter Apian (see Figure 2.4): if geography would be concerned with a description of a head, chorography would describe a feature such as a nose or an ear.

The 'place' described in a chorographic view could be a region, a city, a castle, or a building site. Scale varied, but was always understood as a part of some larger entity. Arthur Hopton's 1611 *Speculum Topographicum* (London), tells us that chorography focuses "on any particular place ... [such] as ports, villages, rivers ... also to describe the platforme [plan] of houses, buildings, monuments, or any such particular thing."[43]

Geographia. Eius similitudo.

CHOROGRAPHIA QVID.

Horographia autem (Vernero dicente) quæ & Topographia dicitur, partialia quædam loca seorsum & absolutè considerat, absque eorum ad seinuicem, & ad vniuersum telluris ambitum comparatione. Omnia siquidem, ac ferè minima in eis contenta tradit & prosequitur. Velut portus, villas, populos, riuulorum quoque decursus, & quæcunque alia illis finitima, vt sunt ædificia, domus, turres, mœnia &c. Finis verò eiusdem in effigienda partilius loci similitudine consummabitur: veluti si pictor aliquis aurem tantum aut oculum designaret depingeretq̃.

Chorographia. Eius similitudo.

2.4 *Cosmographia Petri Apiani*
(A 1545.A75. Special Collections, University of Virginia, Charlottesville, VA)

2.5 Anthony Jenkinson, *Russiae Moschoviae at Tartariae Descriptio* from *Theatrum orbis terrarium* (A 1570.O77. Special Collections, University of Virginia, Charlottesville, VA) and Egnazio Dante, *Genoa*, Galleria delle Carte Geographiche, Vatican Museums, Vatican State (Scala/Art Resource, NY)

Representational means were equally varied; a chorography might be an abstract map at a local scale, an illustrative map using a mix of symbolic and pictorial notations, or even a landscape painting. Figures 2.5 and 2.6 provide examples at the regional scale, while Figure 2.7 is a chorographic view of a city.

The word chorography is derived from the ancient Greek *chōra*, a philosophical concept discussed by Plato and others that opened an understanding of the absolute entities of time and space through an experiential cognition of the world.[44] Thus chorography was expected not only to have as its subject a particular place, but also to communicate its character in addition to (or instead of) technical information such as shape and location. A central problem of chorography was the balance between the abstraction of scaled maps and plans and a pictorial representation of features. Often by combined means, a chorographic image provided a "portrait" of place.[45]

Not only was chorography itself open to interpretation, the cartographic forms were purposely hybridized in many different ways. The monumental maps of Egnazio Danti in the Vatican are a celebrated example of 16th century cartography; they illustrate how a combination of geography and chorography could be used to communicate most effectively. Similar mural maps were produced in other major cities, including Venice. Venetian cartographer Cristoforo Sorte began as a painter; he had worked with Giulio Romano in Mantua. Sorte described his map of the region around Verona in a letter this way: "I oriented the chorography thereof to the prevailing winds. I have drawn it in plan, with its true measures and distances, but the buildings ... I have drawn in elevation ... I drew in such a way that peoples

who are familiar with their countries can *recognize the places* without reading the letters of their names" [emphasis mine].[46] He combined the abstraction of plan with the pictorial nature of building elevations to reveal the specificity of place.

Scamozzi was not only an inheritor of the technical innovations in 16th-century architectural representation; he was immersed in this wider world of representational experimentation in cartography. Cosgrove asserts that cartographic production in Venice was directly related not only to navigation and agriculture, but also to architecture.[47] Scamozzi, as the leading architect of Venice and the Veneto from 1580 on, was especially able to realize the connections, adopting both geographic thinking and cartographic imaging into architectural imagining.

Mapping with Words and Pictures

In addition to serving geographic needs, map-making in the 16th century was readily associated with broader interests aiming at a more accurate description of things in the world. The rise of natural history gave increasing value to observation and description, both verbal and visual, in the early modern attempts to address the infinite variety of nature.[48] The same observational mentality used in the collections of flora and fauna was characteristic of accounts of many travelers and explorers. As a complement to the visualization of mapping, there was an expansion in geographical description; beyond the technical location of a place, geography included whatever that place contained—its people, animals, plants, as well as geological and architectural features.[49] While this was especially true for newly discovered places and species, the same observational approach was being applied to familiar localities by naturalists seeking a comparative view.[50]

Words and pictures were both important in transmitting these early scientific observations. Visual records often included verbal notations and sometimes were accompanied by descriptive passages. The same need for communication by a combination of various graphic and verbal means was already a hallmark of map-making.[51] Though not read discursively, verbal information in combination with the formal and relational information was frequently required for maximum clarity. For geographers with a formal classical education, more extensive verbal accompaniment was a way to synthesize Ptolemy's mathematical and graphic approach with the literary tradition of Strabo. Thus, in addition to words that were labels and other indicators, descriptive texts set in frames or otherwise accompanying the visual depiction became common.

Book Two of *L'Idea* provides ample evidence that Scamozzi fully embraced the ideas that were current in geography and cartography; his two other extant books also contribute to this view of Scamozzi, but in quite different ways.

2.6 Franz Hogenberg, *Venetia* from *Civitates orbis terrarium* (Alfredo Dagli Orti/Art Resource, NY)

The first, *Discorsi sopra L'Anitchità di Roma*, is a guidebook to the Roman ruins published in 1582; the other, *Taccuino di Viaggio da Parigi a Venezia*, is his personal journal from his northern European journey in 1600.[52] In each, images and verbal description work together to describe particular places; both can be regarded as explicit chorographies, portraits of place.

The *Discorsi* is constituted by 40 etchings executed by fellow Vicentine Battista Pittoni (1520–1583) in Rome around 1560; Scamozzi was asked by the publisher over a decade later to provide descriptions for each.

These etchings capture not only the forms of the places, but offer the viewer details that evoke its character. They are not reconstructions or illustrations of Imperial Rome, but views of contemporary Rome as a place dominated by the chaos of ruins. Not only are the monuments of antiquity shown in their ruined, fragmentary state, but they are shown with all of the "accidents" that time has imposed on their forms: risen ground levels, vegetation, and medieval constructions. The clouds, the light, and contemporary Romans animate the scenes. They are touristic *veduti*, landscapes, or what Ackerman might call topographical drawings,[53] not architectural or scholarly investigations. Though modern eyes would tend to interpret these drawings as romantic rather than scientific, the science of the day in fact valued accurate accounts of the world as it is. In this light, they can be seen to be a faithful account of the state of ancient Roman architecture in the 1560s, a mirror of reality.[54]

Their pictorial nature did not discourage the scientifically-minded Scamozzi from the task. He treated these views with the same rigor evident in his treatise, describing each print on a facing page, adding information about the original structure and making sense of fragmentary elements. He added letters to the images as a means to key his identifications. Regarding the Colosseum, he reanimated the ruins with occupants and light:

If the ruins of this building bring such admiration today, we can only imagine the marvel and stupor of seeing this building when it was whole and had all of its ornament, and with it full of people ... the first portico received much natural light, and the light then passed to the second portico through shared archways.[55]

In addition to a meticulous account of each view, and in keeping with the Ptolemaic paradigm, Scamozzi inserted some broadly contextual chapters in advance of the images, establishing the scope of Roman geography and the ancient history into which these chorographic images fit. Location in time was as important to Scamozzi as location in space. Scamozzi also compiled a copious index, a cosmographic grid by which to locate each feature in the book.

The *Taccuino*, Scamozzi's notebook from his journey, provides an even more pointed illustration of his participation in a culture of observation and description. His sole purpose in making the trip to Paris was to see for himself the northern way of building—research through observation of foreign, non-classical design and construction practices.[56]

2.7 Battista Pittoni, *View of the forum*, Rome from *Discorsi sopra L'Anitchità di Roma* (RIBA Library Books & Periodicals Collection)

While more modest in distance than the New World explorations, Scamozzi's journey was in a certain sense just as pioneering, and had the shared objective of the naturalists of collecting examples of new species. His intention was to discover the reasoning underlying another building tradition in order to know more about architecture itself.

Scamozzi traveled with the entourage of the Venetian ambassador to Paris: they apparently set out in August of 1599, taking a long route toward Paris through Hungary and Bohemia; little else is known of this stage of the journey.[57] The party reached Paris in mid-February of 1600, the same week that Giordano Bruno was burned at the stake in the Campo dei Fiori for heresy. Bruno, along with Galileo, symbolizes for us now the fundamental changes that were under way at the start of the 17th century that can help us understand Scamozzi's quest. Their radical re-ordering of the cosmos and a century of expanding knowledge of the physical world was defying old limits and certainties. In brief, the changing perceptions of the world contribute to a whole set of trends summarized by William Bouwsma as a "liberation of knowing":[58] more open critical analysis of ancient authors, an embrace of a more limitless body of knowledge of the world, emphasis on active learning and practical utility over texts on esoteric subjects, value in curiosity, a rise in objective description, and eclecticism of sources. This research, unlike the typical 16th century investigations of classical antiquity, was not aimed directly at design, not meant to fuel a better project in Venice or the Veneto. In pursuing the "how" and the "why" of the northern way of building, Scamozzi wanted to expand his underlying knowledge of the relationship between architecture, geography, and culture.

Written under the harsh circumstances of travel in 1600, the notebook is a record of dates and places on the return to Venice. His narrative includes observations on the condition of roads and the weather, universally important to travelers. He also described the landscapes through which he passed, noting the farmlands, the hills, woods, and rivers: "Leaving flat land, we little by little moved downwards on a rocky road of hard stone and into a spacious valley with pleasant surrounding hills … we passed through pastures and forests. For a long stretch we travelled with … always new and beautiful views on the left."[59] He was attentive to the beauty of certain views and landscapes, the qualities of the stone available, and the productivity of the soils. Rivers and bridges drew his attention. Most commentary on towns and cities is quite brief, but a few buildings and towns provoke more detailed descriptions. In a poetic turn regarding Basel he wrote, "The site for the city is very beautiful, both for its proximity to the river and for its being elevated, as if it were on a hilltop. The shape of the city is like a waning moon, with the river gracefully taking a portion of the circle."[60] Shape and size of towns and buildings were consistently noted, and the materials for construction of walls and roofs were of great importance to him, along with their general state of repair; many towns were showing the effects of the religious wars. Not surprisingly, Scamozzi also consistently named the wind blowing while he was making his notes.

Between these two texts, one encounters the full breadth of Scamozzi's research. As a humanist and architect, he was naturally absorbed with continuing the archaeological explication of ancient Rome. Given his training in the classical texts, he was able to engage with them at a sophisticated level. As a natural philosopher and geographer, he traveled abroad to observe and describe. His tone in each case was largely reportorial, punctuated by occasional judgments on beauty, interest in the quality of light, admiration for ingenuity or for natural features. One might expect more extensive architectural descriptions in the travel journal, but the very fact of the journey itself asserted his profound interest, and his surprising openness to construction practices outside the classical tradition. Moreover, he was not solely focused on buildings and cities because he saw them within a totality of environmental dynamics: "We passed through Reuil-en-Brie, a sparse town with destroyed houses. Up to this point in the journey, we mostly passed fields devoid of fruit trees, but here we found great quantities of nuts. There are also many trade stations along the large and navigable river."[61] Interest in the towns and the buildings could be expected; but his ability to see those towns connected by the roads and rivers, and to read in their rural countryside the conditions for food production and industry (mills and quarries) is a clear sign that he was in fact the architect/geographer he claimed to be.

Scamozzi's Architectural Cartography

While the text of the notebook gives ample evidence of the geographic nature of Scamozzi's interests, the drawings that he produced along the way introduce another dimension of his geographic thinking. Fifteen pages of the 88 total[62] contain drawings; his subjects included seven Gothic cathedrals, one castle, one city plan, one bridge, and one mill machine. The cathedrals were clearly his primary interest; for these he was consistent in producing a plan and from one to three elevations (see Figure 2.8) — the façade for some, an interior partial nave elevation for some, and for two a transverse section.

The detail and control in the freehand drawings is striking when the conditions are taken into account; his notes indicate that the pace was consistently expeditious: "On Tuesday, April 4th, with cold weather and varied winds, we left Saint-Aubin sur Aire and went to the city of Toul. After having done some drawing, we got into the carriage and took a road through a well-cultivated and fruitful countryside."[63] In each case, he was committed to a complete survey of the structure, with an intention to record the whole. The capacity to execute these drawings within the short time frames of each stop on the journey is remarkable; it has prompted some speculation that they were drawn later.[64] This seems unlikely, though, as the drawings and text are fully integrated in the small notebook, and there are some errors that would have been caught and corrected if the notebook had been copied later. It can be supposed that he might have constructed the basic lines of each drawing on-site and later added thickness, shading, and other notations.

2.8 Vincenzo Scamozzi, sketch of cathedral of Meaux from *Taccuino di Viaggio di Parigi a Venezia*, p. 40 (Museo Civico di Vicenza)

In any case, he succeeded in capturing the shape and relationship of interior space and structure in plan, and critical vertical information in the west elevation or in partial interior elevations. Within the limited size and scale of a hand-held notebook (230 x 85 mm), he recorded the essential shapes with clarity and achieved a surprising level of detail.

Scamozzi measured and marked the structural grid with piers, walls, and vaulting. He took care to accurately draw the shape and relative size of the internal vertical structure, but he mostly missed the true anatomy of the exterior wall. Façades and nave elevations are primarily composed of outlines of surface and void, conveying some sense of the character of the building through texture and shading. Certain inaccuracies and omissions can be found, hardly surprising under the conditions. Scamozzi's plans are simpler and slightly more regular than the medieval buildings are; the elevations lack depth and ornament. Simplification may be the result of limited time and space, or it may have been his intention: in the treatise, he recommended that architects "make sketches of plan and elevations [of existing buildings] using actual measurements ... [but] memorize their delightful beauty, which cannot be expressed in drawings."[65] On his journey, he clearly chose to use some level of abstraction from the sensory experience by recording what he saw in plan rather than an interior perspective; the elevations, though available to sight,

were similarly abstracted. It would be fascinating to know from what distance each was produced.

His primary interests were materials and construction, the strength and capacity of the stone to bear and to span, and the ways that a culture had evolved to utilize their resources.[66] Thus, the materiality and the spatial logic of the Gothic presented itself more so than the skeletal structural nature or the sculptural surface qualities. He was interested in monumental construction as an indicator of the highest level of achievement of that culture in its geographic condition—the results of the human need to build in a given place and time. Like his map of the city of Nancy (see Figure 6.5) his fidelity to the whole of each Gothic church was chorographic, a mapping of the location and relationships of the primary elements and their locations in plan and the character of the primary shapes and their relationship in elevation.

Scamozzi's reconstruction of the Baths of Diocletian provides a key to this interpretation of the notebook drawings. This is one of a pair of bath etchings, the only images remaining from his study period in Rome 20 years earlier.

As with the Gothic cathedrals, he presented clear plan, sectional, and elevational information, although in this case they were combined into a single drafted composition. This image, executed by Mario Cartaro, is a reconstruction based on a survey of the ruins, just as the Gothic drawings are surveys of existing monuments. He titled it "Chorography of the whole of the Baths of Diocletian in Rome," indicating that he regarded it as a kind of map of the place. Once again, wholeness is a central intention.

2.9 Vincenzo Scamozzi, *Chorographia Omnium Partium Thermarum Diocletiani, Quae Romae Ad Hvc Visvntvr In Alta Semita Sexta Regione* (The Getty Research Institute, Los Angeles, 870672)

2.10 Vincenzo Scamozzi, plans and elevations for two palace projects from *L'Idea della Architettura Universale*, Book Two, pp. 126–7 (RIBA Library Photographs Collection)

The ground plan is fully dimensioned, noted in the Latin longitudes and latitudes. In this image, as in the Gothic cathedral plans, shape and location were his primary interests. The vertical dimension conveys character. These images are cartographic in nature, and Scamozzi himself tells us by his title that the combination of accurate measure, of proper positioning and relationship of the parts, and the modeling of three-dimensional form animated by light constitute a portrait of place.

Scamozzi's architectural drawings in his treatise can be similarly understood as mappings—building projects represented through cartographic images. Cosgrove defines mapping as "acts of visualizing, conceptualizing, recording, representing, and creating spaces graphically. To map is in one way to take the measure of the world … [which] includes the remembered, the imagined, the contemplated."[67] Like the images of the Gothic cathedrals and the Roman baths, Scamozzi's plans, sections, and elevations plot the size, location, and relation of the parts of a whole building in its place. Not surprisingly, his geographic approach to architecture is most explicit in the three building plans included in Book Two of *L'Idea*. There, two palazzo plans and a villa plan and section are provided as demonstrations of particular site qualities. However, the same approach can be detected in most of the other plans in the treatise, those that illustrate Book Three, his book on domestic architecture.

Though more subtle, the other 17 building plans that illustrate principles of residential design betray a cartographic approach merging with architectural representation, continuing to highlight the importance of place.

The plans and elevations of two Vicentine palazzi appear side by side on a single sheet in chapter 8 of Book Two (see Figure 2.10) as a demonstration of placing buildings on irregular sites.

Here Scamozzi's surveying skills are in forefront: the sheet is overlaid with a continuous square grid with five part divisions marked along the edge. This grid does not suggest a spatial continuity between the two sites; in fact, the different street alignments of each palazzo make it immediately obvious that they are not adjacent to each other. This grid has been mistaken for a design generator, but the accompanying text in Book Two leaves no doubt that it starts as a cartographic grid, used to locate precisely in space the corners of an irregular site to which the building conforms.[68] These corners are numbered 1–12 on the Palazzo Trissino, and 13–22 on the Palazzo Godi. The grid, together with the compass rose, then aid design by helping to maximize orthogonal spaces, and then rationalize them to the irregular site boundaries. Thus, the drawing is a map of the perimeter wall-lines as much as it is a plan of architectural spaces. His artistry is most apparent in the roofs, which adjust between interior regular geometries and exterior angles while maintaining a level eave. In this way, mapping precipitates planning.

A closer look at these two plans reveals another innovative feature — Scamozzi included several floor levels in a single plan. He was representing vertical relationships in a single projection, much like a topographic map. The architectural tradition at that time was to draw a single, principal floor plan — there are only occasional examples of multiple plans for the same building. Scamozzi's building plans in Book Three follow the convention. But for his site maps in Book Two, he collapsed multi-level information into a single floor plan.

Thus, not only are the stalls for the horses in the basement visible under the street-level reception room, but the loggia on the street and the main public rooms above appear simultaneously, and the resolution of the roof ridgelines is also drawn. From a single plan it is possible to comprehend the whole body of the building.

2.11 Andrea Palladio, plan and elevation of Villa Badoer, Polesine from *The Four Books of Architecture*, Book Two, Pl. XXXI and Vincenzo Scamozzi, plan and elevation of Villa Badoer, Peraga from *L'Idea della Architettura Universale*, Book Three, p. 291 (RIBA Library Photographs Collection)

2.12 Vincenzo Scamozzi, plan and elevation of Palazzo Trissino al Duomo, Vicenza from *L'Idea della Architettura Universale*, Book Three, p. 258 (RIBA Library Photographs Collection)

The drawings of the Villa Bardellini for Book Two are equally innovative, but completely different. With this plan and section, Scamozzi was working with other kinds of site qualities than shape—here he was demonstrating the considerations that are necessary with respect to natural light (see Figure 2.3). What emerges is a map of the building's openings and cavities as apertures and receptacles for light, the different ways that light enters, and the regions of light and shadow that result.

While the drawings included in Book Two are the most explicitly cartographic, indications of cartographic thinking are also present in the architectural plans included in Book Three. Maps generally present all of the features in a given territory; a map acknowledges the extensive quality of space, while a building plan describes a finite object. Scamozzi's own project designs, in clear contrast to Palladio's drawings of his residential designs (see Figure 2.11), are set within the surrounding context, showing surrounding features such as streets, canals, gardens, and paths.

The surrounding area is shown right to the boundary of the drawing, a spatial extension that is also clear from notes regarding connection to more distant locations—"Road from Padova that continues toward Trivigiano" on the plan of the Villa Badoer. Thus the chorography of the villa is related to the regional geography.[69] The context is somewhat minimal for urban sites, but the Palazzo Trissino al Duomo provides a good example. Scamozzi showed that the palazzo has a corner site, allowing for two façades, and two party walls with adjacent structures.

2.13 Vincenzo Scamozzi, plan and elevation of Villa Trevisan, San Donà di Piave from *L'Idea della Architettura Universale*, Book Three, p. 293 (RIBA Library Photographs Collection)

2.14 Details from Scamozzi's villa plans from *L'Idea della Architettura Universale*, Book Three (RIBA Library Photographs Collection)

The width of the sidewalk and the carriageway along the façade give a clear sense of the urban condition, and we learn from the note that it is facing the duomo.

Further, there is no clear distinction made graphically between interior and exterior space in Scamozzi's architectural plans—building and surrounding courts and gardens are equally important locations in the place of the villa. All are related by a system of wall-lines and pathways and porticos (see Figure 2.13).

Though these plans lack the 'topography' of multiple floor levels that was introduced into the Book Two plans, a mix of notations and graphics indicating the use of the spaces contribute to a portrait of place: "garden at the back surrounded by water," "path for walking in the shade," "covered entry," "place for making wine," "court where one can monitor the entrance," and "kitchen garden for the use of the house" (see Figure 2.14). Scamozzi's blend of pictograph and logograph is more in tune with maps than with architectural plans of his time.

Vincenzo Scamozzi developed an idea of architecture as a process of mapping universal forms in accordance with surveys of the particularities of place. Edward Casey suggests that maps represent overt landforms in detail, while landscape paintings represent the land's surface in its "implicit and concealed" character.[70] For Scamozzi, the architectural body was a chorography somewhere between these notions, and contained something of each. The following chapters will examine his most important architectural projects in detail for overt and implicit characteristics of their place.

Notes

1. Françoise Choay, *The Rule and the Model: On the Theory of Architecture and Urbanism*, translated by Denise Bratton (Cambridge, MA: MIT Press, 1997): 192–201.

2. Vincenzo Scamozzi, *L'Idea della Architettura Universale* (Venice, 1615): Proemio and Book Two title page.

3. Vitruvius, *On Architecture*, translated by Frank Stephen Granger (Cambridge, MA: Harvard University Press, 1931): I.ii.7: "Natural décor" demands the choice of a healthy site with a spring for shrines, especially those of the gods associated with medicine; and also that there be eastern light for certain domestic spaces, northern light for others. I.iv: On the salubrity of sites. I.v: On the foundations of walls and the establishment of towns. I.vi: Respecting the division of the works which are inside the walls and their arrangement so that the noxious breath of the winds may be avoided. I.vii: On the sites of public buildings.

4. Pietro Cataneo, *I Qvattro Primi Libri di Architettvra di Pietro Cataneo Senese* (Venice, 1554): Cataneo's first book focused on construction of fortifications, but this treatise did not achieve wide influence. The major treatises of Serlio, Vignola, and Palladio include the subjects of site and city only incidentally, if at all.

5. Thomas DaCosta Kaufmann, *Toward a Geography of Art* (Chicago, IL: University of Chicago Press, 2004): 17–26.

6. Clarence Glackens, *Traces on the Rhodian Shore: Nature and Culture in Western Thought from Ancient Times to the End of the Eighteenth Century* (Berkeley, CA: University of California Press, 1967): 246.

7. Scamozzi, *L'Idea*, Book Two Ch. 1.

8. Choay, *The Rule and the Model*, 201.

9. D.J. Gordon, *The Renaissance Imagination* (Berkeley, CA: University of California Press, 1975): 94.

10. Scamozzi, *L'Idea*, Book Two Ch. 1.

11. Denis E. Cosgrove, "Mapping New Worlds: Culture and Cartography in Sixteenth-Century Venice," *Imago Mundi* 44 (1992): 83.

12. Alessandro Nova, "The Role of the Winds in Architectural Theory from Vitruvius to Scamozzi," in *Aeolian Winds and the Spirit in Renaissance Architecture: Academia Eolia Revisited*, edited by by Barbara Kenda (London: Routledge, 2006): 82.

13. Nova, "The Role of the Winds in Architectural Theory," 79.

14. Paula Findlen, *Possessing Nature: Museums, Collecting, and Scientific Culture in Early Modern Italy* (Berkeley, CA: University of California Press, 1994): 63.

15. Findlen, *Possessing Nature*, 60.

16. Scamozzi, *L'Idea*, Book Two Ch. 2.

17. Scamozzi, *L'Idea*, Book Two Ch. 3.

18. Francesca Fiorani, *The Marvel of Maps: Art, Cartography and Politics in Renaissance Italy* (New Haven, CT: Yale University Press, 2005): 210.

19. Andrew Wear, "Place, Health, and Disease: The Airs, Waters, Places Tradition in Early Modern England and North America," *Journal of Medieval & Early Modern Studies* 38/3 (2008): 444.

20. Leon Battista Alberti, *On the Art of Building in Ten Books*, translated by Joseph Rykwert, Neil Leach, and Robert Tavernor (Cambridge, MA: MIT Press, 1988): 1.2. Alberti enumerated the six elements of architecture as: locality, area, compartition, walls, roofs, and openings. Locality and area were analogous to place and site in Scamozzi's treatise. In 1.3–1.6, he discussed the natural conditions that should be considered in the locality when planning a building. He touched on water, wind, topography, social factors, and other dimensions that are later a concern to Scamozzi. His overall intentions seem quite similar, but his information is more limited. More importantly, his estimation of the importance of this information is more limited.

21. Nova, "The Role of the Winds in Architectural Theory," 79.

22 Matthew Hardy, "'Study the Warm Winds and the Cold'—Hippocrates and the Renaissance Villa," in *Aeolian Winds and the Spirit in Renaissance Architecture: Academia Eolia Revisited*, edited by Barbara Kenda (London: Routledge, 2006): 54.

23 See appendix for a list of the 30 chapter titles.

24 Scamozzi, *L'Idea*, Book Two Ch. 6, 12, and 17.

25 Scamozzi, *L'Idea*, Book Two Ch. 9, 10, and 11; also 6 and 19.

26 Scamozzi, *L'Idea*, Book Two Ch. 10.

27 Scamozzi, *L'Idea*, Book Two Ch. 12–16.

28 Alberti, *On the Art of Building*, 9.10, 317; see also Nova, "The Role of the Winds in Architectural Theory," 78.

29 Scamozzi, *L'Idea*, Book Two Ch. 14.

30 Barbara Kenda, ed., *Aeolian Winds and the Spirit in Renaissance Architecture: Academia Eolia Revisited*, foreword by Joseph Rykwert (London: Routledge, 2006): xiii.

31 Nova, "The Role of the Winds in Architectural Theory," 81.

32 Scamozzi, *L'Idea*, Book Two Ch. 13. Part of the chapter title.

33 Scamozzi, *L'Idea*, Book Two Ch. 13.

34 Scamozzi, *L'Idea*, Book Three Ch. 21.

35 Scamozzi, *L'Idea*, Book Two Ch. 10.

36 Fiorani, *The Marvel of Maps*, 44.

37 A Venetian society of noblemen, scholars, humanists, and scientists similar to the Accademia Olimpica in Vicenza.

38 Cosgrove, "Mapping New Worlds," 81.

39 Edward Casey, *Representing Place: Landscape Painting and Maps* (Minneapolis, MN: University of Minnesota Press, 2002): 158.

40 Fiorani, *The Marvel of Maps*, 82.

41 Werner Oechslin, "'Tractable Materials': Der Architekt zwischen 'Grid' und 'Ragion di Stato,'" in *Early Modern Urbanism and the Grid: Town Planning in the Low Countries in International Context: Exchanges in Theory and Practice*, edited by Piet Lombaerde and Charles van den Heuvel (Turnhout: Brepols, 2011): 1–25.

42 Samuel Edgerton, "From Mental Matrix to Mappamundi to Christian Empire: the Heritage of Ptolemaic Cartography in the Renaissance," in *Art and Cartography*, edited by David Woodward (Chicago, IL: University of Chicago Press): 10.

43 Wear, "Place, Health, and Disease," 463 n. 11.

44 Fiorani, *The Marvel of Maps*, 188.

45 Lucia Nuti, "Mapping Places: Chorography and Vision in the Renaissance," in *Mappings*, edited by Denis E. Cosgrove (London: Reaktion Books, 1999): 108: "Mapping places by means of drawing faithful portraits of the world as seen provides a record of visual choices, cultures, and spatialities."

46 Nuti, "Mapping Places," 93; Nuti cites Cristoforo Sorte, "Osservazioni sulla pittura," in *Trattati d'arte del cinquecento*, edited by P. Barocchi (Bari: G. Laterza, 1960): vol. 1, 277.

47 Cosgrove, "Mapping New Worlds," 65 and 79–81.

48 David Freedberg, *The Eye of the Lynx: Galileo, His Friends, and the Beginnings of Modern Natural History* (Chicago, IL: University of Chicago Press, 2002): 4–6.

49 Fiorani, *The Marvel of Maps*, 6.

50 Findlen, *Possessing Nature*, 163. "Collectors, dreaming of places they could not see, mapped out the coordinates of their immediate environment."

51 Casey, *Representing Place*, 174.

52 There has been speculation that he meant to publish this notebook, but in fact it never was published and became lost to history until its re-discovery and publication in 1959.

53 James Ackerman, *The Reinvention of Architectural Drawing, 1250–1550* (London: Sir John Soane's Museum, 1998): 1.

54 Casey, *Representing Place*, 166: "Reinforcing the pictographic propensity of this age is the prominent use of the mirror ... In the early modern Dutch outlook the mirror enacts the world-as-image, the world-as-viewed, the world-as-represented ... Thus geography itself was often thought of in terms of its mirroring powers."

55 Vincenzo Scamozzi and Battista Pittoni, *Discorsi sopra l'antichità di Roma* (Venice, 1582): Plates IX and XIIII.

56 Scamozzi, *L'Idea*, Book One Ch. 22.

57 Vincenzo Scamozzi, *Taccuino di Viaggio da Parigi a Venezia (14 marzo-11 maggio 1600)*, introduction by Franco Barbieri (Venice: Istituto per la Collaborazione Culturale, 1959): 12–14.

58 William Bouwsma, *The Waning of the Renaissance, 1550–1640* (New Haven, CT: Yale University Press, 2000): 35.

59 Scamozzi, *Taccuino*, 42.

60 Scamozzi, *Taccuino*, 73.

61 Scamozzi, *Taccuino*, 43.

62 Jean Guillaume, "Taccuino di Viaggio da Parigi a Venezia," in *Vincenzo Scamozzi, 1548–1616*, edited by Franco Barbieri and Guido Beltramini (Venice: Marsilio, 2003): 393.

63 Scamozzi, *Taccuino*, 55.

64 Guido Beltramini, "'Lionem ex unguibus aestimare': Un Primo Sgardo d'Insieme ai Disegni di Vincenzo Scamozzi," in *Vincenzo Scamozzi, 1548–1616*, edited by Franco Barbieri and Guido Beltramini (Venice: Marsilio, 2003): 54. Beltramini states that the drawings "do not have quick notes or show freehand, of-the-moment impressions of place," so he concludes that the notebook was an architect's sketchbook, meant to be read by the public. But he is incorrect in his assertion that the drawings show no "second thoughts, errors, or corrected dimensions."

65 Scamozzi, *L'Idea*, Book One Ch. 22.

66 Scamozzi, *L'Idea*, Book One Ch. 22: He says he travelled in northern Europe "only to observe the manner and forms of construction of those countries, and to see the quality of materials that they use, and how they build differently there than we do."

67 Denis E. Cosgrove, "Introduction: Mapping Meaning," in *Mappings*, edited by Denis E. Cosgrove (London: Reaktion Books, 1999): 1–2.

68 Edgerton, "From Mental Matrix to Mappamundi to Christian Empire," 39–44.

69 Frangenberg typifies chorographies of cities in part by their inclusion of features of the surrounding region. See Thomas Frangenberg, "Chorographies of Florence: The Use of City Views and City Plans in the Sixteenth Century," *Imago Mundi* 46 (1994): 41–64.

70 Casey, *Representing Place*, 153.

3
Mapping the Natural World: *Casa* and Villa

> In my view, the house on a country estate both delights and offers more possibilities, room for room, than the town house. Maybe because it also offers a landscape of hills, mountains, and valleys ... In summer the air blows more freely and is fresher and purer in the suburbs and on country estates, as we can see by looking at the woods and leafy trees, the lush green meadows full of flowers, the clear water running in brooks and playing fountains, and the brèeze passing through the narrow valleys.
> Vincenzo Scamozzi, *L'Idea della Architettura Universale*

Vincenzo Scamozzi practiced architecture at a time when the transformation of Venice from a Mediterranean port city with a predominantly maritime economy to the socio-cultural center of a Veneto region increasingly dependent on agricultural production and wealth was taking place. Catalyzed by strategic military decisions after the War of the League of Cambrai,[1] a steady pace of change throughout the 16th century had significantly altered the Veneto. Hydrological management and major land reclamation projects were among the most dramatic alterations.[2] But the change from a collection of relatively small and irregularly defined farms serving the markets of regional centers at Verona, Vicenza, and Padua to numerous consolidated landholdings intended to produce agricultural commodities changed the very texture of the landscape. The underlying land divisions from Roman centuriation provided an orthogonal armature for property boundaries marked by tree lines and irrigation channels.[3] Perceptual changes were as important as the physical ones—the rural landscape of the Veneto was no longer conceived as a series of fortified outposts linked by roads to urban centers, but a continuous topography of geometrically bounded fields forming a mosaic of occupied and productive land crossed by roads, rivers, and waterways, and interrupted only by hills and cities.[4]

In short, the rural landscape of the Veneto was domesticated; urban life and rural life were no longer seen as completely contrasting conditions. These changes, stimulated by political and economic forces in Venice and facilitated by relative peace, went hand-in-hand with technological improvements in land surveying, water management, and irrigation. As wealthy Venetians began to develop their landholdings with new purpose, they required country residences of suitable dignity and comfort. Falconetto, Sansovino, Sanmicheli, and especially Palladio were all called upon to provide designs for such clients. They each, in their own way, sought to provide a rural residence with some humanist urbanity by using Renaissance compositional principles and a modest vocabulary of classical ornament. By the time Scamozzi was designing his first country estates in the second half of the century, regular composition, symmetrical planning, classical elements, and a carefully calibrated amount of carved ornament were familiar in the rural landscape. He continued these traditions in the design of his own projects.

Freed from the search for a proper character and expression, Scamozzi focused more rigorously on optimizing the plan in service of two major villa themes: the therapeutic value of nature, and the productive value of nature, or agriculture. Contact with nature brought the visual pleasures of beautiful views and colorful fragrant gardens, the benefits of healthy air, and the chance for regular exercise; all were remedies to the stress of urban life. In addition, on the agricultural estate, the daily rhythms of sunrise and sunset echoed in the patterns of animal husbandry and other farm labor provided another kind of connection with the natural world. Oversight and management, critical for the maintenance of a productive estate, also nourished the soul of the owner. To provide such benefits, the residential and farm activities needed careful placement so that all were properly provided for and well coordinated.

In the relatively flat and open landscape of much of the Veneto, the beauties of nature were not abundantly evident;[5] they needed to be framed to become visible. Sensitivity to natural features at the regional scale and the provision of beautiful gardens proximate to the owner's house were both essential to making nature's qualities palpable. Scamozzi's focus on creating the connection with nature is clear in his treatise. This means, however, that much of Scamozzi's design work is not obvious in the architectural representations of plan and elevation; they could only be comprehended in the experience of the place. A full assessment of Scamozzi's contribution to villa theory and design is therefore difficult since relatively few villas remain intact, his gardens are gone, and the landscape around them is altered.[6] Nevertheless, there is compelling evidence that his approach had some unique and innovative features.

Scamozzi's own drawings and descriptions of the projects in his treatise demonstrate clear intentions, even if the question of their effectiveness remains relatively elusive. The plans are the most critical evidence, so they need to be understood first within the tradition of the Veneto villa, and then examined for their own distinctive and peculiar qualities. These ultimately reveal the

fact that Scamozzi encountered the rural site as a highly differentiated place in nature, and that his designs provided inhabitants with a map for navigating its changeable natural conditions. The significance of the gardens emerges from the plans, but is more fully evident in several chapters at the end of Book Three. Finally, the rural houses that remain intact today provide evidence of Scamozzi's intention for the domestic interior—to create conditions of comfort in a zone between heaven and earth, a place where wind and light animate but never overwhelm.

Villa Culture in the Veneto—Ancient Ideology and Renaissance Interpretations

Vincenzo Scamozzi read for himself the ancient literature on villas and agriculture, as well as their interpretation by humanist scholars of his own time. Although no remains of Roman villas had been discovered, the literature on them was substantial, providing multiple statements of the same basic ideology on the benefits of a country house: escape from political and social intrigues, a daily routine relieved of formalities, and in their place the opportunity for healthful exercise and focused intellectual pursuits. Exposure to the natural environment was itself regarded as salubrious.[7] His familiarity with the ancient ideal is fully apparent in Book Three of *L'Idea*, where he provided two classical villa plans based on literary descriptions as well as a whole chapter on the functional spaces of the ancient villa. His references included not only Vitruvius, whose chapter on country houses focused on the utilitarian needs of an agricultural complex, but Virgil, Columella, Herodotus, Cicero, and Pliny the Younger among others. He also referenced the Bible on the virtue of agriculture. Roman authors on the villa variously described physical requirements, social dimensions of ownership and labor, and agricultural instructions. One of his lengthier quotations on the merits of the country estate was from Ovid, praising agricultural labor over business.[8] Taken together, classical texts contained two sometimes contrasting values— enjoyment, in the form of relaxation, study, contemplation, conversation, and appreciating nature; and hard work, in the form of physical labor, ascetic living, production and management, and making nature useful. But in either case, the villa as an architectural project was consistently connected to positive moral virtues and spiritual wellbeing.

Scamozzi was familiar with the humanist literature on the villa in addition to his direct knowledge of the classical texts on agriculture and country life. Alberti was the first to revive the ancient ideas, citing Cicero, Terence, and Martial. His preference was for sites relatively close to town, easily accessible year-round,[9] but not too busy. However, he did acknowledge that country houses at a greater distance from the town are appropriate for gentlemen that will be running a farm, and he offered detailed information on topics such as the accommodations for farm workers and a variety of

farm animals.[10] Practical information on the compartition of the master's house is followed by the delights of a villa. Alberti cautioned that "every consideration must be given to region, weather, use, and comfort—to keeping out biting Boreas and chill from air and ground in cold climates, or the troublesome sun in hot ones, and to letting in the refreshing breathe of the heavens and a reasonable amount of pleasant light from all directions."[11] While the buildings must provide comfort, "meadows full of flowers, sunny lawns, cool and shady groves ... none of these should be missing, for their delight as well as for their utility."[12] The classical tension between utility and delight was renewed by Alberti, continued throughout the 16th century, and similarly expressed by Scamozzi.

The wide embrace of villa ideology in the 16th century Veneto is visible not only in the abundance of architectural projects and the treatises but in the paintings and literature as well. Books written to describe and praise villa life began to appear around 1540. Agostino Gallo's *Ten Days of True Agriculture*, published in 1566, provides a detailed image of villa life. One account of a day's activities describes rising at dawn for three hours of hawking in the countryside, gathering for a mid-day meal, followed by time for rest or business matters; the company gets together again afterwards for reading or games—quiet activities until the worst heat of the day has passed. Afterwards, there is walking in the gardens or going on visits, enjoying the outdoors. When the men's party happens upon the women's, there may even be dancing at the end of the evening.[13] The paintings of Veronese (1528–1588) and Lodewijk Toeput (1550–1605), known as il Pozzoserrato, portrayed these idyllic activities and harmonious villa landscapes. A poem by Veronica Franco about her visit to Villa della Torre outside Verona asks whether it would have been better to never see such a beautiful place only to have to leave it, but concludes that the memory is still joyful: "My spirit, never quitting this place, recalls its endless beauties again and again."[14]

The broad cultural embrace of villa life highlighted the therapeutic and delightful aspects, but agricultural pursuits remained in the foreground of villa theory and construction in the Veneto. It was an economic necessity of larger-scaled agricultural production that stimulated much, though not all, of the villa construction to begin with. The practical value of technical agricultural knowledge also stimulated a number of new publications.[15] Just as importantly, the Paduan humanist Alvise Cornaro (1484–1556) updated the philosophical dimension of agriculture as a source of honor, dignity, and virtue. Cornaro, like Daniele Barbaro, was a knowledgeable patron of architecture as well as a writer. He wrote on topics ranging from hydraulics and water management, architecture, and "the sober life,"—recommendations for healthy living. Within his concept of 'holy agriculture,' the villa creates a place for man to experience the harmony of the cosmos by the immediacy of the cultivated earth and expansive sky.[16] These views were widely influential, shared by the clients and the architects of 16th-century villas.

Scamozzi presented his own designs for villas in two distinct groups, "suburban structures" that were primarily intended for relaxation, and "rural structures"[17] that combined those intentions with the management of an agricultural estate. The architectural emphasis of the suburban villa was the patrician's residence, or *casa dominicale*. Service structures were minimal, supporting daily life and needs of the residents. The rural villa, on the other hand, was a complex containing farm buildings for animals and equipment, production areas, and workers' housing as well as the *casa dominicale*. He introduced each group with an ancient precedent (see Figure 3.1), but the formal order of the ancient building was not promoted for use as a model — he advised using from them only whatever was still useful. They established the validity of the categories, the longevity of fundamental villa ideology, and a universal idea with which to begin a design.

It was as introduction to the suburban villa that Scamozzi drew his reconstruction of the plan of Pliny's villa at Laurentina; architects since Scamozzi have not tired of giving form to Pliny's vivid description.

Scamozzi's plan is ordered along a single axis with linear assemblies of rooms framing three linked courtyards. The axis ends in a reception room that extends out into a body of water, a feature that connects this plan to a particular, if unknown, site. Scamozzi probably chose this villa

3.1 Vincenzo Scamozzi, reconstructions of Pliny the Youger's villa at Laurentina and the Vitruvian farmhouse from *L'Idea della Architettura Universale*, Book Three, pp. 269 and 284 (RIBA Library Photographs Collection)

because it was widely admired in its own time, and Pliny's description of the "many charms with which my little villa abounds"[18] portrayed not only the layout of the rooms but the experience that each architectural element offered. Scamozzi observed that "from it we can formulate many ideas for the construction of suburban houses."[19] His other precedent, the Vitruvian "farmstead,"[20] is solely devoted to the necessities of agricultural pursuits. Like Pliny's villa, it is a form that was generated on the basis of a text, although this one was not an actual building but a typical condition, an idealized plan rather than a particular precedent. The focus of the composition is the kitchen rather than the house of the patrician landowner, an essential element that is completely missing. These classical precedents were merely offered as types: the first was a picture of the kind of spaces needed for relaxation, the latter those needed for production. Relaxation required options for different seasonal conditions and had numerous spaces oriented outward to the landscape. The working farm was oriented inwardly and featured the kitchen as a center of labor, and the transformation of agricultural products into sustenance. Though serving the opposing functions of villa life, both plans illustrated a complex set of spaces and functions governed by a clear overall formal order, and a general intention to circumscribe and contain. Scamozzi followed these Roman precedents by using the required structures to create courtyards whenever the size of the project will allow it.

By the time Scamozzi was engaged in villa design in the 1570s, the Renaissance revival of the antique villa ideal had a substantial history, and over time he would see many 16th-century villas first-hand. He admired aspects of Villa Madama, Villa Giulia, Villa d'Este, and Palazzo del Te (a suburban villa despite its name) in his treatise. These were all pleasure villas of the most wealthy and powerful strata of society, the ones most fully expressing the humanist project of recalling ancient Roman nobility through re-establishment of villa ideology and a revival of appropriate architectural form and ornament to support it. However, they exhibited a degree of luxury that was not suitable to the circumstances of villa clients in the Veneto. More importantly, they were designed in a different socio-economic context and were set in a completely different landscape. While he found particular features and solutions to be praiseworthy, none of these can be seen to have influenced his own design thinking in specific ways.

In the north, there were relatively few examples of villas inspired by classical themes from the earliest decades of the 16th century as the Veneto region was the site of destructive wars. Alvise Cornaro initiated several projects in the 1520s containing ideas that would inform the 16th century villa in the Veneto. He worked with the exiled Veronese architect Giovanni Maria Falconetto on two unusual structures for his garden in Padua (see Figure 3.2). The first was a pleasure pavilion, a loggia, the first building in the north to utilize a fully Romanized architectural vocabulary.[21]

3.2 Giovanni Maria Falconetto, Cornaro loggia and odeon, Padua (Scala/Art Resource, NY)

In addition to providing a shady retreat, the loggia served as a backdrop for theatrical performances, and may have been designed with Peruzzi's Villa Farnesina in mind. To this, he later added the Odeon, a building meant for indoor readings and performance. Though the function of this structure was non-residential, it was linked to the villa ideal of providing cultural pleasures—relaxation *and* intellectual stimulation—outside a major urban center. As the loggia's façade introduced a new language and syntax, the plan of the Odeon introduced a potent compositional strategy, the centralized figural space within a cubic building block. Taken together with his involvement in the practical matters of land reclamation and his championship for agriculture, these Cornaro projects set many of the conditions for villa development in motion.

Sansovino and Sanmicheli, architects that projected Roman architectural forms more widely in the region in the following decade, produced few villas. Far more numerous were the villas of Palladio, built from about 1540 onward. As a body of work, Palladio's villas have had a far-reaching impact on subsequent Western architecture, and have therefore been the subject of substantial interpretation and analysis. Early analysis focused on the plan of the centrally placed *casa dominicale*, a masonry block consisting of proportionally related rooms arranged symmetrically around a central axis.[22] The lessons of Cornaro's odeon and Serlio's domestic plans were effectively developed by Palladio in his *casa* planning. Palladio's innovation is evident in his adoption of particular classical themes strategically employed and the rigorous attention to proportion and spatial sequence. But Palladio's chief genius lay in his organization of agricultural buildings surrounding the *casa* and their unified architectural expression. The size of the *casa* was relatively modest, but its hierarchical relationship to agricultural buildings that extended outward as wings gave it greater impact. The provision of a loggia on the main residence and continuous porticos or arcades on the agricultural wings tied the previously separated structures of a Veneto estate together into one composition. It has been effectively argued that Palladio developed this vision of the villa by fusing two local vernacular traditions then articulating the whole assembly with classical themes.[23]

3.3 Diagram of Serlian villa plan, Palladio's design for Villa Pisani, Bagnolo, and Scamozzi's design for Villa Pisani, Lonigo (Illustration: E. Anderson)

Though never directly acknowledged by Scamozzi in his treatise, the influence of Palladio's designs on Scamozzi's approach would be hard to deny. His villa designs made use of Palladian motifs like the central pedimented portico, hierarchical planning, and a consistent language of openings and ornament for the whole complex. But it quickly becomes difficult to distinguish between Palladio's influence and the mutual effect of broader cultural currents—shared sources, shared client base, and shared intellectual climate. Scamozzi no doubt benefited from considering Palladio's synthesis of these conditions for design, but he studied it along with all other relevant thinking on the topic. He then formed his own synthesis based on his particular priorities and design process. Scamozzi's first-hand knowledge of antiquity and classical literature and his encounter with the best of early 16th-century architecture were as important as his contact with Palladio's work. Even more importantly, his own interest in local architectural traditions as an indicator of local customs exceeded that of Palladio. Thus, while the pediments and porticos of Scamozzi's villa designs suggest the influence of Palladio, his composition of the whole complex was quite distinct.

It is quite likely that the single most important contemporary influence was not Palladio but Sebastiano Serlio (see Figure 3.3).

Though unpublished, the residential designs of Serlio's planned sixth book, *On Domestic Architecture*, were well circulated in manuscript form. It was the single richest source of formal explorations of houses before Palladio's treatise was published in 1570. While foreshadowed in part by Francesco di Giorgio's interest in combinatory variations for residential plans,[24] Serlio's unique exploration of domestic forms addressed a whole range of sizes, scales, and social strata. Even so, two distinct planning schemes emerged—one with an orthogonal central *sala* that traversed the whole depth of the building, and the other with a central geometrically regular *sala*.

Serlio was the first to state these plan-types so lucidly; both types were repeated first by Palladio and then by Scamozzi. The basic principles were fully explored by Serlio as a set of variations on constant themes. Scamozzi's intellectual connection to Serlio was profound, so evidence of such influence is not at all surprising.

Given the amount of literature on the Palladian villa today, Serlio's influence on Palladio has been underexplored. It may be due to the fact that the book was produced in a different context, in France, and the Palladian villa has consistently been interpreted as an expression of local cultural circumstances. Though Ackerman sees Serlio's volume as an influence on Palladio's treatise,[25] he does not connect it with an influence on Palladio's designs or design thinking. However, Rosenfeld argues that underlying the rural vernacular across Italy and France was a common heritage in the 'Roman portico farm.'[26] More importantly, among Serlio's designs are strategies and elements that have sometimes been described as innovations of Palladio: introduction of a central domed figural space to domestic architecture, rigorously symmetrical planning, a tetrastyle hall, square pavilion design with cross-axial symmetry terminated by loggias, and proportional sequencing of room sizes within an apartment. In any case, Scamozzi was familiar with the work of both Serlio and Palladio, and while either one alone would be sufficient as a precedent for the planning of the central *casa*, Scamozzi almost surely referenced both. It is abundantly clear that Scamozzi's research method was always encyclopedic, even exhaustive. It is unimaginable to any reader of his treatise that he ever worked from a single source.

Evidence of Scamozzi's direct reliance on Serlian precedents goes further than similarities of architectural form. This is most readily illustrated by a comparison of Serlio's Plate III, a "house for a richer citizen or merchant or similar person," and Scamozzi's design for a villa on the Brenta, illustrated in chapter 14 of Book Three. An important connection between the two is the graphic style. Both plans are labeled with letters as a key to the text, which in Serlio's manuscript is found on the facing page. Some spaces are labeled, though not with any pattern or consistency, and a graphic scale is always included. Serlio's text contains dimensions of each space, while Scamozzi usually puts dimensions right on the drawing, although not in this case. (They may be missing from this plan because it was never built.) Both plans are accompanied by elevations indicating the vertical order and the ornament. These are closer in their manner of communication than the more abstract villa plans of Palladio in the *Four Books*.

More importantly, their approach to site planning was quite similar: the building block was woven into a system of site walls that created a forecourt and two passages flanking the building leading from the forecourt to the garden behind the house.

3.4 Diagram of Scamozzi's project for a villa on the Brenta and a Serlian villa site plan (Illustration: E. Anderson)

The forecourt was entered on-axis with the centrally placed house opposite. Walls that defined the front and rear façades of the residence continued beyond the roof to engage the site walls. In the Serlian project, a two-story cubic masonry block rose on a square plan and was finished by an apparently pyramidal roof. The plan of the dwelling was symmetrical about a central axial *sala* that stretched the full depth of the house. It was flanked on each side by two pairs of rooms, and the loggia that terminated the *sala* was flanked by stairwells. The loggia faced a garden, accessed by a semicircular stair reminiscent at a small scale of Bramante's stair at the exedra of the Belvedere. The garden façade was more open than the entry side, and was articulated with classical pilasters and columns. Scamozzi's design for a villa on the Brenta, never constructed, located service spaces behind a portico along the entry wall of the forecourt, thickening the entry from a gate to a loggia. There were additional passages at each end of this structure into the forecourt. On-axis with the main entrance was the residential block, square in plan, fronted by a loggia. The front and rear walls of the house continued outward to engage the continuous site walls, defining two small flanking gardens as they did so.

Though the Serlio and Scamozzi plans differed in certain details, they were both defined by continuous orthogonal walls that established distinct spaces on the site.

If site planning can be seen to connect Scamozzi to Serlian precedent, it also serves to distinguish his work from that of Palladio. The Scamozzi villa design that most resembles a particular Palladian project best illustrates this point.

Palladio's Villa Emo, designed in the late 1550s, is regarded by some historians as the best demonstration of his design principles. The central *casa* is raised on a podium; the pediment on the entry portico is the high point of the whole composition. Two uniform arcades extend from the center, and are terminated with the small towers of dovecots. The emphatic central axis binds the villa into the extended landscape. Scamozzi's design for Villa Contarini is similar in essential elements: a linear assembly of *casa*, arcades, and dovecots. However, the central axis through the casa is tempered by parallel paths leading to the terminal dovecots, and a perimeter wall defining a double square forecourt. The roads pass under the dovecots, connecting the forecourt to the enclosed garden behind the building. Forecourt and garden are both surrounded by a canal-like fish pond. Finally, each of the extended wings is marked at its central bay by a small pediment and a break in the arcade rhythm for a Serliana motif. Villa Emo's simplicity projects as a face infinitely into the landscape; and though the central axis continues, the rear of the villa remained unfinished. Villa Contarini, on the other hand, was designed to be experienced as a filter through which one passes from a court to a garden. The spaces on either side of the main axis were bounded and finite, designed together with the façade that structures them.

Palladio's compositional innovations—symmetrical arrangement hierarchically ordered and unified by simple forms and ornament—gained drama from a final important design decision: he opened the country estate of the Veneto to the landscape. The two vernacular traditions that Palladio's designs seem to derive from were both completely walled-in— the 15th-century landowner's castle was centrally located within a defensive wall, and the more humble farm consisted of a house and farm buildings

3.5 Andrea Palladio, plan and elevation of Villa Emo, Fanzolo from *The Four Books of Architecture*, Book Two, Pl. XXXVIII and Vincenzo Scamozzi, plan and elevation of Villa Contarini, Loreggia from *L'Idea della Architettura Universale*, Book Three, p. 289 (RIBA Library Photographs Collection)

irregularly placed around a work yard closed off by a wall to contain and protect animals and agricultural equipment and stores within. Palladio adopted the centrality and sense of grandeur of the castle type for the house, and regularized the various other buildings of the farm into symmetrical wings, but he had no spatial or defensive need for the perimeter wall; if he used them at all, they were low walls creating a terrace or edge. This was in keeping with the ancient idea that a villa should be visible from a distance and present a noble appearance in addition to offering its occupants views and breezes.[27] Palladio's compositions were meant to be seen as a whole so that their hierarchically ordered unity could achieve full visual effect. Ancient temple complexes outside Rome were the inspiration for tiered structures ordered by cascading porticos that could speak on the scale of the extended landscape.

Scamozzi, on the other hand, continued the vernacular tradition of an enclosed complex. As seen in the villa on the Brenta, walls both organized and contained his architectural assemblage. The visual unity of the whole from a distant viewpoint was not a priority for Scamozzi—while he repeated the standard formula that it is desirable to be visible to passers-by in his generic descriptions of good villa design, he placed far greater priority on the experience of the inhabitants. And though he mostly adhered to symmetrical order in each individual space, symmetry for the entire complex was not the rule. The *casa* was symmetrically planned and usually axial to the entry court, but other elements on the site were placed in accordance with functional relationships and orientation. Where these priorities led to asymmetries, he used a web of site walls to mask and balance it. Most Scamozzi villas were therefore not accessible to a single privileged view. They would be encountered episodically: each realm appeared unified and balanced, but irregularities beyond were hidden by walls or porticos. Scamozzi may have learned from Palladio's masterful designs lessons of scale, and the coherence of uniform architectural elements and ornament. However, his spaces in front of the *casa dominicale* were designed as places to be *in*, rather than as platforms for visual engagement with the landscape as a wide expanse. Instead, his circumscribed realms were meant to frame the landscape inside and outside the walls as a series of distinctive places.

Scamozzi employed his various sources—whether the ancient ideals, vernacular customs, Serlian planning, or Palladian expression—in similar ways, although he was only explicit about antiquity. In introducing his treatise, he acknowledged the others that he had read and stated that his was hardly unique, but it was like an offspring—"a legitimate son"—of the ones that came before.[28] Similarly, he had no interest in recreating the villa of antiquity. Instead, he wished to understand and appreciate how ancient Romans built and used their villas in order to emulate their clarity, reason, and dignity. Serlio and Palladio provided Scamozzi with formal orders that he did not discuss, but he used and developed aspects of each in the planning and the articulation of the central *casa* of the villa complex.

Even so, Scamozzi never deployed these formal schemes mechanically. His own variations arose from concerns about ease of use, practicality, and a consistent attention to movement in addition to structural and volumetric considerations. Scamozzi's contribution to the idea of the villa in the Veneto consisted in extending further certain humanistic interests developed by Cornaro, Serlio, and Palladio. His unique inspiration was to extend the sequencing of interior rooms to the sequencing of exterior rooms, or gardens, and to comprehend their proportional relationship through the presence of nature in its different forms.

The Geography of a Scamozzi Villa

Selecting a site is a customary topic in villa literature, although in practice the site was usually already determined by a client's landholdings and even by previous structures. Yet Scamozzi's guidance on siting the villa optimally, an integral part of Book Two of *L'Idea*, indicates many of the goals and intentions that he brought to villa design. He followed Vitruvius and Alberti in placing the highest priority on healthy air, followed by availability of water, and repeated many of the other standard ideas inherited from antiquity. The difference was that he was able to extend or modify the received wisdom in these texts with emerging scientific knowledge. The sixth chapter of the book was given exclusively to the topic of siting a villa, but recommendations for villas appear frequently in other chapters as well. In his main statement, he repeated standard ideas, not only calling for good air, water, and roads, but also "proximity to a city" and "being on a hill, having views out."[29] These were the parameters of pleasure villas following the classical *topos*, and governing the early Renaissance villa projects of Florence and Rome. In addition to the physical and environmental factors, Scamozzi recommended being careful about neighbors in order to avoid "arguments over land, animals, or crops."[30] And his final advice was for a wealthy gentleman to undertake such an ambitious project early in life when he is full of energy. In doing so, he would maximize his years of use and enjoyment.

Regarding villa design, Alberti had reiterated his observation that a house is a miniature city, "therefore, almost everything relevant to the establishment of a city must be taken into account."[31] In the case of a country house, it was more of a functional observation than a poetic analogy for guiding compartition. The country house needed many more parts for self-subsistence and so its complexity was more city-like; it had many more functions to accommodate and was the place of work and/or residence of a sizable population of servants and laborers. It *was* like a small city, or at least a village. Scamozzi underscored this—almost every observation that he made about the best place to site a city was also recommended for a villa. Thus, although he repeated the standard considerations in his chapter on siting villas, the whole of Book Two addressed a much greater variety of possible site conditions. Scamozzi departed from

the standard literature by not only recommending what would be best, but in describing a full range of conditions with their potential benefits and likely injuries. The villa, like a city, was an assembly of differentiated structures within a walled system; it too stood alone without the protection of other structures nearby, and so bore the full impact of natural forces. The best designer would need to understand these forces in order to build on sites that may not be ideal in a way that provided security and comfort even in the face of severe or potentially dangerous natural conditions.

Cutting across the distinction between suburban pleasure villas and rural agricultural ones, Scamozzi described three categories based on size of the main dwelling, size of the site and its development for pleasure and agriculture, conveniences, and degree of ornament that he called common, distinguished (or honorable), and magnificent.[32] These categories also correlated naturally to the social rank of the client, another indication of his attention to Serlio. The categories provide a way to think about the villa systematically, and to account for universal goals and requirements as well as a variety of site situations and client needs. As there are five species of columns, so there are three species of villas, and in Scamozzi's view size, expense, and degree of elaboration and ornament should vary continuously from one category to the next. Imesch notes that numerous Scamozzi villas appear to mix his categories, explicable if he only determined the categories with hindsight while writing the treatise.[33] However, it could also be the case that the categories were ideal types, mental templates to account for a variety of semi-independent variables in a consistent way. Like his reconstructed classical villas, they provide a universal idea from which a design for a particular place and client is developed. This interpretation is supported by Scamozzi's numerous specific recommendations that several designs fail to follow, including setting the owner's house in the center of a large forecourt facing south, and avoiding the provision of two or three stories above the ground-level podium. The categories provide a conceptual framework of increasing land area, wealth, and design complexity rather than a true set of types, with the implication that the grandest villas will achieve an expression of *magnificenza*, a princely nobility that was usually associated with public buildings in the city.[34]

The houses of the common type had the fewest service structures, so they tended to have a centralized plan and a cubic form as the main source of their dignity. There is a loose correlation between Scamozzi's common type, the idea of the suburban pleasure villa, and the cubic form. Distinguished, or honorable, houses were part of a larger composition of structures that supported the main building block and that divided its site into various territories; whether visible from the forecourt or not, the support buildings had related architectural elements in order to form a unified whole. Magnificent country houses were the largest, commanding full estates; in addition to more extensive support structures, the main hall in the central dwelling was grander, and there were more apartments with a greater variety of rooms.

3.6 Vincenzo Scamozzi, Villa Molino, Mandria from
L'Idea della Architettura Universale, Book Three, p. 275
(RIBA Library Photographs Collection)

3.7 Vincenzo Scamozzi, Villa Cornaro, Paradiso from *L'Idea della Architettura Universale*, Book Three, p. 281 (RIBA Library Photographs Collection)

In the treatise, Scamozzi presented his designs sequentially in terms of increasing size and complexity, suggesting the scheme even though he did not describe his designs according to the categories. Formally speaking, there are four designs that are cubic in form with a central geometrically regular *sala*. These include two of Scamozzi's best-preserved structures, Villa Pisani at Lonigo and Villa Molino at Mandria (see Figure 3.6), while the other two, the villa on the Brenta and the Villa Bardellini, were never completed (see also Figures 1.5, 2.3, and 3.4).

The next three designs show an expanded site development as well as more substantial houses. Villa Verlata is sited on a well-traveled road and therefore the main residence was placed at the front of the site. Here and at Villa Contarini, additional structures extend the main building block laterally. Villa Cornaro al Paradiso (see Figure 3.7) has the greatest complexity of the three, and the main dwelling is quite grand. All three share a rectangular central *sala* at the heart of the plan (see also Figures 3.5 and 4.16).

The last three villa designs are clearly larger houses if not larger estates. Villa Badoer does not have an increase in the support buildings serving it, but it does have more extensive gardens. Villa Trevisan, like Villa Verlata, sits forward on its site, but the detached support structures are more substantial. Villa Cornaro at Poisuolo (see Figure 3.8) is by far the most elaborate estate of all. The final three plans all have a cross-shaped central *sala* and an array of rooms facing all orientations (see also Figures 2.11 and 2.13).

3.8 Vincenzo Scamozzi, Villa Cornaro, Puisuolo from *L'Idea della Architettura Universale*, Book Three, pp. 296–7 (RIBA Library Photographs Collection)

There is some basis for seeing these three sets of designs constituting Scamozzi's three categories, but there are elements that would contradict each as well.

Just as the rural landscape was a mosaic of geometric fields, the typical Scamozzi villa was a mosaic of geometric spaces. Continuous walls defined the whole site, creating indoor rooms, outdoor rooms, and covered rooms, or loggias. While the central dwelling always had a symmetrical plan with a major *sala* on the central axis, Scamozzi's villas were distinctive because the rest of the buildings that comprised the complex were not always governed by this same axial symmetry. Scamozzi continued the Palladian practice of regularizing the appearance of all of the ancillary structures needed for the working estate by using uniform openings with understated classical allusions, but he did not adhere to the use of continuous colonnades or arcades in their layout. More importantly, the structures were disposed on the site less regularly.

In the treatise, Scamozzi described the elements of the agricultural villa as a "kit of parts" that could be arranged in a number of ways: "For instance, with a wing on either side of the main house; or further back, beside the garden; or as a separate block opposite the owner's house, but more to the rear of the

garden; or lastly, as a building in its own right with a courtyard in the center and covered areas on three or four sides."[35] His own strategies were equally varied: Villa Verlato and Villa Contarini had service spaces in lateral extensions of the central dwelling; at Villa Trevisan, the porticos were detached, facing each other across the garden behind the house; at Villa Badoer, the services were also detached, but located adjacent to the forecourt on the north side only; and at Villa Cornaro al Paradiso and Villa Cornaro at Puisuolo they formed more substantial buildings with their own courtyards. The solution arose chiefly from attention to the function that each space served, its need for proximity to other farm functions, and questions of climate control—light and air, and maintaining the best temperature and humidity for each function. For Scamozzi, issues of optimal orientation and functional interrelations took precedence in the placement of the necessary elements. In addition to these, the conditions of the particular site played an important role. In many cases, existing buildings or foundations needed to be incorporated. Other influential conditions included the area geography: the roads, the location of a water source, the direction of the owner's fields, and the best disposition of the primary sequence from court to house to garden to orchard. Scamozzi's villa ideal was a design approach rather than a physical construction; he advocated a compositional method based on an understanding of site, climate, and residential and agricultural needs.[36]

Scamozzi did not particularly favor the placement of farm buildings flanking the *casa*; more often, he placed a garden there to allow light and views on the entire perimeter. He described the forecourt as an element that contributed to a grand appearance for the house, a place where large groups of people arriving by horse and carriage could be received, whether laid out with lawns crossed by paths or left bare.[37] In either case, he created a well-kept and orderly public space, and provided a separate *corte rurale*, or farmyard, for agricultural activities. Where Palladio's designs had followed the vernacular farm in which all buildings faced a single yard, Scamozzi's designs attempted to achieve a similar coherence while also introducing a certain amount of zoning between the patrician family's social activities and the agricultural work. This may have been in response to social changes under way[38] and an increased separation of the classes, but it was also consistent with his own insistence on tailoring each space optimally to its uses, and then establishing their best relationships. The dignity that he felt was necessary in the forecourt was not compatible with threshing and baling or other such agricultural necessities; yet they were never placed at a great distance, either. Though he separated the functions, Scamozzi maintained a close proximity so that the patrician could easily oversee and manage the farm labor.

These principles can be more easily appreciated by examining the Villa Cornaro al Paradiso at Castelfranco in greater detail.

The plan has been reproduced for clarity; by transforming Scamozzi's map into a regular plan, the spatial order is more readily apparent (see Figure 3.9).

3.9 Spatial diagram of Scamozzi's Villa Cornaro, Paradiso (Illustration: E. Anderson)

The piano nobile of the main dwelling is composed of a grand central *sala* that is flanked by two blocks, each subdivided into two large and two supporting rooms. One of the large rooms is filled with a grand stairway. The central *sala* projects forward into the forecourt at the same time that the whole building block is also thrust into the space from the defining back wall of the court. This unusually tall *casa* is approached axially through a broad forecourt along a path from the gate on the public road to Treviso. Behind the house is a much smaller court—the width is the same as the house. Beyond the rear court, a garden extends five times as far. These are the principal spaces for the owner. Extending laterally from the rear court is a service wing containing courtyards and workrooms for the steward and workers. Another wing intersects the first at right angles, providing additional support spaces. The latter wing separates the main forecourt of the complex from a *corte rurale*. All of the covered farm functions fall to one side of the property; behind the wall that matches the service wing is a fishpond. While the overall composition is irregular, all elements are uniformly orthogonal, and are joined together by continuous wall-lines.

The Scamozzi villa was spatially inscrutable—not a labyrinth, but a series of unseen places that were discovered in time. As one moved around the estate, each successive court or garden appeared regularly defined and symmetrical in itself, and every space encountered was uniformly bounded. Instead of a single universally governing axis, there were multiple interlocking axes.

Where the Palladian planning approach has been traced to classical roots in the Imperial baths, the Scamozzian plan is more like the Imperial fora of Rome. Instead of using universal symmetry, he achieved a remarkable level of spatial integration by means of intersecting axes that are lines of movement and visual connections between spaces. As in a city based on a grid, coordinated axes allowed for views that encourage connections with nature beyond.[39]

Just as the central dwelling had a hierarchy of rooms that offered different views and different exposures throughout the day and year, the villa had a hierarchy of spaces that were proportionally tuned from grand to intimate. The forecourt was akin to the central *sala*, the grandest, most impressive spaces. Other spaces offered a variety of views, different relationships to the house, different orientations, a different sense of enclosure, a different encounter with nature. But they were nuanced character differences, never startling or dramatic: a little more open or closed, and little more planted or paved. Like the proportional relationship among the rooms of the house, the relationships were not immediately apparent; choice would be guided by experience and comfort. It is a place that could only be fully known by entering in and moving through it.

Scamozzi's villa plans are like maps of the site both before and after construction. A map is a graphic representation that facilitates spatial understanding, not only of physical elements, but also of concepts, processes, and events. Maps emphasize the measure, direction, and shape of the terrain; Cosgrove unites mapping with planning.[40] While a building plan shows the idea of a future construction, a map shows a condition that exists. If Scamozzi's design process involved placing necessary elements for a villa in accordance with existing conditions, then the design itself is a map of the site. The uniform establishment of territories, whether interior or exterior, expresses a concept of the villa as a place rather than as a building, and his plan is a map of the whole place. Scamozzi's villa maps reveal the processes and events of villa life, where interior/exterior boundaries were meant to lose their meaning. He designed for activities and movement: arrivals and departures, daily journeys to and from the fields, and walks in the gardens. Scamozzi's cartographic tendency started with his site survey that preceded design (see Figure 3.10), and it continued with the process of giving spatial definition to the processes and events that would constitute villa life.

His shaping of the space was sympathetic to the territorial grid, and its embodiment in the material walls of the villa represented a key characteristic of its place-ness.

Scamozzian villa planning arose from the place it was located, and in turn it created places for the activities of villa life: court, garden, farmyard, orchard, but also the streets surrounding the villa that connect to the city, the walkways, the loggias, as well as kitchens and stables. Verbal and graphic notations communicate a sense of the daily habits of villa life. In the 16th century, cartography provided new systems for reflecting on one's place in the world at the same time that it was re-shaping the world picture.[41]

Sixteenth-century maps were exceptionally experimental in nature, utilizing hybrid forms of communication—combining symbols with words and pictograms. In particular, chorographies commonly combined scaled plan information with three-dimensional views of buildings. Together, they described a place by its shape and its character. Scamozzi included elevation and section information in a unique way, often weaving the elevation, which is pictorial at the same time it is orthogonal, into the more abstract plan view, making a single drawing, a portrait of place, a chorography of the villa.

Landshape, Landscape, and Garden

The emergence of landscape painting in 16th-century Venice offers dramatic evidence that the culture was highly sensitive to nature in general, and especially to the visual impact of the natural world. Painters and cartographers were actively seeking to represent the uniqueness of any given place through its morphic qualities, its intrinsic shape. The word landscape emerged around 1600 from the Dutch *landschap*, or land-shape.[42] Cosgrove makes the case that Venetian cartographer Cristoforo Sorte's text, "Osservationi nella pittura," amounts to the first manual on landscape painting.[43]

3.10 Vincenzo Scamozzi, drawings for Villa Verlata, Villaverla and Villa Ferramosca, Barbano (© Devonshire Collection, Chatsworth. Reproduced by permission of Chatsworth Settlement Trustees)

3.11 Vincenzo Scamozzi, aerial view of Villa Pisani, Lonigo (Photo: S. Maruzzo)

It was written in 1580 in response to a patron's question about Sorte's process in the production of one of his many chorographic maps of the Veneto region. A wealth of descriptions and images of places and landscapes produced in the era of villa construction testifies to a general cultural awareness of landscape and the fascination that landscape held.

The demand for villas was, in part, evidence of this interest in architectural terms. More emphatically, frescoed landscapes on their walls expressed a desire to celebrate the power of the landscape. Interpretations of the Villa Rotonda almost always include a quote from Palladio's brief remarks about the design in his treatise in which he described the site and the surrounding landscape: the site was "pleasant" and "delightful"; it was located on a small hill with easy access; it had a river on one side, and hills on the other that "look like a very great theater."[44] The theater metaphor, while providing a major point of interpretation of the distinctive design, was an easy and direct way to provide a mental picture for the reader of the particular shape of the nearby hills, a common habit of the time. But there were "most beautiful views" in all directions, though varied in their spatial extension. These beautiful views were so central to the enjoyment of the experience of the villa that loggias were provided in all four directions—not as entries but as outdoor rooms for enjoyment of the natural realm. The Villa Rotonda shows that in the culture of Venice and the Veneto, the rural landscape itself was valued and appreciated enough to provide a villa owner sufficient sense of contact with nature.

In describing his own villa projects, Scamozzi consistently provided site details, and was also attentive to the wider landscape.

His introduction to the Villa Pisani contained both (see Figure 3.11):

> The site was a hill called La Rocca where some remains of the fortress were still to be found. This hill is lovely to behold due to its almost completely round shape, and it is very pleasant to climb from the surrounding lower hills which it dominates on all sides. Toward the Levante [east] lie the neighboring mountains, alpine in appearance ... Toward midday [south] lie other hills planted with fine trees ... Toward Ponente [west] is a low range of hills with the well-populated town of Lonigo Castle at its foot ... To Tremontana [north] the main road from Vicenza runs past the foot of the hill with a little river beside it. Hills fill the landscape beyond, rising gradually to the foot of the Alps, whereas on the opposite side is a lovely view of the Trissino valley. In short, this site is as fine as any for its wonderful views.[45]

Adjectives such as "pleasant," "lovely," and "beautiful" show the value that was placed on these geographic features. It is clear that they enhanced the experience of life in the villa. While Alberti praised the country house over the city house for its freedom from restrictive site conditions, Scamozzi preferred the country house because of nature's presence: "Our souls are much more satisfied by these fundamental and eternal things than by those of the city that represent skills and knowledge of men."[46]

As landscape features were framed and visual connections emphasized, the landscape became an integral part of the experience of the villa. Distant hills and mountains bounded the villa and defined it at a certain scale. Each feature was full of meaning for Scamozzi, often equated with nature's 'gifts'— these hills were a source of great wines, that was "a fruitful little valley,"[47] over there was a large lake with a good variety of fish. He paid consistent attention to these features, and drew them into the experience of villa life by the strategic placement of windows and loggias. The presence of distant features was stable, but they helped make some of the natural changes visible—atmospheric conditions, changing weather, and seasonal rhythms and patterns. At the larger regional scale, one can readily mark the movement of sunrise and sunset, and watch the colors of the hills as they change throughout the year. This was both practical knowledge for agricultural pursuits and a source for metaphysical speculation in a culture that linked the concept of cyclic renewal in nature to an idea of cosmic perfection, a culture where nature could be seen as a manifestation of the sacred.[48]

The visual connection to these distant features allowed the villa owner to find his own place in nature. Scamozzi surveyed each site not only to account for its particular shape, topography, and qualities but also to heed its relationship to regional features—distant hills, waterways, local landforms. Scamozzi surveyed the site, mapped it, and planned the villa in a continuous operation. His cartographic practice made the natural beauties and their cosmic connections more present as map became plan and section.[49] The views may influence the orientation or even the form of the central dwelling.

Regarding the Villa Cornaro at Poisolo he says the "building takes the form of elongated cross, three stories high and has views on 4 sides."[50] Scamozzi was careful with the views, providing "many openings" as well as a projecting loggia, and not allowing any feature of the complex to block views from the main house. The placement of courts and gardens that are additional to the main sequence were likely influenced by view as well as orientation. These were essential pleasures in villa life, and the views were a continual source of interest and beauty. The distant landscape gave greater focus to the qualities of the geometrically ordered villa landscape, where mathematical reason opened an intimation of the universe.

Many modern interpretations of the Veneto villa have ignored or even denied any role for gardens, focusing entirely on the agricultural functions as the connection with nature. But according to both Puppi and Visentini, an essential pattern was established between the 15th and 16th centuries for villas situated on relatively flat sites: a central entry court was surrounded by porticos for farming functions and terminated by the owner's residence; behind the residence were gardens and an adjoining orchard. Kitchen gardens were provided in proximity to the workers' quarters, and beyond the villa were the cultivated fields. The structured nature of the Veneto garden has been set in contrast to the tradition of the central Italian villa, where the garden was undeniably more operatic. At some, such as Villa Lante and Villa d'Este, the garden was designed to be the primary experience while the architectural elements created a backdrop or brief counterpoint. Their dramatic topographies, extensive waterworks, and lush vegetation form an enduring image of the Italian Renaissance garden. The idea of nature was dramatized in the play of human artifice and natural conditions and processes—parterres that gave way to groves that gave way to woods; man-made grottos that simulated nature's chaotic and unknowable aspects. By contrast, the gardens of the north eschewed the sense of drama and struggle between nature and art; they more simply idealized nature as amenable to human needs and wishes.[51] Their flat terrains, generally low vegetation, and quieter use of water do not strike the same emotional chord, and because of this contrast, the importance of the cultivated fields has been stressed. However, even though the typical Veneto villa of the 16th century was a working farm, its patrician owner still sought contact with nature, and valued the aesthetic expression of his desires.[52] The frescos of many villa interiors certainly testify to that, and the garden, as an expression of nature's beauty "perfected by human action"[53] was also a key element.

Opposite interpretations emerge from the literature on Veneto gardens: some see their geometric order and their quiet character as subservient to the architectural elements, a mere podium to set the architecture off properly. Others see the mutual geometry and the flatness of the ground plane as an intention to integrate the architecture and the garden, creating a continuum of experiences in the daily life rather than contrasting conditions. The garden of the Veneto was in dialogue with farm fields, so it expressed man's capacities to cultivate nature (see Figure 3.12).

3.12 Ludovico Pozzoserrato, *September* (© Fitzwilliam Museum, Cambridge/Art Resource, NY)

Though direct evidence is missing, lost to time and to changes in habit and taste, there is sufficient documentary evidence to know that as the Italian gardens in the south employed ever more artifice and theatricality, the garden of the Veneto remained more unified with the architecture rather than competing with it or even overwhelming it.[54]

The gardens were divided by orthogonal paths into squares, and the plantings were kept low to the ground (see Figure 3.13). Water features were modest as the water was needed for the crops and the animals. Still water provided a play of reflections for vases, potted plants, and statues set on its perimeter. Scamozzi's gardens were part of this tradition, designed in correspondence with the architecture as well as the agricultural landscape surrounding the villa. And while he acknowledged that a garden could increase the grandeur of the *casa*, he was far more concerned throughout the treatise with its role as a place to spend time than as a mere visual embellishment to the architecture.

Scamozzi's gardens were created in the same act of compartition as the residential and agricultural structures of his villas. Walls were the defining elements of the whole site; buildings, courtyards, and gardens were similarly defined by them. Scamozzi determined the placement and overall arrangement of garden spaces, providing the larger villas with as much variety as possible. Within the walled perimeter of each garden, he laid out the paths and determined their surfacing in accordance with their uses. He assured proper drainage for the walks and the planting beds. However, he did not consider

3.13 Illustration from the description of the travels of the Venetian Charles Magius from an Italian manuscript, 18th century (Erich Lessing/Art Resource, NY)

it the proper task of the architect to determine specific planting schemes; that was left to the gardener. In the smaller villas, the flat open space of the forecourt gave way to a garden behind that was more fully planted, with color and textures, shape, and rhythm working together, perhaps articulated by statues and potted plants and punctuated with a fountain and a pergola. The larger villas had a variety of gardens, allowing each to be similar but to have a distinct character, like the rooms of the owner's house. Scamozzi opposed abrupt contrasts and changes, preferring to follow nature's way of gradual change; the insistently walled gardens allowed the experience of nature to be proportionally modulated. His plan for the Villa Badoer in Peraga features two courtyards that precede the *casa dominicale*. From the main forecourt, one could pass through a loggia on the left to enter a space that was likely the farmyard (see Figure 2.11). To either side of the main house a gate leads to symmetrical small gardens (about 50 by 60 feet each) that led in their turn the main garden behind the house (about 130 by 210 feet). Meanwhile, one of the smaller gardens also connected to an orchard.

Gardens provided a convenient place for walking, enjoying healthy air, fragrant flowers, and natural beauty. "Of all colors, green is the most restful to the eye."[55] In addition to their obvious importance in his plans, garden design occupies several chapters of Scamozzi's treatise. He offered many detailed suggestions and a good deal of technical information, devoting two chapters

to site features such as roads, courtyards, gardens, and orchards. Passages on practical planning matters also contain many references to the pleasure of gardens. Scamozzi's gardens were filled with sensorial variety from the visual beauty of plants, to their perfumes, the coolness of shadows, and the music of birdsong.[56] This is apparent in his recommendation for suburban villas:

Behind lies a garden divided into squares with beautiful plants and lawns, and fragrant flowers; paths running along the walls can be shaded by trees for strolling; and in the middle should be set a beautiful fountain with jets and spray; and at the head of the garden, which has a southern exposure, you can make a trellis for citrus fruits or a pergola, which will provide a visual terminus.[57]

And in describing the Villa Trevisan, he tells us:

To the rear is a fine garden with avenues bordering and crossing—6 squares for ornamental plants ... The beautiful paths that border the orchard also divide it in the form of a cross—adorned with roses and espalier vines so one can walk in the shade; in the center a secluded fish pond with a beautiful bower.[58]

A strong sense of quietude reigned, but the garden also contained elements that acknowledged the productive intentions of the villa. He recommended the use of nut trees to shade the perimeter lanes, and lemon trees at the end of the garden near the orchard. While he did not adopt the theatricality or artifice he had seen in the south, he made nature—a variety of gardens, the cultivated landscape, and views of the regional geography—an integral and essential part of the villa experience.

As a middle term between the distant landscape and the constructed spaces of the *casa*,[59] Scamozzi brought the villa garden of the Veneto into relief. Views kept the villa bound to the regional landscape, where the shapes of the hills and other natural features provided an image of the singularity of place. Elements within the garden were kept low so that the views out to the landscape from the house were not interrupted. The shapes of the gardens reflected the geometric operations of measuring and surveying the land, the practical operations by which the Veneto had been transformed. It celebrated control of the environment and man's capacity to use nature. But that does not mean that geometry had become merely instrumental. Neoplatonic cosmology saw geometry as key evidence that the universe was inter-connected. Scamozzi's dual insistence on the view and the geometric garden suggest that he saw in the landscapes a place of harmony between human realms and the cosmic order.[60]

The Cosmography of the Villa

If the square represented the geometry by which man's intellect may control nature's plants and animals, that is, nature bound to the surface of the Earth, it is the circle that represented man's efforts to gain control of the cosmic forces of wind and light, climate and weather. Scamozzi treated these topics theoretically

in Book Two, but it is his villa designs of Book Three that demonstrated his knowledge applied to architectural planning. The annual cycle of the sun and the seasons and the character and direction of prevailing winds were certainly considered in the planning of houses in the texts of Vitruvius and Alberti. Scamozzi used Socrates to add weight to his own amplification of the importance of designing with a full understanding of climate and weather: "'There is nothing more seemly and useful for a man than to live in a good house, which is especially pleasant when it remains cool and is protected from the fierce rays of the sun during the great summer heat.'"[61] Scamozzi was able to bring quasi-scientific knowledge to bear for the first time, and engaged the natural forces for much more nuanced effects. Though he continued to cite ancient literature, he also betrayed more up-to-date sources. Sun and wind both affect the temperature, a key factor in comfort. The wind was the more difficult topic, far more variable, but nonetheless critical knowledge for the creation of habitable spaces. The light was better understood in terms of seasonal and daily patterns of the sun. While Scamozzi continued to stress the importance of orientation and exposure based on function, he also updated received wisdom based on his own judgments, and expanded the architectural response to natural light. Scamozzi considered skylight and moonlight in addition to sunlight, and sought to provide spaces with a range of light and shadow for comfortable dwelling.

The importance of wind was announced with the opening illustration of Book Two—the globe surrounded by 16 winds, and a surveyor's compass (see Figure 2.2). This simple graphic analogy reflected the connections between site, or chorography, and geography and cosmography. The winds, as understood by Scamozzi, had equivalency to orientation, but as wind directions rather than cardinal directions, they connote awareness of a more dynamic condition for human habitation. It would be some time yet before science achieved the global concept of wind movement, but Scamozzi did not simply repeat the generalities of previous architectural treatises. He sought the most up-to-date knowledge from sailors in the port of Venice, and he employed his own keen observational skills. Buildings in the open countryside had none of the difficulties of urban situations in receiving sufficient light and fresh air, but knowledge and experience were needed to modulate the natural forces in order to capture the benefits and mitigate ill-effects. Villa life was a chance to not only experience and appreciate fresh air and a nice breeze in the heat of the summer, but to remind one vividly of the linkages between the sun's daily path and changes in the atmosphere, to change patterns with the seasonal winds, and to watch first-hand the sun's capacity to make things grow.

The winds had particular characters for Scamozzi connected to a wider geographical concept because the winds carry what they have picked up traveling through other regions.[62] Consideration of these characters was as important to the orientation of rooms as solar exposure was. The air from the north, the Tramontana, was the purest, lightest, and coolest, and therefore most pleasant of all the winds in the summer, and the Levante

from the east was also temperate. Hot winds from the west made rooms uncomfortable, and the south was the worst air of all. However, Scamozzi recognized that villas in the country inevitably have rooms facing in all directions, so he offered advice about how to arrange for comfortable spaces. Reception rooms, in use for shorter times, and rooms for the elderly were suitable to the less desirable southern exposure. But the best strategy was to provide options for the inhabitants. Though some rooms had stationary functions, such as libraries, most general use rooms could be used (or not) in accordance with seasonal comfort.

Although Scamozzi presented a wide spectrum of conditions by describing a variety of places, climates, and some seasonal variations, he designed his own villas primarily for the summer heat of northern Italy. Far more emphasis was given to methods for cooling than for heating; in fact, relatively little was said about fireplaces in Book Three. Villas needed thick walls, spacious rooms, and vaulted ceilings to remain comfortable in summer. While Scamozzi never gave a single focused set of instructions on ventilation,[63] his descriptions of his own villa designs provided many examples of his own attention to it and even more specific recommendations followed in several chapters on the design of rooms and their openings.[64] For instance, while openings should be limited to control unwanted heat gain, windows should be provided on more than one wall wherever possible. He insisted on the alignment of all openings to allow for the maximum circulation of air, as well as the easy movement of people throughout the building. He preferred a single story above a basement for country houses because the winds entering windows higher up could be too strong. In addition to providing for good air circulation to combat the heat, floors could be strewn with leaves and cool water sprayed, both measures that would change the humidity.

One villa in particular demonstrates his attention to good ventilation, the Villa Pisani. The Villa Pisani was commissioned by Vettor Pisani; his main purpose in building another villa so close to the one by Palladio at Bagnolo was to enjoy "healthier air."[65] As with almost all of his villas, openings align throughout the structure—in fact, as the villa is approached axially from the road below, it is possible to see straight through the front loggia to the rear arched opening 60 feet away (see Figure 1.5). In addition to the front loggia that provides an open-air room, three axial halls have open ends for their full 10-foot width (see Figure 3.14).

An oculus in the dome of the central rotunda helps to pull air through these halls. Further, the rotunda floor has a perforated stone in the center of the floor, allowing cooler air to flow from vaulted ground level rooms that were excavated into living rock. Scamozzi did not describe this ventilation feature in his account of the villa, nor is there any other evidence of its use in other villa designs. But he did suggest "letting currents of cool air in from underground cellars"[66] in a later chapter; it may be that he never encountered the right site conditions again.

3.14 Vincenzo Scamozzi, plan and elevation of Villa Pisani and view from the northeast (Photo: S. Maruzzo)

More dramatic measures for creating comfortably cool spaces were discussed by him in the context of gardens, where underground porticos or rooms could provide relief in extremely hot climates. "*Grotoportici*," cave-like porticos for walking, and "*ventidoti*" (literal translation, wind tunnels), rooms artificially cooled by using the coolness of the earth or even tapping underground air currents. He cautioned against extremes, however, in describing the famous villas at Costozza, near Vicenza. Here, the air from naturally occurring underground chambers was piped into villa rooms above ground. Scamozzi found the underground air too cool, creating a great contrast with the regular summer air temperatures. He warned that it could cause discomfort or even illness. At the Villa Pisani, a single vent from an underground wine cellar feeds one ground floor room in the southeast corner, so its effects were limited and could be avoided if too dramatic. Scamozzi may not have utilized these strategies more often because he did not think that the climate of the Veneto required it—he explains them as useful in places of extreme heat, while he consistently described his own region as temperate. His text implies that proper attention to design of the villa—room orientation and proportion, openings—and the provision of shaded walks and porticos in the garden was sufficient for comfort.

As with the winds, the effects of the sun were a major concern in the design of a comfortable country house. The heat of the summer sun was controlled within the building in two primary ways—by limiting direct solar exposure as

much as possible, and by promotion of ventilation. However, the admittance of light was another factor that needed to be balanced with the desire to limit solar heat gain. Scientific knowledge of the behavior of light was advancing in the 16th century, and Scamozzi was certainly familiar with it—perspective, optics, and the behavior of light were all related in many perspective treatises, especially the ones by mathematicians.[67] Barbaro's *Commentaries* on Vitruvius expanded on the Vitruvian themes to address the problem of adequate light in the urban density of Venice.[68] It may be from reading Barbaro's Vitruvius that Scamozzi first became devoted to light, but he took this theme much further. Scamozzi developed an original theory about light within the building, light transformed by its encounter with material construction, and explained it by mapping six kinds of light in a building.

The influence of celestial phenomena over life on earth was a constant design consideration. For Vitruvius, knowledge of the celestial bodies was so essential to architects that he made 'dialing'—astronomy and the construction of sundials—the second part of architecture, after building, and fully described it in the ninth book of his treatise. But the architectural application of this cosmic knowledge was principally in the realm of commodity. For instance, Vitruvius prescribed that:

the baths and winter dining rooms should look towards the winter setting sun, because there is need of the evening light. Besides, when the setting sun faces us with its splendour, it reflects the heat and renders this aspect warmer in the evening. Private rooms and libraries should look to the east, for their purpose demands morning light ... Not less should the picture galleries, the weaving rooms of the embroiderers, the studios of painters, have a north aspect, so that, in the steady light, the colors in their work may remain of unimpaired quality.[69]

Although Alberti made "openings" the sixth part of architecture, their placement and dimensions were governed by composition, structural integrity, and subservience to the columnar order, not by qualities of light. Alberti proposed that:

each individual chamber, then, should have windows, to admit light and to allow a change of air; they should be appropriate to the requirements of the interior and should take into account the thickness of the wall, so that their frequency and the light they receive are no greater or less than utility demands.[70]

Sunlight was necessary and desirable for adequate illumination, and, not surprisingly in the Mediterranean latitudes of the Italian peninsula, also a potential nuisance to be controlled.

Though Renaissance architects before Scamozzi showed no special interest in light,[71] artistic and scientific inquiry were continuing to advance. In 16th-century painting, hand-in-hand with increasing interest in landscape, there emerged an increasing desire to capture more precision in the conditions of light perceived in the world.[72] The work of Jacapo Bassano, one of the first to experiment with a nocturnal scene, provides a good example in the Venetian context.

3.15 Vincenzo Scamozzi, a well-lighted stair in the Villa Pisani (Photo: L. Merrill)

This finer appreciation for reproducing accurate light conditions arose from the increasing desire for a painting to seem ever closer to a true imitation of nature. But, of course, there are infinite light conditions to be found in nature. So, by the end of the Renaissance, individual painters were increasingly identified with capturing a particular kind of light in their works, and then, with creating a particular kind of light. Light gained a value independent of its function of revealing the forms, and it became one of the elements of representation, understood well enough to be manipulated effectively and enough to become an artist's signature.

Scamozzi, like the landscape painters of his day, was engaged in capturing and creating certain kind of light in his interiors.

Scamozzi's appreciation for light exceeded Alberti's idea of strict utility; he continued Barbaro's insistence on well-lighted stairs (see Figure 3.15), passages, and workrooms, places that were often tucked into the building mass. A signature element in Scamozzi's villa projects was the design of exterior stairs to the piano nobile that did not block all the light to ground-level rooms. He preferred the fault of too many windows to the possibility of too few. Moreover, he wanted the light entering from windows on one side of a building to "meet and merge" with the light from the opposite side. Clearly, he was not solely concerned with solar exposure. He also showed a new sensitivity to the psychological dimension of light. He repeatedly described particular spaces in his residential designs as "bright," and later asserted that "bright rooms raise one's spirits and can be used for all kinds of purposes, even when it is cloudy."[73] In addition to knowledge of the sun, its daily and seasonal path, Scamozzi would consider the diffuse light of the sky and take account of the lunar cycle in considering the size and placement of openings.

Scamozzi's more acute observations of the behavior of light provoked an interest in greater precision. He attempted to differentiate types and qualities of light, and was the first to establish categories for architectural daylighting.[74] His six different kinds of light are a result of daylight that has been affected by its encounter with an architectural body. They describe a condition that is fundamental to the experience of architecture and had thus far been completely unnoticed. His categories accounted for several different variables, including direction and intensity:[75]

1. *lume amplissimo, o celeste*—[broad heavenly light] intense from direct sun on a clear day;
2. *lume vivo perpendicolare*—[lively and perpendicular light] received from above as in courtyards and through domes;
3. *lume vivo orizontale*—[horizontal free light] received frontally or diagonally as in rooms and porticos;
4. *lume terminato*—[limited light] obstructed by a place's narrowness like a street;
5. *lume di lume*—[light of light] also called secondary light, it comes from an adjacent directly lit space;
6. *lume minimo*—[minimal light] also called tertiary light, from an adjacent space indirectly lit, or reflected light.

3.16 Vincenzo Scamozzi, central rotunda and dome, Villa Pisani (Photos: Scala/Art Resource, NY)

The Villa Bardellini drawings illustrate how far the light entering through various openings will penetrate the space; numbers and letters provided a key to descriptions in the text (see Figure 2.3). For instance, the notation of "D" is keyed to the description "one light only in the corner of the room," and "R" is described as "light of light of the small rooms with the secret stairs." Similarly, the markings on the section are keyed to descriptions as well: "o, p, r, s shows lively perpendicular light, that from the open sky comes through the aperture of the dome and descends to the floor of the room ending at q and t outside the principal doors." The drawing maps the lights and their resultant shadows. Scamozzi's poetic description suggested a range of intensities like the gradient of a penumbral zone.

The unusual drawings of Villa Bardellini are direct evidence of the architect's idea, but, unfortunately, Villa Bardellini was never completed; the client died when the building was incomplete, and the constructed portion was later demolished. However, the similar design of Villa Pisani provides the sensory experience of Scamozzi's interior lights. Photographs reveal that light reaches every space, usually in more than one way (see Figures 3.16 and 3.17).

The simplicity of the ornament and the continuity of surfaces allow the light to creep further within than might otherwise have been the case. Scamozzi's rejection of landscape frescos, a typical feature of villas since the early Belvedere loggia in Rome, also allows light to be the primary actor on the interior, and keeps attention focused on the actual landscape visible from the rotunda on all four axes. Visibility is in the foreground, a dominant theme in the critical treatment in what Frascari described as this "clearing in the forest of dwelling."[76]

3.17 Vincenzo Scamozzi, Serliana and floor of the rotunda, Villa Pisani
(Photos: © The Courtauld Institute of Art, London)

| 1pm | 2pm | 3pm | 5pm |
| 7am | 8am | 5pm | 6pm |

3.18 Daylighting studies of the central rotunda of Villa Pisani: top row—June 21; bottom row—September 21 (Illustration: University of Washington Integrated Design Lab)

Despite Scamozzi's accompanying text, certain aspects of the Villa Bardellini drawings remain difficult to fully decipher. Prompted to get ever closer to a complete appreciation of its meaning, this interpretation takes advantage of an unusual resource. Using physically-based digital simulation methods currently available,[77] it is now possible to more fully examine the landscape of light produced by Scamozzi in the Villa Pisani (see Figure 3.18).

At midsummer, the spot of direct light entering the central rotunda through the oculus (*lume vive perpendicolare*) tracks through the space for 13 hours, tracing a long lazy arc from west to east. The spot descends from the dome at 9 a.m. and crosses back around 3 p.m., at noon just touching the floor. As it crosses the springline, it coincides precisely with the fragment of heavy cornice at the base of one of the dome's ribs, illuminating this unusual ornament. At noon, just as the south-facing loggia is filtering the high noon sun between columns (*lume vivo orizontale*), the north hall catches an hour of direct light through its interior doorway, a magical moment for a north-facing room. On September 21, the sunspot is present for nine hours, but it never escapes from the dome—the springline of the dome splits the sunspot in half at its lowest point, occurring at noon. If December 21 is a sunny day, then that spot will be visible for five hours, though it remains very close to the oculus admitting the light.

While the drama of that vibrant light is probably the most noticeable and memorable daylight event, the lights penetrating the central rotunda from the vertical openings at the perimeter of the building are also compelling. The high summer sun is mostly blocked, but the equinox sun angles allow light to stream across the floor from the east and west Serlianas in the morning and evening. In midwinter, from 11 a.m. to 1 p.m., the sun traverses the south loggia, throwing light and shadows of columns across half of the rotunda

floor. More dramatically, sunrise is captured momentarily, entering from the east Serliana and tracing a line of light across the rotunda floor and up the north wall. This marks and even dramatizes the dawn, symbolic of the mystery and wonder of nature, a time that one can sense the presence of divinity in the terrestrial world.[78] The lines traced by the light and shadow in the Villa Pisani are physical realizations of the idea projected by Scamozzi in his drawing of the Villa Bardellini.

As the dome indicates, the light of the sun is fractured inside the villa, split into its component parts. These parts are forever in motion, intersecting the spaces of habitation in repeating combinations. This explains the fragments of cornice at the springline of the dome, an unusual detail in the context of Scamozzi's ornamental conservatism. The same motif is continuous and unified at the apex of the dome. Scamozzi's villa, then, is more than a sundial. In addition to distilling the rotation of the earth, it is an instrument for revealing new truth about the essence of light. Although painters had described different kinds of light, never before were the nuances of light in the building interior so carefully distinguished. If Scamozzi's treatise contained any nascent indications of the Baroque, as claimed by Jannaco, surely it is most evident in this important essay on light.[79] What is remarkable is that Scamozzi has cast the architectural body as the instrument capable of revealing otherwise invisible qualities of light; it was not until 1666 that Newton made his revolutionary discovery that a prism reveals that another invisible set of lights within—the colors of the spectrum.

While the movement of light on a sunny summer day adds life and beauty to the villa, Scamozzi was also concerned with providing places for relaxing in the shade. Scamozzi had studied Barbaro's interpretation of Vitruvius in which he made the section drawing third after plan and elevation, instead of perspective.[80] Scamozzi's shadowy section recalls the mythic origins of drawing in profile, or the tracing of a shadow. His shadows belong to the vaults and the walls—they are another manifestation of the material density of construction. The web of lines and the enigmatic shadows of the drawing are not literal depictions, but they tell a story nonetheless. Frascari connects the drawing to philosopher Giordano Bruno's 'memory wheels'—geometric images that bridge between fragmentary and mutable sensory knowledge to a diagram of the universal whole[81]—and described the Villa Pisani as a passive machine where the shadows make moving patterns that fuel memory and imagination.[82]

Along with the 16th century interest in light, there was new attention focused on shadow. Leonardo da Vinci (1452–1519) was one of the early artists that observed and painted more nuanced qualities of light than his predecessors, and his careful observation led him to study the transition between light and shadow. Up to this point, shadow had been treated by scientists and artists alike as a sharp edge, a line between conditions of full illumination and complete darkness. He advanced optical theory through an astute analysis of the penumbral zone, the gradient of change between full shadow and full light (see Figure 3.19).[83]

3.19 Diagram based on Leonardo da Vinci's study of the penumbral zone (Illustration: E. Anderson)

Though Leonardo's work remained unpublished, Francesco Maurolico (1494–1575), a Sicilian priest and mathematician, reached similar conclusions independently shortly afterwards in a manuscript called *Photismi de lumine et umbra*. Maurolico was the first to analyze the intensity of illumination as a function of many different variables. He explained the penumbral zone using a diagram much like that of Leonardo.[84] While Maurolico described conditions created by an extended source of particular length, Leonardo's illuminator was the sky, an essentially infinitely extended source. Yet the results of his analysis were essentially the same. Daniele Barbaro studied optics at a sophisticated level and was likely familiar with Maurolico's work; we can be sure that Scamozzi read Barbaro on this topic whether he had direct knowledge of Maurolico's work (either through Clavius or Barbaro) or not. The similarity of Scamozzi's villa drawing to the penumbral studies of Leonardo and Maurolico provides the key to interpretation: Scamozzi was projecting the effects of an extended source. He was plotting the resultant zones of light and shadow taking the whole sky as a source of general illumination.

Scamozzi was the first architect to see light per se as a medium of architecture. He was not as interested in its theatrical possibilities or even its

overt metaphysical implications as the Baroque architects eventually would be. But he was aware of its psychological effect, and a profound connection between cosmos and human dwelling. The mathematical understanding and the rational order that Scamozzi found in light did not exclude a speculative dimension, a demonstration of the harmony of the cosmic order. Scamozzi's six different lights in a villa, like the five proportions for rooms, constituted a range of distinctive conditions for living well and for ordering the habits of everyday life. Scamozzi explored an overtly spatial idea of light, one that insured a rich sensual engagement with the world. He conceived his building as an instrument with apertures and chambers for collecting and combining sunlight, moonlight, and skylight. His transformed light qualified and differentiated architectural spaces into meaningful places. Ultimately, he showed that light in architecture is a varied light, a created light, a light that only truly comes to life in relation to the penumbral zone of shadows. Villa Pisani suggests that buildings in themselves can be understood as that variable zone between shadow and light, between earth and sky.

Notes

1 Antonio Foscari, *Andrea Palladio: Unbuilt Venice* (Baden: Lars Muller, 2010): 24–8. The basic facts of Venetian economic and military history in the first decades of the 16th century are recounted in numerous sources. Foscari's recent account is clear and concise.

2 Denis E. Cosgrove, *The Palladian Landscape: Geographical Change and its Cultural Representations in Sixteenth-Century Italy* (University Park, PA: Penn State University Press, 1993): 139–64.

3 Margherita Azzi Visentini, "The Gardens of Villas in the Veneto from the Fifteenth to the Eighteenth Centuries," in *The Italian Garden: Art, Design, and Culture*, edited by John Dixon Hunt (Cambridge: Cambridge University Press, 1996): 96.

4 Cosgrove, *The Palladian Landscape*, 30–54.

5 Azzi Visentini, "Gardens of Villas in the Veneto," 95.

6 Margherita Azzi Visentini, "Vincenzo Scamozzi e il Giardino," in *Vincenzo Scamozzi, 1548–1616*, edited by Franco Barbieri and Guido Beltramini (Venice: Marsilio, 2003): 111.

7 James Ackerman, *The Villa: Form and Ideology of Country Houses* (Princeton, NJ: Princeton University Press, 1990): 36.

8 Vincenzo Scamozzi, *L'Idea della Architettura Universale* (Venice, 1615): Book Three Ch. 15.

9 Leon Battista Alberti, *On the Art of Building in Ten Books*, translated by Joseph Rykwert, Neil Leach, and Robert Tavernor (Cambridge, MA: MIT Press, 1988): 5.14, 141.

10 Alberti, *On the Art of Building*, 5.14–17: Ch. 14 covers general concerns for site; Ch. 15 and Ch. 16 have technical information on the accommodation of laborers and various farm animals, and Ch. 17 describes the house of the gentleman/owner.

11 Alberti, *On the Art of Building*, 5.17, 146.

12 Alberti, *On the Art of Building*, 9.2, 295.

13 Ackerman, *The Villa*, 131; Ackerman provides an appendix with the translation of Day VIII of Gallo's *Le Dieci giornate della vera agricoltura e piaceri della villa* (Venice: Giovanni Bariletto, 1556), fols. 138r–151v.

14 Veronica Franco, *Poems and Selected Letters*, translated by Ann Rosalind Jones and Margaret F. Rosenthal (Chicago, IL: University of Chicago Press, 1998): 253.

15. Cosgrove, *The Palladian Landscape*, 110: Crescenzi's *Five Books of Agriculture* republished 1561, Tarello's *Ricordo dell'agricoltura* in 1567, Clementi's *Trattato dell'agricoltura* in 1567, and Bornado's *Le richesse dell'agricoltura* in 1584 in addition to Gallo.

16. Cosgrove, *The Palladian Landscape*, 112.

17. Scamozzi, *L'Idea*, Book Three Ch. 12 and Ch. 15. The names seem to designate location, but location does not always correlate to functional type.

18. Pliny, *Complete Letters*, translated by P.G. Walsh (Oxford: Oxford University Press, 2006): Book Two, 17, 47–51.

19. Scamozzi, *L'Idea*, Book Three Ch. 12.

20. Vitruvius, *On Architecture*, translated by Frank Stephen Granger (Cambridge, MA: Harvard University Press, 1931): VI.vi.

21. Robert Tavernor, *Palladio and Palladianism* (New York: Thames & Hudson, 1991): 22.

22. Rudolf Wittkower, *Architectural Principles in the Age of Humanism* (New York: Norton, 1971): 70–75. This study intiated a substantial number of later investigations.

23. Howard Burns, Lynda Fairbairn, and Bruce Boucher, *Andrea Palladio, 1508–1580: The Portico and the Farmyard* (London: Arts Council of Great Britain, 1975): 163–6; Ackerman, *The Villa*, 89–107; Paul Holberton, *Palladio's Villas: Life in the Renaissance Countryside* (London: Murray, 1990): 190–205; Cosgrove, *The Palladian Landscape*, 94–8.

24. George Hersey, *Pythagorean Palaces* (Ithaca, NY: Cornell University Press, 1976): 69–73. Hersey calls Francesco's palace plans 'gameboards.' His analysis describes the clustering of certain room-forms (tesserae) and their repetition and distribution.

25. Ackerman, *The Villa*, 96.

26. Myra Nan Rosenfeld, *Sebastiano Serlio on Domestic Architecture: Different Dwellings from the Meanest Hovel to the Most Ornate* (New York: Architectural History Foundation, 1978): 50.

27. Ackerman, *The Villa*, 61 and 77–8; Alberti, *On the Art of Building*, 9.2, 295.

28. Scamozzi, *L'Idea*, Book One Ch. 6.

29. Scamozzi, *L'Idea*, Book Two Ch. 6.

30. Scamozzi, *L'Idea*, Book Two Ch. 6.

31. Alberti, *On the Art of Building*, 5.14, 140.

32. Scamozzi, *L'Idea*, Book Three Ch. 8.

33. Kornelia Imesch, *Magnificenza als architektonische Kategorie: Individuelle Selbstdarstellung versus asthetische verwirklichung von gemeinschaft in den venezianischen Villen Palladios und Scamozzis* (Oberhausen: Athena, 2003): 208–26.

34. Imesch, *Magnificenza als architektonische Kategorie*, 37–41. Imesch describes the philosophical context for Scamozzi's use of the term *magnificenza*.

35. Scamozzi, *L'Idea*, Book Three Ch. 15.

36. David Michael Breiner, "Vincenzo Scamozzi, 1548–1616: A Catalogue Raisonné" (Ph.D. diss., Cornell University, 1994): 346.

37. Scamozzi, *L'Idea*, Book Three Ch. 22.

38. Rosenfeld, *Sebastiano Serlio on Domestic Architecture*, 50; Lionello Puppi, "The Villa Garden of the Veneto," in *The Italian Garden*, edited by David R. Coffin (Washington, DC: Dumbarton Oaks, 1972): 108.

39. Hannah B. Higgins, *The Grid Book* (Cambridge, MA: MIT Press, 2009): 58.

40. Denis E. Cosgrove, "Mapping New Worlds: Culture and Cartography in Sixteenth-Century Venice," *Imago Mundi* 44 (1992): 65. Cosgrove cites Harley and Woodward.

41. Chandra Mukerji, "Printing, Cartography and Conceptions of Place in Renaissance Europe," *Media, Culture & Society* 28/5 (2006): 664.

42. Edward Casey, *Representing Place: Landscape Painting and Maps* (Minneapolis, MN: University of Minnesota Press, 2002): 168. "The Dutch suffix -schap, like the affiliated English suffixes -ship, -skip, and -scape (as well as the German -schaft), connotes 'shape.'"

43 Cosgrove, "Mapping New Worlds," 74.
44 Andrea Palladio, *The Four Books of Architecture*, translated by Isaac Ware (London, 1738): Book Two Ch. 3.
45 Scamozzi, *L'Idea*, Book Three Ch. 13.
46 Scamozzi, *L'Idea*, Book Three Ch. 12.
47 Scamozzi, *L'Idea*, Book Three Ch. 14.
48 Cosgrove, "Mapping New Worlds," 81.
49 Cosgrove, "Mapping New Worlds," 83. "The universality of the harmonia mundi was made visible through concepts of mapping and carried towards the … creation of new, more perfect worlds partly through the ideal of planning implicit in cartographic practice."
50 Scamozzi, *L'Idea*, Book Three Ch. 17.
51 Lionello Puppi, "Nature and Artifice in the Sixteenth-Century Italian Garden," in *The Architecture of Western Gardens: A Design History from the Renaissance to the Present Day*, edited by Monique Mosser and Georges Teyssot (Cambridge, MA: MIT Press, 1991): 54.
52 Puppi, "The Villa Garden of the Veneto," 84. The garden "existed as the highest form, aesthetically, of agriculture."
53 Puppi, "The Villa Garden of the Veneto," 84.
54 Puppi, "Nature and Artifice," 57.
55 Scamozzi, *L'Idea*, Book Three Ch. 23.
56 Azzi Visentini, "Vincenzo Scamozzi," 116.
57 Scamozzi, *L'Idea*, Book Three Ch. 13.
58 Scamozzi, *L'Idea*, Book Three Ch. 16.
59 Azzi Visentini, "Vincenzo Scamozzi," 117.
60 Denis E. Cosgrove, "The Geometry of Landscape: Practical and Speculative Arts in Sixteenth-Century Venetian Land Territories," in *The Iconography of Landscape: Essays on the Symbolic Representation, Design, and Use of Past Environments*, edited by Denis E. Cosgrove and Stephen Daniels (Cambridge: Cambridge University Press, 1988): 265.
61 Scamozzi, *L'Idea*, Book Three Ch. 1.
62 Scamozzi, *L'Idea*, Book Two Ch. 16.
63 Barbara Kenda, ed., *Aeolian Winds and the Spirit in Renaissance Architecture: Academia Eolia Revisited*, foreword by Joseph Rykwert (London: Routledge, 2006): xiii.
64 Scamozzi, *L'Idea*, Book Three Ch. 21.
65 Scamozzi, *L'Idea*, Book Three Ch. 13.
66 Scamozzi, *L'Idea*, Book Three Ch. 19.
67 Lyle Massey, ed., *The Treatise on Perspective* (Washington, DC: National Gallery of Art, 2003): 14.
68 Margaret Muther D'Evelyn, *Venice and Vitruvius: Reading Venice with Daniele Barbaro and Andrea Palladio* (New Haven, CT: Yale University Press, 2012): 176–90.
69 Vitruvius, *On Architecture*, VI.iv.
70 Alberti, *On the Art of Building*, 1.12.
71 D'Evelyn makes the case that Palladio, in his work with Barbaro, developed a significant interest in interior light, but light has not been an important theme in the interpretation and appreciation of his works.
72 Moshe Barasch, *Light and Color in the Italian Renaissance Theory of Art* (New York: New York University Press, 1978): xii.
73 Scamozzi, *L'Idea*, Book Three Ch. 21.
74 Charles Davis, "Vincenzo Scamozzi Architetto della Luce," in *Vincenzo Scamozzi, 1548–1616*, edited by Franco Barbieri and Guido Beltramini (Venice: Marsilio, 2003): 33.

75　Scamozzi, *L'Idea*, Book Two Ch. 13.

76　Marco Frascari, "A Secret Semiotic Skiagraphy: The Corporal Theatre of Meanings in Vincenzo Scamozzi's Idea of Architecture," *VIA* 11 (1990): 47.

77　Radiance Synthetic Imaging System, see http://radsite.lbl.gov/radiance/ (accessed July 18, 2012).

78　Cosgrove, *The Palladian Landscape*, 202.

79　Carmine Jannaco, "Barocco e Razionalismo nel Trattato d'Architettura di Vincenzo Scamozzi (1615)," *Studi Secenteschi* 2 (1961): 47–60. One part of the evidence of Baroque tendency Jannaco sees in Scamozzi is the view that art perfects nature.

80　Frascari, "A Secret Semiotic Skiagraphy," 43.

81　Hilary Gatti, *Giordano Bruno and Renaissance Science* (Ithaca, NY: Cornell University Press, 1999): 192.

82　Frascari, "A Secret Semiotic Skiagraphy," 43.

83　David Lindberg and G.N. Cantor, *The Discourse of Light from the Middle Ages to the Enlightenment* (Los Angeles, CA: University of California, 1985): 34.

84　Lindberg and Cantor, *The Discourse of Light*, 34.

4
Mapping the City: Palaces and Civic Buildings

> Palaces for the nobility and other illustrious people can be designed by selecting what is relevant from my descriptions of Greek and Roman houses and the other information I have given so far, and adapting and adding features to suit the traditions of a particular city or region.
> Vincenzo Scamozzi, *L'Idea della Architettura Universale*

Scamozzi constructed an urban theory in the dense layers of the text of Book Two of *L'Idea*. Drawing on a combination of his own careful travel observations and his extensive knowledge of classical and contemporary literature on cities, he demonstrated the importance of environmental, economic, and socio-political factors in the prosperity, longevity, and renown of cities. By thoroughly considering various origins and situations of a variety of historic and contemporary cities, he linked the physical construction of its buildings to the physical and social conditions of a city as a particular place, not an abstract idea. Scamozzi compiled an urban tradition for western civilization and placed the architect in the central role of urban designer.[1] For Scamozzi, the city existed as much in time as in space. In also accounting for the destruction of cities, whether by warfare, natural disaster, or by slower effects of poor conditions, he acknowledged the forces of time and the constancy of change. Confronting the city as mutable, and as vulnerable to loss, he obligated the designers of cities (`founders and renovators) to be more than cautious—rigorous inquiry and reasoning based on sound knowledge was required. Through the observation of diverse conditions and circumstances, Scamozzi sought an accumulated understanding of the dynamic forces that govern urban form and fate. In contrast to prevailing theories of the city as a beautiful ideal, Scamozzi's was an urban theory of the real.

In Scamozzi's theory, the urban condition was a major consideration for each building project within. Every site had its own character, much of which was owing to its wider context. Scamozzi recommended finding an elevated

point in a tower or on a hill in order to fully comprehend "all the peculiarities of a site—intersections, street layout, and sight lines."[2] In addition to physical features, local traditions and customs would need to be observed. However, Scamozzi never implied that the architect should simply replicate the manner of building that already existed in a place. Sensitivity to particularities of the city guided the architect in choosing whichever universal forms were "relevant" and in adapting them to "suit the traditions of a particular city."[3] Nor did his approach necessarily imply conservatism; he supported innovation, recognizing that the city changes over time.[4] Still, Scamozzi's urban projects were conceived within a profound appreciation for what is now commonly referred to as "a sense of place."[5]

Scamozzi built urban projects principally in Venice, Padua, and Vicenza, his hometown. Venice is, of course, the most unique in its urban condition, a city whose location and physical fabric most clearly impact the way of life of its residents. The watery soul of the city was a constant, but social, economic, and political changes were profound in the 16th century. The turmoil of these changes would take a toll on the public projects that Scamozzi was involved with at the end of the century. Padua's image was, by contrast, relatively stable—city of St. Anthony and seat of the regional university. Scamozzi's projects in Padua were for various religious orders, most notably two monastic complexes in Padua proper, and another in nearby Este. Vicenza, smaller and more provincial than Venice and Padua, had nevertheless experienced a building boom in the middle decades of the 16th century. By the time Scamozzi began his career, the new Basilica (though still under construction) and other Palladian projects had established a humanistic stamp on the medieval city. Though, like Padua, Vicenza was under Venetian rule, it had historical sympathies with the Hapsburg Empire that produced tensions in its political relations with Venice and religious relations with Rome. The Vicentine nobility consciously sought an independent political and cultural identity, making their city over into a suitable stage for the drama of civic life among the nobility.[6] The 16th century rulers and nobility of Venice, Padua, and Vicenza were all highly self-aware of their collective identities as expressed in history, myth, and culture[7] and were conscious of the role of architecture in maintaining or promoting a coherent civic image.

While clients and patrons were intensely concerned with the question of image, Scamozzi understood the responsibility of the architect to provide citizens and families the best possible conditions for living together; in other words, utility, commodity, and society were foremost for Scamozzi in determining what and how to build.[8] In the design of his urban projects, Scamozzi took account of the particular needs of the client together with the cultural and physical character of the city. The resultant calculus of planning, or compartition as Alberti called it,[9] invested the building with reason and nobility. Scamozzi not only provided spaces for the various functions desired, he considered their relationships and the means of communication and correspondence between them. His conceptual equivalence between the

making of the city and the making of the buildings in it had two corollaries: the city is not founded on divine paradigms,[10] but made to provide a place for human comfort, commerce, and community; and the building in the city simultaneously inheres and re-constitutes the city.

The City as Place: Urban Chorographies of the 16th Century

'The ideal city' is an idea that dominates our historical view of Renaissance architects' interests in urban form and function. Vitruvius included information in the last chapters of his first book on siting and arranging new cities, practical knowledge as the Roman Empire continued to expand, suggesting that the city is a subject of design. In the 15th century, Alberti made the city a protagonist in his theory of architecture, consistently placing the house, the temple, and civic buildings in the context of the city as well as considering the requirements and benefits of a well-designed city; he suggested a circular form as the most perfect. Filarete and Francesco di Giorgio further explored the idea of a unified geometric order. But the city as a subject of interest was largely absent from the important treatises of the 16th century until Scamozzi's *L'Idea*.[11] When Scamozzi took up the topic at the end of the century, it was not in the abstract diagrammatic and symbolic sense of the ideal city, but as a functioning social, economic, and political center whose elements and attributes had consequences. For example, he examined a number of ports to compare their specific attributes[12] — why they are necessary, the history of some significant ports, and the characteristics and qualities of particular ports. Each one was presented in its own dynamic relationship with the city it serves. Throughout the whole book, Scamozzi compared the origins, the climate, and the topography of the major cities of Europe and beyond. Scamozzi considered each city a particular place with its own unique characteristics.

Though the plan of the ideal city remained a theoretical diagram, architectural practice of the Italian Renaissance consistently confronted the city as both a site and a subject. The revival of ancient architectural forms concentrated study on Rome, whose monuments and building typologies had served an urban culture. As knowledge excavated from the visible remains accrued over time, the possibility of reconstructing a complete image of the ancient city as the ultimate monumental construction of the Romans came into focus.[13] Meanwhile, the influence of the geometries and regular rhythms of classically conceived buildings from Brunelleschi onward extended to the urban spaces they fronted. The spaces themselves soon became the object of design as a setting for civic life, a potential fully articulated by Alberti and realized in projects from Pienza to the Campidoglio. This perception was accelerated by the development of mathematically precise perspective as a way of representing the buildings of the city. Architects were also involved in urban infrastructure projects such as fortifications, bridges, roads, and gates.

4.1 Leonardo da Vinci, plan of the city of Imola from the Windsor Codex (Scala/Art Resource, NY)

It was through the design of smaller scale projects in existing medieval cities that architects could explore the idea of the city.

In addition to articulating the desire to rationalize civic space with geometric principles, Alberti also realized the power of geometry to represent, and in doing so to comprehend, an existing non-rational city. He was among the first to bring mathematical abstraction and uniform scaling to urban representation.[14] His own accurately scaled map of Rome has been lost, but he recorded his procedure around 1450 in a small volume, the *Descriptio urbis Romae*. Leonardo da Vinci famously implemented Alberti's method to make a plan of Imola for papal military purposes in 1502 (see Figure 4.1).

Scaling of some urban representations had begun to appear in the 15th century, but Imola may be the earliest completely detailed and consistently scaled urban map that remains.[15] At any rate, the capacity to represent the complexity of an existing city abstractly in plan was established by the early 1500s. However, the proliferation of urban images in the next 100 years did not generally adhere to its spatial abstraction.

While architects focused on theories of urban form derived from classical sources and representations, real and ideal, in plan, cartographers and printers were collaborating to produce a large body of graphic depictions of the cities of Europe. Pictorial representation of cities was not new,

4.2 Jacopo de'Barbari, perspective plan of Venice (Cameraphoto Arte, Venice/Art Resource, NY)

but had reached a new capacity for comprehensiveness with the bird's-eye views of the late 15th century at the same time global exploration was fueling a widespread interest in geography. Despite the technical capacity for producing purely planimetric views, an interest in cities as unique places with recognizable features persisted.[16] It may be attributable to Ptolemy's definition of chorography in *Geography*: "Chorography is most concerned with what kind of places those are which it describes." He went on to say that chorography requires the skill of an artist in order "to paint a true likeness, and not merely to give exact positions and size."[17]

The first known collection of city maps appeared in three manuscripts of the *Geography* in the second half of the 15th century, that is, between Alberti's map of Rome and Leonardo's of Imola; though less technically competent, they may have had a greater impact. In fact, the impulse among many cartographers was to hybridize these two different approaches, using the techniques of the survey for accurate scaling together with three-dimensional images. The resulting image was particularly suited to communicating visually both the shape (cityscape) and character of a city. Though Alberti wished to exclude sight and describe a place in terms of measured space, the bulk of Renaissance chorography was produced to balance visual appeal based on sensory reality with abstraction.[18]

The proliferation of city maps in the 16th century was propelled by a variety of factors. With the wide distribution of maps that printing allowed, Europeans confronted a new global image and were forced to re-define their own place in the world. Images of previously unknown territories brought with them a new self-awareness and a desire to make comparisons. Images such as Roselli's late 15th century view of Florence and de'Barbari's early 16th century view of Venice (see Figure 4.2) demonstrated the map's unique capacity to express urban identity.

The pre-modern city, restricted in size and walled for defense, was to a certain degree able to be experienced by its inhabitants as a whole, but the visual realization of it in a single image made its outlines and character all the more vivid. With the expansion of technical survey expertise and the printed map, more and more minor cities were subjects of such portraiture in addition to major cultural centers. Practical purposes, such as military and infrastructure planning, continued to play a role in map production, but interest in maps as expressions of political power and other less instrumental motives also fueled the production of city maps. The *Civitates orbis terrarium*, six volumes of engraved views of towns by Braun and Hogenberg published between 1572 and 1618, provides additional evidence of the broad extent of this interest (see Figure 2.7).[19] A political and symbolic function was particularly evident in the monumental maps used as wall decorations in Venice, Florence, and Rome. By the end of the 16th century, these chorographies were so common that they became central to how the city was perceived. Originating as a mirror to capture and communicate the identity of the city, their unique synthesis of sensory knowledge and extra-sensory scale eventually became a shared visual image.[20]

It is not difficult to see in Book Two of *L'Idea* a verbal equivalent to the *Civitates orbis terrarium*; Scamozzi's immersion in the culture of geography conditioned his view of the city. Scamozzi's was a humanist geography that sought the characters and meanings,[21] in tune with this modern definition offered by Cosgrove: exploring, reporting and recording (and for Scamozzi, modifying) the earth's surface as a place of human activity and habitation.[22] The architect needed wide geographic knowledge in order to build cities and place buildings in them properly, and in order to convince others of his superior judgment in these matters. Urban chorographies advanced knowledge of the city as essential to cultural identity.[23] Scamozzi firmly believed that true architecture, an architecture suitable for its place and time, depends on this knowledge to meet its primary goal.

Fundamental to an appreciation of Scamozzi's architecture are these paired facts: he was passionate about the city as a place; and the two cities most central to his architectural production had been undergoing profound renewal programs in the decades preceding his maturity. In both Venice and Vicenza, a new formal order had been adopted, one that arose out of shared cultural values in each place, and a renovated urban image had emerged. Even more to the point, each was strongly marked by a single architect of the previous generation. Jacopo Sansovino (1486–1570) was engaged in Venice to provide new civic structures in accordance with his Roman architectural training; Palladio had been steadily employed in his native city of Vicenza after designing the new loggia for the Basilica. Scamozzi's approach to architecture was of course bound to be in general agreement with the classically-based designs of Sansovino and Palladio. But one need only compare those two predecessors to remember that the same set of principles can be present within buildings of distinctly different image and character.

4.3 Jacopo Sansovino, Libreria Marciana, Venice and
Andrea Palladio, the Basilica, Vicenza
(Photos: author)

Scamozzi's major works discussed in detail in this chapter must be viewed within his intention of connecting buildings to the specificity of the site, and designing in respect of local customs. Scamozzi's designs for Venice and Vicenza show a willingness to acknowledge the urban character recently established by other architects while bringing his own ideas and judgment to bear.

The physical fabric of 16th century Venice is most comprehensively known to us today by means of the famous map of Jacopo de'Barbari of 1500. The image of the city is multi-dimensional, but two essential aspects are most apparent. One is the overall condition of the city—its shape, bounded by water, crossed by the serpentine Grand Canal, and constituted by a tight mass of buildings. The other is its center—the grand public space of Piazza San Marco in dialogue with the confluence of waterways in the Baccino was the social and cultural heart of Venice. The Basilica of San Marco and the Doge's Palace had formed the core of the civic image for centuries, and remained stable as such throughout the 16th century. But the century following the production of the de'Barbari map brought significant changes to the rest of Piazza San Marco, and inevitably re-characterized its image. It was in the midst of these changes that Scamozzi arrived in Venice in 1580.

The extent of 16th century renewal at the heart of Venice is remarkable for a time of political and economic instability.

Major alterations to the space of the piazza had begun with the construction of the Torre dell'Orologio and the reconstruction of the Procuratie Vecchie on the northern edge of Piazza San Marco.[24] The Procuratie, begun in 1513, shows Renaissance influences: round-headed arches, simplified column capitals and entablature, horizontal and vertical consistency. The Torre, designed by Mario Codussi and completed in 1500, is a slightly more elaborate composition with a greater variety of elements, but its classical ornament is equally restrained. The Torre serves as both gate and clock tower, but Codussi made no allusions to the classical motif of Roman gates, the triumphal arch. Blended in with the restrained vaguely classical expression, certain medieval Venetian themes are still detectable in both structures. On the Procuratie Vecchie, the tall narrow proportions of the continuous arcades of the second and third stories echo Gothic palazzo galleries, while the central bay of the tower contains polychrome surfaces in its top two tiers. The Torre is a wall structure, and its classical elements serve as frames rather than sculptural relief or implied structural members.

A new era of construction began in the 1530s when Jacopo Sansovino was hired as *proto*[25] to be in charge of the public works on the piazza. Sansovino was a refugee from the 1527 Sack of Rome, and the first architect of significance in Venice with first-hand knowledge of Roman Renaissance design. He had initially been trained as a sculptor, and he arrived in Venice with relatively little architectural experience though he had studied the ruins of antiquity in Rome.[26] With the sponsorship of Doge Andrea Gritti, Sansovino designed the Loggetta at the base of the Campanile and the Libreria Marciana, both of which face the Doge's Palace across the Piazzetta, and the Zecca nearby, which looks out on the lagoon (see Figures 4.3 and 4.5).

4.4 Diagram of Piazza San Marco, Venice: A—early 16th century construction; B—Sansovino's Loggetta; C—Sansovino's Library; D—Sansovino's Zecca; E—line of medieval structures in 1580; F—Scamozzi's completion of Library; G—Scamozzi's Procuratie Nuove (Illustration: E. Anderson)

The library replaced a number of nondescript medieval commercial structures with a cultural institution that expressed humanistic intellectual aspirations. The library was built to house a collection of Greek and Latin manuscripts, and its architectural expression was decidedly *all'antiqua*, even if the classical elements were composed in a manner sympathetic to Venetian qualities. Sansovino's Loggetta and Zecca, serving important state institutions, were also classically conceived. Since Constantinople had been lost to the Turks and Rome itself had fallen to Imperial troops, some Venetians saw an opportunity to claim international primacy. Sansovino's projects in the Piazza San Marco were intended by the Doge to realize his aspirations to reconceive Venice as the "Third Rome."[27]

By Sansovino's death in 1570, however, the idea of Roman classicism at the heart of Venice came to be challenged within the ruling class. Palladio was rejected as a candidate for *proto* of the Salt Office, and then met with difficulties gaining approval for his church designs. Even so, his classical church façades, especially San Giorgio and Il Redentore, were major contributors to the urban image due to their highly visible locations (see Figure 4.6).

4.5 Jacopo Sansovino, the Zecca and the Loggetta, Venice
(Photos: Abxbay and Joanbanjo)

4.6 Andrea Palladio, San Giorgio Maggiore and Il Redentore, Venice (Photos: D. Descouens and A. Fernandez)

Palladio's importance in re-forming the image of Vicenza was far greater, acknowledged even in the 16th century. His heroic architectural debut re-imagined the heart of the city by replacing the ruined Gothic loggia of the civic meeting hall with an innovative arcade in the classical language. The private commissions for palaces that followed were numerous enough to register a new sense of scale, order, and ornament on the streets of the city. Though there is truly no "typical" Palladian palazzo, together they communicated the humanist interests of the wealthy class. Vicentine social coherence arose from shared intellectual passions and a desire to maintain civic liberty in spite of internal political stresses in the face of Venetian rule. So, the combined effect of private residences perfectly expressed the image of Vicenza. Further, the classical language was in contrast with the Gothic construction associated with Venetian rule, reaching back instead to Roman foundations.

The profusion of city maps, along with other expressions such as encomia and local costumes, reinforced the conception of each city as a unique and distinct place. The wide cultural consciousness of civic image is evident in the controversies caused by major civic projects. In Book Two, Scamozzi highlighted the distinct character of each city due to its climate, topography, history, government, and resources. All of these distinctions were a major factor in his architectural production. Every design for an urban site was conceived within the awareness of its city as a place.

The House and the City—Commodity and Compartition

Scamozzi followed Alberti in his attention to commodity as it is achieved through careful planning. His narrative on the origin of architecture proceeded from the necessity for shelter to the provision of comfort and a better quality of life: "It is a fact that of all things made by man, nothing gives

so much honor, joy and the truest and highest pleasure as the possession of a well-organized house with its various quarters and other conveniences."[28] He praised buildings that were "an excellent arrangement of the required parts within the whole"[29] and offered greater detail in his chapter on the general requirements for houses in cities:

The available space should be divided so that all the various parts of the house maintain a proportional relationship with each other; and similarly the rooms themselves should be conveniently laid out and not cramped or jumbled together. Their shapes and sizes should not appear random, but combine to form a harmonious, proportionate whole with nothing superfluous and lacking nothing essential.[30]

This echoes Alberti's explanation of compartition, which "divides up the whole building into the parts by which it is articulated, and integrates its every part by composing all the lines and angles into a single, harmonious work."[31] The English word "compartition" is easily associated with a process of division, but it is important to remember that it requires both division and integration—not just defining various parts within a whole, but relating the parts harmoniously to each other and to the whole. Alberti wanted the process of compartition to "respect utility, dignity, and delight," while Scamozzi's "nothing superfluous, nothing lacking" seems to have expressed the same intention, especially if we remember Alberti's definition of beauty.

Alberti further elaborated using his well-known house–city analogy; since "the house is like some small city," then it follows that the parts of the house, the rooms, are best understood as "miniature buildings"[32]— in other words, he also proposed a room–house analogy. Compartition therefore requires simultaneous attention to various scales, room to house to city, and a consistent approach so that the parts are not mere cells but true analogues.[33] No wonder then that Alberti warned that compartition required the architect's greatest skill and creative power. Planning is a question of utility alone, the capacity to provide spaces that are appropriate to their uses, while compartition requires the adjustment of spaces to the contingencies of use.[34] While commodity admits of individual needs and differences, and requires attention to the particular, it also entails simultaneous attention to universal integrity. Alberti suggested that the architect is responsible to the city as a whole in every discrete act of construction.

When Scamozzi described the necessary parts of houses and their arrangement, he continued to refer back to the city. For instance, his general recommendations on planning for urban residences, which are divided into types by class—professionals, noblemen, citizens, tradesmen—included examples of cities where such arrangements were customary.[35] He also devoted a whole chapter to describing the typical noble palace layout for Rome, Naples, Genoa, Milan, Florence, and Venice.[36] He was in essence establishing a matrix with cities as one set of variables and social status as the other. Along the 'cities' axis, we learn that the Roman palazzo was generally large, and was organized around a central courtyard with loggias all around,

Aspetto della Fabrica delli Sig.¹ Rauaschieri.

while the palaces of Naples were smaller, and they used the ground floor for some living spaces. Genoa's topography required palaces that were narrow-fronted and deep, with relatively small courtyards. In another chapter, he described climate conditions and the appropriate palace forms in Spain, France, and Germany. Through this, the house was shown to respond to the physical conditions and the social customs of each place—"Convenience, beauty, and the customs of a particular country are some of the issues that have to be considered in order to build well and appropriately."[37]

The palazzo Scamozzi designed for a prominent site in Genoa provides a good example of Albertian compartition from his own work. Palazzo Ravaschieri (1611) is an unusual design in several respects (see Figure 4.7).

Unlike many urban sites in the heart of Italy's cities, this site has streets on all sides—its front is on one of the most important streets climbing the hill from the port, Via di San Lorenzo, and the site goes through to Via di Canneto il Lungo behind. It is flanked by two narrower alleyways. In recognition of this site condition, Scamozzi aligned two entries on opposite faces, and eliminated the usual courtyard since light and air were available on the whole perimeter. The axis of movement that connected the two entries was crossed by a transverse monumental stair hall that divided the rear third of the plan from the front part. Its four interwoven flights of stairs occupied the full (approximately 60-foot) width of the building. The stairs had open wells so that "light can spread from above to below."[38]

4.7 Vincenzo Scamozzi, façade and plan of Palazzo Ravaschieri, Genoa from *L'Idea della Architettura Universale*, Book Three, p. 265 (RIBA Library Photographs Collection)

4.8 Vincenzo Scamozzi, plan and façade of Palazzo Fino, Bergamo from *L'Idea della Architettura Universale*, Book Three, p. 263 (RIBA Library Photographs Collection)

Although Scamozzi's site did not traverse the steep grades that characterize Genoa, stairs to climb the hills were a part of the Genoese way of life. He had seen the palaces of the Strada Nuova and admired the arrangements of the stairs in the palaces there that did cut across the grade. Among Scamozzi's urban residences, the scale and prominence of this stair is unique to his Genoa project.

His acknowledgment of the unique image of Genoa extended to the façade, which fronts Genoa's medieval cathedral and its piazza. The polychrome church of San Lorenzo was not only the neighboring context, it was also central to the image of the city. Scamozzi's composition was not particularly remarkable given the overall proportions, but expertly realized. The distribution of the openings recalls one of Serlio's designs for Venice, but Scamozzi ordered this façade with a more complete classical language. The material selection stands out from the rest of his work as unusual: he followed the local custom of using a rich palette of colored marbles. Most strikingly, in place of the rustication typically used on the ground floor, he mirrored the church across the street and used alternating black and white courses of marble, "which is a sign of great stateliness in Genoa."[39] He was rather equivocal about the merits of this tradition, but his sense of fitness for the place governed the choice, and there was a certain logic in the way that he chose to include it. The expression of coursing and the visibility of the units of construction are similar to rusticated masonry. However, it is impossible to know how well he integrated this visually vibrant pattern with the language

of the upper stories; a complete reconstruction in the 19th century adopted polychromy for the whole façade.

An even more unusual plan arrangement for a palazzo in Bergamo probably arose in part from the specific needs of the client, a "refined and wealthy nobleman,"[40] but Scamozzi did not reveal anything on this point. There is a compelling case for the city of Bergamo as a source of inspiration. The two-story design for Palazzo Fino (1611) defined a site 188 feet by 93 feet, with two sides facing streets (see Figure 4.8).

The main (longer) façade was articulated on the piano nobile by a uniformly spaced Ionic order; the only accents occurred at roughly the third points, where arched openings were fit within the regular intercolumniation on both levels. Those at the base were framed with a Doric order; one served as a portal for the main entry, while the other was not an entry at all, but indicated on the façade the presence of an important space within. Apartments of mostly square rooms were placed along the perimeter of the two street edges. The rest of the rectangular plan was dominated by a cortile that the main and a secondary entry around the corner were both centered upon. A large two-story hall with a coffered ceiling defined the side of the courtyard opposite the secondary entry. The other long edge of the hall in turn delimited a second smaller cortile, which had the same dimensions as the hall. A gallery lined the opposite side of the second courtyard. Situated as it was between the two courtyards, the hall had double ranges of windows "which form a splendid ornamentation"[41] on its two long sides—an unusual and grand space in a private residence.

If one regards the perimeter apartments and the gallery as a frame, the remaining space of the plan consists of the two courtyards, each with a portico on one edge, divided by a single grand interior space, a special room. This arrangement is in fact analogous to the center of Bergamo, where the twin spaces of Piazza Duomo and Piazza Vecchia are both separated and linked by the medieval Palazzo della Ragione (see Figure 4.9).

The medieval structure consists of an open ground-level hypostyle hall that supports a single large meeting room above. It helps define the two central urban spaces and forms a joint between them. Scamozzi was working on designs for the Palazzo Nuovo (now the Palazzo Communale—see Figure 1.9) on a site facing the Palazzo della Ragione across the piazza and certainly had occasion to see how its position between two open spaces made the room memorable.

The Palazzo della Ragione may have inspired Scamozzi in one additional way. The regularly spaced columns forming a nine-square vaulted grid at the ground level are the mathematical description of the meeting space above. Scamozzi certainly already used the definitions and measure of columnar systems as a basis for rationalizing space, but the visible demonstration of these relationships at the heart of Bergamo may have struck a chord. Whether as inspiration or as analogy, Scamozzi designed the plan of Palazzo Fino as a completely consistent grid in which the spaces were like tesserae.

4.9 Plan of central Bergamo: A—Duomo; B—Palazzo della Ragione; C—Palazzo Nuovo; D—Piazza Duomo; E—Piazza Vecchia (Illustration: E. Anderson)

It was not unusual for him to describe a façade in terms of the number of "intercolumniations," or bays, into which he divided it—in this case, it is 16 on the front, eight on the side. But he also dimensioned the spaces within by the same terms, rather than by measure in feet: the main cortile was five by seven modules; the secondary one was three by five, as was the two-story hall; all rooms were exactly two by three or two by two. Unfortunately, Palazzo Fino was never built, and it is not even known now where the site was. However, both of these projects give strong evidence that Scamozzi practiced design as compartition, and that he connected his designs conscientiously to the particular characteristics of the site and its urban context, practicing a humanistic geography.[42]

Palazzo Trissino al Corso, a Chorography of Vicenza

Scamozzi grew up in Vicenza as it was transformed by Palladio; having witnessed the profound changes may have initiated his views on the architect's role in urban design. His own earliest architectural experience working with his father was rooted in Vicenza, and as early as 1569 he was hired on his own to design two palaces for the Godi family on a single site.

This project was never constructed, but Scamozzi included it in his treatise to illustrate proper management of an irregularly-shaped site along with his later design for Palazzo Trissino al Corso (1592). Plans and elevations of these two designs appear on a single sheet first in Book Two, to illustrate site conditions, and again in Book Three to illustrate compartition (see Figure 2.12) The earlier design can certainly be seen as a continuation of Palladian intentions for the Renaissance architectural character of Vicenza, but includes nothing specifically "Palladian." It is a rather large building, and follows the pattern of many two-story palaces of the 16th century: rusticated base with uniform unadorned openings, and a piano nobile with uniform bays and framed windows. In this design, an order of engaged columns frames the central seven bays over the two main arched entries. Round mezzanine windows are sandwiched between the pediments over the windows and the entablature above. The plan, complicated by the necessity to accommodate two independent households, is not symmetrically ordered in the manner of Palladio.

The later design likewise extends the Palladian civic project, and in this case, there are elements that may be identified as specifically Palladian palace design. The façade's character recalls the sculptural effects of Palladian façades. In fact, a casual look at the façade of Palazzo Trissino might suggest that it is an imitation of Palladio's Palazzo Chiericati (begun in 1550 and illustrated in Palladio's treatise) just down the street (see Figure 4.10).

However, more careful observation reveals creativity and innovation in accordance with Scamozzi's own architectural ideas. The resemblance is chiefly due to an unusual shared element— an open portico spanning the entire width of the ground level.[43]

4.10 Andrea Palladio, Palazzo Chiericati, Vicenza and Vincenzo Scamozzi, Palazzo Trissino al Corso, Vicenza (Photos: author)

4.11 Bird's-eye view of Vicenza c. 1580 (Biblioteca Angelica, Rome) and Palazzo Trissino al Corso site plan

However, each building has a particular reason for its portico arising from different site conditions. Palladio's project on a shallow site fronts an open piazza; he adopted this unusual feature in order to convince city officials to allow a private room on the piano nobile to project into the public space. More typically, open space at the ground level would be articulated as an arcade. Here, Palladio's trabeated portico is more unified with the space of the piazza than a shadowy arcade would be. This greater sense of openness might have been necessary to convince the public officials.[44]

Palazzo Chiericati anchors one end of Vicenza's main east–west street, today the Corso Andrea Palladio, that connects at the city gates to regional roads—west toward Verona, east toward Trieste. (Scamozzi put it this way: from Garbino (southwest) to Greco (northeast), connecting Lombardy to Venice.)[45] Scamozzi's site was located mid-way on the same street, occupying about half of a block on the narrowest section of the street. One side abutted another residential building, the other faced the Strada dei Giudici, now the Contrà Camillo Benso Conte di Cavour, a side-street leading from the Corso to Piazza dei Signori, the city's main public piazza, less than a block away. At the time of Scamozzi's commission, the site was occupied by a house of his client's uncle who had left it to him in 1570, visible in a 1580 map of the city (see Figure 4.11). Galeazzo Trissino decided to replace the existing structures on the site when he married in 1587.[46]

The existing structure and its next-door neighbor both had an open arcade at street level. This atypical condition was likely due to the narrowness of the Corso at that particular block. An open passageway at ground level is a significant benefit to pedestrians when the street is crowded. It is not unreasonable to imagine that Scamozzi and his client wished to maintain the advantage of the open passage to the public. Adopting the Chiericati's columnar solution over a typical arcade would maximize a sense of openness to the street and also allow a greater amount of reflected light (*lume di lume*) to enter the ground level space on this north-facing façade.

Only one other feature of the Scamozzi design links Palazzo Trissino explicitly to Palazzo Chiericati: use of a double column to define a central figure.

4.12 Andrea Palladio, elevation of Palazzo Chiericati, Vicenza from *The Four Books of Architecture*, Book Two, Pl. II and Vincenzo Scamozzi, elevation of Palazzo Trissino al Corso, Vicenza from *L'Idea della Architettura Universale*, Book Three, p. 260 (RIBA Library Photographs Collection)

The Palladian design captured five central bays that stepped slightly forward with the doubled column, flanked by three bays to either side. Scamozzi defined three bays at the center of his nine bay façade with this motif, and then repeated it on each end. He intended a pediment to complete the central figure of the façade, but the building was left incomplete by Trissino's death and the upper story of the façade was not completed until the 1660s, when this feature was eliminated.[47] Instead the figural nature of the central bays was completed by the arched opening on the piano nobile, and by an A-B-A pattern of bay widths. The visual harmony achieved, one of Scamozzi's best façade designs, can only be known from his drawing; the narrow street in front of the Palazzo Trissino prohibits a frontal view. The design may well have been inspired by Palazzo Chiericati, but similar elements were worked into a distinctly different composition.

4.13 Vincenzo Scamozzi, corner detail and axial entry sequence of Palazzo Trissino al Corso, Vicenza (Photos: author and J. Derwig)

The strategic use of the double column by Scamozzi cannot be seen; instead it is experienced by passersby. It is noticeable as a punctuation on either end, and a quickening of the rhythm at the center. This difference in the way each façade can be experienced may account for another difference that is less important to modern eyes, but would have been significant to 16th century viewers. Palladio, in agreement with standard theory, used a Doric order for his base with a fully articulated Doric frieze; the second story is Ionic as expected in vertically stacked orders. Scamozzi made the unorthodox choice of Ionic for his ground level portico, and used a Roman (his name for Composite) order for the pilasters of the piano nobile. The Ionic is directional in form, suggestive of movement if used in a continuous series. Scamozzi would have experienced the effect in the nave of Santa Maria Maggiore in Rome. The unbroken lines of the entablature works with the directionality of the Ionic capitals to heighten the experience of movement down the street.

On the east end, the façade simply aligns with its neighbor, and the space of the portico adjoins the neighboring arcade. On the west, the façade turns the corner and presents the street with an arched entry to the portico. The rest of this secondary building face is planar. Scamozzi used the terminating doubled column of the main façade to advantage in turning this highly visible corner effectively (see Figure 4.13).

The final column has an Ionic capital with two faces; the entablature above turns the corner over the column and then abruptly steps back above the arch, which is flanked by an additional column on the other side. Once the entablature steps out over this engaged column, it dies in the wall. It was a masterful use of the classical elements to make a smooth transition. The arched entry to the portico is echoed by the arched portal of the palazzo's main entry at the half-way point (see Figure 4.13). The entry axis is perpendicular to the portico; the entry leads directly into a generous vestibule that in turn connects to a central cortile.

Starting from the street along this axis of movement, the Ionic columns of the portico frame the pilasters that flank the arched portal, through which can be seen the columns of the near side of the courtyard which frame their correspondents on the far side. A second arched doorway to a reception room terminates the axial view. The cascading perspective effect is punctuated by alternating light and shadow.

The square cortile can also be accessed from a side door through a slightly smaller vestibule that is mirrored across the courtyard by a loggia and stair. The central square cortile where these two axes cross is slightly taller than its approximately 40-foot width (see Figure 4.14).

The openness of the ground level gives way to solid walls above punctured by windows in accordance with the bays but not articulated by pilasters. Heavy blocks above the entablature of the first order support a small continuous balcony above. The cortile feels ample, an unexpected contrast to the dark and narrow streets.[48] It provides a luminous center within the constellated rooms of the building block on the piano nobile at the same time it articulates and fulfills the intersecting visual axes of entry.

The realization of a double axis as a basis for planning the Vicentine palazzo clearly distinguishes Scamozzi's design from Palladian ideas (see Figure 4.15).

Palladio, in attempting to re-create the Roman *domus*, focused on consistent symmetry about a single axis; his plans unfold on a controlled linear sequence. Scamozzi was inspired by the Roman model, but had no intention of a literal re-creation. He wished to adopt only those elements that were appropriate to the customs of Vicenza, and to achieve the dignity and nobility he found in the Roman model. The cross-axis acknowledged the particular site for which he was designing, always an important consideration. In this design he finally realized with great impact a theme he had experimented with in Palazzo Godi and Palazzo Trissino al Duomo (1577), both also corner sites.[49] Palazzo Godi had a larger rectangular cortile serving two joined houses with three entries; though orthogonal, the relationships were not axial (see Figure 4.12).

4.14 Vincenzo Scamozzi, plan of Palazzo Trissino al Corso, Vicenza from *L'Idea della Architettura Universale*, Book Three, p. 260 (RIBA Library Photographs Collection) and view of cortile (Photo: author)

4.15 Diagram of Scamozzi's Palazzo Trissino al Corso and Palladio's Palazzo Valmarana (Illustration: E. Anderson)

Palazzo Trissino al Duomo was planned for a more elongated site; the rectangular cortile is directly on axis with the main entry, but the axis of the secondary entry is crossed in an adjacent colonnade rather than in the cortile.

At the Palazzo Trissino al Corso, the axes not only meet so as to order the important central space of the cortile, but each one structures a meaningful sequence of spaces.

Scamozzi's care in compartition is evident in other ways as well. A transition of scale from the street to the cortile is subtly accomplished by an ingenious manipulation of the columnar order. The portico consists of nine evenly spaced columns to which another four are added, two in the bays flanking the central bay creating a central three-bay figure, and two on the ends to echo the edge treatment. The resultant smaller intercolumniation flanking the central portico is translated to the cortile as the regular interior bay size. More impressively, on an irregular site, he achieved a sequence of regular formal spaces in two directions at once. He used the infilled corner bays of the cortile to mask wall-lines and utility spaces, leaving the perimeter free for formal rooms. A large and gracious stair occupies part of the corner between the two entry vestibules, allowing a direct path from either entry to the piano nobile. There, three grand semi-public rooms extend out over the street-level portico. The central grand *sala*, located directly above the main vestibule, is about 30 by 35 feet, getting light from both street and cortile.

A secondary apartment of rooms is arranged enfilade along the other outer wall, and once again, the grandest has windows on both the cortile and the street.

By analyzing more closely Scamozzi's 'map' of the palazzo, distinct levels can be extracted, revealing the habits of a family in the relationships of the rooms (see Figure 4.17).

Service spaces, horse stalls, and storerooms are in a basement level, freeing most of the first floor for useful living spaces, a distinctly Vicenzan arrangement.[50] Because the cortile does not provide the typical peripheral circulation, each level has its own distinct order. The logic may not be immediately evident, but the result is the optimization of commodious apartments that suit the family's needs, and the establishment of useful relationships among them. On the second floor the outlines of the grand *sala* of the house show a room of generous size receiving light and air from both north and south, and overlooking the activities of the street, the cortile, and the to-and-fro of the reception hall. It is flanked by its proportional offspring[51] on both sides. Light and air move freely through every space, fully animating and elevating the places of daily human activity.

4.16 Vincenzo Scamozzi, drawing for Palazzo Trissino al Duomo, Vicenza with drawing for San Gaetano, Padua (© Devonshire Collection, Chatsworth. Reproduced by permission of Chatsworth Settlement Trustees)

4.17　Diagram of separate levels of Palazzo Trissino al Corso, Vicenza
(Illustration: E. Renouard and E. Anderson)

The cross-axial arrangement of the plan fully acknowledges the site of the palazzo as a particular place in the city. But it is also an indicator of Scamozzi's process of compartition in which he reiterated the fundamental order of the city of Vicenza. As the patrician class expressed its desire to renew classical Rome through the arts, theater, and architectural expression, they were no doubt conscious of the traces of Roman Vicenza (*Vicentia*) that still ordered their city. The Corso, Vicenza's *decumanus maximus*, is anchored at each end by an open piazza, each marked by the presence of one of the city's most important families. The Palazzo Trissino, located at the half-way point between them, both accommodates and re-presents the *decumanus* in its portico (see Figure 4.18).

Further, it turns the corner to indicate the short path to Piazza del Signori to the south, the primary public open space that originated as a Roman forum. As the portico represented the *decumanus*, so the cortile represented the open space of the piazza to which the whole city oriented.[52] The important spaces of the house echoed the important spaces of the city and their relationship. Alberti's house/city analogy acknowledged that each room of the house, like each building of the city, must be formed to suit particular uses and conditions.[53]

Scamozzi's idea of compartition went beyond Alberti's universal idea; by careful mapping of the particulars, the design of the Palazzo Trissino celebrated the figure of the city.

Today the Palazzo Trissino al Corso serves as Vicenza's city hall. Though the city is universally associated with the name Palladio, it is Scamozzi's unique interpretation of the universal idea of the Renaissance palazzo "adjusted" to the strongly Palladian context of Vicenza that is the most fitting architectural image for the city government. Scamozzi represented the shape and character of the city in Palazzo Trissino, making it a chorography of Vicenza.

4.18 Diagram of the correspondence between Palazzo Trissino al Corso and Vicenza: A—the Corso; B—Piazza del Signori; C—Pal. Trissino portico; D—Pal. Trissino cortile (Illustration: E. Renouard and E. Anderson)

Procuratie Nuove, a Chorography of Venice

Scamozzi returned to the Veneto from two years in the south in May, 1580; his studies in Rome were a necessary element in finishing his humanistically conceived architectural education. His return coincided with a renewal of important public projects in Venice, starting with the city's decision to complete Sansovino's Library in Piazza San Marco, begun in the 1530s but stalled for over 25 years. After Palladio's death in August of the same year, Scamozzi was the only architect in the region with the intellectual credentials of classical studies and a first-hand knowledge of Roman architecture. For this reason, Scamozzi was favored by Marc'Antonio Barbaro, one of the city's procurators, as the best choice to finish the *all'antica* library building. But even before Scamozzi was selected, completion of the Library became linked to another important civic project nearby, the provision of new residences for the city procurators around the corner, on the south side of Piazza San Marco.

Administration of public works in the Piazza San Marco was the responsibility of the three person Procuratia de Supra, essentially the building subcommittee of the Procuratia di San Marco. These nine procurators were government officials selected from the highest ranks of Venetian society, a politically charged and contentious group with responsibilities for social welfare and wills city-wide as well as all buildings on the Piazza San Marco. At the time of the decision to renew construction on Sansovino's Library, Barbaro was in a position of some authority for the building projects. Brother of the translator of Vitruvius, Daniele, and former client of Palladio for their shared villa at Maser, Barbaro was a champion of the architectural ideas represented by Scamozzi. But influence, oversight, and decision-making processes as the projects progressed were constantly shifting. In the end, there would be several controversies that caused major delays, hurt Scamozzi's reputation, and still today cloud the historical record. Most importantly, there would be objections to the project raised periodically on the grounds that it was not stylistically appropriate to the Venetian urban image.[54] Since the bulk of Italian Renaissance architecture was designed and constructed to please a single powerful patron, it is important to explain the Venetian process for public architecture, an important factor in the difficulties surrounding the execution of Scamozzi's Procuratie Nuove.

Before engaging in a detailed account of the project, it may be useful to assess Scamozzi's response to the Venetian architectural context by means of a private project without such complexity in the process. Palazzo Contarini dagli Scrigni (1609), commissioned for a site adjacent to an existing Contarini palazzo on the Grand Canal, provides an example of Scamozzi's ability to temper his classical language to a Venetian dialect.

Almost the same size, it was intended to look like an independent palazzo but to function as an expansion of the earlier Gothic residence (see Figure 4.19).

MAPPING THE CITY: PALACES AND CIVIC BUILDINGS 123

4.19 Vincenzo Scamozzi, Palazzo Contarini dagli Scrigni and Palazzo Contarini Corfù, Venice (RIBA Library Photographs Collection)

The façade of the earlier Palazzo Contarini Corfù is typical of medieval Venice: three stories, polychrome façade, central portal from the canal with continuous gallery windows above, and ogee-arched windows. Large solid wall panels flanked by single corner windows balance the perforated nature of the central bay. The classical language of Scamozzi's addition may initially seem unrelated to the older structure, but the composition is clearly inflected to it. Of course, Scamozzi was familiar with precedents adapting the classical language to the Venetian type built by Sansovino and others; designs in Serlio's fourth book[55] appear particularly influential in this case. Scamozzi's façade is horizontally ordered, with two stacked orders over a rusticated base, and executed in a single material—the white Istrian stone of Venice. Windows have round-headed arches, they are evenly spaced, located on the centerlines of each of the five bays. Though lacking the key Venetian motif of multiple lights arranged in series, the central bay is wider, and achieves emphasis by means of a gable with a Serliana window above the cornice. The even spacing of the windows suggests regular bays, but in fact there is a more complex bay rhythm established by the columns, which are doubled, except at the outermost point. The result is two-fold—there is a window close to the corner, just as in the older palace, and these voids are balanced by blank wall panels closer to the center.

Scamozzi aligned the floors of the new structure with the existing, which was important functionally but did not necessarily need to be expressed. Moreover, the proportions of the orders are tall and slender to gain some of the general verticality of the Gothic. The windows are similarly vertical in proportion, very close in dimensions to their Gothic neighbors. The openings on the ground story match the existing in placement and proportion as well. Ornamental punctuations on the Gothic side are mirrored by balustrades, capitals, springblocks, and keystones. Scamozzi used flat-faced pilasters for his orders rather than engaged columns in acknowledgment of the flat white stone frames on the upper stories of the older palace. Breiner sees the new façade as a faithful translation of the medieval one that achieves a stately expression,[56] and also credits Scamozzi with a successful integration of the interior spaces. This design provides a demonstration of Scamozzi's design process: selecting the most appropriate universal forms, which for him could only be classical, and adjusting them to suit the local customs and conditions.

The circumstances for the Procuratie Nuove design almost three decades earlier were, as noted, quite different in major respects. The existing building that brought Scamozzi to Venice in 1581 was a thoroughly classical structure; Sansovino's state projects were all definitively *all'antica* even if they were unique in their detail and character. In 1580, the 16 previously constructed bays of Sansovino's ornate Library were still flanked by medieval market structures to the south, including the meat market; and by a hospital and other medieval structures containing official offices and residences at its northwest corner, clinging to the base of the Campanile and facing onto the main piazza (see Figure 4.20).[57]

Sansovino had deliberately started the Library well clear of the Campanile's south wall, anticipating its total disengagement as a freestanding tower. Before the markets at the south end of the Library site could be removed to make space for the final bays, a new meat market was needed elsewhere. This requirement was finally satisfied in 1580, and apparently, demolition of both sets of medieval structures went ahead in 1581. The five additional bays needed to complete the library were a linear extension of the constructed portion, but the design of the new residences on the main piazza was an open question. Though Sansovino's placement of the library was strongly suggestive that the Procuratie Nuove should not engage the Campanile, there was some reluctance to reduce the area available for building by aligning the new residences with the Library's north end (see Figure 4.4).

Although with hindsight the final result seems inevitable, these were unresolved questions even as demolition proceeded in 1581. Venice was a city that encouraged a lively public discourse on architectural matters,[58] and the commissioning procurators usually engaged in a deliberate process of consultation before making decisions. Expertise was not uniformly valued, knowledge of local practices often took precedence, and authority was dispersed.

4.20 Gentile Bellini, detail from *Procession of the Cross in Piazza San Marco* (Cameraphoto Arte, Venice/Art Resource, NY)

Most accounts describe the selection process for the Procuratie Nuove as a competition, but Howard has characterized it as a consultation process consistent with other major projects such as the replacement of the Rialto bridge by the Salt Office: a variety of experts were asked to submit opinions and proposals on all of the technical and aesthetic issues of a project. In this case, Scamozzi was one of three experts consulted, and his recommendation in the form of a design proposal was accepted over the others. He placed the residences in alignment with the Library; it is unclear if they had two or three stories at the time of adoption. Though his design was selected, Scamozzi was not appointed to an official position or even commissioned in the usual sense, so his authority in the project was never secure.

The procurators traditionally hired a *proto*, a master-builder, to take charge of construction of all of their projects. Venetian master-builder Simon Sorella, *proto* since 1572, was one of the two others consulted on the Procuratie Nuove. Though his recommendation was not adopted, he was nevertheless in charge of executing the work. As a native, he was expected to have experience with the unique technical problems and labor practices of Venetian construction. Sansovino's appointment as *proto* 40 years before was unusual because at the time he was new to Venice and had little experience in construction of any kind. But it had allowed him to function effectively as designer and builder, realizing major projects with relatively little adversity. While Howard sees in the Venetian consultation process the positive possibilities of negotiation and collaboration, there is also an inherent potential for negative impacts of dispute and the pursuit of cross-purposes. In his treatise, Scamozzi, following Daniele Barbaro, was adamant about appropriate limits of the influence of master-builders, and about the importance of the architect's wider knowledge base in making sound judgments. Though he may have appeared arrogant in disagreements with Sorella in the context of the Venetian process, his views were based on principles that went well beyond mere egoism: he invested in and had great faith that the highest engagement with intellectual culture would yield better buildings, better cities, and better lives for the people in them.

It was possible to begin foundation work for the completion of the library and for the first two residences on Piazza San Marco in late 1582. The first controversy arose when Scamozzi proposed adding a third story to the Library, presumably to match a third story he intended for the procurators' residences. Though it is likely that public discourse considered the visual impact of a third story with respect to the Doge's Palace across the Piazzetta, the record of the debate is focused on the capacity of the existing foundations rather than any aesthetic or symbolic issues, or even financial issues. Though Scamozzi had a design for making a transition from the two-story Library to a three-story Procuratie, he would have favored continuity between the two aligned structures. Also, he knew that third stories had eventually been added to both the Procuratie Vecchie and the Zecca, so he may have been somewhat pragmatic about anticipating the inevitable, and wanting the work done all

at once for a more harmonious result. Finally, he was also concerned about the joint between the two-story library and the three-story Zecca on the south façade (see Figure 4.21).

In any event, a third story for the library was ultimately rejected, and work on the Library and a first phase of the Procuratie Nuove proceeded.[59] The time frame for construction of the latter eventually extended throughout the 1580s and into the 1590s, leaving room for second thoughts and for objecting to what was regarded by some as a foreign importation on the main political and symbolic space of the city.[60] In 1590 and again in 1596, the rhetorical implications of the design were the main topic of debate, although the visual impact of the third story was also implicated. Objections that were raised to the design of the façade were primarily focused on its ornamental expression and overall character. One political faction felt that the Roman-ness of the design betrayed the image of the city right at its core even though the ornamental program was largely set by the Sansovino building. Moreover, a wide embrace of Roman classicism was already evident between the Library and the Zecca on one side of the Bacino, and the Palladian façades of San Giorgio Maggiore and Il Redentore on the other. Scamozzi's authority in the project, never strong, was severely weakened in these disputes. In the end, he was dismissed in 1597 after the completion of the first 10 bays of the Procuratie. Construction thereafter was undertaken in several stages, and was only substantially completed around 1640 by Baldassare Longhena. By then, the intensity of the political debate was long forgotten.[61] While of course Scamozzi was a proponent of the classical language, there is evidently no record of his specific arguments in support of his design, only the continued pursuit of the same goal for over 15 years despite the fact that he was poorly compensated and his work was compromised by continual constraints.[62]

4.21 Jacopo Sansovino and Vincenzo Scamozzi, joint between the Zecca and the Libreria Marciana, Venice (Photo: Abxbay)

4.22 Vincenzo Scamozzi, two designs for the joint between the Libreria Marciana and the Procuratie Nuove (Uffizi Gabinetto Disegni e Stampe A194 and © RMN-Grand Palais/Art Resource, NY)

With full acknowledgment of these disputes and difficulties, an assessment from a modern perspective can discern ways that, like the later Palazzo Contarini dagli Scrigni, Scamozzi's design *all'antiqua* was adapted to its particular context. Scamozzi's insistence on a three-story structure, even after a matching third story for the Library was rejected, has been regarded as a sign of insensitivity to Venetian priorities and an arrogant determination to achieve his own vision for the project. But he designed two different ways, both nuanced and sensitive, that a smooth transition from the two-story Library could be accomplished (see Figure 4.22).

This may have been done to persuade opponents to accept his third story, but it also showed a willingness to work carefully to fit existing conditions. Though neither one was executed, they show his skill at manipulating the elements of the language for subtle effects.

Even as built, the abrupt height change is not that disruptive. Scamozzi continued as many horizontal lines as possible (see Figure 4.23): the ground level arcade is completely continuous with that of the Library, and the second order is only altered at the entablature, whose height Scamozzi objected to anyway.

By reducing the entablature on the second order and filling that dimension with balusters for third floor openings, Scamozzi balanced the elements that step down and those that step up at the transition point. The crowning balustrade of the Library is quite tall, so the full visual impact of the height of

the Procuratie is reduced. Continuities visually outweigh the disparities of the façades. In terms of massing, the height shift occurs at the same point at which the vertical shaft of the Campanile is in view. As it turns out, the play of heights lends a compelling dynamic to the corner between the two piazze.

Scamozzi, egotistical or not, had very good reasons for desiring a three story structure. The strongest one arises from compartition, and accommodation of all the required activities. But there is a reasonable case to be made in terms of the building elevation as well. Scamozzi was extremely sensitive to both custom and decorum. The building was to be occupied by nine families from the wealthiest class of Venetians. Typical Venetian palaces of the nobility were three or four stories in height (see Figure 4.24), never two-story structures. Though this was not an individual family's palace, as the offices and residences of the highest nobility it required the dignity and decorum of a three-story façade.

Furthermore, the third story placed the relative heights of the largest buildings in this monumental core of the city in proper sequence: tallest for the Doge's Palace, next the new Procuratie, and a bit lower, the old Procuratie across the piazza, which had apartments for regular citizens in its upper levels. If the Procuratie Nuove had only two stories, it would have been shorter than the older building across the piazza, and therefore inappropriate.

4.23 Jacopo Sansovino and Vincenzo Scamozzi, continuous elevation of Libreria Marciana and the Procuratie Nuove, Venice (Illustration: E. Renouard, photo: author)

4.24 Façades along the Grand Canal, Venice (Photo: author)

Finally, there is a visual balance achieved by two elongated three-story structures facing each other across the piazza. Though they are not the same height, and each has its own distinct rhythm, they are both continuous three-story "liners" for the piazza.

Scamozzi was focused on the convenient arrangement of the interior spaces and their appropriateness to their function. The requirements for the Procuratie Nuove included ground level shops fronting the piazza and official residences for the nine procurators above. The procurators were the second tier of government in Venice, after the Doge. Like him, they represented its citizens, the collective social coherence of Venice. They were obliged by law to live on Piazza San Marco in order to "be present"—to serve the people, be accessible to them, but also to represent the body politic at the heart of the city, along with the Doge in his palace. Like the Doge, they assumed their position for life; the design of permanent residences that would be suitable to their dignity, above anything else, required a third story. Venetian palaces were constructed so that the living rooms were on the piano nobile and above, never at canal level. This served practical purposes of water entries in addition to street entries, but it also kept the living spaces away from the inevitable dampness and flooding. In any case, half of the ground level of the new building was already designated for shops, and the dimension of the site from piazza to canal meant that internal courtyards would be necessary for adequate light and air circulation. After deleting the area of the shops and the

area for courtyards, there would not be sufficient floor area left in a two-story structure, even if part of the ground level were used. Three stories allowed Scamozzi to provide residences that followed some essential Venetian patterns.

In his treatise, Scamozzi described a typical Venetian palace with two entrances, one on the canal, and one on the land that both lead to a large hall (*sottoportico*) with storerooms on both sides, and perhaps some of the workrooms needed for household management. There was a mezzanine level over the storerooms, and then the piano nobile had a grand hall stretching from front to back to get light from both sides and rooms along each side for daily use. He later described his layout of the procurators' residences:

Each has a canal entrance and a land entrance where colonnades lead to a courtyard … [on the second floor] at the front is the main hall and the gentlemen's apartments of large, medium, and small rooms. Facing south east over the canal at the rear is another hall and the womens' apartments … Connecting these apartments are two loggias, each as long as the width of the courtyard. Between the loggias two wide main flights of stairs climb in opposite directions, crossing one above the other, thus serving two floors from one starting point.[63]

Thus, the residences were stacked, one above another, a single courtyard serving two. They were each served by their own stair to maintain privacy. A mezzanine level above each primary story was accessed by smaller service stairs (see Figure 4.25).

Scamozzi's commitment, in spite of a highly constrained site, was to "create a very comfortable home of appropriate status and dignity."[64] The courtyards provided an infrastructure for bright light and well-managed movement. The stairs and connecting loggias that they contain created buffers between public and private functions, between the procurators' offices and reception rooms (the mens' apartments) and the spaces for family life (the womens' apartments). Scamozzi noted the flexibility of his design: "they can also be connected whenever desired by opening the doors to the staircases that give on to the loggias on each floor."[65] Unfortunately, the layout was modified after the completion of the first phase of construction, so only the first courtyard and loggia show the beauty of this arrangement. (This was also the only one to be articulated with the orders in accordance with his design; the expense was found objectionable and so the others were left bare.) Even with a subsequent modification to the definition of each residence,[66] the effectiveness of the Scamozzian compartition of the site is still evident.

The Grand Canal is a watery public space, the main thoroughfare of Venice, lined by noble palaces of three- and four-stories. The width of Piazza San Marco is quite similar to the Grand Canal, and it was frequently filled with the fluid motion of processions and pageantry. The piazza served as a grand entry space for all visitors to the city, and the three-story Procuratie Nuove was meant to be as impressive to foreigners as possible without upstaging the basilica or the Doge's Palace.

4.25 Vincenzo Scamozzi, partial plan and section of Procuratie Nuove, Venice
(Illustration: E. Renouard)

But beyond the show of power that monumental urban centers demanded, specific sensitivities to Venetian society were also a factor. The offices of city procurators would be visited by a full spectrum of citizens on business. In a city where maintaining visible signs of the distinctions between social ranks was codified in sumptuary law,[67] and where frequent public processions represented and reinforced the careful calibrations of the social hierarchy, Scamozzi understood the necessity of maintaining an architectural image suitable to the rank of the intended residents. This would be as important to the comfort of the petitioner of lower rank as it would be to the maintenance of dignity for the procurator. Scamozzi's insistence on the third story over the objections of vociferous opponents and even in the face of his dismissal from the project may have been artistic egoism, or it may have been an insistence on fulfilling the needs and desires of Venetians in a broader sense. The Senate had had difficulty in compelling the procurators to live on the piazza in the past; the crumbling medieval structures were totally inadequate for the patrician class, its habits and expectations. New residences would need to at least approximate the comfort and style of life in their personal residences in order to keep them in place. It was even more important than in villa design for the most noble families that these urban residences with a public function express the concept of *magnificenza*—the glory, luxury, and generosity of a Venetian prince.[68] Scamozzi was confident that his ability to provide for the unique "manner of life"[69] of Venice in the proper form of the project was ultimately more correct than the narrow concerns of his opponents.

Scamozzi's aim was to make a building that not only recognized the standing of the patrician class in the context of Venice, but one that would be seen as noble by all of Europe. He was conscious that the image of Venice was changing, as Wilson puts it, "from myth to metropole."[70] In addition to the overt Romanization of the republican ideal, there was an embrace of cosmopolitan tendencies. Francesco Sansovino's guidebook of 1561 described Venice as a "theater of the world" because the constant presence of exotic foreigners made Venice unique. Scamozzi subsequently described Venice in his treatise as "City of the World," wealthy in all things.[71] Thinking geographically, he fixed the city globally by its latitude and longitude, and described the beneficial effects of its natural environment. Venice is a city dramatically located on the boundary between Italy and the Mediterranean. Analogously, Piazza San Marco is a space of the city, a clearing located between the open water of the Baccino and the dense maze of urban street life. Scamozzi had a modern view of the piazza as a container of space rather than a collection of iconic structures. Forming its edge, Scamozzi's project answered to issues of Venetian geography and Venetian society, the distinctive "manner of life of the nobility and the citizens."

Notes

1 Vincenzo Scamozzi, *L'Idea della Architettura Universale* (Venice, 1615): Book Two Ch. 1, 12, and 17.

2 Scamozzi, *L'Idea*, Book Two Ch. 8.

3 Scamozzi, *L'Idea*, Book Three Ch. 6.

4 Scamozzi, *L'Idea*, Book One Ch. 16: "Each city should not have a singular and unchanging building style."

5 For a concise review of various dimensions of the idea, see Lineu Castello and Nick Rands, *Rethinking the Meaning of Place: Conceiving Place in Architecture-Urbanism* (Farnham, England: Ashgate, 2010): 2–20.

6 Denis E. Cosgrove, *The Palladian Landscape: Geographical Change and its Cultural Representations in Sixteenth-Century Italy* (University Park, PA: Penn State University Press, 1993): 86.

7 Carrie Benes, *Urban Legends: Civic Identity and the Classical Past in Northern Italy, 1250–1350* (University Park, PA: Pennsylvania State University Press, 2011): 170. "The ideological dialogues between Padua and Venice … are conspicuous examples; each city formulated its own civic myth not only for itself but also against its rival, bolstering its civic honor at the other's expense."

8 Scamozzi, *L'Idea*, Book Two Ch. 17: "Many would have it, like Strabo, among others, that the city … was introduced in order to build for the convenience, utility, and conversation of men; because in them, they reunite together for their needs, and in them, they celebrate God and they solemnly observe the holidays; in that all nations concur. Whence all these effects are reasons to retain friendships, which will become greater, the greater the utility and commodity they receive."

9 Leon Battista Alberti, *On the Art of Building in Ten Books*, translated by Joseph Rykwert, Neil Leach, and Robert Tavernor (Cambridge, MA: MIT Press, 1988): 1.9, 23; see also 421.

10 Françoise Choay, *The Rule and the Model: On the Theory of Architecture and Urbanism*, translated by Denise Bratton (Cambridge, MA: MIT Press, 1997): 201.

11 Choay, *The Rule and the Model*, 188.

12 Scamozzi, *L'Idea*, Book Two Ch. 5 and 19.

13 Ann C. Huppert, "Mapping Ancient Rome in Bufalini's Plan and in Sixteenth-Century Drawings," *Memoirs of the American Academy in Rome* 53 (2008): 85. Raphael was first to suggest it in his letter to Pope Leo X.

14 Lucia Nuti, "Mapping Places: Chorography and Vision in the Renaissance," in *Mappings*, edited by Denis E. Cosgrove (London: Reaktion Books, 1999): 91.

15 Naomi Miller, "Mapping the City: Ptolemy's Geography in the Renaissance," in *Envisioning the City: Six Studies in Urban Cartography*, edited by David Buisseret (Chicago, IL: University of Chicago Press, 1998): 39–48.

16 Francesca Fiorani, *The Marvel of Maps: Art, Cartography and Politics in Renaissance Italy* (New Haven, CT: Yale University Press, 2005): 101.

17 Ptolemy, *The Geography*, translated by Luther Stevenson (New York: Dover, 1991): Book One Ch. 1.

18 Nuti, "Mapping Places," 93.

19 P.D.A. Harvey, *The History of Topographical Maps: Symbols, Pictures and Surveys* (London: Thames & Hudson, 1980): 158.

20 Bronwen Wilson, *The World in Venice: Print, the City and Early Modern Identity* (Toronto: University of Toronto Press, 2005): 17.

21 Paul C. Adams, Steven D. Hoelscher, and Karen E. Till, *Textures of Place: Exploring Humanist Geographies* (Minneapolis, MN: University of Minnesota Press, 2001): xix.

22 Denis E. Cosgrove, *Geography and Vision: Seeing, Imagining and Representing the World* (London: I.B. Tauris, 2008): 3–4.

23 Wilson, *The World in Venice*, 14.

24 Deborah Howard, *Jacopo Sansovino: Architecture and Patronage in Renaissance Venice* (New Haven, CT: Yale University Press, 1975): 14.

25 The *proto* was the highest authority in building construction; sometimes the position included design authority as well.

26 Howard, *Jacopo Sansovino*, 3.

27 Antonio Foscari, *Andrea Palladio: Unbuilt Venice* (Baden: Lars Muller, 2010): 21.

28 Scamozzi, *L'Idea*, Book Three Ch. 1.

29 Scamozzi, *L'Idea*, Book Three Ch. 1.

30 Vincenzo Scamozzi, *The Idea of a Universal Architecture III, Villas and Country Estates*, translated by Koen Ottenheym, Henk Scheepmaker, Patty Garvin, and Wolbert Vroom (Amsterdam: Architectura & Natura Press, 2003): Book Three Ch. 6. This translation is from the 2003 Dutch edition; a more direct but less fluid translation would be: "The compartition combines corresponding parts of the building in such a way that the one correlates with the other, and is conveniently placed, and not distorted or confused; they should be convenient shapes and sizes that combine in a way that brings harmony, with nothing random; but with proportions and modules, with nothing superfluous, or lacking anything necessary and important."

31 Alberti, *On the Art of Building*, 1.9, 23.

32 Alberti, *On the Art of Building*, 1.9, 23.

33 Choay, *The Rule and the Model*, 80.

34 Choay, *The Rule and the Model*, 76.

35 Scamozzi, *L'Idea*, Book Three Ch. 9: For example: "In Rome, these houses lie in the vicinity of Via Banchi"; "here in Venice, many merchants live near the Rialto"; "In Bologna and other cities one finds good examples of these types of houses"; "Such houses are quite usual in Padua."

36 Scamozzi, *L'Idea*, Book Three Ch. 6. The title of the chapter is "General expectations for palaces of the nobility in Rome, Naples, Milan, and also here in Venice."

37 Scamozzi, *L'Idea*, Book Three Ch. 2.

38 Scamozzi, *L'Idea*, Book Three Ch. 11.

39 Scamozzi, *L'Idea*, Book Three Ch. 11.

40 Scamozzi, *L'Idea*, Book Three Ch. 11.

41 Scamozzi, *L'Idea*, Book Three Ch. 11.

42 Adams et. al., *Textures of Place*, xiv: "It is precisely the move from 'knowing about' places in an objective way … to 'understanding' places in a more empathetic way, their character and meanings that remains the hallmark of humanistic geography."

43 I am unaware of any other instance of this feature spanning the entire ground level. (Palazzo Massimo in Rome has such a feature at the center only.) However, there was an illustration in the 1550 Bartoli edition of Alberti that shows the arrangement for a public building on a forum. See Margaret Muther D'Evelyn, *Venice and Vitruvius: Reading Venice with Daniele Barbaro and Andrea Palladio* (New Haven, CT: Yale University Press, 2012): 290.

44 Foscari, *Andrea Palladio*, 78.

45 Scamozzi, *L'Idea*, Book Three Ch. 10.

46 Franco Barbieri and Howard Burns, "Palazzo Trissino Baston sul Corso a Vicenza," in *Vincenzo Scamozzi, 1548–1616*, edited by Franco Barbieri and Guido Beltramini (Venice: Marsilio, 2003): 288.

47 Barbieri and Burns, "Palazzo Trissino Baston," 293.

48 Franco Barbieri and Mario Michelon, *Palazzo Trissino Baston: Sede Municipale* (Vicenza: s.n., 2005): 12.

49 Barbieri and Michelon, *Palazzo Trissino Baston*, 12.

50 Bruce Boucher, *Andrea Palladio: The Architect in His Time* (New York: Abbeville Press, 1994): 69.

51 George L. Hersey, *Pythagorean Palaces: Magic and Architecture in the Italian Renaissance* (Ithaca, NY: Cornell University Press, 1976): 160–61.

52 Alberti, *On the Art of Building*, Book Five Ch. 17. It seems to follow Alberti's prescription precisely: "The most important part … is the 'court' or 'atrium' … acting like a public forum, toward which all the lesser members converge; it should incorporate a comfortable entrance, and also openings for light as appropriate."

53 Choay, *The Rule and the Model*, 90.

54 There are two main sources for a detailed account of the political influences on the process: Deborah Howard, *Venice Disputed: Marc'Antonio Barbaro and Venetian Architecture, 1550–1600* (New Haven, CT: Yale University Press, 2011): 171–91; and Manfredo Tafuri, *Venice and the Renaissance*, translated by Jessica Levine (Cambridge, MA: MIT Press, 1989): 166–79.

55 Sebastiano Serlio, *Sebastiano Serlio on Architecture*, translated by Vaughan Hart and Peter Hicks (New Haven, CT: Yale University Press, 1996): Book Four, 313 and 315.

56 David Michael Breiner, "Vincenzo Scamozzi, 1548–1616: A Catalogue Raisonné" (Ph.D. diss., Cornell University, 1994): 220.

57 My narrative is intended for general awareness of the conditions for the design of the Procuratie Nuove. Some of the details are disputed among historians, but they are not critical to this interpretation.

58 Howard, *Venice Disputed*, 2.

59 Tafuri and Howard differ on the timing of the decision. Tafuri places it in 1588, when the structure was complete to the entablature of the second story. I am following Howard's more recent study.

60 Paola Placentino, "Politica ed Economia nella Riconfigurazione Tardocinquecentesca di Piazza San Marco: il Cantiere delle Procuratie Nuove," *Mélanges de l'Ecole Française de Rome, Italie et Méditerranée* 119/2 (2007): 340.

61 Placentino, "Politica ed Economia nella Riconfigurazione Tardocinquecentesca di Piazza San Marco," 340.

62 Howard, *Venice Disputed*, 191.

63 Scamozzi, *L'Idea*, Book Three Ch. 6.

64 Scamozzi, *L'Idea*, Book Three Ch. 6.

65 Scamozzi, *L'Idea*, Book Three Ch. 6.

66 Breiner, "Vincenzo Scamozzi 1548–1616," 140. Scamozzi's 10-bay single-story residences were re-defined as five-bay double-story residences.

67 Wilson, *The World in Venice*, 120.

68 Kornelia Imesch, *Magnificenza als architektonische Kategorie: Individuelle Selbstdarstellung versus asthetische verwirklichung von gemeinschaft in den venezianischen Villen Palladios und Scamozzis* (Oberhausen: Athena, 2003): 37.

69 Scamozzi, *L'Idea*, Book Three Ch. 6.

70 Wilson, *The World in Venice*, 8–17 and 23–69. In the introduction, Wilson describes a 1599 view of Piazza San Marco as a "perspectival space," and in her first chapter she traces a transformation of the city's image in 16th century through an interpretation of maps.

71 Scamozzi, *L'Idea*, Book Two Ch. 18.

5
Chorography and Cosmography: Place and Transcendence

> Cosmos is expressed in our meaningful ornament, so that much more will
> be comprehended, and its nobility comes to reveal itself ample and mighty.
> Vincenzo Scamozzi, *L'Idea della Architettura Universale*

Whether his projects were sited in the country or in the city, Scamozzi approached domestic design as a geographer, taking account of the particular qualities of the natural or urban environment. He designed buildings that represented their situation and portrayed the character of their place and use. He established his geographic intelligence in Book Two of his treatise, and his chorographic inclination in Book Three. Scamozzi's concerns for the private realm were practical, aimed at ease of use and comfort, acknowledging the contingent nature of commodity. But his practicality did not exclude philosophical and spiritual interests; Scamozzi was part of a Venetian culture in which the practical was always associated with the speculative.[1] Through a design process of compartition, he mapped the necessary spaces and their relationships so as to resolve the unevenness and uncertainties of a site and create a noble place for dwelling. He mapped shadow, light, and wind as well as the material construction, composing and ornamenting the interior spaces. His design process was demonstrably synthetic as he thought through the Ptolemaic hierarchy, and inhered the cosmos through the harmonious correspondences of the world. He maintained that drawing plan, section, and elevation was "an unfailing way to know all the natural and artificial (man-made) things, and also in part the supernatural: since by means of drawing we reduce to small form the terrestrial world, and also the celestial."[2]

Alberti and Serlio expressed the belief that architectural mass and space should only be represented by models, and Scamozzi agreed. He never used perspective to suggest the experiential qualities of his designs, though he

5.1 Vincenzo Scamozzi, sketch of the cathedral of Basel from *Taccuino di Viaggio di Parigi a Venezia*, p. 40 (Museo Civico di Vicenza)

was highly skilled at perspective construction. Of course, orthogonal drawings are necessary to accurately depict measure and form, true size and shape. Moreover, Scamozzi wanted to distinguish architectural knowledge and the architect ever more sharply from the artist, so it is not surprising that he adhered to the plan and elevation or section, while painters showed buildings in perspective. In the treatise, he recalled Vitruvius' three kinds of drawing — plan, elevation, and *scaenography*. The third has often been simply translated as perspective, but Scamozzi gave a more specific definition, following the Vitruvian text as closely as possible: an orthogonal view of the front of the building with a receding view of one side.[3] This type of drawing was commonly used in 16th century chorography;[4] Scamozzi used it in sketching existing structures, but not in representing his own projects (see Figure 5.1).

Scamozzi quickly went on to replace the third Vitruvian drawing type, declaring his own preference for plan, elevation, and *"profilo,"* or section, adopted from Barbaro's interpretation of Vitruvius.[5] Architects' rejection of the orthogonal/perspectival combination has been seen by historians as an indication of increasing professionalization — the capacity to distinguish between a drawing that projects the material construction and one that portrays the sensorial appearance of the building.[6] Scamozzi's rigorous logic would naturally prefer that the third type be more consistent with the orthogonal abstraction of the first two.

Architects continued their interest in perspective nonetheless. The discourse on perspective in the 16th century was used to investigate mathematics and optics as well as representation. This scientific inquiry was a key crossroads for greater comprehension of nature as well as artistic production. Using perspective to create a perception of reality in a space of representation was understood to be proof of the sympathy between perspective geometry and the laws of creation.[7] Though Scamozzi excluded perspective from architectural representation, he wrote a full treatise on the subject. Never published and now lost, Scamozzi's treatise was probably a synthesis of Serlio's and Barbaro's books on the topic, both of which relied

heavily on Piero della Francesca's treatise for examples of technical construction methods;[8] perhaps he also had access to Vignola's unpublished manuscript. But Barbaro's treatise established a wider intellectual breadth than the others, one that Scamozzi probably approximated: anatomy of the eye, rules of optics, principles of Euclidean geometry relevant to perspective, stage design, sundials, instruments, and regular bodies.[9] Scamozzi's education would have enabled him to write on all of these topics. He did not master perspective in order to represent his architectural projects; it was to comprehend the nature of reality and truth, and to explore the difference between a form as built, "form in the surfaces of materials," and a form as perceived, "sense perceptible."[10]

Scamozzi used perspective expertly in the creation of illusory space in theaters. The first and most famous were the sets of Palladio's Teatro Olimpico in Vicenza. Though originally intended to be temporary, the sets constructed for the opening production in 1585 have remained in place. The wooden sets placed behind Palladio's stage screen represented the streets of ancient Thebes for the Sophocles tragedy *Oedipus Rex*. Perspective was an aid in the creation of theatrical magic—besides the artifice of illusory space, that is, streets appearing to stretch into the distance though constructed within the confines of a limited backstage space, there was another kind of conjuring: the appearance of a place distant in time and space before the audience. This capacity to bring the distant near put perspective in the realm of cosmography; the power of theater to represent the wide world in a small space provoked the widespread use of 'theater' as a metaphor. Perspective theory and perspective theater scenery were two related demonstrations of a unified cosmos.

The idea of theater as a representation of the world was even more explicit in the Venetian tradition of *teatri del mondo*, pavilions built for processions and other public spectacles. The dome over the pavilion was explicitly cosmographic: images of the planetary spheres, the signs of the zodiac, and other symbolic structures of the cosmos were represented on its surface. Scamozzi designed a theater of the world himself for the 1597 celebration of the coronation of dogaressa Morosina Morosini Grimani in Venice. Together with the cosmic implications of perspective stage scenery, the theater was widely recognized as a transcendental structure. Its cosmic promise was most explicit in the influential work of Venetian Giulio Camillo Delminio. He constructed a famous wooden theater structure in Venice in the 1530s that was intended as a mnemonic device, where memory could assist in accessing all of the knowledge of the world, and which demonstrated in a geometrically and numerologically significant form the connectedness of all things.[11] Theater was explicitly linked in Venetian culture to cosmos and memory; though a material construction existing in a fixed place and time, it escaped terrestrial limitations through the representation of an ideal.

Cosmic Order—Number, Geometry, Proportion

By Scamozzi's time, the appeal of number, geometry, and proportion as evidence of cosmic harmony was well established, and was widely accepted as

a valid basis for architectural design. His work and ideas are readily understood within that world-view. But as with all things, Scamozzi thought through the ideas and relationships for himself, and found his own particular interpretation and logic for widely held beliefs and practices. He studied mathematics with a unique level of commitment among architects, and further rationalized some existing ideas of harmonic order. Having started his career as a surveyor and an estimator with his father, his ease with measure and calculation were early skills and lifelong practices. Measure and number were a habit of mind, evident in almost all of his sketches that survive. His early acquaintance with arithmetic and geometry was expanded through classical studies at school, but more importantly, when he studied contemporaneous mathematics at an advanced level under Clavius in Rome. Highly reputed and extremely influential in his time, Clavius is most famous today for his correspondence with Galileo on Copernican cosmology, his edition of *Euclid's Elements*, published in 1584, and for the Gregorian calendrical reform.[12] From Luca Pacioli to Clavius and others, 16th-century mathematics was indistinguishable from philosophy and cosmography; it was seen as the key for understanding the true nature of being. Today Clavius is considered a key figure in the history of astronomy.[13] Though numbers had many practical uses, including some new ones like accounting, they were still perceived in cosmic terms. Scamozzi was not merely aware of this discourse, he undertook study at its highest level. He conceived of number as a bridge from heavenly phenomena to the earth, and their effect on daily life and habits is an important theme of his treatise.

Scamozzi's theories on the human body and the orders show how he used number in a variety of ways to understand and describe the world. He cast his numeric speculation on the proportions of the body with a wide net of correspondences and sympathies:

And because we have touched many times on the human body, which the Greek sages called the Microcosmos, or little world; whence with great reason it was known as the greatest miracle: first for the immortality of the Soul and of its power; and for its heart, which gives its spirit, and its motion, and the life force to all extremities; and for the easy mobility of all its members; then for the superiority held over all other creatures: and for the spherical form of all its parts together; and for the proportion, and correspondence of all the parts, both internal and external members; and for the excellence of the seeing of the eyes, that are like the two lights of the Sun and the Moon; and for the beauty and ornament of the face; and the four humors and the five senses and many other parts which all have great correspondence and sympathy with the world.[14]

Number provided the links for correspondence between disparate things like the four humors and the four seasons,[15] the two eyes and the two heavenly bodies that illuminate the earth. Two, five, seven, and ten were numbers with special meaning that established correspondence of the body to the rest of nature. In addition to the physical form and features and of the body, invisible attributes such as the soul, the heart, and human intelligence were equally considered. Analogical relationships were established through simple numeric correspondence, sometimes bridging between the visible and the invisible.[16]

He viewed the world in terms of proportional relationships, amongst which number was the primary vehicle of negotiation. Musical harmonies were the demonstration, reaching back to Pythagoras, of proportional relationships in number having cosmic significance. Scamozzi followed in the Pythagorean tradition of holding number as the basis of all learning and learning as coincident with memory, and traditions of the occult as indicated by his marginal reference to the text of Hermes Trismegistus in the discussion of the body as a microcosm cited above.[17] This pre-Socratic tradition was transmitted into classical Greek philosophy by Plato, for whom knowledge was a total apprehension of the divine that came about only through pursuit of the divine truth of number, lost to the soul at birth, and recovered by the arduous exercise of memory throughout the soul's transmigratory life.[18] Scamozzi adhered to the humanists' similar dedication to knowledge, believing that continuous pursuit of knowledge was the essence of the good life,[19] and he insisted on a "remarkable memory" as a necessary attribute of the architect.[20]

Scamozzi combined numerical correspondence with numeric proportion schemes and the geometry of the body in his own complex version of the widely explored Vitruvian man (see Figure 5.2).[21]

His figure combines the stasis of an upright body, vertical support leg and horizontally outstretched arm, with the mobility that he valued—the right leg swings out 45 degrees from the left, and the right arm bends upward. Scamozzi's explication shows the sophistication of his mathematical mind. Like Cesariano's figure, Scamozzi's is related to several concentric geometric figures: in his case, a single circle and three squares. The largest square circumscribes the circle, the smallest is inscribed in the circle, and the third is the mean between the other two, subtending arcs of the circle at its corners. While all of the body's limbs touch the unifying circle, only the upright leg meets the circumscribed square; the right limbs in motion both meet the inscribed square, while the outstretched arm meets the median. Scamozzi was unique for adding numbers to this diagram, and in so doing giving clues to his complex numerology.

The perimeter of the largest square in the figure is divided into 21 small units; Scamozzi then used two-unit measures (marked numerically on the vertical) and three-unit measures (marked graphically) simultaneously to

5.2 Vincenzo Scamozzi, proportional diagram of the human body from *L'Idea della Architettura Universale*, Book One, p. 40 detail (RIBA Library Photographs Collection)

relate body and geometry. Focusing on the larger three-unit module first, the circle's diameter equals seven modules, while the squares have lengths of five, six, and seven. Scamozzi continued the tradition of calling the diagonal of the five-unit square seven (rather than the square root of 50), making all these figures both numerically and geometrically linked in a harmonious way despite his increased mathematical sophistication. Though Scamozzi did not note it in the text, the three-unit modules indicate the man's height as six modules, which accords with the Vitruvian description using the head or foot as a module. By the alternative two-unit body-based module, the upright figure is nine modules tall to the hair-line (as described in the text[22]), a widely used artistic description of the body. The combination of these two systems shows Scamozzi's desire to rationalize the mathematics of the body and its geometries rather than to be content with a graphic approximation. He used number to more convincingly connect the physical, natural form to the abstract geometric form. Scamozzi used the diagram in order to point to the simultaneity of terrestrial and celestial meanings.

Scamozzi was not content to simply show that a body can be fit to a circle and a square as they can best be positioned. His geometric figures are in a fixed relationship to each other, centered on the man's groin and symbolizing man as maker,[23] origin of the circle and square. Scamozzi further explored this iconic diagram for hermetic and Pythagorean numerology in other geometric demonstrations which surround the figure, suggesting their generation by the body. Many of the figures demonstrate the number magic that the r=7 circle contains: its circumference and area are both divisible by 11; an inscribed square measures 10 on each side (the most perfect number[24]) and has an area of 100; an inscribed equilateral triangle measures 12 on each side, corresponding to the months and the zodiac. In Pythagorean numerology, seven symbolizes understanding and health,[25] a numerological link between mind and body, or between the abstract and the physical. In addition to the seven days of the week, the very structure of creation, and the seven planets, the significance of seven was also seen, as Vickers tells us, in the seven creative powers, seven spiritual powers, seven bodily organs, seven bodily orifices, seven geographical areas of the Earth, seven races inhabiting those regions, seven classes of angels, seven months in the life of a human embryo, seven periods of man's life, seven human characteristics, and the seven colors.[26] Scamozzi was the first architect to associate figures with area calculations rather than just linear dimensions, expanding the descriptive power of number, and its usefulness.

Number and proportion are fundamentals of the classical orders. The orders operate in the realm of beauty, making the inherent proportion and order of a building's form visible. Scamozzi's theory of the orders stands in relation to its most immediate predecessors, Vignola and Palladio, in the same way that his Vitruvian figure does—he was re-presenting widely discussed and universally acknowledged forms and ornaments from his own particular point of view, which is to say applying greater rigor and system, and making certain changes that seemed to him more logical (see Figure 5.3).

For instance, his interest in consistency led him to re-name the Composite order. All the others were named for people living in a certain place; therefore the mix of Corinthian and Ionic became "Roman" in his system, as it was first developed by the Romans. He also changed the sequence of the orders, first proposed by Serlio but codified by Vignola and Palladio; in the rank from shortest to tallest, he placed the Roman between the Ionic and Corinthian rather than last. Recognizing that this switch may startle some readers, he offered a number of justifications.[27] He saw it more in keeping with nature, where changes occur gradually from one kind of thing to the next rather than abruptly.

He defined the architectural orders more broadly than previous theorists, as "a particular group or combination of various proportionate and corresponding connected elements," not only the column and entablature. Each appears not only in isolation but also in a full assembly of elements, each tuned to the character of the order (see Figure 5.4).

In his view, the ancients invented them in order to "improve and perfect buildings,"[28] and he placed the details of his system in his sixth book, after three planned books on the proper design of whole buildings (domestic, civic, and sacred). The orders were not the starting point of Scamozzi's design process, but a stage at which the forms and measures of a building were 'improved' with consistency and clarity.

Among the array of Renaissance theorists on the orders, scholars agree that it is the most elaborate,[29] clearly communicating his interest in logic, completeness, and intelligibility.[30] The problem that all 16th-century architects faced with respect to the orders was two-fold: information in Vitruvius was piecemeal and incomplete, and evidence in the fragments and ruins from antiquity varied considerably. Scamozzi had enough historical knowledge to comprehend that most archeological evidence was from a time after Vitruvius, so he had no inclination to follow Palladio's attempts build his system on a Vitruvian foundation.

5.3 Vincenzo Scamozzi, the orders in proportional sequence from *L'Idea della Architettura Universale*, Book Six, pp. 6 and 34–5 (RIBA Library Photographs Collection)

5.4 Vincenzo Scamozzi, Doric arcade from
L'Idea della Architettura Universale, Book Six, p. 75
(RIBA Library Photographs Collection)

5.5 Vincenzo Scamozzi, Ionic capital and entablature from
L'Idea della Architettura Universale, Book Six, p. 101
(RIBA Library Photographs Collection)

His approach was closer to Vignola's, studying Imperial Roman usage and making his own aesthetic judgments. However, he believed in the proportional basis of the idea of the orders, and was determined to establish a system with rigorous logic and integrity to that idea (see Figure 5.5).

In an exceptionally refined and subtle system of proportions, he managed to achieve the comprehensive and systematic theory of Vignola along with the specificity of Palladio.[31] He proposed that the orders are all variations on a single theme, initiated with the Tuscan. They have important distinctions, distinctions that must be maintained in order for the five different manners to make sense. Scamozzi followed tradition in the character basis of his descriptions, ranging from the solidity of Tuscan to the grace of the Corinthian, though he avoided direct physical resemblances to human body types.[32] For him, numerical proportions were the soul of the matter.

Height as a function of the diameter of the column, the module, is a basic defining feature of each order. In explaining his range of heights, Scamozzi connected the perfection of the number 10 to a perfect body to explain the use of 10 modules for his tallest order. Scamozzi recalled the perfection of 10 in antiquity: "it is the start and end to everything for when 1, 2, 3, and 4 are added together they equal 10. As I discussed earlier, these numbers are used to represent the point, line, surface, and volume on which all regular and irregular forms depend."[33] Making the Corinthian order 10 modules tall, he then established the shortest, the Tuscan, in a 3:4 proportional relationship to the Corinthian, or 7-1/2 modules. The middle of the five, the Ionic, was placed halfway between these two, at 8-3/4 modules. No particular reason was given for the Doric and Roman, placed at 8-1/2 and 9-3/4 respectively. But some significance can be found in his Vitruvian figure: 7-1/2 was the level of the outstretched hand, 8-1/2 was the level of the eyes, the "most noble" part of the body, and 9-3/4 was the length of the six-module square. Scamozzi related the orders as a set to geometry and the idea of the body through number and proportion.

From Ideal to Real—Geometry and Geography

Pure geometry had a strong association with urban form in the Renaissance city—it was a shared dream of architects, known as the ideal city, and military designers of urban fortifications (often architects or even artists in the 16th century). For the former, it expressed perfection and the unity of microcosm and macrocosm; for the latter, geometric forms approaching the circle were the most efficient way to enclose a maximum amount of space. Although the majority of Book Two of *L'Idea* is devoted to describing the conditions of existing and historical cities, Scamozzi included three chapters speculating on the construction of a new city from the ground up, a diagram that Scamozzi called universal rather than ideal, and seven more on the design of fortifications, applicable to fortresses or cities. His diagram of

the universal form of a city has the same familiarity as the Vitruvian man diagram; Scamozzi was revisiting essential ideas that were inherited from his predecessors (see Figure 2.1). Two important distinctions must be noted though. First, the plan (and, even more so, its accompanying text) shows a more complex and differentiated urban scheme than preceding plans. More importantly, Scamozzi did not imagine an ideal as a template for material construction. His form was a geometric concept for a design that would need to be adjusted to actual conditions of a chosen site and the socio-political structure the city would serve.

Features that fit well within the ideas that had been explored by architects for at least 100 years include a geometrically regular perimeter wall, a regular pattern of streets, and a regular pattern of open public spaces, especially a principal central space. The perimeter of Scamozzi's plan is dominated by bastions of the type that were in regular use from mid-century onward. Interestingly, his city plan is 12-sided, more than most, and therefore approximating an ideal circular plan more than any since Filarete's plan of the imaginary Sforzinda. The bastions are placed at 180 *passa*, or paces,[34] apart, which was his ideal distance for adequate shielding of the curtain wall in between. As he explained here and elsewhere, 12 points at this distance yields a total perimeter of 2,160 paces, and an area of 376,470 square paces, which he considered large enough to be the seat of a prince (see also Figure 6.4). Scamozzi's plan has a large public square at the center, with a cathedral and the other most important buildings nearby.

Two major groups are distinguishable among the ideal plans of the Renaissance—those with a radial street pattern, and those that fit an orthogonal grid within the geometry of the perimeter walls. The radial plans are more geometrically perfect, and were better suited to military functions,[35] but Scamozzi adhered to the grid in his own version. He was not thinking about military efficiency or classical precedent—he dismissed both as the proper basis for modern urban design. For Scamozzi, an orthogonal grid was a physical trace of the cosmos, and it best served the comfort of the streets and buildings with respect to light and wind. Gates were indicated on some but not many of the preceding ideal plans; Scamozzi's city was connected to the surrounding territory not only by four gates on the cardinal points, but also by the roads shown passing through them and out into the countryside.

Scamozzi's idea had a great deal more detail than its predecessors, going further than the central placement of the main piazza and church. He recommended a hierarchy of street widths based on traffic and use, though the streets in the drawing appear uniform. A large double-square central piazza was ringed by four square ones; every street entering the city passed through a minor piazza before arriving at the main central one. The main square was for the patrician class and political matters; it was meant to be the most ornate. The other squares were assigned a variety of commercial functions, with different products and activities purposely either associated or segregated. His descriptions of them painted a picture of life in the city:

"This is where there will be a general market two or three times a week, based on the needs of the town ... this piazza will be used to sell and buy necessary household items ... the fifth piazza is the one for wine, wood, grain, and hay, for the use of families and the animals they keep."[36] In addition to locating the prince's palace, government buildings, and the cathedral at the center, he described the best places for residences, gardens, and shops, and located eight additional neighborhood churches. Finally, near the perimeter, he placed the arsenal, armory, barracks for soldiers, and horse stalls. Thus his city was not a set of uniformly blank geometric blocks but a hierarchically distributed set of complex functions. He thought not only about where the various ranks of citizens would best be located, but also provided for the soldiers and even the animals. Perhaps the most innovative feature was the waterway that transects the city in its southern half. This engineered canal served transportation and utilitarian functions for the markets and light industries of the city.

This was a time when even existing cities were constructing the style of fortification walls that had been developed to resist canon fire, so Scamozzi of course fortified his city, and designed it with many practicalities of siege in mind. But Scamozzi carefully distinguished between fully functioning city serving a prince that was fortified, and a military fortress that, like a Roman army camp, had only soldiers and the light industries and markets necessary to maintain them. In his city, a military road ringed the perimeter so that soldiers and equipment could move freely between the bastions, and two through-roads traversed the city in each direction without impediment. He placed the armory with care, and strategically split the waterway into two channels outside the walls. But he regarded the military necessities for a defensible city as one of many considerations, and would not let them dictate the whole arrangement.[37] While he provided the necessary defensive elements according to the standards of his day, his city plan was aimed at the physical and spatial rationalization of an urban society.

Scamozzi conceived his city as a universal form that would be adapted to particular conditions in the construction of an actual city. It existed in the realm of geometry, a form in the architect's mind. Its construction in the material realm was not expected to achieve such perfection, though the idea would be visible in the sensible matter. He anticipated the actual conditions of daily life and its necessities, adopting a more demanding approach to the complexities of the social realm and the physical realities of production, consumption, and maintenance of a healthy environment.[38] In addition to church, piazza, streets, and palace, Scamozzi introduced water to his nearly circular city; like Vitruvius, he based the street layout on the winds; and he proposed a city of four gates, participating in a global tendency of urban form that has been called "astrobiological": one that acknowledges an intimate correspondence between the mathematical expression of celestial phenomena and earthbound biologically-based patterns.[39]

Scamozzi followed his chapters on the ideal city with a highly technical treatment of fortresses—military posts designed so that a small number can defend against a larger force. Fortresses either served a nearby city or defended a border. The entire discussion (chapters 23–30) focuses on the engineering of the fortification walls. Scamozzi never addressed the internal layout of the fortress; the two plans that accompany these chapters are partial plans of a segment of the fortifications with a perimeter road, curtain wall, and the bastions, with no interior plan. However, another distinction from the true city is evident—the diameter was about half that of the city. He provided six detailed sections through the fortifications, and placed particular emphasis on calculations, comparing the area enclosed to the length of the perimeter, and the total area of the earthworks (see Figure 5.6).

The superior planning that such detailed calculations provided are a sign that Scamozzi was right up to date with the military treatises of his time, the first architect able to show a scientific approach.[40]

The roles of architect and military engineer were often mixed in the 16th century, but there were an increasing number of experts devoted solely to military planning. Most of the work they did involved the replacement of

5.6 Vincenzo Scamozzi, fortification details from *L'Idea della Architettura Universale*, Book Two, n.p. (RIBA Library Photographs Collection)

medieval wall systems with modern fortifications for existing cities. Scamozzi was among the last to participate in both sides of this mixed discourse at a time when it finally came to be used for a completely new city. The Venetian Senate determined after a century of delay to build a fortress to guard the eastern border of its territories. Begun in 1593, Palmanova remains a unique physical mark in the world that best represents a century of Renaissance ideas of the city despite the difficulties and failures of its construction. Though mistakenly attributed to Scamozzi in the past, Palmanova was most likely constructed on a plan principally authored by Giulio Savorgnan, an official Venetian military engineer, with major alterations and modifications by Lorini, Villachiara, and others during construction.[41] The culmination of 100 years of design development, it is perhaps fitting that a single attribution is impossible. Though it was intended as a fortress, its similarity to ideal city plans and certain details of its construction have caused most historians to regard it as a realization of that architectural idea.

It is ironic that although Palmanova is usually regarded as the most complete realization of the ideal city, the perfection of its polygonal perimeter is the only aspect of its form and construction that was ideal. From the start, it was a confusion of types—the military post and the socio-economically differentiated city—and rather than becoming a fertile hybrid, it widely missed the mark of each. It was not a great fortress, and never a great city. The radial street layout and noticeably large central piazza serve the military function, but only three of the nine radians connect the center to a bastion, a major flaw in military terms.[42] Also, the roads that enter its three gates connect directly to the center, allowing an enemy breach to reach the command point rapidly. The size of Palmanova is closer to the size of Scamozzi's ideal city that to his fortress plans. Palmanova was too large from the start to serve a military function only, but the physical infrastructure for a civil population was never adequately planned or provided. It remained sparsely populated through most of its history, and even though its form is a captivating mark on the surface of the planet, today it lacks the charm and personality of most Italian cities.

Though Palmanova was not designed by Scamozzi, it serves as a contemporaneous physical example of a discourse in which he was engaged, some of which he expressed in his treatise. The historical association to Scamozzi's name arose from the combination of two things: the similarity of its plan to his ideal city plan, and the fact that Scamozzi claimed to have participated in the founding of Palmanova in his treatise. Francesco Milizia, an 18th century historian, was the first to jump to the conclusion that he was the designer, and this error was subsequently repeated.[43] Scamozzi never made that claim, but he did take credit for a major role in the siting of the city, among the party fixing its centerpoint and surveying the first bastion in the fall of 1593. The presumed designer Savorgnan was not there himself, too old and sick to leave Venice. And while others in the party were also capable of handling the surveying, if Scamozzi were there then he could indeed have led that effort. There is room for doubt, as a detailed account of the

whole process of choosing the site was recorded in a diary by one of the five Venetian senators present, Leonardo Donà, and Scamozzi's name was never mentioned.[44] But Howard and de la Croix agree that Scamozzi could have been an unofficial participant brought along by another of the five senators, Marc'Antonio Barbaro. Donà had opposed Barbaro and Scamozzi in debates over the Procuratie Nuove, and he may have omitted Scamozzi's name in his notes on that basis. Whether or not Scamozzi had any direct involvement in founding Palmanova,[45] he must have known much about the disputes and difficulties that plagued its construction, and he can hardly have regarded the result as ideal. His claim is therefore interesting in itself—founder but not designer. As founder, he could be associated with the vision, the idea, rather than with the compromises, contingencies, and failures of the muddy realization.[46]

In any case, Scamozzi buried his contribution to the discourse on the ideal city in Book Two between lengthier sections on his survey of actual city conditions and his highly technical material on modern fortifications. His more innovative investigation into the nature of the city encompassed historical determinants of city location and form, including environmental factors such as water, air, light, and wind, and cultural factors such as population size, economic, and political relationships to other cities, and defenses. Perhaps in the aftermath of Palmanova, where five senators and nine military experts and engineers were officially appointed to determine the site, he declared that only the architect has the comprehensive body of knowledge necessary to determine an advantageous location and the best design for cities. The theoretical stance that emerges from Scamozzi's lengthy treatment is most remarkable because he moved beyond static descriptions of building types and hierarchies typical of Renaissance thinking, seeing in the city what Choay calls "a dynamic field of desires, the power of invention, and the creativity of humankind."[47] He appreciated the cosmic dimension in the idea of the city, but he was more fully tuned to the city as the realm of human affairs.

Villa Duodo, a Cosmography of Rome

The city as an idea operates in quite a different way in the Via Romana, part of a villa commissioned by Venetian brothers Francesco and Domenico Duodo in the late 1580s.[48] Here, Scamozzi explored a relationship between Renaissance interests in body and number, on the one hand, and Pythagorean and hermetic connections between number and memory on the other in creating a representation of Rome in the small town of Monselice. A small church dedicated to San Giorgio was located on the designated villa site. The family obtained permission to reconstruct the chapel in its entirety, but were required to maintain its original dedication. Scamozzi therefore provided a design for the new San Giorgio in its original location, along with plans for a *casa* immediately adjacent.

5.7 Vincenzo Scamozzi, Villa Duodo and San Giorgio, Monselice (Photo: author)

The *casa* itself is unusual—a relatively small belvedere joined to the remaining structure of a medieval tower, the space of which was re-used as an open-air room or cortile. The current L-shaped structure is the result of an addition in the 17th century.

However, the most striking feature of Scamozzi's design remains completely intact: six additional new chapels incorporated into the hillside along the approach road. These six nearly identical chapels were named for the pilgrimage churches in Rome, and by an act of Pope Paul V in 1605, visitors to the Duodo chapels earned the same pardons and indulgences as pilgrims who traveled to the seven churches of Rome. The idea of a villa was hybridized with the Counter-Reformation typopology of the *sacro monte*, and the usual forecourt of the villa was replaced with a 'Via Romana.'

Monselice guards the southernmost reach of the Eugenian Hills, halfway between Padua and Ferrara. In its earliest history, a *rocca*, or fort, controlled the surrounding plain from the top of a prominent hill, while the town skirted its base to the south and west. The *rocca* lost its strategic importance when the town came under Venetian control and instead served as a retreat for a number of Venetian families. The land acquired by the Duodo family was located along a road rising from the town square along the southern flank of the hill. The road climbs at a moderate but steady grade, passing the town's original cathedral and continuing to climb to San Giorgio. From there, the road turns to ascend more steeply to the old fort.

From the start, this project mixed certain categories in an unusual way: the villa combines new construction with the medieval tower structure anchored deep in the hill; while the combination of a villa with the chapel combined public and private, sacred and profane. The two buildings were of relatively similar scale, and were placed side-by-side.

5.8 Vincenzo Scamozzi, Via Romana at the Villa Duodo, Monselice (Photo: author)

The additional chapels along the road to the villa were meant to transform the site into a devotional path, a political act on the part of the clients that demonstrated their allegiance to Roman Catholicism. From the town below, the six chapels climbing the hill dominate the view of the hill, a memorable image. Their repeating forms are a kind of crown, an ornament for the town as well as a new holy destination for the citizens. An 18th century gate now marks the entry of the road to the villa. The carriageway proceeds directly while a footpath departs to the left, rising quickly by stairs in order to parallel the carriageway some two to three meters above it (see Figure 5.8).

Scamozzi's chapels front on this path, spaced out relatively evenly along its gentle curve. The path, a terrace created by a large retaining wall, widens to allow space for each 15-foot square-plan chapel, whose rear wall is engaged in the retaining wall. The six pavilions are backed by a stately row of cypresses, and face a sweeping vista. Each chapel is named for one of the pilgrimage churches of Rome, except the last, which is named for two.

The representation of cities as part of a mythological garden-map was known to Scamozzi from Ligorio's Villa d'Este, under construction in Tivoli

while Scamozzi lived in Rome and mentioned in his treatise. But the Via Romana was not part of a larger narrative garden; it is the primary experience of the site—it is more of a *sacro monte*[49] than a garden promenade. *Sacri monti* were first constructed to represent inaccessible places in the holy land. Others were constructed as their value in Counter-Reformation religious culture was recognized. They generally consisted of a group of small chapels set in a mountain landscape representing a distant or mythic place. The chapels contained dramatic visual representations of religious events in that place. Pilgrims climbed a mountain, leaving behind the everyday world, and then viewed striking religious images of a place and time they had never been, but knew from tradition. The *sacri monti* as a group can be understood as mnemotopias, memory places whose primary purpose was to allow visitors to experience a sense of participation in historical events central to cultural memory; in this case, events of a shared religious narrative.[50] Via Romana, on the other hand, stood for the not-so-distant Rome; pilgrims may have seen the actual place that was represented here. Rather than the representation of dramatic events, the image of Rome is evoked at Villa Duodo by its most significant buildings, the seven pilgrimage churches. Each chapel is identified by a painted inscription and contains an altar surmounted by a painting. The painting portrays the patron saint and incorporates in its background an image of the actual church in Rome. These images are not dramatic or striking like the images at other *sacri monti* are. But Scamozzi's architecture provides additional means to suggest the correspondence of his chapels to the churches of Rome and to stimulate memory.

The numerological correspondence between Rome and its shadow in the Veneto is a central fact of the site: seven pilgrimage churches, seven chapels. Seven is not only the key number of Rome, but also of Delminio's Theater of Memory that contained seven significant images on each of seven levels. Scamozzi had a problem with the numerology of the Via Romana, however. One of Scamozzi's seven chapels was required to maintain its dedication to St. George, and therefore it could not be mapped onto one of the Roman basilicas. Scamozzi gave San Giorgio, the seventh in the row, a different form and aspect. He then assigned the last of the six nearly identical chapels a correspondence with two churches of Rome. The logical choice was Peter and Paul, frequently paired in the history represented by Rome's churches. More importantly, their Constantinian basilicas in Rome were twins, each containing five aisles and seven altars that corresponded to each other.

Numbers and bodies (both burials and relics) were a conspicuous part of the experience of Christian pilgrimage. Their importance was recorded in the written itineraries such as this one by Palladio:

San Sebastiano: This church is located along the Via Appia about a mile outside of Rome ... On the Day of St. Sebastian and on all Sundays in May, there is a plenary remission from sins ... Every day there are 6048 years and as many quarantines of indulgence and the remission of a third part of all sins. Whoever celebrates or has celebrated for him a mass at the altar of St. Sebastian will free one soul from the

punishment of Purgatory ... One hundred and seventy four thousand martyrs are there, among which are numbered eighteen popes. [51]

The use of number in a non-rational scheme such as the indulgences promoted within Christian dogma the occult practice of numerology, establishing in its own terms a correspondence between the visible relic and the invisible life of souls. Body fragments, the relics that sanctified a site within the religious community, stood for shadowy wholes that populated the churches. Indeed, the saints had put their bodies forth as a primary testament of faith, so their corpses were readily understood as the *pignora*, or security deposits, left behind as guarantees of their continuing influence on earthly life.[52] Relics were of course the main currency of medieval pilgrimage in Europe, and they remained of central importance to a pilgrim in Renaissance Rome.

Scamozzi's design for the chapels agreed with other *sacri monti* in its architectural essentials. He rejected the obvious possibility of creating an association to the seven venerated basilicas through explicit architectural imitation. His small centralized structures, though not containing the dioramas of similar centralized chapels at other *sacri monti*, are yet intended to be *looked into* through a screen rather than *entered into*, evoking the sense of theater. The definitive use of the centralized structure at *sacri monti* may have sprung from a number of considerations:

1. the use of pure geometry set up an analogical rather than an imitative relationship to the actual structure;
2. the shape of the plan was easily recognized, therefore it formed an image that was more distinct as a 'place' in the memory operations relying on images and places;
3. it may also have been associated with the early Christian use of centralized structures for martyria.

At Monselice, the chapels were arranged in a fixed sequence, but they were not visually isolated for sharper individuation of each experience as at other sites. Instead, Scamozzi labored to establish a memorable sequence noticeable in three registers: chapel form, the orders, and the dedication. Here, the accumulated presence was equally important as the ability to remember the individual moments.

Two of the six chapels are variations of the basic scheme, having square plans slightly elaborated by lateral niches and a full cupola in place of a groin vault. These formal distinctions produce an A-B-A | A-B-A rhythm as encountered sequentially by the pilgrim. Harmonizing with the rhythm of forms is a more complex pattern in the orders: Doric-Roman-Doric | Ionic-Roman-Ionic. Correspondence with the Roman basilicas associates the Doric with Santa Maria Maggiore and Santa Croce; Roman with San Giovanni and San Sebastiano; and Ionic with San Lorenzo and San Pietro-San Poalo. While this pattern in the disposition of the orders is not immediately apparent as the chapels are encountered sequentially, the variety is readily noticed on otherwise identical edifices.

5.9 Vincenzo Scamozzi, two chapels of the Via Romana (Photos: author)

Within the system of decorum in the application of the orders articulated by Scamozzi in Book Six, the use of the Roman for the more elaborate forms of the second and fifth chapels is clearly logical; the domed structure is a common association for John the Baptist, and may have be seen as a memorial structure for San Sebastiano, which houses the entry to the catacombs in Rome. Roman was perhaps chosen over Corinthian because of its name, and also the small scale of the structures. Attempts to find logic for the use of Doric and Ionic along traditional lines are fruitless; however Book Six demonstrates Scamozzi's purposefulness in matters of the orders. So we must assume that on the Via Romana the traditional gender and character associations were displaced by a more pressing program, an historical account of Christianity. This interpretation is supported by the sequence of chapel dedications as well. The order in which the pilgrim encountered the chapels was not based on a Roman itinerary, as it might have been.[53] Instead, those dedications most closely associated with the life of Christ in the Holy Land were placed first, and their originating role was marked with the more ancient order, the Doric. Those dedications that were associated with the transfer of the center of Christianity to Rome followed; they were marked by the migrant order, the Ionic.[54] Once again, Scamozzi was trying to reconcile two disparate bodies of knowledge by getting them to reflect each other.

His chapels point past the basilicas in Rome for which they are analogues to the story of humanity and divinity they tell. He used the pagan orders to place into memory the historical origins of Christianity.

Scamozzi's pilgrimage site was sanctified at the time of its design neither by historical events nor by a condition of remoteness and isolation as at other *sacri monti*, nor by significant relics. It was sanctified only by correspondence to buildings that were fragmented medieval versions of classical buildings, basilicas in Rome that contained the holiest relics. Scamozzi, who said that "the use of a house is more noble than the house itself,"[55] saw the seven churches of Rome not as built objects but as places of pilgrimage and the symbol of the body of the saint, whose remains it contained. Working analogically and within the tradition of classical forms, he constructed small temples in order to associate the sacrificial body of pagan religion with the martyred saints.[56] The minimal depth of the flat pilasters he used for the orders are in stark contrast to the carved capitals; their recognizable forms are like relics of a fully sculpted column, here standing in for relics of the saints (see Figure 5.9).

Thus, number, proportion, and the orders were all used by Scamozzi to create a memorable image of Rome, a cosmographic map for the religious pilgrim seeking indulgences in Monselice.

Vespasiano Gonzaga's Theater, a Chorography and a Cosmography

Palmanova has been seen as an ideal city because of its perfect shape, but its internal constitution was never ideal. There is a less well-known ideal city where the opposite is the case. Sabbioneta has been largely overlooked in the scholarship on the ideal city, probably because of its irregular perimeter, but the town's geometrically rational plan was built to reflect its social order. Duke Vespasiano Gonzaga (1531–1591) conceived and constructed, starting in 1556 and remarkably complete by the time of his death, an ideal city as a seat of power for himself that would be distinct from the Gonzaga court at Mantua. The city plan was not Scamozzi's design; Gonzaga may have designed it himself,[57] possibly consulting with Pietro Cataneo on the fortifications. But Scamozzi designed one of its most important buildings, the one that still earns Sabbioneta a place in history—the theater, famous as the first permanent theater to be constructed since antiquity. Gonzaga's death led to a rapid decline in the social and cultural importance of the town, but the theater has been preserved as a result. In the theater, Scamozzi united the audience space with the ideal city represented by the perspective stage sets to create a chorographic image of Sabbioneta.

Gonzaga probably chose Scamozzi to design a theater *all'antiqua* based on his skill in the completion of Palladio's Teatro Olimpico in Vicenza.[58] Palladio died in 1580 when construction of the Olimpico had just begun, but the work continued in accordance with his drawings for the *cavea* and *scenae frons*, a curved audience hall and a classically conceived backdrop for the stage.

5.10 Andrea Palladio and Vincenzo Scamozzi, plan and view of stage scenery, Teatro Olimpico, Vicenza (Photo: P. Geymayer)

5.11 Vincenzo Scamozzi, drawing for stage scenery at Teatro Olimpico, Vicenza (Uffizi Gabinetto Disegni e Stampe A197r)

Palladio had attempted to follow Vitruvius, imagining the scenic element as a façade of a noble palace. It was an imposing planar element that emphatically terminated the space of the theater just a short distance from the audience, and it was quite different from the perspective scenery that was typical of 16th century theatrical productions staged in palaces. It was mostly static, although changeable images were intended to be visible behind three relatively small doorways. There were no spatial ambiguities in the Palladian project. When Scamozzi was asked to create a representation of Thebes for the Sophoclean tragedy *Oedipus Rex*, he increased the number and size of the openings in the Palladian façade and placed wooden sets in forced perspective behind each one to represent city streets (see Figure 5.10).

The introduction of the perspective sets completely altered the spatial perceptions from the audience; no longer contained, the ideal urban space receded immeasurably. It was a unique hybrid of the classical theater space and 16th-century stage design, never to be repeated. Other 16th-century architects designed stage sets; Peruzzi and Serlio were likely as skilled in producing the perspective effects as Scamozzi. However, his are the only ones that survive from this period, and they are Teatro Olimpico's most memorable feature. His contemporaries were sufficiently impressed with their virtuosity that a temporary feature became permanent.

The sets of Teatro Olimpico had another significance for the audience viewing them in 1585—in addition to representing ancient Thebes, they were a chorographic image of their own city of Vicenza (see Figure 5.11).

The wealthy citizens of Vicenza had transformed it into an urban theater for their power and privilege, and they built the Teatro Olimpico in order to see themselves reflected in its artistry. The theater captured an ideal image of Vicenza; Cosgrove notes that "it becomes difficult to distinguish between

5.12 Vincenzo Scamozzi, view of theater, Sabbioneta and location diagram
(Photo: J. Derwig; illustration: E. Renouard)

the creation of an illusion of the city in a theater stage set and the creation of the city itself as a stage set."[59] Gonzaga enlisted Scamozzi in order to produce an even more elaborate representation of his political, social, and cultural cityscape at Sabbioneta.[60]

5.13 Palazzo Ducale, Sabbioneta (Photo: D. Papalini)

Scamozzi spent seven days in May of 1588 surveying Sabbioneta and the theater site. His design is preserved in a single autographed drawing, a plan and section that express the synthesis of his response, and was built relatively quickly between 1588 and 1590. Though Palladio's Teatro Olimpico was also intended to be permanent, it shared with the temporary theatrical spaces of the cinquecento the limitations of being constructed within an existing building. Moreover, Teatro Olimpico was built within a mute brick structure that offered no face to the city. Therefore, the massing and façades at Sabbioneta carry special significance: Duke Gonzaga's theater was the first to declare through its form and character an articulate relationship to the street and the city. Scamozzi did not look to the ancient theater as a model for form or expression; he invented a proper character for the theater in the city according to his own time and his own ideas on architecture.

The theater in Sabbioneta fills a rectangular site designated by the city plan in a location halfway between the Duke's fortress and palazzo (see Figure 5.12).

A barn-like box that is about three times as long as wide, and two stories in height, it is engaged in a city block along one of its long walls, but the other three sides face what were then brand new streets. The basic articulation of the box is a palazzo scheme: a base that consists of a plain podium, with rustication at the edges of openings and corners; and a piano nobile with paired pilasters flanking alternating framed niches and windows, mostly blind.

5.14 Vincenzo Scamozzi, elevation details of the ducal theater, Sabbioneta (Photos: author)

The long edge of the theater fronts on Via Giulia, the main east–west street, or *decumanus*, of Sabbioneta, and consists of nine bays, while the short sides are three bays wide. A central portal punctuates each of the three sides; they are identical, though the one facing Via Giulia (south) has a Gonzaga coat of arms above. The two-story articulation, not called for by the interior disposition of space, fit the overall fabric of the city.

Scamozzi aimed at a certain grandeur, but he carefully maintained decorum with respect to other important buildings, in particular the ducal palace and the church, both of which front on the main piazza a few blocks to the north (see Figure 5.13).

The ground floor ornament of the theater is relatively subdued—the rustication is in low relief with a smooth surface. The ornament of the piano nobile has greater variety and higher relief but the overall effect is still fairly flat. Double pilasters sit on a barely projecting string course; minimal articulation suggests that the job of the orders in this façade is to provide rhythm and framing without any substantial sculptural or expressive effect of their own.

Attention is thereby focused on the elements that occupy each bay (see Figure 5.14). These alternate between framed round-headed niches topped by projecting triangular pediments and similarly framed rectangular windows topped by broken segmental arches with inserted oval medallions. The pediments, and the plain sills below them, are the boldest elements of the composition. Though the overall effect as we see it today is not dramatic, it is clearly noble in the context of Sabbioneta. To truly appreciate Scamozzi's intention for the theater's character, however, it is necessary to populate the piano nobile with the statues that would have occupied the niches and the busts in the medallions (see Figure 5.15).

5.15 Vincenzo Scamozzi, speculative elevations of the ducal theater, Sabbioneta (Illustration: E. Renouard)

This lively ensemble would have been the defining feature marking this building as a unique institution in Sabbioneta, signaling on the exterior something of the character of the interior space. The statues with their gestures would have animated the façades, advertising the drama of performances within, and projecting some of that drama to the daily performance of civic life on the street.

The interior contains a double-story theatrical space, book-ended by secondary spaces on two floors at either end. The longitudinal main space contains a raised stage at one end and stepped tiers of seating topped by a curved loggia at the other end. Rooms behind the stage provide access and accommodations for actors and musicians; rooms behind the *cavea*, or audience seating, allowed access for privileged spectators. One of Scamozzi's innovations was to provide separate entries for the players, the audience, and the patron. Stage structure and seating structure occupy either end of a unified space—there is no division between audience and action, just a neutral zone where the space is bounded by the exterior walls (see Figure 5.16).

These lateral surfaces are frescoed to visually link the illusory architectural elements of the stage and the constructed elements of the loggia atop the seating risers. The painted architectural elements of the fresco form monumental arches that appear to open onto bucolic landscapes punctuated with monuments of Rome. Images of the Colosseum and Castel Sant'Angelo (Hadrian's tomb) contribute to an elaborate iconography that was intended to remind theatergoers of Vespasiano's mythic ancestry among the Roman emperors. The painted decorative ornament was carefully designed to knit together the architectural details of the loggia and the downstage elements of the scenery to provide complete visual continuity at the level of the entablature (see Figure 5.17). The open-air scenes seen through the arches, however, simultaneously suggested a spatial gap, signifying an indeterminate space between audience and players. Above the painted arch, a continuous painted balustrade was populated with animated theatergoers of a lesser rank than the live audience seated on the risers.

Though the peristyle surmounting the seating risers is a strong reminder of the Teatro Olimpico, the proportions of Scamozzi's interior are in sharp contrast, with a significantly stretched axis of viewing. Forster shows how the perspective geometries of the entire space, including the stage scenery, maximized the visual effect for the duke in his place of honor in the loggia. The elongation also gave all audience members a view within a visual angle that maintained the effectiveness of the scenery's spatial illusion.

5.16 Vincenzo Scamozzi, plan and speculative section of the ducal theater, Sabbioneta (Illustration: E. Renouard)

At Teatro Olimpico, the radiating street scenes were carefully spaced and angled to provide every sector of the wide audience space an effective illusion; at Sabbioneta, a single street scene sufficed. The addition of the painted elements on the enclosing walls helped the eye to move more easily over apparent inconsistencies, engaging the suspension of disbelief even as the central stage set achieved its full illusion.

It is not surprising that Scamozzi did not repeat Palladio's approach to the scenic structure; he was disposed to work within the theatrical traditions of his own time, best represented by Serlio in his book on perspective. Unfortunately, the original Scamozzi scenery has not survived. Although recent renovations to the whole building have included the construction of some scenery loosely based on Scamozzi's drawing, it does not approximate the rich rhythms and textures seen in the Teatro Olimpico sets, and therefore is not entirely satisfactory in recreating Scamozzi's illusion. His striking innovation at Sabbioneta was the elimination altogether of any framing device through which the audience viewed the stage scene. He made a significant alteration to the Serlian scheme by setting the downstage scenery at an obtuse angle to the theater wall rather than placing it perpendicular to the wall and frontal to the audience.

5.17 Vincenzo Scamozzi, interior views of the ducal theater, Sabbioneta
(Photos: J. Derwig)

In the Serlian stage, these frontal flats did not form a proscenium arch in the modern sense of the term, but they created a similar spatial boundary, an implied plane between the real space of the audience and the illusory space of the set. The frontal planes could be scaled to the real world of the audience hall; a corner or gap could be used to resolve discontinuities as scale changed in the perspective sets. Scamozzi's foremost planes led the eye into the depth of the stage by continuing the painted architectural ornament of the theater walls. Rather than signaling a break to a separate zone of space, the space of illusion, Scamozzi's design unified the audience and actors in a single space while still achieving the illusory urban space of the stage sets. Only the Duke's party seated in the loggia above was partially separated, seated in a location reminiscent of his palace balcony above the main piazza of the city.[61] The relationships of the real world were replicated, miniaturized, captured in a box.

The perspective paradigm is a visual scheme that positions the viewer in relation to a picture or a space; it generated the spatial realm of the Renaissance ideal city.[62] Brunelleschi first demonstrated the laws of perspective with two painted panels of an urban scene, an astonishing accomplishment that has been written about ever since. Kemp recounts how Brunelleschi drilled a viewing hole through his painted panel at the vanishing point and set up a mirror, so a viewer could look through from behind the painting to see the reflected illusion and then lower the mirror to compare it with the actual view of the city square.[63] This double transmission has particular interest for theater: an image passing from the actual urban fabric to the illusion of a panel, and then to the mirror. Summers puts it this way: "the inversion of the rationalization of vision as the possibility of creation of new kinds of illusion leads to theater, the *theatron*, the place for seeing, or *for seeing illusion as if seen*" [italics mine].[64] Kemp is rather less delicate: "Brunelleschi constructed a form of peepshow to heighten its illusion."[65] In the theater at Sabbioneta, Scamozzi used the perspective paradigm, but surpassed its limitations to weave a more complex possibility for the role of the theater in the city. He was not content with seeing an illusion, he wanted the "illusion as if seen." As if in a camera obscura, the spectators entered into a room in which the ideal city outside was projected onto the stage. At the same time, an image of theatrical space was projected outside onto the façades. The ambiguities between urban space and performance space were allowed to echo. Scamozzi's theater as a camera obscura projected the ideal city of Sabbioneta directly into the theater, a city within a city, with a consequential perception of performance space amplified outward from stage, to theater, to street and city and back.

Scamozzi certainly knew of such optical devices from Barbaro and might easily have pondered it, metaphorically, as he used science, mathematics, optics, and perspective to solve an architectural problem and create the illusion of an ideal city in an architectural box located at the center of an ideal city. An even more apt description was available to him in the 1558 *Magia Naturalis* of Giovanni Battista della Porta, who called his room-sized

projection device a *cubiculum obscurum*, and showed that the upside-down image of the simple camera obscura could be corrected by using a lens in the aperture, which also preserved the colors of the projected scene.[66] This improved camera obscura came at the beginning of a new era of scientific instruments for seeing and observing the world. Scamozzi was disposed toward the technical innovations of cartographers and surveyors; and while he may not have seized upon Della Porta's invention literally, his innovative design at Sabbioneta has the aura of early instruments and mechanical wonders. His whole interior, not just the stage scenery, is a miniature ideal city where the essential urban image of Sabbioneta was realized in a space only 37 feet wide and 120 feet long. The theater was a portrait of place in which even the theatergoers formed part of the illusion by maintaining the city's physical and social hierarchy (see Figure 5.18).

The 16th century city was often transformed for festivals with ephemeral constructions that temporarily re-ordered space as the festival itself re-ordered time. The painted frescos visible through the triumphal arches of the theater were not mere reminders of Roman grandeur; they in fact suggested that Sabbioneta was a construction in the heart of another ideal city, Rome. While the suggestion suited his patron's self-image, Scamozzi was an architect for whom all buildings were located in history as well as in space.[67] The Latin inscription featured prominently on the façade, and also repeated within, suggests that Scamozzi invoked perspective with respect to time as well as space: *ROMA QUANTA FUIT IPSA RUINA DOCET* [Rome teaches us how great she was by her ruins]. His use of the phrase, which had been used prominently by Serlio among others, has been interpreted as nostalgic.[68] But Scamozzi had less nostalgia for antiquity than his predecessors. The inscription in fact acknowledges his own chronological perspective and its limitations. It reminds us that even Rome, however great, passed to ruin; it provokes the pretenders to antique forms of performing, of building, and of ruling to remember not only the grandeur but also the past-ness of the past.

5.18 Diagram of the correspondence between the ducal theater and Piazza Ducale: A—Duke's balcony; B—Piazza Ducale; C—Theater; D—Duke's viewpoint; E—Stage (Illustration: E. Anderson)

Notes

1. Denis E. Cosgrove, "Mapping New Worlds: Culture and Cartography in Sixteenth-Century Venice," *Imago Mundi* 44 (1992): 81.

2. Vincenzo Scamozzi, *L'Idea della Architettura Universale* (Venice, 1615): Book One Ch. 6.

3. Scamozzi adheres to orthogonal drawings in the treatise; among his few surviving sketches there is evidence of occasional use of perspective combinations.

4. For instance, Egnazio Danti used this type of view in compiling views of structures throughout the territory of Bologna for his monumental map cycles. See Mario Fanti, *Ville, Castelli e Chiese Bolognesi da un Libro di Disegni del Cinquecento* (Bologna: Arnaldo Forni, 1996).

5. Scamozzi, *L'Idea*, Book One Ch. 14; Vitruvius, *I Dieci Libri dell'Architettvra*, translated with commentary by Daniele Barbaro (Venice: Appresso Francesco de'Franceschi Senese, 1567): 1.ii.

6. James Ackerman, *Origins, Imitation, Conventions: Representation in the Visual Arts* (Cambridge, MA: MIT Press, 2002): 46–56.

7. Denis E. Cosgrove, *The Palladian Landscape: Geographical Change and its Cultural Representations in Sixteenth-Century Italy* (University Park, PA: Penn State University Press, 1993): 200.

8. Francesca Fiorani, "Danti Edits Vignola: The Formation of a Modern Classic on Perspective," in *The Treatise on Perspective: Published and Unpublished*, edited by Lyle Massey (Washington, DC: National Gallery of Art, 2003): 134.

9. Fiorani, "Danti Edits Vignola," 147.

10. Scamozzi, *L'Idea*, Book One Ch. 12.

11. Cosgrove, *The Palladian Landscape*, 242. See also: Frances Yates, *The Art of Memory* (London: Routledge and Paul, 1966) and Marco Frascari, "The Mirror Theater of Vincenzo Scamozzi," in *Paper Palaces: The Rise of the Renaissance Architectural Treatise*, edited by Vaughan Hart and Peter Hicks (New Haven, CT: Yale University Press, 1998). Delminio's memory theater was fully described and analyzed by Yates; Frascari has connected Delminio to Scamozzi's work in several ways.

12. Peter Dear, "The Church and the New Philosophy," in *Science, Culture, and Popular Belief in Renaissance Europe*, edited by Stephen Pumfrey, Paolo L. Rossi, and Maurice Slawinski (Manchester: Manchester University Press, 1991): 119–39: Clavius was professor of mathematics at the Collegio Romano until his death in 1612. In addition to putting "the Catholic world back in tune with the sun in 1582," he championed the establishment of mathematics as a standard part of the Jesuit curriculum.

13. James M. Lattis, *Between Copernicus and Galileo: Christoph Clavius and the Collapse of Ptolemaic Cosmology* (Chicago, IL: University of Chicago Press, 1994): 3.

14. Scamozzi, *L'Idea*, Book One Ch. 12.

15. Scamozzi, *L'Idea*, Book Two Ch. 16.

16. Scamozzi, *L'Idea*, Book One Ch. 3. Scamozzi makes a distinction between abstract use of numbers and quantities.

17. Ancient Egypt was the supposed source of both the texts of Hermes Trismegistus and the special knowledge of Pythagoras.

18. Alister Cameron, "The Pythagorean Background of the Theory of Recollection" (Ph.D. diss., Columbia University, 1938): 36.

19. Cameron, "The Pythagorean Background," 30. The "theoretic life" was axiomatic to Pythagoreanism of the 5th century B.C.E.

20. Scamozzi, *L'Idea*, Book One Ch. 7.

21. Scamozzi, *L'Idea*, Book One Ch. 12.

22. Scamozzi, *L'Idea*, Book One Ch. 12: 1 m from the beginning of the hair to the chin, ½ m from the chin to the pit of the throat, 1 m from throat to breasts, 1 m from breasts to navel, 1 m from navel to genitals, 1 m to the middle of the thighs, 1 m to the knees, 1 m to the middle of the shins, 1 m to the ankle, ½ m from ankle to the bottom of the feet = 9 m.

23 George L. Hersey, *Pythagorean Palaces: Magic and Architecture in the Italian Renaissance* (Ithaca, NY: Cornell University Press, 1976): 119.

24 Scamozzi, *L'Idea*, Book Six Ch. 10: In choosing 10 as the height in modules for the Corinthian order, Scamozzi elaborates on the perfection of 10. See also, Alistair Macintosh Wilson, *The Infinite in the Finite* (Oxford: Oxford University Press, 1995): 367. "The Pythagoreans were particularly fascinated by the number ten … Philolaus [wrote in 450 B.C.]: 'The activity and the essence of the number must be measured by the power contained in the notion of 10. For this (power) is great all-embracing, all-accomplishing, and is the fundament and guide of the divine and heavenly life as well as of human life.'"

25 Wilson, *The Infinite in the Finite*, 367.

26 Brian Vickers, "On the Function of Analogy in the Occult," in *Hermeticism and the Renaissance: Intellectual History and the Occult in Early Modern Europe*, edited by Ingrid Merkel and Allen G. Debus (Washington: Folger Shakespeare Library, 1988): 268.

27 Scamozzi, *L'Idea*, Book Six Ch. 24.

28 Scamozzi, *L'Idea*, Book Six Ch. 1.

29 Joseph Rykwert, *The Dancing Column: On Order in Architecture* (Cambridge, MA: MIT Press, 1996): 33.

30 Vincenzo Scamozzi, *The Idea of a Universal Architecture VI, The Architectural Orders and Their Application*, translated by Patti Garvin, Koen Ottenheym, and Wolbert Vroom (Amsterdam: Architectura & Natura, 2008): Introduction, 13.

31 Scamozzi, *The Idea of a Universal Architecture VI*, Introduction, 9–13.

32 Scamozzi, *L'Idea*, Book Six Ch. 10.

33 Scamozzi, *L'Idea*, Book Six Ch. 10.

34 The Venetian foot was 34.8 cm; a pace equalling 5 feet would be approximately 1.75 m.

35 Horst De la Croix, *Military Considerations in City Planning: Fortifications* (New York: Braziller, 1972): 48–50.

36 Scamozzi, *L'Idea*, Book Two Ch. 21.

37 Scamozzi, *L'Idea*, Book Two Ch. 22.

38 Alessandro Nova, "The Role of the Winds in Architectural Theory from Vitruvius to Scamozzi," in *Aeolian Winds and the Spirit in Renaissance Architecture: Academia Eolia Revisited*, edited by Barbara Kenda (London: Routledge, 2006): 83. Nova's observation is in regard to Scamozzi's capacity to design for natural forces, but applies equally well to his consideration of urban social factors.

39 Paul Wheatley, *The Pivot of the Four Quarters: A Preliminary Enquiry into the Origins and Character of the Ancient Chinese City* (Chicago, IL: Aldine, 1971): 14.

40 Martha Pollack, "Military Architecture and Cartography in the Design of the Early Modern City," in *Envisioning the City: Six Studies in Urban Cartography*, edited by David Buisseret (Chicago, IL: University of Chicago Press, 1998): 114.

41 De la Croix, *Military Considerations*, 51; David Breiner, "Vincenzo Scamozzi, 1548–1616: A Catalogue Raisonné" (Ph.D. diss., Cornell University, 1994): 726; Deborah Howard, *Venice Disputed: Marc'Antonio Barbaro and Venetian Architecture, 1550–1600* (New Haven, CT: Yale University Press, 2011): 193–211. Each give somewhat different accounts, but are essentially agreed that Scamozzi was not the designer, that Savorgnan was the most likely source of the original plan, and that it was subjected to numerous changes.

42 De la Croix, *Military Considerations*, 50.

43 Horst De la Croix, "Palmanova: A Study in Sixteenth Century Urbanism," *Saggi e Memorie di Storia dell'Arte* 5 (1966): 26.

44 Howard doubts his presence at the founding on these grounds, but a fabrication of this nature seems out of character with the rest of the treatise. Scamozzi is often proud and boastful, but he credits others liberally throughout and he is a constant champion of truth and virtue.

45 De la Croix, "Palmanova," 41. De la Croix suggests that Scamozzi was responsible for some of the design changes later in the process.

46 Howard, *Venice Disputed*, 200–207. Howard gives a vivid detailed account of the difficulties faced by Marc'Antonio Barbaro as the first supervisor of the construction of the fortifications.

47 Françoise Choay, *The Rule and the Model: On the Theory of Architecture and Urbanism*, translated by Denise Bratton (Cambridge, MA: MIT Press, 1997): 198.

48 Adriana Augusti and Guido Beltramini, "La villa per Francesco e Domenico Duodo," in *Vincenzo Scamozzi, 1548–1616*, edited by Franco Barbieri and Guido Beltramini (Venice: Marsilio, 2003): 301.

49 Thomas K. Davis, "Scamozzi's Duodi Estate in Monselice: Affirming an Architecture of Ambiguity," *Proceedings of the 78th Annual Meeting of the Association of Collegiate Schools of Architecture* (1990): 55–65. Davis interprets the Villa Duodo complex as "an architecture of ambiguity" based on a typological reading, identifying in the project elements of villa gardens, *sacri monti*, and urban design.

50 Judith Wolin, "Mnemotopias: Revisiting Renaissance Sacri Monti," *Modulus* 18 (1987): 47–8.

51 Eunice D. Howe, *The Churches of Rome* (Binghamton, NY: Center for Medieval and Early Renaissance Studies, State University of New York, 1991): 84.

52 Patrick Geary, "Sacred Commodities: The Circulation of Medieval Relics," in *The Social Life of Things: Commodities in Cultural Perspective*, edited by Arjun Appadurai (Cambridge: Cambridge University Press, 1986): 176.

53 Howe, *The Churches of Rome*, 76–85. Palladio's sequence in his guidebook to Rome was: San Giovanni, San Pietro, San Paolo, Santa Marie Maggiore, San Lorenzo, San Sebastiano, and Santa Croce.

54 Scamozzi, *L'Idea*, Book Six Ch. 21. Scamozzi discussed at length the history and wandering of the Ionic population.

55 Scamozzi, *L'Idea*, Book One Ch. 3.

56 George Hersey, *The Lost Meaning of Classical Architecture: Speculations on Ornament from Vitruvius to Venturi* (Cambridge, MA: MIT Press, 1988): 77–117: Hersey shows that Renaissance architects were keenly sensitive to the meaning of the temple and its sacrificial rituals as the original site of the orders.

57 Kurt Walter Forster, "From *Rocca* to *Civitas*: Urban Planning at Sabbioneta," *FMR* 7/30 (1988): 99.

58 The story of Teatro Olimpico can be found in many sources. See Bruce Boucher, *Andrea Palladio: The Architect in His Time* (New York: Abbeville Press, 1994): 250–53; Lionello Puppi, *Andrea Palladio: The Complete Works* (New York: Electa/Rizzoli, 1989): 277–82; Robert Tavernor, *Palladio and Palladianism* (New York: Thames & Hudson, 1991): 103–5.

59 Cosgrove, *The Palladian Landscape*, 241.

60 Kurt Walter Forster, "Stagecraft and Statecraft: The Architectural Integration of Public Life and Theatrical Spectacle in Scamozzi's Theater at Sabbioneta," *Oppositions* 9 (1977): 99–120; Lex Hermans, "The Performing Venue: The Visual Play of Italian Courtly Theatres in the Sixteenth Century," *Art History* 33/2 (2010): 293–301; Stefano Mazzoni, "Vincenzo Scamozzi Architetto-Scenografo," in *Vincenzo Scamozzi, 1548–1616*, edited by Franco Barbieri and Guido Beltramini (Venice: Marsilio, 2003): 71–86. Forster's seminal interpretation of the project focuses on its role in the development of theater design as a distinctive social and spatial type and he articulates its political and rhetorical message in terms of a symbolically potent location and iconographic program. Hermans and Mazzoni updated and extended Forster's work so that we can now fully appreciate the dramatic intentions of its patron, Duke Vespasiano Gonzaga in making a highly visible gift of a theater to his city just as the Emperor Vespasian, his mythic predecessor, had bequeathed the Colosseum to the Roman population. Both rulers gave something to the city that had heretofore been privately held by the ruling class.

61 Forster, "Stagecraft as Statecraft," 74.

62 Renée van de Vall, *At the Edges of Vision: A Phenomenological Aesthetics of Contemporary Spectatorship* (Aldershot: Ashgate, 2008): 40.

63 Martin Kemp, *The Science of Art: Optical Themes in Western Art from Brunelleschi to Seurat* (New Haven, CT: Yale University Press, 1990): 11–14.

64 David Summers, "'The Heritage of Agatharcus': On Naturalism and Theatre in European Painting," in *The Beholder: The Experience of Art in Early Modern Europe*, edited by Thomas Frangenberg and Robert Williams (Aldershot: Ashgate, 2006): 13.

65 Kemp, *The Science of Art*, 12.

66 Siegfried Zielinski, *Deep Time of the Media: Toward an Archaeology of Hearing and Seeing by Technical Means* (Cambridge, MA: MIT Press, 2006): 89.

67 Choay, *The Rule and the Model*, 197.

68 Hermans, "The Performing Venue," 298.

6
"A Scientific Habit"

> ... and from his reasoning man comes to knowledge of the causes ... and in this way becomes a scientist; so, from this is finally born a beautiful Idea, which is a habit of our intellect, from which the architect pulls out noble inventions and graceful designs of the things that he wants to build.
> Vincenzo Scamozzi, *L'Idea della Architettura Universale*

Vincenzo Scamozzi was born in the same year as Giordano Bruno and died the same year as Shakespeare, two of the many contemporary figures that represent for us the essential cultural changes that took place in what Bouwsma has called "the waning of the Renaissance."[1] It is a fascinating time, just when the possibility of one person knowing everything there was to know was disappearing. His architectural work is characterized chiefly by the tradition he inherited and fully embraced, even though suggestions of emergent Baroque and neoclassical themes have been observed.[2] Some see his treatise in the same light, an imposing assimilation of previous Renaissance treatises, the final and most complete statement of the tradition.[3] But others see in *L'Idea* something far more profound, a proposal that fundamentally altered the definition of architecture.[4] Its length and complexity, Scamozzi's wide knowledge of Roman antiquity and contemporaneous architecture, and his embrace of the intellectual and cultural changes taking place in his own lifetime allow both to be true at once: Scamozzi both synthesized his inheritance and applied his own unique outlook to it. This book has focused on Scamozzi's built work and Book Two of his treatise, but in reflecting back on the works that have been presented, it may be helpful to convey a few of its other important themes.

Scamozzi continued an effort evident among Renaissance architects from Alberti onward to define architecture as an independent profession. There were two related conditions that professionalization could address. One was a confusion about whether architecture was more properly allied to the

fine arts or to technical training in construction and mechanics. The other, more important, was the fact that in either case, it had a low status as a discipline previously based in the guilds and involving hand labor. Alberti was fully aware of the tensions that arose from the widely disparate social status of the guild-formed architect, still indistinguishable from a master craftsman in the 15th century, and the princely patron, and its potentially negative consequences for architecture and the city. The architect needed at least enough social standing to discuss the ideas and intentions of the project; better, the architect should be able to command the respect of the patron and convince him of the superiority of his judgment in architectural matters. This social context for the architects of the 16th century underwent a certain degree of change, but the fundamental problems identified in the 15th century by Alberti were not left behind. Scamozzi made a vigorous effort to push professionalization farther still through his definition of the architect as an intellectual, his ideas on the necessary knowledge and skills of the architect, and his view of the process of design.

Scamozzi's capacity to reach backwards and look forward simultaneously is evident in his definition of architecture as "a speculative science." He read Barbaro's edition of Vitruvius three times, which begins with the words "Architecture is a science of many disciplines ..."[5] Barbaro went on to emphasize science, an intellectual understanding of the world, over art or skill, over a poetic or experience-based approach to building. Scamozzi was also greatly influenced by the emerging experimental sciences of his time. At the core, Scamozzi meant by his own characterization that architectural production was an intensely intellectual process requiring knowledge, memory, and will, and that design should always be guided by the rational rules of nature. The architect should constantly refine his architectural intelligence by "studying and seeking the reason of things."[6] In addition to his vast learning from books (he was proud of his library), Scamozzi was a keen observer of the world around him. Though he continued to consider ancient Roman architecture superior, Scamozzi sought architectural knowledge by studying other building traditions as well. Like the natural philosophers of his day, he wished to account for the variety of an expanding world. He held the conviction that by meticulous observation and description, the architect could accumulate an understanding of the causes of things, the way that things work. Scamozzi practiced architectural design as a process of collecting information, reflecting on it, and finding a single solution that would work well as a part of the *macchina del mondo*. Scamozzi advanced architectural thinking in a time of cultural change and transition.

Describing the Architect, Advancing the Profession

The status of the architect in 16th century Italy varied widely based on custom and circumstances. Wilkinson maintains that the emergence of the architect as an independent specialist occurred earlier in the north, where

the architect had achieved "full professional status" by the 1560s.[7] By this, she means an education that did not depend entirely on construction sites and craft workshops, and a career that did not rely on one or two influential and wealthy patrons,. Alberti had defined the architect as distinct from the craftsman in the mid-1500s, suggesting that the architect was an intellectual with a liberal education in addition to superior technical knowledge. But his view on the proper education of the architect remained implicit in his treatise, and his vision made no immediate impact on architectural practice. Daniele Barbaro, in his 1556 commentary on Vitruvius, confronted the architect/client relationship directly, essentially assigning the programming to the client and leaving design to the architect,[8] somewhat surprising since he was a well-informed client, and not an architect. French architect Philibert de l'Orme also set educational standards, defined roles and responsibilities for the architect, and defined relationships to the client and the builder in his 1567 treatise. Scamozzi read all of these, and by virtue of his own experiences, he was ready to go even further on matters of professional education and authority.

In fact, Scamozzi's biography suggests that his father, Giovanni Domenico Scamozzi, had formed an equally distinct idea of the architect around the same time as Barbaro did. After deciding early on that his son Vincenzo would be an architect, he provided his son with a classical liberal arts education instead of apprenticing him within a trade or a practicing architect's workshop. Perhaps he was inspired to choose this route by seeing first-hand Palladio's successful transition, in the decade before Vincenzo's birth, from craftsman to architect as a result of a late humanistic education and several trips to Rome. Palladio's education was provided by a patron, humanist Giangiorgio Trissino. But Vincenzo Scamozzi was the first to enter into this educational path as a youth with the goal of practicing architecture, an education provided for by his own father. Thus he was truly independent of the workshops and patrons of the old system.

In addition to choosing a path for his son that was unique, the elder Scamozzi also wrote about the knowledge and qualities needed by an architect and about the architects' relations to client and builder in his preface to his collected edition of Serlio's books. The preface, entitled "Discourse of M. Gio Domenico Scamozzi Vicentino," proposes that the architect must be a person of "very high quality both of mind and body ... the highest intellect ... lively and ready to embrace important things and know how to bring them to completion. He should be of a serious demeanor, but also pleasant when giving orders."[9] He listed six competencies: educated in humanistic studies, ideas of beautiful forms and knowledge of antiquity, knowledge of mathematics (geometry, proportion, measure, estimates), perspective theory, model-making skill, and knowledge of natural forces affecting sites and the nature of materials.

Giovanni Domenico Scamozzi was never recognized in any surviving accounts as an architect, but is believed by some historians to have designed some of the buildings around Vicenza that he worked on. There is more certainty that he was a land surveyor and a construction cost estimator,

indicating that he had a mathematical education at the very least. In addition to technical work related to architecture, G.D. Scamozzi was engaged at a reasonably sophisticated level in the architectural discourse of Vicenza. Barbieri credits him with recognizing a problem inherent in Serlio's treatise but never fully confronted: the gap between conception and execution of a building, between design and construction. Scamozzi addressed it by defining the roles of the architect, the patron, and the craftsmen. Some have hypothesized that the "Discourse" was actually the work of his son Vincenzo, but if so, his ideas changed somewhat by the time he was writing *L'Idea*. The unique thing about the "Discourse" is that it not only separated the spheres of the architect and the craftsmen by making the architect a scholar, it actually inserted another figure into the construction process, an "under-architect" or site supervisor. This role was described as needing someone "very intelligent," but with practical knowledge of materials and construction processes. It is not clear if this was intended to re-characterize the master-builder, or if this under-architect would have a master-builder under him. But in either case, this figure was intended to serve the interests of the architect, which the master-builder was not necessarily known to do. Perhaps G.D. Scamozzi was trying to legitimize his own role in the work he had done. If so, this self-portrait anticipates the autobiographical element of *L'Idea*.

In *L'Idea*, Vincenzo Scamozzi built on many of the other ideas of the "Discourse," expanding in particular the intellectual expectations for an architect. But he expected the architect to supervise the work himself, and to make sure that the master-builder did not attempt to make independent decisions or impose his own ideas on the project. Scamozzi intended to discredit two common paths to practice in his day: painters, who may know how to make images of buildings but know nothing of architectural principles or construction; and master-builders, who have technical knowledge, but can only imitate other designs without understanding them. In either case, Scamozzi scorned the capacity for "natural instincts" born of craft experience or artistic intuition to yield satisfactory results. He repeatedly asserted the authority of the architect, the one who could understand "causes" and aims, over the master-builder: the relationship between the two was described by him in separate places as master/servant and general/soldier. Though he never put it this way himself, a reader can surmise that the builder would at best take care of that part of architecture that is physical but would be blind to its responsibility to create a better quality of life. Comprehensive education would not only assure a better building, it would allow the architect to communicate more effectively with patrician clients. This would in turn assure that the client would be less likely to confuse the locus of authority in the project. Scamozzi also recommended that the architect have plenty of money to be able to afford both formal education and travel, not only furthering the social distinctions between architect and builder, but essentially restricting the profession in terms of socio-economic origins.

Vitruvius had included a wide array of subject areas within architectural knowledge, but had only expected general knowledge of each. Scamozzi pointedly disagreed, and insisted that the architect must attain expertise, requiring a complete liberal arts education. In addition to commanding an impressive body of knowledge, Scamozzi required the architect to think like a mathematician or natural philosopher, not like a poet—able to question, to reason, and to discern truth. He needed refined judgment in surveying the work of others, and the capacity to question his own intuitive ideas through a process of reasoning. In addition to substantial general knowledge, Scamozzi also enumerated plenty of discipline-specific knowledge: "various kinds of building, capability to invent solutions, clarity in illustrating with drawings and models, knowledge of forms and their manipulation, calculate the expenses, consider materials."[10] He thought that the architect needed to know the principles of materials and construction but not in the same way as the builder—a more theoretical knowledge of causes and goals, so that he can explain things to the client and also to make sure that no decisions are left to the master-builder.

Interest and desire, wealth, travel, and education were yet not enough; Scamozzi went further. "An architect should be clever, phlegmatic, ready to find new solutions, creative, with a remarkable memory and very well up on his discipline; he should be healthy in order to face studies and travels. He should also be handsome and very kind in talking in order to convince his audiences."[11] Scamozzi saw certain innate qualities such as creativity, good health, and good looks as contributors to success. He thought that design skill could not be taught, but was a natural gift. Scamozzi recognized that he was establishing a high standard of expectation, and he acknowledged that it was extremely difficult to reach any level of excellence as an architect. In his mind, a design was the result of profound learning and reflection, a synthesis of celestial, terrestrial, and human factors. It should never be subjected to the instincts, opinions, or judgments of anyone with a less than complete understanding of the world. In his view, no one else was qualified to interfere with the design of the properly educated and practiced architect—not the client or the builders.

In addition to narrowing the path of entry to the profession by disqualifying artists and builders and by establishing an extremely ambitious educational expectation, Scamozzi broadened the scope of the profession and established certain professional responsibilities. In Book Two, he challenged the architect to be a geographer and urban designer. He should also be an effective speaker—drawings and models alone will not "sell" the building. The architect must not merely explain, but should excite others about his design. The architect must oversee the master-builder, and provide the client with realistic and accurate cost estimates so that work is never begun without sufficient funds for completion. Repeatedly throughout *L'Idea*, the reader can see how pained Scamozzi was by unfinished buildings and fragments of construction that detracted from the nobility of a city. He also wanted the

architect to take responsibility for knowing how to restore buildings rather than only being concerned with new works. His interest in the upkeep of the urban fabric was consistent with a general attitude we might now describe as environmental stewardship.

He gave advice on the ethics of payment for work, and also on professional comportment.[12] Scamozzi may have been the first to establish fair competitive practices: no illicit means (such as bribes) to win a job, and no courting another's client. In a competition, an architect should never look at someone else's design, or he may inadvertently adopt some aspect of it. He should not "excessively praise" his own works or criticize them, but should modestly accept positive comments of others. Other advice includes checking the drawings before beginning construction—a relatively modern idea indicating the authority of the drawing and its relationship to the construction. The drawing is more than an indication of general intentions to be interpreted and brought to full completion in construction, it is instead an explicit set of instructions for the overall design and the details, ornament, and finishes. He was also explicit about protecting "authorship," essentially intellectual property rights, from the master-builder. This need for protection had been implicit in Vasari's story of Brunelleschi and the construction of dome in Florence at the start of the Renaissance,[13] but in that case the technical idea was out of reach of the builders on the job. In most of Scamozzi's work, no unusual technical knowledge was called for, so any builder could proceed without him once he had drawings indicating the dimension and arrangement of elements. To maintain authority, he found he had to maintain control of the drawings, only giving information as needed. Finally, after a career marked by significant work of this kind, he advised avoiding taking care of "those works left incomplete by someone else, since in the end all the praises would go to his predecessor, and all the mistakes would be attributed to him."[14] In the case of the praises, he may have been thinking of Teatro Olimpico; the joint between the Zecca and the Library in Venice might have been a "mistake" that he had been blamed for (see Figure 4.23).

Scamozzi was acutely aware of his reputation and legacy. He saw his treatise, as others before him saw theirs, as a service to the profession, a means to spread sound architectural knowledge. He was also either author or major contributor to an index for the Serlio publication that included his father's "Discourse." These were additions that were meant to make Serlio's treatise easier to use. They were meant to help other professionals, and in doing so to boost the quality of architecture overall. This interest in spreading architectural knowledge seems at first to be counter to a provision of his will to burn all of his drawings. Drawings were a primary means in the Renaissance of sharing knowledge, and Scamozzi himself said that there are some things that can only be expressed visually. However, his wish was consistent with his belief in a certain truth of architecture. Studies or iterative schemes might have contained what he would later regard as errors once he had finalized a design. He did not wish to propagate anything that was imperfect, or, in his

way of thinking of it, erroneous. Furthermore, he wished his reputation to survive on the basis only of his completed thoughts, not his 'speculations.' Finally, he did not really value drawings as artifacts with any independent worth. He regarded drawings as communications to clients and builders, instruments of the design and construction process, not generally interesting or valuable in and of themselves.

Scamozzi consistently reminded the reader of *L'Idea* that the real point of architecture and the city is to improve the quality of life. This fundamentally ethical positioning of architecture in the service of society was not itself new; Alberti certainly appreciated this dimension, as did Cornaro, Barbaro, and others. But Scamozzi made it the architect's responsibility to take account of many more factors than others before him, and to only put into the world things with integrity and quality, even if it meant disagreeing with a client— like a doctor, the architect must adhere to the precepts of his profession first and foremost.[15] With Scamozzi's *L'Idea*, we get what Lionello Puppi regards as the first "decisive authoritative statement regarding liberal dignity of the architectural profession."[16]

Defining Architecture as Invention

Along with the qualities and knowledge needed by the architect, Scamozzi followed the Vitruvian and Albertian example by defining architecture and identifying its parts. Like others before him, he recognized the combination of theoretical knowledge and practical knowledge that was inherent in the subject, but he expanded the scope of theoretical knowledge significantly. Though he agreed with Vitruvius in defining architecture as a science, he delimited the parts of architecture completely differently. He replaced the Vitruvian division of architecture into building, dialing (astronomy), and mechanics with a four-part scheme: precognition, construction, finishing, and restoration. Rather than identifying architecture with its products, Scamozzi described it as a process. The completed portions of his treatise cover the first two parts only; finishing and restoration were to have been explained in the ninth and tenth books.

Though a modern reading of the word 'science' (i.e. taking it at face value today) can give some valid insight into Scamozzi's architectural ideas, it is worthwhile examining the different historical meanings of the word. Barbaro's explanation of Vitruvius' meaning is this: "by science he means cognition, (knowledge, understanding, reasoning) and gathering of many precepts and teachings, which together relate to the knowledge of a proposed order."[17] But even if the Vitruvian idea of 'science' was simply theoretical knowledge of many disciplines in opposition to craft or experience-based knowledge, the important point he went on to make is that architecture is the discipline providing the capacity for judgment with respect to all the other fields. Scamozzi accepted this particular Vitruvian statement and claimed

a premier position for architecture among the sciences. Part of Scamozzi's intention was the proposition that architectural knowledge depends upon principles defined by theory.[18]

Still, Scamozzi had a more specific meaning for 'science' than Vitruvian 'knowledge' which the reader of *L'Idea* encounters before even starting the treatise in earnest. Scamozzi placed a long explanation of the division of knowledge between sciences and arts in his preface to the first volume. Generally speaking, the sciences "probe the causes of all things divine and human, and demonstrate the good life, and virtuous work; only they can make in this world some state of happiness for man."[19] This initial definition of the sciences contains two words that are consistently repeated by Scamozzi and that are somewhat related to a modern definition—'cause' and 'demonstrate.' He understood the sciences as those disciplines seeking knowledge of how and why things are the way they are. The sciences reveal things that are not immediately apparent or visible, they show the underlying relationships, and they give man the capacity to live happily instead of being subjected to the unknown and the unexpected. It is Scamozzi's list of the subjects that comprise the sciences that reveals a substantial difference with the modern usage of 'science.' In the system of knowledge that he inherited and used, there were three kinds of science, which he also called philosophies: moral, natural, and supernatural—in modern terms, ethics, physics, and metaphysics. Of these, only physics belongs to the modern realm of science. Taking authority from Aristotle's *Magna Morali*, he allied architecture to moral philosophy alongside political science, law, and government, ethical pursuits requiring temperance, prudence, and justice. Scamozzi was thereby elevating architecture even further than Barbaro had done, making it an area of knowledge requiring the highest levels of human understanding.

The arts in Scamozzi's scheme are equally mixed in terms of modern categories. They are divided into five different sorts, among which are the liberal arts, the mechanical arts, and the imitative arts. Imitative arts are painting and sculpture, while mechanical arts are more technical in nature, including agriculture, navigation, and military arts. It was a common idea that architecture belonged to this area of human understanding, although Vasari and others saw it allied with painting and sculpture. Among the arts, Scamozzi would place architecture with the liberal arts, which included mathematics and geometry. He did not say this in the preface, but throughout Book One he stated that architects not only needed mathematical knowledge, but had to think like mathematicians. It seems that in writing the preface, which he likely wrote last, Scamozzi wished to go further than he had before, not only removing architecture from the mechanical and fine arts in order to make it an intellectual discipline as a liberal art, but moving it to an even higher-level intellectual realm as science, or philosophy.

These old categories were already undergoing some changes, and Scamozzi himself was an emerging practitioner of the "new science," actively involved in observing the world and questioning rather than merely accepting and

explaining classical precepts.[20] His habits of observation and reasoning are evident throughout the whole treatise. Despite his efforts in Book One to be precise, architecture for Scamozzi was in fact many things. Scamozzi insisted on the placement of architecture among the "speculative sciences," by which he meant principally mathematics and natural science, in order to stress its theoretical over its practical side. He stated that "architecture is undoubtedly a speculative science, highest among disciplines, and in erudition, and as noble and singular, investigating the causes and the reasons of the things concerning it."[21] Architectural speculation deals with mathematical considerations and the essences of things.[22] To know the technical, detail-laden side of a discipline only, its applied knowledge, limits one to a single discipline; to know the concepts of things, their theoretical basis, allows an individual much broader scope. By connecting the notion of "speculation" or questioning and reasoning to architecture, he pulled his theory back from a foundation in the specifics of the classical idiom and made the fundamental intellectual processes universal: "to know the causes and understand the effects of the natural and supernatural, as well as the wonderful and majestic operations of them."[23]

Scamozzi implicitly criticized other treatises and wanted to confront in his work the founding themes of architecture, analytically remaking the theory.[24] He consistently allied architecture to mathematics; his quest for the universal mathematical order and appeal to reason was relentless and prescient.[25] He dislodged it from connections to painting and sculpture, the imitative arts, because they capture natural forms, while architecture does not. That is why he said that architecture is not as "delightful to the senses" as the *belle arti* are—natural forms are by his definition more pleasing than artificial ones. Throughout the entire first and second books, Scamozzi reiterated the place of architecture alongside moral and natural philosophy. For Scamozzi, architecture deals with the meaning of the material construction and the form.[26]

"A design is the architect's explanation of difficult and obscure questions, and the reason that he brings excellent rediscovered things to them with acuteness and vivacity."[27] This rather difficult definition is important for an understanding of Scamozzi's work. Scamozzi repeatedly called the first part of the design process "invention," which was not unusual for his time but was consciously chosen by him to highlight the difference between the creative act and the construction. To modern eyes, the word "invention" may suggest something born of instinct or imagination, but for Scamozzi, and Barbaro before him, invention meant "finding" the best idea in accordance with principles; architectural invention highlights the rational intellect within the design process.[28] The invention is the form in the mind of the architect: "a desire projected in search of certainty."[29] It is a concept that has been subjected to reason.[30] Thus, when Scamozzi says that a building is a "scientific habit located in the architect's mind," he means the universal principles that are the best answer to the problem. He supported Barbaro's idea that design

required and interaction between the client's needs (the program), the mind of the architect, the form found in memory, and the material.[31] Inventing involved finding in memory the correct form to answer to the problem; demonstration was the process of fitting that form to contingent conditions, the process of moving it from a universal idea to the particular application. Architectural invention belonged to the architect alone, while construction was shared with the master-builder.

Scamozzi's Will and Legacy

Scamozzi consciously crafted his professional image right up to the time of his death, and he wished to extend his interests and influence. In addition to inserting his own image in the frontisepiece of *L'Idea*, Scamozzi had portraits by Veronese (see Figure 1.1) and Bassano. Of course, portraiture is inescapably narcissistic, but Puppi has interpreted the inclusion of Scamozzi's image in the frontispiece of *L'Idea* as a way to establish the architect's intellectual and social dignity more so than a conceit.[32] Publishing the treatise was a way to continue to influence the perception of architects and ideas about architecture, and to increase the general quality of architecture.

Other 16th-century architects had, in addition to publishing treatises, trained younger family members or protégés in order to extend the influence of their ideas. Architectural knowledge was handed along. For instance, Francesco di Giorgio is credited with training his fellow Sienese Baldassare Peruzzi, who in turn imparted important knowledge and skills to Sebastiano Serlio. Though there is some evidence that he may have contributed to "training" Baldassare Longhena[33] (1598–1682), Scamozzi never really had a protégé and he had forgone a conventional family life in order to devote himself to architecture. So, in addition to his treatise, he left money in his will for an architectural scholarship.

It is a sign of some degree of success in managing his professional affairs that at the time of his death Scamozzi had some property and money to bequeath. Though he had rejected marriage and family as a young man, he had some children late in life with two different women. However, they all pre-deceased him. So, in order to secure some sense of architectural progeny, he re-wrote his will in the last year of his life to endow a scholarship for young Vincentines that would study architecture, stipulating that they adopt his surname.[34] While this provision aimed at perpetuating his name, it was also the first instance of extending the profession itself as a value as worthy as personal tutelage or familial inheritance. It is another sign of movement away from the guilds toward the establishment of a profession.

The will was contested for almost 100 years; the only recipient of this endowment to actually fulfill its intentions was Ottavio Bertotti (1719–1790), son of a barber; he was assisted by a noble patron in securing the scholarship in 1756, 140 years after Scamozzi's death. Bertotti Scamozzi duly studied

architecture and designed numerous buildings in northern Italy, but he is chiefly remembered today for his publications. Most importantly, he researched and documented in a thorough and consistent manner the work of Andrea Palladio. The publication in 1795 of his *Le Fabbriche e Disegni di Andrea Palladio* added a new stimulus to the interest that Palladio's works attracted in Europe and the Americas. It is unquestionably an irony that the Scamozzi name became once more enmeshed in the fame of Palladio, but it is a pure and simple accident of history. Vincenzo Scamozzi never specified that the recipient would undertake this area of research, either as homage to an acknowledged inspiration or as recompense for unacknowledged theft of his ideas.[35]

Scamozzi's approach to design continued to have its own influence on subsequent generations of architects in the Veneto. The first among them was Longhena in Venice, who finished the Procuratie Nuove; Hopkins traces specific influences in Longhena's independent work. Beltramini examines the architecture of the 17th and 18th centuries in the Veneto in order to distinguish Scamozzi's influence among buildings have generally been labeled Palladian.[36] He finds numerous instances of direct quotation, especially in villa designs. Architects Antonio Pizzocaro (1605–1680), Francesco Muttoni (1667–1747), Giorgio Massari (1687–1766), and Francesco Maria Preti (1701–1774) adopted ideas from Scamozzian planning as well as façade composition and articulation. Beltramini even accuses Bertotti Scamozzi and Ottone Calderari (1730–1803), though openly devoted to Palladio, of "crypto-Scamozzianism."

Scamozzi's treatise generated another kind of legacy. It spread quickly after its 1615 publication, with records of its purchase in London (Inigo Jones) and Antwerp (Peter Paul Ruebens) as early as 1617. There were 670 unsold copies of *L'Idea* in Scamozzi's possession at the time of his death in August of 1616.[37] A Dutch-born Venetian, Justus Sadeler, purchased these in bulk, and it appears that he took a large number of them to Holland in 1620. In this way, it became the most widely available resource for Dutch architects wishing to design in accordance with Vitruvius. Scamozzi's influence can be traced from 1625 onward in the works of Jacob van Campen, Salomon de Bray, Constantijn Huygens, and Simon Bosboom. Dutch translations of Books Three and Six of his treatise were produced in the 1640s and 1650s. These were the basis of later translations of Book Six into German, English, Polish, and French. Of particular appeal to northern Europeans were Scamozzi's emphasis on strict observance of the classical proportions and rational order along with a certain austerity and economy.[38]

The role of Inigo Jones in forming Scamozzi's reputation in the English-speaking world was described in Chapter 1. But there is more complexity to the connection between Jones and Scamozzi. Though Jones insulted Scamozzi, there is plenty of evidence that his disdain was mixed with sincere interest, if not admiration. Jones owned a number of Scamozzi's drawings, a fortunate circumstance or they would probably have been destroyed with others at his death.

6.1 Lord Burlington, Chiswick House, Greenwich and William Kent, Mereworth Castle
(RIBA Library Drawings & Archives Collections)

He read *L'Idea* carefully and made many notes in the margins over more than a decade. While Palladio remained Jones's primary reference, he freely used Scamozzi's and Barbaro's ideas to enrich and personalize his understanding of the principles learned there. Scamozzi clearly stimulated Jones intellectually.[39] Evidence of direct influence on specific designs of Jones has been pointed out by several historians, and the generation that followed him, including John Webb and Roger Pratt, continued to use Jones's sources.[40] William Kent's Mereworth Castle is a clear approximation of the form of the Villa Rotonda, but shares with Scamozzi's designs a single axis of movement, and the consequent difference between the front and the sides. Chiswick House, designed by Lord Burlington in the early eighteenth century, is also ususally described as descending from Villa Rotonda, but its octagonal drum, the absence of an articulated attic, and more elaborate stairs are closer to Scamozzi's designs (see Figure 6.1).

In fact, Palladio's design for Villa Rotonda was in a unique poetic category of its own, and the functional residential architecture it inspired shared necessary transformations.[41]

Scamozzi's Scientific Habits

Renaissance mathematics were slow to evolve, and knowledge of geometry was fragmented. Mathematics in the university was allied to astronomy, and chiefly served the description of the motion of heavenly bodies. Though Euclid's *Elements* was available in print in the 16th century, Euclidean geometry was not generally taught. Piero della Francesca applied Euclidean geometry to perspective construction, which was widely used by painters and architects, but without the mathematical fundamentals. If taught at all, Euclidean geometry was part of philosophy, a kind of logic that had no particular use or meaning. Finally, there was a relatively elementary form of geometry and mathematics that served business, trade, and surveying; a more sophisticated level of this applied mathematics was developed by Galileo to solve military problems. Galileo was evidently unusual for having geometric knowledge that spanned all of these differentiated realms.[42] Scamozzi was contemporary with Galileo (1564–1642), and shared this broad exposure to the different realms of geometry. Scamozzi grew up with a full immersion in the applied mathematics of surveying and he developed his knowledge to the sophisticated level as shown in his fortification designs. He likely studied geometry as philosophy in his early education. He wrote a full treatise on perspective, and in his study under Clavius in Rome, he was immersed in both the astronomical uses of geometry and Euclidean geometry. Scamozzi's mathematical knowledge far exceeded that of other Renaissance architects.

Geometry has a significant presence in *L'Idea*; only Serlio had included geometry as a part of architectural knowledge before. Serlio's geometry was aimed at practical applications in construction—an instruction book of on the tools of the trade.[43] In *L'Idea*, Scamozzi included geometry in Books One and Two.

6.2 Vincenzo Scamozzi, geometric figures from
L'Idea della Architettura Universale, Book One, p. 32
(RIBA Library Photographs Collection)

6.3 Vincenzo Scamozzi, natural, architectural, and geometric forms from
L'Idea della Architettura Universale, Book One, p. 40
(RIBA Library Photographs Collection)

6.4 Vincenzo Scamozzi, areas of irregular sites and polygonal fortresses from *L'Idea della Architettura Universale*, Book Two, pp. 123 and 185 (RIBA Library Photographs Collection)

In Book One, the first plate deals with the properties of basic geometric figures, and it includes a graphic proof of the Pythagorean theorem (see Figure 6.2).

The second is a graphic exploration of the geometry of the body, and an illustration of the three kinds of form: mathematical form, natural form, and architectural form, which lies between the other two (see Figure 6.3).

In Book Two, a table of geometric figures shows various ways to find the area of irregular shapes, useful in describing sites; it is followed by a table of regular polygons for fortification walls with circumferences and areas indicated.

This is followed by the highly detailed geometries of fortifications based on cannon fire (see Figure 5.7). The Villa Bardellini drawings and the globe and compass illustrate the cosmic geometries of sunlight and wind (see Figures 2.2 and 2.3). Scamozzi used his varied knowledge of geometry and mathematics to assist in establishing relationships among the variety of phenomena in the world. The architect brings an order to these relationships through a process of reasoning. The order of the architecture is a description of the order of nature, an order ultimately made visible by ornament.

Scamozzi began as a surveyor, helping his father in using instruments for seeing and measuring, and mathematics for describing the earth. None of Scamozzi's early survey maps have survived, but similar ones by others can

give an idea of his capacity to comprehend and map a place. He observed from a young age the shape and the character of places, and as he matured, he added more and more knowledge of earth and atmospheric science to his comprehension of a place. Observation is a skill that is heightened by training and use, and Scamozzi was an astute observer. Scamozzi continued to build on his early experiences as part of an intellectual class in the century of world voyages. Geographers and naturalists increasingly engaged the expanding scope of the world through a neutral stance of observation, mapping, and description.

Scamozzi was born to a world in motion— the globe had been circumnavigated, the order of the cosmos was in question, the static order of architectural space was under question. He was able to see the dynamism of nature—the body as a set of systems rather than parts, for example. He paid a great deal of attention to aspects of movement in his building design: the movement of people from space to space and from level to level, the movement of necessary goods, the movement of air and light. Thus it is fitting that a key distinction between Scamozzi and earlier Renaissance architects is travel. Scamozzi traveled to see unknown places and things for himself and to arrive at more universal understanding. He may have been inspired by Serlio, who included French elements in his book on domestic architecture. But Scamozzi's motives were unique. He was a geographer and naturalist charting new territories for the discipline of architecture. Scamozzi was familiar with the growing number of 'collections' that naturalists were assembling, and their need for a new kind of room, the gallery. There was wide interest in knowing the world in all of its variety; a similar outlook characterizes much of Book Two of *L'Idea*, and is even better illustrated by his travel notebook. In addition to studying Gothic cathedrals as an alternate mode of monumental architecture, he observed and recorded regional resources, topographies, and towns (see Figure 6.5).

6.5 Vincenzo Scamozzi, sketch of the city of Nancy from *Taccuino di Viaggio di Parigi a Venezia from Taccuino di Viaggio di Parigi a Venezia*, p. 26 (Museo Civico di Vicenza)

Scamozzi continued to travel throughout his life, and he studied the buildings in every city he visited. He was not solely focused on understanding the excellence of classical architecture; he sought to understand the relationship between architecture, the city, and the culture that builds it. He sees each city as a unique place, a locus of meaning,[44] a physical manifestation of a culture.

The poetry of Book Two is a real appreciation of the distinct qualities of each place. Considering the environment as a factor in design, Scamozzi used description to evoke a clear picture of the diversity of places: not only in terms of climate and topography, but also in the inhabitants, the customs, and the political structure.

Scamozzi's definition of architecture as a scientific habit does not solely indicate the insistence on understanding causes of things and reason as the basis of judgment; it also recalls the ethical responsibilities of moral philosophy. No longer dictated by religion or history, architectural judgment had the aim of providing the place for people to live harmoniously with other people, and to improving their quality of life. This requires an awareness of customs and habits. To build well one must "first consider the place, next the quality and form of the structure, third, the most appropriate materials, and forth, the instruments and methods to bring it to completion."[45] This statement could be taken in a narrow sense as "consider the site," and would not be all that unusual. But Books Two and Three of the treatise give a substantial basis on which to propose a wider scope indicated by the word "place." The topics of Book Two were not unique to Scamozzi's treatise, but the amount of attention and the level of detail were completely unprecedented, and his attitude was distinct. Palladio began his chapters on villas with site planning principles, but he ultimately situated his villas in a relatively benign nature.[46] Scamozzi's nature was far from benign; it was architecture that had the capacity to confront nature and make a comfortable place for human habitation. The architect was responsible for understanding the particular qualities of a place and designing in response to its natural properties. Though his treatise aimed at universal principles of architecture, he insisted that design account for the particular environmental circumstances of the site. He expected an architect to understand how to use buildings as passive machines for living comfortably in nature.

Though historical periods have long been questioned as a valid framework for describing the past, there are some that persist because they are a useful reference. Scamozzi is interesting in part because he defies simple categorization. He lived at a transitional time between two different worldviews. Yet it can still be useful to say that Vincenzo Scamozzi was the last Renaissance architect, the most significant of his time.[47] He was considered by his successors in the 17th century to be the last of a group of critical theorists that stabilized the classical canon of architectural orders.[48] In addition to writing on architecture, perspective, and ancient Rome, he designed numerous significant buildings in Venice and the Veneto. His work in theory and design are unique—both can be described as continuous with the main ideas and themes of Italian Renaissance architecture while showing distinctive qualities that derive from cultural changes leading to the Scientific Revolution. Among the themes that he inherited and interpreted anew are the correspondence of microcosm and macrocosm, nature and the human body as an example of perfection, adherence to proportion, the use of the classical orders to make a

building's order visible, the concept of building types as public, private, and sacred, and the professionalization of the architect. Themes that he innovated upon include the city as a cultural creation, the dynamics of motion and change, environmental design, the importance of place, the intellectual basis of design, and the role of mathematics and science in architectural thinking, especially observation, description, invention, and demonstration. He was last in part because there could be no more. Contemporaries Giacomo Della Porta (1533–1602) and Carlo Maderno (1556–1629) were already exploring completely new formal and spatial possibilities in Rome.

Scamozzi is important on these terms in his own right, but there is another reason that he is important to architects today—finishing the last works of Palladio. Mention of Palladio could have been confined to the discussion of these two works, and doing so could have helped to extricate Scamozzi from mistaken ideas of their relationship. However, historical proximity to Palladio qualifies the story of Scamozzi in so many ways that, in the end, comparison to such a well-known figure as Palladio helps in understanding Scamozzi as a unique figure, especially in assessing his architectural designs.

Not all of Scamozzi's work is equal in visual beauty to his masterpieces, but every building he made was a beautiful thought. Though certain compositions may be judged severe, his works are capable of the delight of surprise. The beauty of Scamozzi's remaining buildings is principally experienced in the spaces they make: piazza, street, and garden on the outside; and cortile, loggia, *sala*, and stairwell on the inside. As an ethical architect, he sought foremost to improve the quality of life by being knowledgeable and responsible. Scamozzi created an architecture of place, one giving more to the urban space than it takes for itself, and bringing the particular lights, airs, and views together on the interiors to be re-mixed by the building and given presence in the experience of the inhabitants.

Though many architects asserted their interest in designing in accordance with nature, Scamozzi was able to see and to therefore take account of much more—region, not site; areas as well as lengths; sun angles throughout the day and year, not only generalities of direction; wind at ground level and wind three stories up; six kinds of light in a building, not just insufficient or sufficient; different kinds of water in motion. Not only could he see more significant elements when he looked at the world, he built a subtle understanding of what a balanced harmony of natural conditions could be.

Cosgrove tells us that "to map is in one way or another to take the measure of a world ... and to figure the measure so taken in such a way that it may be communicated among people, places, or times. The measure is not restricted to the mathematical, it may be spiritual, political, or moral ... acts of mapping are creative, sometimes anxious, moments in coming to knowledge of the world."[49] This is why Scamozzi required the architect to be a cartographer, to take the measure of a place and to increase his knowledge of it by observing and describing it. For him, mapping the site was a necessary "creative moment" in the design process that produced knowledge that he

used together with universal ideas in the process of architectural invention. That knowledge was in turn communicated through the meaningful order of the architectural chorography he constructed there.

Notes

1. William J. Bouwsma, *The Waning of the Renaissance, 1550–1640* (New Haven, CT: Yale University Press, 2000): vii–xi.

2. See Franco Barbieri, *Vincenzo Scamozzi* (Verona: Cassa di Risparmio di Verona e Vicenza, 1952) and Carmine Jannaco, "Barocco e Razionalismo nel Trattato d'Architettura di Vincenzo Scamozzi (1615)," *Studi Secenteschi* 2 (1961): 47–60. There is less interest in more recent scholarship in assigning stylistic categories.

3. Alina A. Payne, *The Architectural Treatise in the Italian Renaissance: Architectural Invention, Ornament, and Literary Culture* (Cambridge: Cambridge University Press, 1999): 214.

4. See Françoise Choay, *The Rule and the Model: On the Theory of Architecture and Urbanism*, translated by Denise Bratton (Cambridge, MA: MIT Press, 1997): 192–201; Marco Frascari, "The Mirror Theater of Vincenzo Scamozzi," in *Paper Palaces: The Rise of the Renaissance Architectural Treatise*, edited by Vaughan Hart and Peter Hicks (New Haven, CT: Yale University Press, 1998): 32–51; Lionello Puppi, "'Questa Eccellente Professione delle Mathematiche e dell'Architettura'—Idea di Cultura e Ruoli Sociali nel Pensiero di Vincenzo Scamozzi," in *Vincenzo Scamozzi, 1548–1616*, edited by Franco Barbieri and Guido Beltramini (Venice: Marsilio, 2003): 11–21; and Werner Oechslin, "L'Architettura Come Scienza Speculativa," in *Vincenzo Scamozzi, 1548–1616*, edited by Franco Barbieri and Guido Beltramini (Venice: Marsilio, 2003): 23–31.

5. Vitruvius, *I Dieci Libri dell'Architettvra*, translated with commentary by Daniele Barbaro (Venice: Appresso Francesco de'Franceschi Senese, 1567): 7.

6. Vincenzo Scamozzi, *L'Idea della Architettura Universale* (Venice, 1615): Book One Ch. 2.

7. Catherine Wilkinson, "The New Professionalism in the Renaissance," in *The Architect: Chapters in the History of the Profession*, edited by Spiro Kostof (New York: Oxford University Press, 1977): 124–59.

8. James Ackerman, *Origins, Imitation, Conventions: Representation in the Visual Arts* (Cambridge, MA: MIT Press, 2002): 222.

9. Sebastiano Serlio, *Tutte l'Opere d'Architettura et Prospetiva*, foreword by Giovanni Domenico Scamozzi (Venice: De'Francheschi, 1619): n.p.

10. Scamozzi, *L'Idea*, Book One Ch. 23.

11. Scamozzi, *L'Idea*, Book One Ch. 7.

12. Scamozzi, *L'Idea*, Book One Ch. 6 and 9.

13. Giorgio Vasari, *Lives of the Artists*, translated by George Bull (Harmondsworth: Penguin, 1965): 141–7.

14. Scamozzi, *L'Idea*, Book One Ch. 9.

15. Scamozzi, *L'Idea*, Book Eight Ch. 1.

16. Puppi, "'Questa Eccellente Professione,'" 11.

17. Vitruvius, *I Dieci Libri*, 7.

18. Katia Basili, "Vincenzo Scamozzi e le Meccaniche," in *Vincenzo Scamozzi, 1548–1616*, edited by Franco Barbieri and Guido Beltramini (Venice: Marsilio, 2003): 65.

19. Scamozzi, *L'Idea*, Vol. 1 Proemio.

20. Mark A. Peterson, *Galileo's Muse: Renaissance Mathematics and the Arts* (Cambridge, MA: Harvard University Press, 2011): 237–54.

21. Scamozzi, *L'Idea*, Book One Ch. 1.

22. Scamozzi, *L'Idea*, Book One Ch. 24.

23 Scamozzi, Vol. 1 Proemio.

24 Basili, "Scamozzi e le Meccaniche," 65.

25 Frascari, "The Mirror Theater of Vincenzo Scamozzi," 258.

26 Scamozzi, *L'Idea*, Book One Ch. 3.

27 Scamozzi, *L'Idea*, Book One Ch. 14.

28 Ackerman, *Origins, Imitation, Conventions*, 224.

29 Scamozzi, *L'Idea*, Book One Ch. 14.

30 Scamozzi, *L'Idea*, Book One Ch. 7.

31 Ackerman, *Origins, Imitation, Conventions*, 224.

32 Puppi, "'Questa Eccellente Professione,'" 17.

33 Andrew Hopkins, "Vincenzo Scamozzi e Baldassare Longhena," in *Vincenzo Scamozzi, 1548–1616*, edited by Franco Barbieri and Guido Beltramini (Venice: Marsilio, 2003): 121.

34 Guido Beltramini, "Testamento di Vincenzo Scamozzi, 1602, 2 settembre e 1616, 3 agosto," in *Vincenzo Scamozzi, 1548–1616*, edited by Franco Barbieri and Guido Beltramini (Venice: Marsilio, 2003): 533.

35 Frascari, "The Mirror Theater of Vincenzo Scamozzi," 248.

36 Guido Beltramini, "The Fortunes and Misfortunes of Scamozzi's 'Idea della Architettura Universale' in Palladian Territory," *Annali di Architettura: Rivista del Centro Internazionale di Studi di Architettura Andrea Palladio* 18–19 (2006): 199–213.

37 Konrad Ottenheym, "A Bird's Eye View of the Dissemination of Scamozzi's Treatise in Northern Europe," *Annali di Architettura: Rivista del Centro Internazionale di Studi di Architettura Andrea Palladio* 18–19 (2006): 187–98; also, "Introduction," in Vincenzo Scamozzi, *The Idea of a Universal Architecture VI, The Architectural Orders and Their Application*, translated and edited by Patti Garvin, Koen Ottenheym, and Wolbert Vroom (Amsterdam: Architectura & Natura, 2008): 26–9.

38 Ottenheym, "Dissemination of Scamozzi's Treatise," 196.

39 Howard Burns, "Inigo Jones and Vincenzo Scamozzi," *Annali di Architettura: Rivista del Centro Internazionale di Studi di Architettura Andrea Palladio* 18–19 (2006): 222.

40 Giles Worsley, "Scamozzi's Influence on English Seventeenth Century Architecture," *Annali di Architettura: Rivista del Centro Internazionale di Studi di Architettura Andrea Palladio* 18–19 (2006): 229–31.

41 Beltramini, "The Fortunes and Misfortunes of Scamozzi's 'Idea,'" 211.

42 Peterson, *Galileo's Muse*, 21–8.

43 Sebastiano Serlio, *Sebastiano Serlio on Architecture*, translated by Vaughan Hart and Peter Hicks (New Haven, CT: Yale University Press, 1996): introduction, xxvii.

44 Yi-Fu Tuan, *Space and Place: The Perspective of Experience* (Minneapolis, MN: University of Minnesota Press, 1977): 173.

45 Scamozzi, *L'Idea*, Book Eight Ch. 1.

46 Denis E. Cosgrove, *The Palladian Landscape: Geographical Change and its Cultural Representations in Sixteenth-Century Italy* (University Park, PA: Penn State University Press, 1993): 98.

47 Andrew Hopkins, *Italian Architecture: From Michelangelo to Borromini* (London: Thames & Hudson, 2002): 138.

48 Oechslin, "L'Architettura Come Scienza Speculativa," 23–5.

49 Denis E. Cosgrove, "Introduction: Mapping Meaning," in *Mappings*, edited by Denis E. Cosgrove (London: Reaktion Books, 1999): 2.

Appendix

Book Two, *L'Idea della Architettura Universale*

CHAPTER TITLES

1. Climates and regional differences; why the architect must understand them and also know cartography
2. Observations on prosperous and admirable countries, especially Italy, which fostered the greatness of the Roman Empire
3. Observations on countries not suited for habitation, and on others abandoned or destroyed
4. How countries should promote cities of healthy situations and abundance, and should discourage cities with unhealthy conditions
5. Observations on the importance of water routes, and on some major ports in Italy and elsewhere
6. Observations on historically admired sites for cities and the qualities they have
7. Some qualities of sites that should be avoided, the difference between "place" and "site," and how to find the area of irregular sites
8. Mapping irregular sites, and on how to square them for a building
9. Tides and the origins and effects of large rivers
10. Various qualities of the water in lakes, ponds, and swamps
11. Floods and other ill effects of water; observations on mills and other structures built on the water
12. The differences between various airs and their positive and negative effects on health
13. Good and bad effects of air in buildings, the diverse kinds of light in buildings, and how to make a solar clock
14. The substance and nature of the winds, including their number, names, and positions
15. The etymology of the names of the winds, their various qualities, and when they blow
16. The motions and effects of the winds, especially the weather they cause

17. Conceiving and founding a city, and designing for growth
18. Observations on the sites of the main cities of Italy (and elsewhere) and what makes them work
19. The advantages of sea ports and the best sites for them
20. The overall shape and the enclosing wall of the city, its plan and appearance, and the form of its street system
21. The placement of important public spaces and institutions
22. The placement of necessities for defense, such as ammunition, barracks, and stables
23. General observations on forts and the best sites for them
24. The best forms for royal castles, fortresses, castles, and citadels
25. The best shapes and sizes for fences, walls, parapets, and ramparts, weighing good and bad aspects
26. The forms and placements of bastions, platforms, ditches, gates, bridges, counterscarps, covered roads, and esplanades
27. The best way to design the plans and the profiles, with their parts and measures
28. Making models for fortresses and calculating their construction costs, and the best materials for them
29. How to plan and execute a royal fortress without errors
30. The benefits and the difficulties of the main parts of a fortress

Bibliography

Ackerman, James S. *Palladio*. London: Penguin, 1966.

Ackerman, James S. *The Villa: Form and Ideology of Country Houses*. Princeton, NJ: Princeton University Press, 1990.

Ackerman, James S. *The Reinvention of Architectural Drawing, 1250–1550*. London: Sir John Soane's Museum, 1998.

Ackerman, James S. *Origins, Imitation, Conventions: Representation in the Visual Arts*. Cambridge, MA: MIT Press, 2002.

Adams, Paul C., Steven D. Hoelscher, and Karen E. Till. *Textures of Place: Exploring Humanist Geographies*. Minneapolis, MN: University of Minnesota Press, 2001.

Alberti, Leon Battista. *On the Art of Building in Ten Books*. Translated by Joseph Rykwert, Neil Leach, and Robert Tavernor. Cambridge, MA: MIT Press, 1988.

Alberti, Leon Battista. *Descriptio urbis Romae*. Translated by Jean-Yves Boriaud, Francesco Furlan, Carmela Colombo, and Mario Carpo. Florence: L.S. Olschki, 2005.

Alpers, Svetlana. *The Art of Describing: Dutch Art in the Seventeenth Century*. Chicago, IL: University of Chicago Press, 1983.

Anderson, Christy. "Words Fail Me: Architectural Experience Beyond Language." In *Architecture et Theorie, L'Heritage de la Renaissance*, edited by Jean Philippe Garric, Frederique Lemerle, and Yves Pauwels, 1–14. Collections electroniques de l'INHA.

Augusti, Adriana, and Guido Beltramini. "La villa per Francesco e Domenico Duodo." In *Vincenzo Scamozzi, 1548–1616*, edited by Franco Barbieri and Guido Beltramini, 301. Venice: Marsilio, 2003.

Aureli, Pier Vittorio. "The Geo-Politics of the Ideal Villa: Andrea Palladio and the Project of an Anti-Ideal City." *AA Files* 59 (2009): 76–85.

Azzi Visentini, Margherita. "The Gardens of Villas in the Veneto from the Fifteenth to the Eighteenth Centuries." In *The Italian Garden: Art, Design, and Culture*, edited by John Dixon Hunt, 93–126. Cambridge: Cambridge University Press, 1996.

Azzi Visentini, Margherita. "Vincenzo Scamozzi e il Giardino." In *Vincenzo Scamozzi, 1548–1616*, edited by Franco Barbieri and Guido Beltramini, 111–19. Venice: Marsilio, 2003.

Barasch, Moshe. *Light and Color in the Italian Renaissance Theory of Art*. New York: New York University Press, 1978.

Barbieri, Franco. *Vincenzo Scamozzi*. Verona: Cassa di Risparmio di Verona e Vicenza, 1952.

Barbieri, Franco. *La Rocca Pisana de Vincenzo Scamozzi*. Vicenza: G. Rumor, 1985.

Barbieri, Franco, and Howard Burns. "Palazzo Trissino Baston sul Corso a Vicenza." In *Vincenzo Scamozzi, 1548–1616*, edited by Franco Barbieri and Guido Beltramini, 288. Venice: Marsilio, 2003.

Barbieri, Franco, and Mario Michelon. *Palazzo Trissino Baston: Sede Municipale*. Vicenza: s.n., 2005.

Basili, Katia. "Vincenzo Scamozzi e le Meccaniche." In *Vincenzo Scamozzi, 1548–1616*, edited by Franco Barbieri and Guido Beltramini, 65–9. Venice: Marsilio, 2003.

Bates, E.S. *Touring in 1600: A Study in the Development of Travel as a Means of Education*. Boston, MA: Houghton Mifflin, 1911.

Beltramini, Guido. "'Lionem ex unguibus aestimare': Un Primo Sgardo d'Insieme ai Disegni di Vincenzo Scamozzi." In *Vincenzo Scamozzi, 1548–1616*, edited by Franco Barbieri and Guido Beltramini, 53–7. Venice: Marsilio, 2003.

Beltramini, Guido. "Testamento di Vincenzo Scamozzi, 1602, 2 settembre e 1616, 3 agosto." In *Vincenzo Scamozzi, 1548–1616*, edited by Franco Barbieri and Guido Beltramini, 533–4. Venice: Marsilio, 2003.

Beltramini, Guido. "The Fortunes and Misfortunes of Scamozzi's 'Idea Della Architettura Universale' in Palladian Territory." *Annali di Architettura: Rivista del Centro Internazionale di Studi di Architettura Andrea Palladio* 18–19 (2006): 199–213.

Benes, Carrie E. *Urban Legends: Civic Identity and the Classical Past in Northern Italy, 1250–1350*. University Park, PA: Pennsylvania State University Press, 2011.

Bertotti Scamozzi, Ottavio. *Le Fabbriche e i Disegni di Andrea Palladio*. Vicenza, 1796; edited by J. Quentin Hughes. London: Tiranti, 1968.

Borys, Ann Marie. "Vincenzo Scamozzi, Inventor: Architectural Demonstrations from the Last Renaissance Treatise." Ph.D. dissertation, University of Pennsylvania, 1998.

Boucher, Bruce. "The Last Will of Daniele Barbaro." *Journal of the Warburg and Courtauld Institutes* 42 (1979): 277–82.

Boucher, Bruce. *Andrea Palladio: The Architect in His Time*. New York: Abbeville Press, 1994.

Boucher, Bruce. "Nature and the Antique in the Work of Andrea Palladio." *Journal of the Society of Architectural Historians* 59/3 (2000): 296–311.

Bouwsma, William J. *The Waning of the Renaissance, 1550–1640*. New Haven, CT: Yale University Press, 2000.

Breiner, David Michael. "Vincenzo Scamozzi, 1548–1616: A Catalogue Raisonné." Ph.D. dissertation, Cornell University, 1994.

Brockett, Oscar G., Margaret Mitchell, and Linda Harberger. *Making the Scene: A History of Stage Design and Technology in Europe and the United States*. San Antonio, TX: Tobin Theater Arts Fund, 2010.

Burns, Howard. "Note sull'Influsso di Scamozzi in Inghilterra: Inigo Jones, John Webb, Lord Burlington." In *Vincenzo Scamozzi, 1548–1616*, edited by Franco Barbieri and Guido Beltramini, 129–32. Venice: Marsilio, 2003.

Burns, Howard. "Inigo Jones and Vincenzo Scamozzi." *Annali di Architettura: Rivista del Centro Internazionale di Studi di Architettura Andrea Palladio* 18–19 (2006): 215–24.

Burns, Howard, Lynda Fairbairn, and Bruce Boucher. *Andrea Palladio, 1508–1580: The Portico and the Farmyard*. London: Arts Council of Great Britain, 1975.

Burroughs, Charles. "Palladio and Fortune: Notes on the Sources of Meaning of the Villa Rotonda." *Architectura* 15 (1988): 59–91.

Cameron, Alister. "The Pythagorean Background of the Theory of Recollection." Ph.D. dissertation, Columbia University, 1938.

Carpo, Mario. "How Do You Imitate a Building That You Have Never Seen? Printed Images, Ancient Models, and Handmade Drawings in Renaissance Architectural Theory." *Zeitschrift fur Kunstgeschichte* 64 (2001): 223–33.

Carpo, Mario. "Drawing with Numbers: Geometry and Numeracy in Early Modern Architectural Design." *Journal of the Society of Architectural Historians* 62/4 (2003): 448–69.

Carroll, Linda L. "A Nontheistic Paradise in Renaissance Padua." *The Sixteenth Century Journal* 24/4 (1993): 881–98.

Casey, Edward S. *The Fate of Place: A Philosophical History*. Berkeley, CA: University of California Press, 1997.

Casey, Edward S. *Representing Place: Landscape Painting and Maps*. Minneapolis, MN: University of Minnesota Press, 2002.

Castello, Lineu, and Nick Rands. *Rethinking the Meaning of Place: Conceiving Place in Architecture-Urbanism*. Farnham: Ashgate, 2010.

Cataneo, Pietro. *I Qvattro Primi Libri di Architettvra di Pietro Cataneo Senese*. Venice, 1554; facsimile Ridgewood, NJ: Gregg Press, 1964.

Cevese, Renato. *Ville della Provincia di Vincenza*. Milan: SISAR, 1971.

Choay, Françoise. *The Rule and the Model: On the Theory of Architecture and Urbanism*. Translated by Denise Bratton. Cambridge, MA: MIT Press, 1997.

Clubb, Louise George. "Italian Renaissance Theater." In *The Oxford Illustrated History of Theater*, edited by John Russell Brown, 107–41. Oxford: Oxford University Press, 1995.

Coffin, David R. *Magnificent Buildings, Splendid Gardens*. Princeton, NJ: Department of Art and Archeology, Princeton University, 2008.

Connerton, Paul. *How Societies Remember*. Cambridge: Cambridge University Press, 1989.

Cooper, Tracy E. *Palladio's Venice: Architecture and Society in a Renaissance Republic*. New Haven, CT: Yale University Press, 2005.

Cosgrove, Denis E. "The Geometry of Landscape: Practical and Speculative Arts in Sixteenth-Century Venetian Land Territories." In *The Iconography of Landscape: Essays on the Symbolic Representation, Design, and Use of Past Environments*, edited by Denis Cosgrove and Stephen Daniels, 254–76. Cambridge: Cambridge University Press, 1988.

Cosgrove, Denis E. "Mapping New Worlds: Culture and Cartography in Sixteenth-Century Venice." *Imago Mundi* 44 (1992): 65–89.

Cosgrove, Denis E. *The Palladian Landscape: Geographical Change and its Cultural Representations in Sixteenth-Century Italy*. University Park, PA: Penn State University Press, 1993.

Cosgrove, Denis E. "Introduction: Mapping Meaning." In *Mappings*, edited by Denis E. Cosgrove, 1–23. London: Reaktion Books, 1999.

Cosgrove, Denis E. *Geography and Vision: Seeing, Imagining and Representing the World*. London: I.B. Tauris, 2008.

Damisch, Hubert. *The Origin of Perspective*. Cambridge, MA: MIT Press, 1994.

Davis, Charles. "Vincenzo Scamozzi Architetto della Luce." In *Vincenzo Scamozzi, 1548–1616*, edited by Franco Barbieri and Guido Beltramini, 33–45. Venice: Marsilio, 2003.

Davis, Charles. "Vincenzo Scamozzi Progettista di Monumenti Commemortivi?" In *Vincenzo Scamozzi, 1548–1616*, edited by Franco Barbieri and Guido Beltramini, 197–9. Venice: Marsilio, 2003.

Davis, Margaret Daly. "Vincenzo Scamozzi: Studi Antiquari, Studi Archeologici." In *Vincenzo Scamozzi, 1548–1616*, edited by Franco Barbieri and Guido Beltramini, 59–63. Venice: Marsilio, 2003.

Davis, Thomas K. "Scamozzi's Duodi Estate in Monselice: Affirming an Architecture of Ambiguity." *Proceedings of the 78th Annual Meeting of the Association of Collegiate Schools of Architecture* (1990): 55–65.

Dear, Peter. "The Church and the New Philosophy." In *Science, Culture, and Popular Belief in Renaissance Europe*, edited by Stephen Pumfrey, Paolo L. Rossi, and Maurice Slawinski, 119–39. Manchester: Manchester University Press, 1991.

De la Croix, Horst. "Military Architecture and the Radial City Plan in Sixteenth Century." *The Art Bulletin* 42/4 (1960): 263–90.

De la Croix, Horst. "Palmanova: A Study in Sixteenth Century Urbanism." *Saggi e Memorie di Storia dell'Arte* 5 (1966): 23–41.

De la Croix, Horst. *Military Considerations in City Planning: Fortifications*. New York: Braziller, 1972.

D'Evelyn, Margaret Muther. *Venice and Vitruvius: Reading Venice with Daniele Barbaro and Andrea Palladio*. New Haven, CT: Yale University Press, 2012.

DeVilliers, Marq. *Windswept: The Story of Wind and Weather*. New York: Walker, 2006.

Dueck, Daniela. *Strabo of Amasia: A Greek Man of Letters in Augustan Rome*. London: Routledge, 2000.

Edgerton, Samuel Y. "From Mental Matrix to Mappamundi to Christian Empire: The Heritage of Ptolemaic Cartography in the Renaissance." In *Art and Cartography: Six Historical Essays*, edited by David Woodward, 10–50. Chicago, IL: University of Chicago Press, 1987.

Eisenman, Peter. "Vincenzo Scamozzi, Fabbrica Fino, Bergamo." *Lotus International* 42 (1984): 72–3.

Eisenstein, Elizabeth L. *The Printing Revolution in Early Modern Europe*. Cambridge: Cambridge University Press, 1983.

Evans, Robin. *The Projective Cast: Architecture and its Three Geometries*. Cambridge, MA: MIT Press, 1995.

Fanti, Mario. *Ville, Castelli e Chiese Bolognesi da un Libro di Disegni del Cinquecento*. Bologna: Arnaldo Forni, 1996.

Field, Judith Veronica. *The Invention of Infinity: Mathematics and Art in the Renaissance*. Oxford: Oxford University Press, 1997.

Findlen, Paula. *Possessing Nature: Museums, Collecting, and Scientific Culture in Early Modern Italy*. Berkeley, CA: University of California Press, 1994.

Fiorani, Francesca. "Danti Edits Vignola: The Formation of a Modern Classic on Perspective." In *The Treatise on Perspective: Published and Unpublished*, edited by Lyle Massey, 133–48. Washington, DC: National Gallery of Art, 2003.

Fiorani, Francesca. *The Marvel of Maps: Art, Cartography and Politics in Renaissance Italy*. New Haven, CT: Yale University Press, 2005.

Forster, Kurt Walter. "Stagecraft and Statecraft: The Architectural Integration of Public Life and Theatrical Spectacle in Scamozzi's Theater at Sabbioneta." *Oppositions* 9 (1977): 63–87.

Forster, Kurt Walter. "From *Rocca* to *Civitas*: Urban Planning at Sabbioneta." *FMR* 7/30 (1988): 99–120.

Foscari, Antonio. *Andrea Palladio: Unbuilt Venice*. Baden: Lars Muller, 2010.

Franco, Veronica. *Poems and Selected Letters*. Translated by Ann Rosalind Jones and Margaret F. Rosenthal. Chicago, IL: University of Chicago Press, 1998.

Frangenberg, Thomas. "Chorographies of Florence: The Use of City Views and City Plans in the Sixteenth Century." *Imago Mundi* 46 (1994): 41–64.

Franz, Rainald. *Vincenzo Scamozzi (1548–1616) Der Nachfolger und Vollender Palladios*. Petersburg: Imhof, 1999.

Frascari, Marco. "A Secret Semiotic Skiagraphy: The Corporal Theatre of Meanings in Vincenzo Scamozzi's Idea of Architecture." *VIA* 11(1990): 32–51.

Frascari, Marco. "The Mirror Theater of Vincenzo Scamozzi." In *Paper Palaces: The Rise of the Renaissance Architectural Treatise*, edited by Vaughan Hart and Peter Hicks, 247–60. New Haven, CT: Yale University Press, 1998.

Frascari, Marco. "*Honestamente Bella*, Alvise Cornaro's Temperate View of Lady Architecture and Her Maids, *Phronesis* and *Sophrosine*" (Typescript, 2008).

Freedberg, David. *The Eye of the Lynx: Galileo, His Friends, and the Beginnings of Modern Natural History*. Chicago, IL: University of Chicago Press, 2002.

Frommel, Christoph Luitpold. "Reflections on the Early Architectural Drawings." In *The Renaissance from Brunelleschi to Michelangelo: The Representation of Architecture*, edited by Henry A. Millon, 101–21. New York: Rizzoli, 1997.

Frommel, Sabine. *Sebastiano Serlio: Architect*. Translated by Peter Spring. Milan: Electa, 2003.

Garberi, Mercedes. *Frescoes from Venetian Villas*. London: Phaidon, 1971.

Gatti, Hilary. *Giordano Bruno and Renaissance Science*. Ithaca, NY: Cornell University Press, 1999.

Geary, Patrick. "Sacred Commodities: The Circulation of Medieval Relics." In *The Social Life of Things: Commodities in Cultural Perspective*, edited by Arjun Appadurai. Cambridge: Cambridge University Press, 1986.

Glackens, Clarence J. *Traces on the Rhodian Shore: Nature and Culture in Western Thought from Ancient Times to the End of the Eighteenth Century*. Berkeley, CA: University of California Press, 1967.

Goode, Patrick. "Scamozzi, Vincenzo." In *The Oxford Companion to Architecture*, edited by Patrick Goode. Oxford: Oxford University Press, 2009.

Gordon, D.J. *The Renaissance Imagination: Essays and Lectures*. Berkeley, CA: University of California Press, 1975.

Goss, John, ed. *Braun & Hogenberg's 'The City Maps of Europe': A Selection of 16th Century Town Plans & Views*. London: Studio Editions, 1991.

Greenblatt, Stephen. *The Swerve: How the World Became Modern*. New York: Norton, 2011.

Guillaume, Jean. "Taccuino di Viaggio da Parigi a Venezia." In *Vincenzo Scamozzi, 1548–1616*, edited by Franco Barbieri and Guido Beltramini, 391–3. Venice: Marsilio, 2003.

Hardy, Matthew. "'Study the Warm Winds and the Cold'—Hippocrates and the Renaissance Villa." In *Aeolian Winds and the Spirit in Renaissance Architecture: Academia Eolia Revisited*, edited by Barbara Kenda, 48–63. London: Routledge, 2006.

Hart, Vaughan. "Decorum and the Five Orders of Architecture: Sebastiano Serlio's Military City." *RES Journal of Anthropology and Aesthetics* 34 (1998): 75–84.

Hart, Vaughan, and Peter Hicks. *Palladio's Rome: A Translation of Andrea Palladio's Two Guidebooks to Rome*. New Haven, CT: Yale University Press, 2006.

Harvey, P.D.A. *The History of Topographical Maps: Symbols, Pictures and Surveys*. London: Thames & Hudson, 1980.

Hermans, Lex. "The Performing Venue: The Visual Play of Italian Courtly Theatres in the Sixteenth Century." *Art History* 33/2 (2010): 292–303.

Hersey, George L. *Pythagorean Palaces: Magic and Architecture in the Italian Renaissance*. Ithaca, NY: Cornell University Press, 1976.

Hersey, George L. *The Lost Meaning of Classical Architecture: Speculations on Ornament from Vitruvius to Venturi*. Cambridge, MA: MIT Press, 1988.

Hersey, George L. *Architecture and Geometry in the Age of the Baroque*. Chicago, IL: University of Chicago Press, 2000.

Higgins, Hannah B. *The Grid Book*. Cambridge, MA: MIT Press, 2009.

Hippocrates. *Hippocratic Writings*. Edited by G.E.R. Lloyd, translated by J. Chadwick and W.N. Mann. Harmondsworth: Penguin, 1983.

Holberton, Paul. *Palladio's Villas: Life in the Renaissance Countryside*. London: Murray, 1990.

Hon, Giora, and Yaakov Zik. "Geometry of Light and Shadow: Francesco Maurolyco (1494–1575) and the Pinhole Camera." *Annals of Science* 64/4 (2007): 549–78.

Hopkins, Andrew. "Longhena Before Salute: The Cathedral at Chioggia." *Journal of the Society of Architectural Historians* 53/2 (1994): 199–214.

Hopkins, Andrew. *Italian Architecture: From Michelangelo to Borromini*. London: Thames & Hudson, 2002.

Hopkins, Andrew. "Vincenzo Scamozzi e Baldassare Longhena." In *Vincenzo Scamozzi, 1548–1616*, edited by Franco Barbieri and Guido Beltramini, 121–7. Venice: Marsilio, 2003.

Howard, Deborah. *Jacopo Sansovino: Architecture and Patronage in Renaissance Venice*. New Haven, CT: Yale University Press, 1975.

Howard, Deborah. "The Status of the Oriental Traveller in Renaissance Venice." In *Re-Orienting the Renaissance: Cultural Exchanges with the East*, edited by Gerald M. MacLean, 29–49. New York: Palgrave Macmillan, 2005.

Howard, Deborah. *Venice Disputed: Marc'Antonio Barbaro and Venetian Architecture, 1550–1600*. New Haven, CT: Yale University Press, 2011.

Howe, Eunice D. *The Churches of Rome*. Binghamton, NY: Center for Medieval and Early Renaissance Studies, State University of New York, 1991.

Hui, Desmond. "Ichnographia, Orthographia, Scaenographia: an Analysis of Cesare Cesariano's Illustrations of Milan Cathedral in his Commentary of Vitruvius, 1521." In *Knowledge and/or/of Experience: The Theory of Space in Art and Architecture*, edited by John Macarther, 77–97. Queensland: Institute of Modern Art, 1993.

Huppert, Ann C. "Mapping Ancient Rome in Bufalini's Plan and in Sixteenth-Century Drawings." *Memoirs of the American Academy in Rome* 53 (2008): 79–98.

Imesch, Kornelia. *Magnificenza als architektonische Kategorie: Individuelle Selbstdarstellung versus asthetische verwirklichung von gemeinschaft in den venezianischen Villen Palladios und Scamozzis*. Oberhausen: Athena, 2003.

Jannaco, Carmine. "Barocco e Razionalismo nel Trattato d'Architettura di Vincenzo Scamozzi (1615)." *Studi Secenteschi* 2 (1961): 47–60.

Johnston, Norman J. *Cities in the Round*. Seattle, WA: University of Washington Press, 1983.

Kapuściński, Ryszard. *Travels with Herodotus*. Translated by Klara Glowczewska. New York: Knopf, 2007.

Kaufmann, Thomas DaCosta. *The Mastery of Nature: Aspects of Art, Science, and Humanism in the Renaissance*. Princeton, NJ: Princeton University Press, 1993.

Kaufmann, Thomas DaCosta. *Toward a Geography of Art*. Chicago, IL: University of Chicago Press, 2004.

Kubelik, Martin. "Palladio's Villas in the Tradition of the Veneto Farm." *Assemblage* 1 (1986): 90–115.

Kemp, Martin. *The Science of Art: Optical Themes in Western Art from Brunelleschi to Seurat*. New Haven, CT: Yale University Press, 1990.

Kemp, Martin. *Seen | Unseen: Art, Science, and Intuition from Leonardo to the Hubble Telescope*. Oxford: Oxford University Press, 2006.

Kenda, Barbara, ed. *Aeolian Winds and the Spirit in Renaissance Architecture: Academia Eolia Revisited*, foreword by Joseph Rykwert. London: Routledge, 2006.

Lattis, James M. *Between Copernicus and Galileo: Christoph Clavius and the Collapse of Ptolemaic Cosmology*. Chicago, IL: University of Chicago Press, 1994.

Leatherbarrow, David. *The Roots of Architectural Invention: Site, Enclosure, Materials*. Cambridge: Cambridge University Press, 1993.

Leatherbarrow, David. *Topographical Stories: Studies in Landscape and Architecture*. Philadelphia, PA: University of Pennsylvania Press, 2004.

Lindberg, David C., and G.N. Cantor. *The Discourse of Light from the Middle Ages to the Enlightenment*. Los Angeles, CA: University of California, 1985.

Lestringant, Frank. *Mapping the Renaissance World*. Translated by David Fausett. Berkeley, CA: University of California Press, 1994.

Lombaerde, Piet, and Charles van den Heuvel. *Early Modern Urbanism and the Grid: Town Planning in the Low Countries in International Context: Exchanges in Theory and Practice, 1550–1800*. Turnhout: Brepols, 2011.

Long, Pamela O. *Openness, Secrecy, Authorship: Technical Arts and the Culture of Knowledge from Antiquity to the Renaissance*. Baltimore, MD: Johns Hopkins University Press, 2001.

Magagnato, Licisco. "The Genesis of the Teatro Olimpico." *Journal of the Warburg and Courtauld Institutes* 14/3–4 (1951): 209–20.

Massey, Lyle, ed. *The Treatise on Perspective*. Washington, DC: National Gallery of Art, 2003.

Mazzoni, Stefano. "Vincenzo Scamozzi Architetto-Scenografo." In *Vincenzo Scamozzi, 1548–1616*, edited by Franco Barbieri and Guido Beltramini, 71–86. Venice: Marsilio, 2003.

Mazzoni, Stefano, and Ovidio Guaita. *Il Teatro di Sabbioneta*. Florence: L.S. Olschki, 1985.

McClung, William Alexander. "A Place for a Time: The Architecture of Festivals and Theaters." In *Architecture and Its Image: Four Centuries of Architectural Representation*, edited by Eve Blau and Edward Kaufman, 86–108. Montreal: Canadian Center for Architecture, 1989.

Miller, Naomi. "Mapping the City: Ptolemy's Geography in the Renaissance." In *Envisioning the City: Six Studies in Urban Cartography*, edited by David Buisseret, 34–74. Chicago, IL: University of Chicago Press, 1998.

Miller, Naomi. *Mapping the City: The Language and Culture of Cartography in the Renaissance*. London: Continuum, 2003.

Mitrovic, Branko. "Paduan Aristotelianism and Daniele Barbaro's Commentary on Vitruvius' De Architectura." *The Sixteenth Century Journal* 29/3 (1998): 667–88.

Mitrovic, Branko. *Learning from Palladio*. New York: Norton, 2004.

Mitrovic, Branko, and Ivana Djordevic. "Palladio's Theory of Proportions and the Second Book of the 'Quattro Libri dell'Architettura.'" *Journal of the Society of Architectural Historians* 49/3 (1990): 279–92.

Mitrovic, Branko, and Victoria Senes. "Vincenzo Scamozzi's Annotations to Daniele Barbaro's Commentary on Vitruvius' De Architectura." *Annali di architettura, Revista del Centro Internazionale di Studi di Architettura Andrea Palladio* 14 (2002): 195–213.

Morresi, Manuela. "Treatises and the Architecture of Venice in the Fifteenth and Sixteenth Centuries." In *Paper Palaces: The Rise of the Renaissance Architectural Treatise*, edited by Vaughan Hart and Peter Hicks, 263–80. New Haven, CT: Yale University Press, 1998.

Mukerji, Chandra. "Printing, Cartography and Conceptions of Place in Renaissance Europe." *Media, Culture & Society* 28/5 (2006): 651–69.

Muraro, Michelangelo. *Venetian Villas: The History and Culture*. Translated by P. Lauritzen, J. Harper, and S. Sartarelli. Udine: Magnus Edizioni, 1986.

Neagley, Linda. "A Late Gothic Arch Drawing at the Cloisters." In *Reading Medieval Images: The Art Historian and the Object*, edited by Elizabeth Sears and Thelma K. Thomas, 91–9. Ann Arbor, MI: University of Michigan Press, 2002.

Nova, Alessandro. "The Role of the Winds in Architectural Theory from Vitruvius to Scamozzi." In *Aeolian Winds and the Spirit in Renaissance Architecture: Academia Eolia Revisited*, edited by Barbara Kenda, 77–83. London: Routledge, 2006.

Nuti, Lucia, "Mapping Places: Chorography and Vision in the Renaissance." In *Mappings*, edited by Denis E. Cosgrove, 90–108. London: Reaktion Books, 1999.

Oechslin, Werner. "L'Architettura Come Scienza Speculativa." In *Vincenzo Scamozzi, 1548–1616*, edited by Franco Barbieri and Guido Beltramini, 23–31. Venice: Marsilio, 2003.

Oechslin, Werner. "'Tractable Materials': Der Architekt zwischen 'Grid' und 'Ragion di Stato.'" In *Early Modern Urbanism and the Grid: Town Planning in the Low Countries in International Context: Exchanges in Theory and Practice*, edited by Piet Lombaerde and Charles van den Heuvel, 1–25. Turnhout: Brepols, 2011.

Olson, Lois. "Pietro De Crescenzi: The Founder of Modern Agronomy." *Agricultural History* 18/1 (1944): 35–40.

Osler, Margaret J. *Reconfiguring the World: Nature, God, and Human Understanding from the Middle Ages to Early Modern Europe*. Baltimore, MD: Johns Hopkins University Press, 2010.

Ottenheym, Konrad. "'L'Idea della Architettura Universale' in Olanda." In *Vincenzo Scamozzi, 1548–1616*, edited by Franco Barbieri and Guido Beltramini, 133–41. Venice: Marsilio, 2003.

Ottenheym, Konrad. "A Bird's Eye View of the Dissemination of Scamozzi's Treatise in Northern Europe." *Annali di Architettura: Rivista del Centro Internazionale di Studi di Architettura Andrea Palladio* 18–19 (2006): 187–98.

Pacey, Arnold. *Medieval Architectural Drawing*. Chalford Stroud: Tempus, 2007.

Padoan Urban, Lina. "Teatri e 'Teatri del Mondo' nella Venezia del Cinquecento." *Arte Veneta* 20 (1966): 137–46.

Palladio, Andrea. *The Four Books of Architecture*. Translated by Isaac Ware, London, 1738; facsimile New York: Dover, 1965.

Payne, Alina A. "Rudolf Wittkower and Architectural Principles in the Age of Modernism." *Journal of the Society of Architectural Historians* 53/3 (1994): 322–42.

Payne, Alina A. *The Architectural Treatise in the Italian Renaissance: Architectural Invention, Ornament, and Literary Culture*. Cambridge: Cambridge University Press, 1999.

Percerutti Garberi, Mercedes. *Frescoes from Venetian Villas*. Translated by Patricia Lamar. London: Phaidon Press, 1971.

Peterson, Mark A. *Galileo's Muse: Renaissance Mathematics and the Arts*. Cambridge, MA: Harvard University Press, 2011.

Placentino, Paola. "Politica ed Economia nella Riconfigurazione Tardocinquecentesca di Piazza San Marco: il Cantiere delle Procuratie Nuove." *Mélanges de l'Ecole Française de Rome, Italie et Méditerranée* 119/2 (2007): 321–40.

Pliny. *Complete Letters*. Translated and edited by P.G. Walsh. Oxford: Oxford University Press, 2006.

Pollack, Martha. "Military Architecture and Cartography in the Design of the Early Modern City." In *Envisioning the City: Six Studies in Urban Cartography*, edited by David Buisseret, 109–24. Chicago, IL: University of Chicago Press, 1998.

Pollack, Martha. *Cities at War in Early Modern Europe*. Cambridge: Cambridge University Press, 2010.

Ptolemy. *The Geography*. Translated by Luther Stevenson. New York: Dover, 1991.

Pullan, Brian. "Town Poor, Country Poor: The Province of Bergamo from the Sixteenth to the Eighteenth Century." In *Medieval and Renaissance Venice*, edited by Ellen E. Kittell and Thomas F. Madden, 213–36. Urbana, IL: University of Illinois Press, 1999.

Pumfrey, Stephen, Paolo Rossi, and Maurice Slawinski, eds. *Science, Culture, and Popular Belief in Renaissance Europe*. Manchester: Manchester University Press, 1991.

Puppi, Lionello. "The Villa Garden of the Veneto." In *The Italian Garden*, edited by David R. Coffin, 81–114. Washington, DC: Dumbarton Oaks, 1972.

Puppi, Lionello. *Scamozziana-Progetti per la "Via Romana" di Monselice e Alcune Altri Novità Grafiche con Qualche Quesito*. Florence: Edam, 1974.

Puppi, Lionello. *Andrea Palladio: The Complete Works*. New York: Electa/Rizzoli, 1989.

Puppi, Lionello. "Nature and Artifice in the Sixteenth-Century Italian Garden." In *The Architecture of Western Gardens: A Design History from the Renaissance to the Present Day*, edited by Monique Mosser and Georges Teyssot. Cambridge, MA: MIT Press, 1991.

Puppi, Lionello. "'Questa Eccellente Professione delle Mathematiche e dell'Architettura'—Idea di Cultura e Ruoli Sociali nel Pensiero di Vincenzo Scamozzi." In *Vincenzo Scamozzi, 1548–1616*, edited by Franco Barbieri and Guido Beltramini, 11–21. Venice: Marsilio, 2003.

Reeve, Matthew M. *Reading Gothic Architecture*. Turnhout: Brepols, 2008.

Romanelli, Giandomenico. "Scamozzi Versus Venezia? Venezia Versus Scamozzi?" In *Vincenzo Scamozzi, 1548–1616*, edited by Franco Barbieri and Guido Beltramini, 47–51. Venice: Marsilio, 2003.

Rosenfeld, Myra Nan. *Sebastiano Serlio on Domestic Architecture: Different Dwellings from the Meanest Hovel to the Most Ornate*. New York: Architectural History Foundation, 1978.

Rosenfeld, Myra Nan. "From Bologna to Venice and Paris: The Evolution and Publication of Sebastiano Serlio's Books I and II, On Geometry and On Perspective, for Architects." In *The Treatise on Perspective: Published and Unpublished*, edited by Lyle Massey, 281–322. Washington, DC: National Gallery of Art, 2003.

Rosenau, Helen. *The Ideal City, Its Architectural Evolution*. New York: Harper & Row, 1975.

Rykwert, Joseph. *The Dancing Column: On Order in Architecture*. Cambridge, MA: MIT Press, 1996.

Scamozzi, Vincenzo. *Taccuino di Viaggio da Parigi a Venezia (14 marzo-11 maggio 1600)*. Introduction by Franco Barbieri. Venice: Istituto per la Collaborazione Culturale, 1959.

Scamozzi, Vincenzo. *L'Idea della Architettura Universale*. Venice, 1615; facsimile Ridgewood, NJ: Gregg Press, 1964.

Scamozzi, Vincenzo. *Intorno alle Ville: Lodi e Comodità delle "Fabriche Suburbane" e "rurali" (1615)*. Edited by Lionello Puppi and Lucia Collavo. Turin: Allemandi, 2003.

Scamozzi, Vincenzo. *The Idea of a Universal Architecture III, Villas and Country Estates*. Translated and edited by Koen Ottenheym, Henk Scheepmaker, Patty Garvin, and Wolbert Vroom. Amsterdam: Architectura & Natura Press, 2003.

Scamozzi, Vincenzo. *The Idea of a Universal Architecture VI, The Architectural Orders and Their Application*. Translated and edited by Patti Garvin, Koen Ottenheym, and Wolbert Vroom. Amsterdam: Architectura & Natura, 2008.

Scamozzi, Vincenzo, and Battista Pittoni. *Discorsi sopra l'Antichità di Roma*. Venice, 1582; Milan: Il Polifilo, 1991.

Schulz, Juergen. "Jacopo de'Barbari's View of Venice: Map Making, City Views, and Moralized Geography before the Year 1500." *The Art Bulletin* 60/3 (1978): 425–74.

Semenzato, Camillo. "La Rocca Pisana dello Scamozzi." *Arte Veneta* 16 (1962): 98–110.

Serlio, Sebastiano. *Tutte l'Opere d'Architettura et Prospetiva*. Foreword by Giovanni Domenico Scamozzi. Venice: De'Francheschi, 1619.

Serlio, Sebastiano. *Sebastiano Serlio on Architecture*. Translated by Vaughan Hart and Peter Hicks. New Haven, CT: Yale University Press, 1996.

Smienk, Gerrit, Johannes Niemeijer, Hans Venema, and Frits van Dongen. *Palladio, the Villa and the Landscape*. Basel: Birkhauser, 2011.

Sorte, Cristoforo. "Osservazioni sulla pittura." In *Trattati d'arte del cinquecento*, edited by P. Barocchi, vol. 1, 277. Bari: G. Laterza, 1960.

Summers, David. "'The Heritage of Agatharcus': On Naturalism and Theatre in European Painting." In *The Beholder: The Experience of Art in Early Modern Europe*, edited by Thomas Frangenberg and Robert Williams, 9–35. Aldershot: Ashgate, 2006.

Tafuri, Manfredo. *Venice and the Renaissance*. Translated by Jessica Levine. Cambridge, MA: MIT Press, 1989.

Tavernor, Robert. *Palladio and Palladianism*. New York: Thames & Hudson, 1991.

Tuan, Yi-Fu. *Space and Place: The Perspective of Experience*. Minneapolis, MN: University of Minnesota Press, 1977.

Van de Vall, Renée. *At the Edges of Vision: A Phenomenological Aesthetics of Contemporary Spectatorship*. Aldershot: Ashgate, 2008.

Vasari, Giorgio. *Lives of the Artists*. Translated by George Bull. Harmondsworth: Penguin, 1965.

Vickers, Brian. "On the Function of Analogy in the Occult." In *Hermeticism and the Renaissance: Intellectual History and the Occult in Early Modern Europe*, edited by Ingrid Merkel and Allen G. Debus, 265–92. Washington, DC: Folger Shakespeare Library, 1988.

Vignola. *Régles des Cinq Ordres d'Architecture*. Paris: Jean, 1776.

Vitruvius. *I Dieci Libri dell'Architettvra*. Translated with commentary by Daniele Barbaro. Venice: Appresso Francesco de'Franceschi Senese, 1567.

Vitruvius. *On Architecture*. Translated by Frank Stephen Granger. Cambridge, MA: Harvard University Press, 1931.

Wear, Andrew. "Place, Health, and Disease: The Airs, Waters, Places Tradition in Early Modern England and North America." *Journal of Medieval & Early Modern Studies* 38/3 (2008): 443–65.

Wheatley, Paul. *The Pivot of the Four Quarters: A Preliminary Enquiry into the Origins and Character of the Ancient Chinese City*. Chicago, IL: Aldine, 1971.

Wilkinson, Catherine. "The New Professionalism in the Renaissance." In *The Architect: Chapters in the History of the Profession*, edited by Spiro Kostof, 124–59. New York: Oxford University Press, 1977.

Wilson, Alistair Macintosh. *The Infinite in the Finite*. Oxford: Oxford University Press, 1995.

Wilson, Bronwen. *The World in Venice: Print, the City and Early Modern Identity*. Toronto: University of Toronto Press, 2005.

Wittkower, Rudolf. *Architectural Principles in the Age of Humanism*. New York: Norton, 1971.

Wolin, Judith. "Mnemotopias: Revisiting Renaissance Sacri Monti." *Modulus* 18 (1987): 44–61.

Worsley, Giles. "Scamozzi's Influence on English Seventeenth Century Architecture." *Annali di Architettura: Rivista del Centro Internazionale di Studi di Architettura Andrea Palladio* 18–19 (2006): 225–33.

Wu, Nancy Y., ed. *Ad Quadratum: The Practical Application of Geometry in Medieval Architecture*. Aldershot: Ashgate, 2002.

Yates, Frances A. *The Art of Memory*. London: Routledge and Paul, 1966.

Zielinski, Siegfried. *Deep Time of the Media: Toward an Archaeology of Hearing and Seeing by Technical Means*. Cambridge, MA: MIT Press, 2006.

Index

"a scientific habit"
 defining architecture as invention 179–82
 describing the architect, advancing the profession 174–9
 introduction 173–8
 scientific habits 185–92
 will and legacy 182–5
Accademia Olimpica 6
Alberti, Leon Battista 30–32, 57–8, 67, 77, 85, 87, 98–100, 107–8, 137, 173, 175, 179
all'antiqua design
 Gonzaga, Vespasiano 157
 Libreria Marciana 105
 Palazzo Contarini degli Scrigni 128
 Palazzo, Vicenza 9
 Rome 1
Almerico, Paolo 10
architecture 181
architectural clients and works (Scamozzi) 9–17
Aristotle 180
astronomy 140

Barbaro, Daniele 7–8, 20–21, 58, 91–2, 122, 126, 175
Barbaro, Marc'Antonio xvii, 122, 138, 151, 166, 174, 179, 180–82
Barbieri, Franco xvii
Bardellini, Valerio 12
Baroque 173
Basilica, San Marco 104
Basilica, Vicenza 102–3
Bassano, Jacapo 85
Baths of Diocletian 5, 45
Bergamo 111–12
Bertotti Scamozzi, Ottavio 182–3

body analogy 21, 31
Bosboom, Simon 183
Boyle, Richard, Lord of Burlington 184
Bracciolini, Poggio 1
Bramante, Donato 64
Brunelleschi, Filippo 1–2, 99, 166, 178
Bruno, Giordano 40, 91, 173

Calderi, Ottone 183
Cartaro, Mario 5, 45
casa dominicale 59, 61, 66, 80
Casey, Edward 50
Castel Sant'Angelo, Rome (Hadrian's tomb) 163
Cataneo, Pietro 157
Centro Internazionale di Studi di Archittetura Andrea Palladio (CISA) xvi, xviii
Cesariano, Cesare 141
Chiswick House, Greenwich 184
Choay, Françoise xvii 151
chorography
 definition 101
 derivation xvi, 38
 see also geography
chorography and cosmography: place and transcendance
 cosmic order – number, geometry, proportion 139–46
 from idea to real – geometry and geography 146–51
 introduction 137–9
 Vespasiano Gonzaga's theater – chorography and cosmology 157–67
 Villa Duodo, cosmography of Rome 151–7
Christian Europe 22

"citizen of the world"
　introduction 1–4
　Scamozzi
　　— architectural clients and works 9–18
　　— early life and education 4–6
　　— influences and the problem of Palladio 6–9
　　— treatise 18–22
city 25
city as a cultural creation 191
Civitates orbis terrarium 102
Clavius, Christopher 5–6, 92, 140, 185
Codussi, Mario 104
Colosseum, Rome 41, 163
columns (orders) 142–6
Commentaries (Barbaro) 85
'compartition' 108
Composite order 143
Contarini buildings 13, 15
Copernicus 5
Corinthian order (columns) 143, 146, 156
Cornaro, Alvise 58, 60–61, 67, 179
Corso, Vicenza 121
corte rurale (farmyard) 72, 72–3
Cosgrove, Denis E. 39, 74–5, 102, 159–60, 191
cross-axis design 117

da Sangallo, Antonio the Younger 2
da Vinci, Leonardo 91–2, 99
Dante, Egnazio 38
De Architectura 25
de Bray, Saloman 183
de'Barbari, Jacopo 101, 104
de l'Orme, Philip 174
decumanus, Sabbioneta 162
decumanus maximus, Vicenza 121
della Francesca, Piero 138, 185
della Porta, Giacomo 191
della Porta, Giovanni Batista 166–7
Delminio, Guilio Camillo xviii, 7, 20, 139, 154
Descriptio urbis Romae 100
di Giorgio, Francesco 62, 99, 182
Discorsi sopra L'Anitchità di Roma 5, 40
"Discourse" (Scamozzi, G.D.) 175–6
Doge's Palace, Venice 104, 126, 129, 131
Donà, Leonardo 151
Doric Order (columns) 111, 144, 146, 155–6
Duodo, Domenico 151

Duodo, Francesco 151
dynamics of motion and change 191

early life and education (Scamozzi) 4–6
Elements 140, 185
environmental design 191
Euclid 5, 140, 185

Falconetto, Maria 56, 60–61
Filarete (Averlino, Antonio di Pietro) 147
fortified city 27
Franco, Veronica 58
Franz, Rainald xvii
Frascari, Marco xviii, 88, 91

Galileo 5, 42, 185
Gallo, Agostino 58
gardens 78–81
Gastaldi, Giacomo 35–6
Genoa 109–10
geographic knowledge xv
geography and chorography: Scamozzi's theory of place
　16th century 35–9
　book 2 of *L'Idea* ...: A Natural History of Cities and a Theory of Place 28–35, 39–40, 46, 49
　introduction 25–8
　mapping with words and pictures 39–43
　Scamozzi's architectural cartography 43–50
Geography (Ptolemy) xv, 29, 36, 101
geometric order 21, 31, 99
geometry 185–8
Gonzaga, Vespasiano 14, 157–67
Grand Canal, Venice 122, 130–31
Grimani, Morasina Morasini 139
Gritti, Andrea 104
grotoportici (cave-like porticos for walking) 84

Hapsburg Empire 98
Hermes Trismegistus 141
Hersey, George xvii
Hippocrates 29–30, 30
Hogenberg, Franz 40
Hopton, Arthur 36
Howard, Deborah xvii
human body 140–42
humanist literature (villas) 57

Huygens, Constantijn 183

il Pozzoserrato 58
Il Redentore, Venice 107, 127
Imola 99, 101
importance of place 191
intellectual basis of design 191
'invention' 181
Ionic Order (columns) 143, 145–6, 155–6

Jannaco, Carmine xvii 91
Jenkinson, Anthony 38
Jones, Inigo 2–4, 9, 22, 1̄0̄2̄

Kaufman, DaCosta 25
Kent, William 184–5
'kit of parts' (agricultural villa) 71

La Rotonda, Vicenza 10
landscape derivation 75
Le Fabbriche e Designi di Andrea Palladio 183
Levante wind 82–3
Libreria Marciana, Venice 14, 103–5, 122–4, 126–9, 178
Libro Estraordinario 6–7
L'Idea della Architettura Universale
 arts 183
 book 1 141, 180–81, 185–7
 book 2 A Natural History of Cities and a Theory of Place 28–35, 39–44, 46–7, 49, 67, 82, 97, 107, 137, 146, 149, 173, 177, 85, 188–90
 — chapter titles 195–6
 book 3, villa plans 32, 47, 49–50, 57, 69–70, 82–3, 115, 117, 137, 190
 book 6 144–5
 Cosmos 137
 description xvii, 1
 geometric order 99
 geometry 185
 intellectual expectations for an architect 176
 palaces 97
 portraits (Scamozzi, Vincenzo) 182
 quality of life 179
 science 173, 180
 summary 18–21
 unfinished buildings 177
 unsold copies 183
 Villa Pisani 13
light 31, 34, 82, 85–93

light categories 34, 87
Loggetta, Venice 105–6
Longhena, Baldassare 127, 182–3
 'luogo' xvi

macchina del mondo 174
Maderno, Carlo 191
Magia Naturalis 166
Magius, Charles 80
Magni Morali 180
magnificenza 68, 133
mapping the city: palaces and civic buildings
 city as place: urban chorographies of 16th century 99–107
 house and city – commodity and compartition 107–12
 introduction 97–9
 Palazzo Trissino al Corso, chorography of Vicenza 112–21
 Procuratie Nuove, chorography of Venice 122–33
mapping the natural world: *casa* and villa
 cosmography of villas 81–93
 geography of Scamozzi's villas 67–75
 introduction 55–7
 landshape, landscape, garden 75–81
 villa culture in the Veneto – ancient ideology and Renaissance interpretations 57–67
Massari, Giorgio 183
mathematics and science in architecture 191
Maurilico, Francesco 92
'memory wheels' 91
Mereworth Castle 184–5
Milizia, Francesco 150
Muttoni, Francesco 183

Nancy map 45, 189
neoclassical 173
"new science" 180
Newton, Isaac 91

Odeon, Padua 61
Oedipus Rex 11, 139, 159
Oeschlin, Werner xviii, 36
On Domestic Architecture 62
"openings" (architecture) 85
"Osservationi nella pittura" 75, 75–6

Ottenheym, Koen xviii

Pacioli, Luca 140
Padua 13, 98
Palazzo
 Chiericati, Vicenza 113–15
 Contarini Corfù 123
 Contarini dagli Scrigni 122–3, 128
 del Te 60
 della Ragione, Bergamo 111–12
 Ducale, Sabbioneta 35, 161
 Fino, Bergamo 110–12
 Godi, Vicenza 47, 117
 Nuovo (Palazzo Communale), Bergamo 14, 16, 111
 Ravaschieri, Genoa 109–10
 Trissino al Corso, Vicenza 112–21
 Trissino al Duomo, Vicenza 10, 47–9, 117
 Valmarana 118
Palladio, Andrea
 ancillary structures 71
 Basilica, Vicenza 103
 brevity 29
 casa dominicale 61
 Christian pilgrimage 154–5
 CISA xvi
 designs 20, 32, 62, 66, 72, 76, 102
 Doric order 116
 education 175
 humanistic interests 67
 Il Redentore 107, 127
 Jones, Inigo 2–4, 9, 185
 ordered unity of villas 66
 Palazzo Chiericati, Vicenza 113–15
 Palazzo Valmarana 118
 planning approach 74
 residential designs 49
 Roman *domus* 117
 Salt Office 105
 San Giorgio Maggiore 107, 127
 Scamozzi, Giovanni Domenico 174
 Scamozzi, Vicenzo xvii, 6–9, 12, 183, 191
 Serlio, Sebastiano 63
 site planning 65
 Teatro Olimpico 11–12, 139, 157–9, 161, 164
 theory of orders 21, 142
 Trissino, Giangiorgio 174
 two-story palazzos 9
 unfinished works 9

Vicenza 10, 107, 112
Villa Pisani, Bagnolo 12, 83
Villa Badoer 47
Villa Rotonda 11, 185
villas 190
Palmanova 150
Pantheon, Rome 1
Paris architecture 2
Payne, Alina xviii
Peruzzi, Baldassare 182
Photisme de lumine et umbra 92
Piazza Duomo, Bergamo 111
Piazza San Marco, Venice 104–5, 122, 125, 126, 130–31, 133
Piazza Vecchia, Bergamo 111
Pisani, Vettor 12, 83
Pittoni, Battista 40, 40–41
Pizzocaro, Antonio 183
Plato 38, 141
Pliny the Younger 21, 57
Pope Paul V 152
Pozzoserrato, Ludivico 79
Preti, Maria 183
Procession of the Cross in Piazza San Marco 125
Procuratia de Supra (Piazza San Marco) 122
Procuratie Nuove, Venice 14, 16, 105, 122–33, 183
Procuratie Vecchie, Venice 104, 126
"profilo" 138
proportional diagram (human body) 140–42
proto (master builder) 105, 126
Ptolemy xv–xvi, 20, 29–30, 36, 39, 41, 101, 137
Puppi, Lionello xvii–xviii, 78
Pythagoras 140–42, 151, 188

Raitenau, Theodore Wolfgang 15
Ramusio, Gian Battista 35
Renaissance
 architects 85, 99
 architecture 1
 cartographers 36
 chorography 101
 compositional principles 56
 design 1
 palazzo 9
 sharing knowledge 178
 theory of orders 143
Roman order (columns) 143, 146, 155
Romano, Guilio 38
Rome

basilicas 155
building design 1
Castel Sant'Angelo 163
Colosseum 41, 163
Christianity 156
Discorsi sopra l'Anitchità di Roma 40–41
domus 117
Empire 29
Pantheon 1
Santa Maria Maggiore 116
Rubens, Peter Paul 183

S. Gaetano, Padua 13, 15, 119
S. Michele, Este 13
S. Nicola dei Tolentini, Venice 13
Sabbioneta ducal theater 14, 160–67
Sack of Rome (1527) 104
Sacri monti 154–55, 157
Sadeler, Justus 183
Salzburg Cathedral 15, 17
San Giorgio Maggiore, Venice 107, 127, 151–2, 154
Sansovino, Francesco 133
Sansovino, Jacopo 8, 14, 56, 61, 102–6, 122–4, 126–7
Santa Maria Maggiore, Rome 116, 155
Savorgan, Guilio 150
scaenography 138
Scamozzi, Giovanni Domenico 4–5, 6–8, 174–5
"science" term 179
Scientific Revolution 21, 22, 190
Serlio, Sebastiano 6–7, 20–21, 29, 61–5, 67, 110, 137–8, 143, 159, 164, 167, 174, 178, 185, 189
Shakespeare, William 173
"sito" xvi
Socrates 82
Sorella, Simon 126
Sorte, Cristoforo 38, 75–6
"speculation" 181
Speculum Topographicum 36
Strabo 29–30, 35
Strozzi, Roberto 15

Taccuino di Viaggio da Patigi a Venezia 40–41
teatri del mondo 139
Teatro Olimpico, Vicenza 8, 11–12, 139, 157–9, 161, 163–4, 178
Ten Days of True Agriculture 58

The Four Books of Architecture 11, 47, 63, 65, 115
"the ideal city" 99
theater of memory 154
"theater of the world" 133
"Third Rome" (Venice) 105
Toeput, Lodewijk 58
Torre dell'Orologio, Venice 104
Tramontana wind 82
treatise
 Scamozzi 18–22, 131, 183
 see also L'Idea …
Trissino, Francesco 9
Trissino, Galeazzo 10, 114–15
Trissino, Giangiorgio 174
Tuan, Yi-Fu xv
Tuscan 146

Vasari, Gorgio 178, 180
Vatican 38
Veduti (landscapes) 40
Venetian 104
Venice
 "City of the World" 133
 history 98
 palaces 13
 "theater of the world" 133
 'Third Rome' 105
ventidoti (wind tunnels) 84
Verlato, Leonardo 12
Veronese, Paolo (painter) 3, 58, 182
"Via Romana" 152, 154, 156
Vicenza 9–10, 98, 107, 114
Vignola (Giacomo Barozza da Vignola) 29, 138, 142–3
Villa
 d'Este 60, 78, 153
 Badoer, Peraga 47, 70, 72, 80
 Bardellini 33–4, 34, 49, 88, 90–91, 188
 Contarini 13, 15, 65, 72
 Cornaro al Paradiso, Castelfranco 7, 13, 72–3
 Cornaro, Puisuolo 71–2, 78
 della Torre, Verona 58
 Duodo 13, 151–7, 152–4
 Emo 65
 Farnesina 61
 Ferramosca 75
 Giulia 60
 La Rocca Pisani 12
 Lante 78
 Madama 60

Molino, Mandria 12–13, 69, 69–70
Pisani, Lonigo 13, 62, 70, 76–7, 83–4, 86, 88–91
Rotonda 8, 11, 76, 89
Trevisan 49, 70, 81
Verlata 70, 72, 75
Villaverla 75
Vitruvius xviii 1, 7, 9, 20–21, 25, 30–32, 57, 82, 85, 91, 99, 122, 138, 143, 147–8, 174, 177, 179, 183

von Campen, Jacob 183

War of the League of Cambrai 55
water 31
wind 31–2, 82–3
wind rose 32

Zecca, Venice 105–6, 126–7, 178